Screening Statues

Edinburgh Studies in Film and Intermediality
Series editors: Martine Beugnet and Kriss Ravetto
Founding editor: John Orr

A series of scholarly research intended to challenge and expand on the various approaches to film studies, bringing together film theory and film aesthetics with the emerging intermedial aspects of the field. The volumes combine critical theoretical interventions with a consideration of specific contexts, aesthetic qualities, and a strong sense of the medium's ability to appropriate current technological developments in its practice and form as well as in its distribution.

Advisory board
Duncan Petrie (University of Auckland)
John Caughie (University of Glasgow)
Dina Iordanova (University of St Andrews)
Elizabeth Ezra (University of Stirling)
Gina Marchetti (University of Hong Kong)
Jolyon Mitchell (University of Edinburgh)
Judith Mayne (The Ohio State University)
Dominique Bluher (Harvard University)

www.euppublishing.com/series/esif

Screening Statues
Sculpture and Cinema

Steven Jacobs, Susan Felleman, Vito Adriaensens, and Lisa Colpaert

EDINBURGH
University Press

Edinburgh University Press is one of the leading university presses in the UK. We publish academic books and journals in our selected subject areas across the humanities and social sciences, combining cutting-edge scholarship with high editorial and production values to produce academic works of lasting importance. For more information visit our website: edinburghuniversitypress.com

Edinburgh University Press Ltd
The Tun – Holyrood Road
12 (2f) Jackson's Entry
Edinburgh EH8 8PJ

Typeset in 11/13pt Garamond MT Pro by
Servis Filmsetting Ltd, Stockport, Cheshire
and printed and bound in Great Britain by
CPI Group (UK) Ltd, Croydon CR0 4YY

A CIP record for this book is available from the British Library

ISBN 978 1 4744 1089 2 (hardback)
ISBN 978 1 4744 1090 8 (webready PDF)
ISBN 978 1 4744 1091 5 (epub)

Contents

PART II

Figures

PART II

All images from the *Sculpture Gallery* in Part 2 are digital stills taken from
DVD, BluRay, or digital editions of the films, except for:

> page 188 *Die steinernen Wunder von Naumburg* (Curt Oertel and Rudolf
> Bamberger, 1932): book cover of Edwin Redslob, *Die steinernen Wunder
> von Naumburg* (Leipzig: Seemann Verlag, 1933);
> page 191 *Night Life of the Gods* (Lowell Sherman, 1935): Advertisement
> from *Cine-Mundial* vol. XX no. 1 (January 1935), p. 38;
> page 196 *Venus vor Gericht* (Hans H. Zerlett, 1941): Advertisement from
> *Illustrierter Film-Kurier* no. 3214 (1941).

Acknowledgments

This book was made possible thanks to the help and support of numerous individuals and institutions. First of all, we are grateful for the support of the KASK School of Arts at University College Ghent, Belgium, as this volume is the result of a research project (2010–14) focusing on the visualization of artists and artworks in film, sponsored by that institution. Supervised by Steven Jacobs and Susan Felleman and with Vito Adriaensens and Lisa Colpaert as researchers, this project resulted in a number of lectures, film programs, symposiums, conference papers, articles, books, and films. While the fictitious museum guide, *The Dark Galleries* (published by Aramer in 2013), by Jacobs and Colpaert deals with painted portraits in noir thrillers and gothic melodramas of the 1940s and 1950s, this book focuses on the representation of sculpture in cinema.

Several chapters of this book are based on previously published materials. An earlier version of the chapter on sculpture in early cinema was published by Adriaensens and Jacobs in a 2015 issue of *Early Popular Visual Culture*. Several paragraphs of the chapter dealing with art documentaries were taken from an article published by Jacobs in Dutch in a 2012 issue of *De Witte Raaf*. The chapter on statues in peplum films is an adaptation of an article by Adriaensens published in *Cineaction* in 2013 while some paragraphs dealing with *Last Year in Marienbad* in the chapter on modernist cinema were developed earlier in an essay by Jacobs published in the exhibition catalogue on *Marienbad* and its relation to the arts published by Kunsthalle Bremen. We would like to thank the editors of these journals and books as well as some readers for their comments and valuable suggestions.

Other parts of this book originated as lectures or conference papers, including a paper on sculptures and wax museums (by Adriaensens and Jacobs) at the conference entitled *Desiring Statues: Statuary, Sexuality, and History*, organized by Jana Funke and Jennifer Grove at the University of Exeter in 2012. Earlier versions of Felleman's Coda were presented to the session *Motion Pictures: Contemporary Visual Practices of Movement and Stillness*, a panel organized

by Bettina Papenburg and Marta Zarzycka for the 2015 annual meeting of the College Art Association in New York and to *Figurations of Intermediality in Film*: XV Film and Media Studies Conference in Transylvania (Cluj-Napoca, 2014), where Adriaensens also delivered a paper related to Chapter 7. Felleman and Jacobs presented papers on a panel dedicated to sculpture in film at the 2013 conference of the Society of Cinema and Media Studies in Chicago. Ideas from these papers resonate in this book, particularly in the chapters on art documentaries and postwar American cinema. Our ideas were also shaped, tested, and refined at various lectures, screenings, and film programs curated by Steven Jacobs at Art Cinema OFFoff and KASK Cinema in Ghent and Wiels in Brussels.

For their inspiring discussions, useful suggestions, information and/ or support, we thank Godart Bakkers, Martine Beugnet, David Bordwell, Paul Buschman, Hallie Chametzky, Peter Chametzky, Birgit Cleppe, Karel De Cock, Hilde D'haeyere, Edward Dimendberg, Martina Droth, Caroline Dumalin, Christoph Girardet, Elena Gorfinkel, David Grotell, Christoph Grunenberg, Eva Fischer-Hausdorf, Vera Lutter, Lynda Nead, Brigitte Peucker, Linda Phipps, Brigid von Preussen, Imogen Racz, Jenny Romero, Bénédicte Savoy, Ben Singer, Dirk Snauwaert, Kato Van Broeckhoven, Bram van Oostveldt, Bart Versteirt, and Ray Watkins, as well as Kim Gore and Mary Anne Fitzpatrick of the University of South Carolina. For their generosity and assistance with illustrations, we thank Arthur and Corinne Cantrill, Sandra Gibson and Luis Recoder, Anthony McCall and Lauren Nickou, and Agnès Varda and Stéphanie Scanvic of Ciné-Tamaris. Last but not least, we would like to express our gratitude to Edinburgh University Press, in particular to commissioning editors Gillian Leslie and Richard Strachan as well as series editors Martine Beugnet and Kriss Ravetto for their support and patience.

Introduction: The Marble Camera

STEVEN JACOBS

> I desire in moving pictures, not the stillness, but the majesty of sculpture. I do not advocate for the photoplay the mood of the Venus of Milo. But let us turn to that sister of hers, the great Victory of Samothrace, that spreads her wings at the head of the steps of the Louvre.
>
> Vachel Lindsay, *The Art of the Moving Picture* (1915)[1]

> Brutal and positive like nature, sculpture is at the same time vague and eludes one's grasp, because it presents too many sides at once.
>
> Charles Baudelaire, *Why Sculpture Is Boring* (1846)[2]

LOOKING AT SCULPTURES

According to Rudolf Arnheim, "much sculpture lacks the essential quality of life, namely, motion."[3] This is why, no doubt, marble statues and plaster casts played such an important role in the works of early photographers of the late 1830s and 1840s, who had to cope with long exposure times.[4] Given this perspective, what can be said about the relation between sculpture and film, a medium often first and foremost characterized by motion? This book deals with a wide range of magical, mystical, cultural, historical, formal, and phenomenological interactions between the two media. Apart from the contrast between stillness and movement, sculpture and film can be seen as opposites in other ways. Whereas sculpture is an artistic practice that involves not only static but also material, three-dimensional, and durable objects, the cinema produces kinetic, immaterial, two-dimensional, and volatile images. However, the history of cinema amply illustrates the attraction of these opposites. Sculpture and film were made for each other, so to speak. Apart from the fact that sculpture – much more than painting – has always been an art of reproduction (i.e. is often cast), it is often seen as an art that invites movement as shifting positions of the viewer in space are necessary to see and experience it in the round. This was also the rationale for the filmmakers around the period of the First World War who made travelogues showing

monuments and public sculptures that could be considered the earliest films focusing on artworks.[5] Having the advantage that they could be filmed in natural light and were often monochromatic, such subjects lent themselves to early cinema better than paintings. Hans Cürlis, for instance, the major pioneer of the art documentary, considered paintings and drawings *unfilmisch* while he saw sculpture as an art form well suited to the medium of film.[6] From 1919 onwards, he made several films containing shots of sculptures displayed on a slowly rotating pedestal. Notably, these films featured no camera movement; rather, the sculptures were put into motion in front of the camera, a way of looking that evoked the rotating base in a sculptor's studio, as well as in some nineteenth-century exhibition practices.[7]

However, precisely because film also involved mobility by means of editing and camera movement, it came to be seen as perfectly able to emphasize the immobility of sculpture. "We feel the necessity of movement in order to grasp the statue's immobility," French art historian Henri Focillon asserted in a 1935 article on the use of film for teaching the arts.[8] Because of its dynamic nature and because it enabled the integration of multiple perspectives into a single experience, film could make manifest the stability as well as the three-dimensional or spatial properties of sculpture. These qualities have made the extensive cinematic visualization of sculptures highly attractive throughout film history, as demonstrated by László Moholy-Nagy or Constantin Brancusi filming their own sculptural creations in the 1920s and 1930s. Likewise, widely divergent films such as *Angel* (Joseph Cornell, 1957), *Gyromorphosis* (Hy Hirsch, 1958), *Spatiodynamisme (Visions condensées)* (Nicolas Schöffer, 1958), *Césarée* (Marguerite Duras, 1979), *Les dites cariatides* (Agnès Varda, 1984), and the mid-twentieth-century documentaries discussed in Chapter 3 illustrate the film medium's capacity to represent or evoke the plastic qualities of sculpture.

Even recently, prominent filmmakers and artists have created films that first and foremost consist of the cinematic study or reverie of sculptural volumes: *Angel* (David Claerbout, 1997), *Lo Sguardo di Michelangelo* (Michelangelo Antonioni, 2004), *Static* (Steve McQueen, 2009), *Concrete & Samples III Carrara* (Aglaia Konrad, 2010), *The Eternal Lesson* (Christoph Girardet, 2012), *Inventory* (Fiona Tan, 2012), *Rotations* (Javier Tellez, 2012–13), *The Beginning. Living Figures Dying* (Clemens von Wedemeyer, 2013), *It for Others* (Duncan Campbell, 2014), and *The Night Gallery* (Mark Lewis, 2014).

These meticulously cinematic explorations of sculpture rearticulate some of the discussions central to sculptural theory since the eighteenth century. In his 1778 treatise on sculpture, Johann Gottfried Herder, for instance, linked the difference between painting and sculpture to the distinction between sight

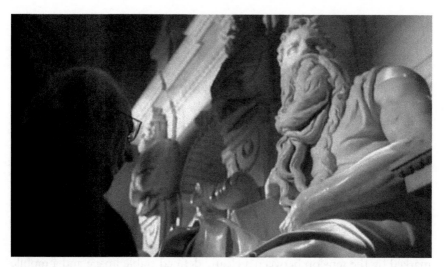

Figure I.1 Lo Sguardo di Michelangelo *(Michelangelo Antonioni, 2004) – Digital Still.*

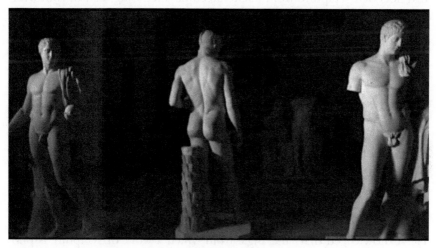

Figure I.2 The Night Gallery *(Mark Lewis, 2014) – Digital Still.*

and touch, but he also noted that the apprehension of sculpture is not a liter-
ally tactile experience but a visual perception that was closely connected to a
tactile exploration.[9] Herder also emphasized the kinesthetic apprehension of
sculpture since it involved a mobile kind of viewing, which does not seize on
the statue as a fixed form but senses its wholeness as the gaze moves across
over its surfaces. Clearly different from the simultaneity of painterly viewing,
the apprehension of a sculptural shape, according to Herder and others,
could never be assimilated in a single fixed image.

These ideas informed theories on sculpture throughout the nineteenth century and were particularly important at the moment of the film medium's inception. In *Das Problem der Form in der bildenden Kunst* (1893), which would become a key reference for early formalist accounts of sculpture, Adolf Hildebrand advocated the idea that the apprehension of free-standing sculptures was dependent on a painterly model of formal coherence.[10] Although he recognized a tactile or haptic way of seeing, which differs from a painterly one in which stable forms were dissolved in atmospheric effects, Hildebrand's concept of vision was essentially two-dimensional. Inspired by perceptual psychology, Hildebrand was convinced that our spatial mapping of the world involves two-dimensional representations. He consequently conceived plastic form not so much as a three-dimensional shape but rather as the two-dimensional view of an object which presented its overall shape with greatest clarity. The apprehension of a piece of sculpture was thus marked by the tension between a clearly defined stable image and a mobile kinesthetic experience of the shifting partial views. Modern sculptors, who had liberated sculpture from its architectural anchoring, had thus to over-come the many variable forms of a sculpture in the round by defining a principal viewpoint from which the sculpture became manifest as a satisfy-ing whole, also a major problem for the photography of sculpture, as art historian Heinrich Wölfflin noted in a series of articles published between 1896 and 1915.[11] For André Malraux, who published three volumes of *Le Musée imaginaire de la sculpture mondiale* in the early 1950s, sculpture benefits from photography (more than painting does), not because photography is more faithful to sculpture, but because photography (as well as film, the other art of the camera) acts more forcefully upon objects that demand to have a point of view imposed on them.[12] According to Malraux, "our albums have found in sculpture – which black and white prints reproduce more faithfully than they do paintings – their privileged domain."[13] However, Malraux recognized that photography was not a simple transparent medium. He acknowledged that "the angle from which a work of sculpture is pho-tographed, the focusing, and, above all, skillfully adjusted lighting, may impart violent emphasis to something the sculptor himself merely hinted at."[14] Photography and film, consequently, do not represent sculptures but rather translate, transform, or "metamorphosize" them. Photographic reproductions bring sculptures to the two-dimensional space that is the realm of photography and film. Several chapters of this book demonstrate that filmmakers explicitly play on this tension, transforming sculpture into a cinematic experience.

SCULPTURE, FILM, AND MODERNITY

Hildebrand's combination of reliance on a classical model of formal coherence, on the one hand, and a modern sensitivity to kinesthetic effects on the other also marked the development of a modernist sculptural aesthetics in the late nineteenth and early twentieth centuries. Before focusing on modernist sculpture and its relations to film, however, it is important to note that, by 1900, "sculpture" and "modernity" had come to be seen as antagonistic concepts. Already several eighteenth-century authors such as Diderot, in his discussion of the Salon of 1765, had noted that sculptors relied much more on the pure forms of classical art than painters. Diderot explained this by referring to the simple fact that high-quality pieces of sculpture had survived from antiquity while paintings had not. However, Diderot also noted that sculpture was further removed from nature and had to focus more on the formal beauty of a figure than on expressive feeling. "No laughter in marble," Diderot wrote.[15]

This idea was further developed in Georg Wilhelm Friedrich Hegel's highly influential theory of the nature and historical role of the different arts.[16] Presenting the different stages of art history as an expression of the different stages of the development of the Spirit, Hegel interpreted Greek sculpture, with its focus on the human figure, as the art in which the Spirit had found its most adequate form of expression. Painting, by contrast, was for Hegel best suited to the expression of a modern or "romantic" Christian spirituality. This is because the absence of bodily solidity and the presence of color allow the more inward spirituality of the Christian world to manifest itself. If classical art can be compared to the human body suffused with spirit and life, romantic art can be compared to the human face, which discloses the spirit and subjectivity within. Although disconnected from their spiritual and teleological connotations, Hegel's ideas proved very influential for modern art theory and its different attitudes *vis-à-vis* painting and sculpture. Hegel's metaphors even resonate in Vachel Lindsay's 1915 *The Art of the Moving Picture*, the first book to treat movies as art. Lindsay called the "Action Film" "sculpture-in-motion," whereas he described the "Intimate Photoplay" as "painting-in-motion."[17]

First and foremost, however, Hegel's ideas paved the way for nineteenth-century art theorists such as Charles Baudelaire, Joris-Karl Huysmans, and Théophile Gautier, who linked the modern with subjectivity, atmospheric effects, and thus the dematerialization of solidity. Sculpture was envisioned as the art form whose essence lay in plastic form, painting as the art form whose essence lay in changing visual appearances.[18] Throughout the later nineteenth century and far into the twentieth, painting became the paradigmatic medium of modernity while sculpture became something obsolete.

In *The Language of Sculpture*, William Tucker notes that "nineteenth-century sculpture was wholly unprepared to sustain any serious aesthetic purpose: all the great issues that had torn painting apart – the choice between Ingres and Delacroix and between color and line; the realism of Millet and Courbet; the rise of pure landscape – had left sculpture untouched."[19] Sculpture, consequently, became "boring" according to Baudelaire in his famous review of the Salon of 1846. Thirty years later, Huysmans stated that if sculpture cannot acclimatize itself to modern life, "sculptors will have to content themselves with being 'ornamentistes' and they should not encumber the art Salon with their products."[20] For many leading modernist artists and critics, sculpture had become uninteresting, as indicated by the oft-quoted statement by the abstract painter Ad Reinhardt: "Sculpture is something you bump into when you back up to look at a painting."[21] While painting was presented as a medium perfectly capable of expressing the condition of modernity, sculpture was often associated with eternity, antiquity, lost civilizations, and death. "The statuary art," Théophile Gautier wrote, "now exists only as Sanskrit, Greek and Latin do: as a dead language."[22]

This notion of sculpture as a dead medium became a recurring topic in twentieth-century art theory. In 1945, Italian sculptor Arturo Martini famously called sculpture a *lingua morta*, a "dead language" – not only because it basically offers a lifeless spectacle when compared to its sister arts but also because it is "constantly looking back over its shoulder to a happier past."[23] This element of nostalgia, no doubt, was inherently linked to the fact that sculpture is the funerary art *par excellence*, but also stemmed from the importance of the classical tradition for sculpture. Throughout the nineteenth and the first half of the twentieth century, not only public monuments but also pieces of autonomous modern sculpture were, to a large extent, marked by a restrained and archaizing classicism. This classicism can be found in works by seminal sculptors such as Antoine Bourdelle, Charles Despiau, Eric Gill, Georg Kolbe, Aristide Maillol, and Paul Manship, who often favored a heavy figuration expressing a kind of "gravitas." According to Penelope Curtis, this kind of "figurative sculpture represented one of the more tangible links with this past, in the very real form of surviving ancient statuary."[24] Sculpture's reliance on the classical tradition is also demonstrated in the popular imagination. When a sculpture plays an important part in a film, for instance, it is often a classical statue. This is already clear in early cinema, the topic of the first chapter of this book. In this case, the use of statues or tableaux vivants referring to classical antiquity can simply be related to the dominant neo-classicist style in late nineteenth and early twentieth-century sculpture. However, as other chapters in this book amply demonstrate, classical statues pervade film history, even in later film styles that are self-consciously modern

such as Surrealist film, the American trance film, and postwar European modernist cinema (the topics of Chapters 2, 5, and 6 respectively).

These obstinate instances of classicism indicate sculpture's struggle with modernity. This is reflected in discourses about cubist sculpture, something of a contradiction in terms, since the simultaneous representation of multiple perspectives on a single plane is cubism's *raison d'être*. Furthermore, many other modernist experiments in sculpture can be described as "pictorial investigations of the third dimension," or a kind of "painting or drawing in space and time" as promoted by artists such as Umberto Boccioni, Alexander Rodchenko, Vladimir Tatlin, Katarzyna Kobro, László Moholy-Nagy, Alexander Calder, Georges Vantongerloo, or David Smith.[25] Nonetheless, notwithstanding the modernist fascination with the idea of dematerializing solidity, several variations of a modernist sculptural aesthetic developed between the late nineteenth and the middle of the twentieth centuries.[26] One of these variations, unmistakably best exemplified by Auguste Rodin's work, suggested something fragmented, sketch-like, incipient, or unfinished. Through the play of light, surfaces seem to break out beyond their literal boundaries and the sculptures seem to penetrate the spaces around them – issues that will be discussed more elaborately in the third chapter, dealing with art documentaries on sculpture, Henri Alekan's 1957 film on Rodin among them. Also, Brancusi, who photographed and filmed his sculptures extensively with the help of Man Ray, was highly concerned with the ways light defined his sculptural shapes, as well as with the placement of the object and its interaction with the viewer.[27] In contrast to Rodin, however, Brancusi located the essence of sculpture in its rendering of plastic form – something that was further emphasized by a return to solidity and plasticity in the works of other artists such as Aristide Maillol, Hans Arp, Henry Moore, and Barbara Hepworth.

The development of modernist sculpture also includes a quite different practice exemplified by works of constructivist artists who created sculptures as a kind of mediation between painting and architecture. Sculptural works by Naum Gabo and László Moholy-Nagy, or artists of *De Stijl*, relate more to experiments in non-objective painting and architecture than to the art of sculpture. Inspired by a new spatial sensibility, which destroyed traditional perspective in painting and conventions in architecture, constructivist artists abolished the idea of a sculpture as an organic, delineated, solid, and closed volume. Instead, their sculptural works articulated space in a way reminiscent of the new architecture, which seemed to defy gravity and the traditional boundaries between inside and out. For these avant-garde artists experimenting with sculptural forms in the 1920s and 1930s, the emphasis on frontality and a "pictorial" apprehension of sculpture had become outdated.

Hildebrand's ideas "were aberrations resulting from a *fear* of space, fear of seeing the sculptural *object* lose itself in the world of objects, fear of seeing the limits of art blur as real space invaded the imaginary space of art."[28]

Notably, avant-garde artists, architects, and filmmakers linked this new conception of space to the medium of film and its mobilization of the gaze through camera movements and editing. Theo van Doesburg, for instance, emphasized that, "freed from stability and gravity," film can realize "an architecture of light and time that is satisfying for our modern way of life."[29] Sergei Eisenstein, likewise, compared the cinema's power to surpass traditional spatial and temporal boundaries with the effect of the architecture of Le Corbusier.[30] On the pages of the avant-garde art journal *G* (1923–6), contributions by pioneers of abstract film such as Viking Eggeling and Hans Richter, who mobilized the painter's static canvas through the introduction of movement and temporality, are combined with texts and images by architects and artists such as Ludwig Mies van der Rohe and El Lissitzky, who worked with open plans and free-flowing spatial conceptions.[31] For constructivist artists, architects, and filmmakers, the dynamic spatiality in their works was unmistakably linked to the medium of film, which the art historian Erwin Panofsky in the 1930s defined as the "spatialization of time" and the "dynamization of space."[32]

Likewise, László Moholy-Nagy stated that "motion pictures, more than anything else, fulfill the requirements of a space–time visual art."[33] Without a doubt, Moholy-Nagy created the most "sculptural" of all the abstract films of the 1920s, if not the most sculptural film ever made. His *Ein Lichtspiel: Schwarz Weiss Grau* (1930) is exclusively based on sculptural preoccupations such as light, volume, voids, texture, and materiality. Instead of the "graphical" animation techniques used in most other early abstract films, *Ein Lichtspiel* consists entirely of "photographic" imagery. On the one hand, the

Figures I.3 and I.4 Ein Lichtspiel: Schwarz Weiss Grau *(László Moholy-Nagy, 1930) – Digital Stills.*

film can even be conceived as a documentary – a documentary on the *Light/ Space-Modulator*, the artist's own kinetic sculpture made in 1921–30. Thus, Moholy-Nagy's film announces an entire series of intriguing documentaries on kinetic sculpture, which is, for evident reasons, a perfect subject for film: for example, several films on the works by Alexander Calder such as *Sculpture and Constructions* (Herbert Matter, 1944), *Works of Calder* (Herbert Matter, 1950), *Le Cirque de Calder* (Carlos Vilardebo, 1961), and *From the Circus to the Moon* (Hans Richter, 1963), or D. A. Pennebaker's *Breaking It Up at the Museum* (1960) dealing with Jean Tinguely's self-destructive sculptural installation *Homage to New York* (1960). On the other hand, *Ein Lichtspiel* is not so much a portrait as, rather, a filmic extension of the sculptural construction. Light and movement, which are crucial elements in the *Light/Space-Modulator*, are after all also the basic elements of the film medium. Answering perfectly to the constructivist ambitions stipulated in the *Realist Manifesto* (1920) by Naum Gabo and Antoine Pevsner, the film shows sculptural volumes that merge with their surrounding space and masses that dissolve into a spatial continuum. By means of alienating close-ups, multiple exposures, and the combination of positive and negative images, as well as the alternation between direct and indirect light, Moholy-Nagy creates a construction consisting entirely of light and space. *Ein Lichtspiel* illustrates beautifully how the boundaries between sculpture and film can be blurred. In his 1947 book *Vision in Motion*, Moholy-Nagy discerned five stages of volume modulation – the last one being the "kinetic (moving)" after the ones he described as "blocked out," "modeled (hollowed-out)," "perforated (bored-through)," and "equiposed (suspended)."[34] Modern sculpture, according to Moholy-Nagy, was in itself marked by a tendency toward dematerialization and movement, perfectly symbolized by the mobile, which he described as "a weightless poising of volume relationships and interpenetrations. With this transformation, the original phenomenon of sculpture – the elements of which equaled material plus mass relationships – becomes dematerialized in the abstract formula: sculpture equals volume relationships."[35] Modern sculpture tended, as it were, toward a kind of ephemeral, immaterial art of space akin to film. Throughout the twentieth century, this was demonstrated not only by experiments with kinetic sculpture but also by an entire tradition in which light was presented as a sculptural medium. Apart from Moholy-Nagy with his *Light/Space-Modulator*, artists such as Ludwig Hirschfeld-Mack, György Kepes, Lucio Fontana, Otto Piene, Nicolas Schöffer, François Morelet, Dan Flavin, Martial Raysse, and many others used light to fuse the art object and its environment into a perceptual whole, making a step toward an art of total immateriality.[36]

Somewhere in the first half of the twentieth century, consequently, a shift occurred in sculpture's relation to modernity due to its shifting relation to film.

As mentioned earlier, throughout the nineteenth and early twentieth centuries, painting was presented as the modern medium *par excellence*. Moreover, while emphasizing painting's capacity to express the condition of modernity, it was often associated with qualities which would later be described as *filmic*: painting was an art that was able to evoke speed, movement, the play of light, the endless flux of contingencies, et cetera. While the pictorial innovations of impressionism, cubism, and futurism were often explained by referring to the vividness and flux of the photographic snapshot and the new art of the cinema, sculpture was presented as a dead language. But from the 1920s onwards, artists started to refer to the new spatial dynamics of film to develop new models of sculpture – a form of sculpture that itself became "filmic" as it mobilized spatial relationships, became "kinetic" in itself, or consisted first and foremost of light.

REAL BODIES, DEATH, AND DESIRE

Evoking light, space, and movement perfectly, *Ein Lichtspiel*, in its attempt at transposing sculpture into film, ignores, however, a feature that is often seen as an essential characteristic of sculpture: solidity. Solid form makes sculpture seem "real." According to William Tucker, "sculpture, of its nature, *is* object, in the world, in a way in which painting, music, poetry are not."[37] This "reality effect" of sculpture, its materiality in space, or its physical existence in the "real world," is a recurring topic in seminal theoretical texts on sculpture and is even emphasized in key texts on modern twentieth-century sculpture by authors such as Carola Giedion-Welcker, Eduard Trier, Herbert Read, A. M. Hammacher, William Tucker, Rosalind Krauss, Jack Burnham, Penelope Curtis, Rudolf Arnheim, and Alex Potts.[38] In contrast to paintings, sculptures are part of the realm in which we are living; they occupy our space. As a result, sculptures, much more than paintings, are often regarded as decorative objects, and as things among our other possessions and furnishings. They may have symbolical functions, evoke illusory worlds, and stir our imagination, but they remain resolutely material; they can be touched, moved, or manipulated in ways that paintings cannot – an effect on which many twentieth-century sculptures are highly dependent, from the hyperrealist figures by John De Andrea to ready-mades, minimalist and post-minimalist installations, and various forms of appropriation art. Moreover, as solid objects, sculptures summon a material and spatial relationship with their surroundings. This is why, according to Rudolf Arnheim, "sculpture calls for the outdoors"[39] – an effect rewardingly used in the attractive footage of statues against natural backgrounds such as shifting clouds or moving foliage in documentaries such as *A Sculptor's Landscape* (John Read, 1958), experimental

films such as James Broughton's, or feature films such as *The Damned* (Joseph Losey, 1963) or *Le Mépris* (Jean-Luc Godard, 1963).

Since sculpture exists in real space, it gives us a more immediate physical sense of a human presence. "More radically than the other arts, sculpture is monopolized by the subject matter of the human figure," Arnheim wrote.[40] But this physical sense of human presence is not restricted to figurative sculpture: it is even at stake in the most abstract, self-contained "specific objects" of minimalist art. According to Rosalind Krauss, "sculpture is constantly forming an analogy with the human body."[41] In addition, critics such as Michael Fried recognized a "hidden anthropomorphism" in minimalist sculptures because of their symmetry, hollowness, and approximation to human size.[42] Moreover, even without these anthropomorphic associations, sculpture, because it is real rather than illusory, always tends to evoke a physical response. For Fried, minimal art became "theatrical" as it increasingly shifted its *raison d'être* to the relationships between the object and the beholder. According to Rosalind Krauss, minimal and post-minimal artworks are marked by "an extended temporality, a merging of the temporal experience of sculpture with real time that pushes the plastic arts into the modality of the theater . . . A certain sculpture was intended to theatricalize the space in which it was exhibited."[43]

In minimalist art theory, the physical reaction that the artwork enticed in the beholder was often described as a quality of "presence" – a qualification that connotes certain metaphysical, mystical, or totemic powers, contradicting the positivist, formalist, and phenomenological aspirations of minimalism. This "presence," no doubt, is dependent on the relationship between the sculpture/object and the physicality of the beholder, which became very important in minimalism but which is also characteristic of the apprehension of sculpture in general. For William Tucker, sculptures and their beholders are united because of a sense of gravity, which "has been central to the most vital modern sculpture since Rodin. Gravity unites sculpture and spectator in a common dependence on and resistance to the pull of the earth."[44] For filmmakers – perhaps in part so as to overcome the lack of physical co-presence between the film beholder and object – this physical confrontation between sculpture and beholder has proven an attractive motif, as can be seen in scenes involving figurative sculpture – the touching of a statue's face in the MoMA garden scene in John Cassavetes' *Shadows* (1959), for instance, or the knocking on the hollow metallic figure in Jean-Luc Godard's *Le Mépris* (1963) – as well as in scenes that show abstract or minimalist sculptural forms, such as the enigmatic black monolith in Stanley Kubrick's *2001: A Space Odyssey* (1968), which evokes the mysterious silence of contemporaneous minimal artworks by Tony Smith, Donald Judd, or Carl Andre.

The physical reactions that sculptures entice can be very intense. According to Rudolf Arnheim, the "substantial presence" of sculptures "invites bodily intercourse."[45] Cultural history abounds in instances of *agalmatophilia*, or humans falling in love with statues. As George Hersey demonstrated, the phenomenon harks back to the Hellenistic era, when writers not only praised sculptures that were so masterful that they seemed truly alive, but even wrote stories and testimonies involving the act of physical love with statues.[46] Athenaeus of Naucratis, for instance, advised philosophers in unrequited love with women to make love to statues, whereas Pseudo-Lucian tells the story of a sperm-stain on the buttocks of Praxiteles' Knidian Aphrodite, left in a failed attempt at anal intercourse with the famous sculpture. Likewise, Francis Haskell and Nicholas Penny have demonstrated that Venus sculptures became the object of the most impassioned statue love in the eighteenth century.[47] Heinrich Heine is supposed to have remarked that he had only ever been in love with dead women and statues.[48] In modern culture, the erotic attraction of sculpture, both heterosexual and homosexual, is undoubtedly linked to forms of sexual repression. Statues, and especially classical statues, denote sensual bodies and nudity. Evoking a chthonic and libidinal past, the classical nude became a highly ambiguous sign in Victorian culture.[49] As Barbara Johnson writes, "numerous are the Parnassian poems addressed to silent female statues, marble Venuses, and graphite sphinxes whose unresponsiveness stands as the mark of their aesthetic value."[50] Johnson demonstrated how the ideal woman is petrified and how men turn to statues to understand something of sexual pleasure. Likewise, the "gay" preference for classical statuary (in which the male nude was a dominant motif) reaches back to Winckelmann and hence to the modern rediscovery of antiquity.

Not surprisingly, the bodily and erotic interactions between humans and statues are often emphasized in film scenes involving sculptures. Hence, physical attraction to and bodily intercourse with sculptures are recurrent themes in several chapters in this volume: the erotic power of sculptures is already apparent in early cinema (Chapter 1), it also marks several masterpieces of postwar European modernist cinema (Chapter 6), and it is definitely a crucial element in many Surrealist and Surrealist-inspired films (Chapter 2) and American psychodramas (Chapter 5), as well as in the horror subgenre of films set in wax museums (Chapter 4).

Many of the instances discussed in these various chapters are variations on the myth of Pygmalion, the legendary Cypriot sculptor who created his own perfect female out of ivory. According to Ovid's *Metamorphoses*, the beauty of his virtuous statue was so breathtaking that the sculptor fell in love with his own creation and beseeched Venus to bestow life upon it. The artist's wish was granted and the cold ivory turned to warm flesh at his touch. As Victor

Stoichita has demonstrated extensively, the myth of Pygmalion has inspired poets, painters, and sculptors for centuries, but the motif was revitalized in the eighteenth and nineteenth centuries both in the visual arts and on the stage.[51] Not surprisingly, the motif of a sculpture coming to life has also been cherished by filmmakers, as their medium is based on the animation of the still image. Statues enabled film pioneers including Georges Méliès, and later, in a more conscious way, experimental and modernist filmmakers, to play on the boundaries between stasis and movement, the two- and the three-dimensional, and the artificial and the real. In many films featuring a sculpture, there is a Pygmalion-like character or a Pygmalion-like plot, but, more interestingly, in many instances cinema presents itself as a Pygmalionist medium. With the help of camera movements, editing, and light, it is first and foremost the film that "animates" the static sculptures. Although unmistakably indebted to older "proto-cinematic" display techniques (such as rotating platforms or the praxis of nocturnal visits to sculpture galleries under flickering torchlight), film brings statues to life in an unprecedented manner.

This fascination with a moving statue is often combined with a Pygmalion-like, frozen eroticism. As Chapter 3 demonstrates, this topic reached its most literal development in Surrealism, which was marked by a veritable statuomania and even an agalmatophilia. It can be found in the paintings of Paul Delvaux, for instance, but the Surrealist fascination for Pygmalion motifs (statues coming to life) or Medusa effects (petrified human figures) acquires a new dimension in the art of the moving image. Living statues can be found in surrealist films such as *Le Sang d'un poète* (1932) and *La Belle et la bête* (1946) by Jean Cocteau, who repeatedly referred in his writings to the idea that the composer Modest Mussorgsky had already proposed in the 1880s: an art that "will express itself by statues that are moving."[52] Sculptures pervade Cocteau's entire oeuvre and are even closely related to his persona – in *Le Musée Grévin* (Jacques Demy and Jean Masson, 1958), Cocteau staged a remarkable encounter with his own wax image. Cocteau also wrote an infamous homage to the statues of Arno Breker, Hitler's favorite artist.[53] Cocteau imagined that Breker's sculptures would walk the Place de la Concorde during a spring night, in the light of the moon, which he called "the veritable sun for all sculptures." References to Breker's aesthetics and this moonlight quality can also be found in *L'Eternel retour* (Jean Delannoy, 1943), for which Cocteau wrote the screenplay. James Williams notes the "statuesque poses" of the protagonists and he even wonders whether "the background image in the film's opening credits – the close-up of a sculptured hand – is a sample of Breker's work."[54]

In the 1940s and 1950s, the fetishistic fascination for sculpture not only marked late Surrealist films or Surrealist-inspired trance films, but

also became a topic in Hollywood productions such as *One Touch of Venus* (William A. Seiter, 1948), *Pandora and the Flying Dutchman* (Albert Lewin, 1951), and *The Barefoot Contessa* (Joseph L. Mankiewicz, 1954), in which a lead female character portrayed by Ava Gardner is frequently visualized next to statues while she also acquires a kind of sculptural or statuesque beauty.[55] This statuesque beauty of humans is also developed in Surrealist films, which are exemplary in the way they feature statues. The living statue not only is a theme on the level of the narrative, but also determines the mise-en-scène and style of acting, which is characterized by tableaux-like scenes, moments of standstill, and frozen or petrified characters in dream states. To a certain extent, this also characterizes several European modernist films of the 1950s and 1960s discussed in Chapter 6. Postwar modernism presented itself as a cinema of slowness resisting the narrative dynamics and visual speed of the conventional feature film, but in *Viaggio in Italia* (Roberto Rossellini, 1953), *L'Année dernière à Marienbad* (Alain Resnais, 1961), *Le Mépris* (Jean-Luc Godard, 1963), and many other films, the resulting stasis is often visualized through an often highly-mobile camera exploring both statues and immobilized characters. Moreover, characters are often shown in the vicinity of sculptures and their juxtaposition or approximation often results in an enigmatic atmosphere.

The Pygmalion effect or the fascination with statues coming to life that runs through film history also invokes several variations or reversals of the theme. While sculptures are brought to life, living people are turned into, or trapped inside, statuary. In his 1832 pamphlet "Auto-Icon; or Farther Uses of the Dead to the Living," utilitarian philosopher Jeremy Bentham suggested that all persons could become their own statue or "Auto-Icon," a monument to themselves. Bentham's own "Auto-Icon," consisting of his skeleton padded out with hay and dressed in his clothes with a wax head fitted with some of his own hair, is even the subject of a film. In *Figures of Wax (Jeremy Bentham)* (1974), Belgian artist Marcel Broodthaers staged a conversation between himself and the uncanny waxwork.[56] Other variations of humans changed into statuary hark back to many mythological, literary, pictorial, and sculptural precedents. In *The Dream of the Living Statue*, Kenneth Gross notes that the idea of a statue coming to life is bound to the opposing thought: that the statue was once something living, "a creature stilled, emptied of life, turned to stone or bronze or plaster," and that cultural history abounds in fantasies in which living beings are turned into stone whether through love, grief, terror or jealousy – including such figures as Niobe, Aglauros, Echo, and Atlas.[57] Several artist characters in films discussed in this book present these forms of petrification as an attempt to immortalize the beauty of their subjects. The sadistic fantasies involved in this process proved highly popular

in horror films, as the wax museum films in Chapter 4 illustrate. Likewise, sadistic fantasies in combination with sculpture are also at stake in films in which the human body itself has become the artist's favorite material. Films such as *The Penalty* (Wallace Worsley, 1920), *Stolen Face* (Terence Fisher, 1952), *Blind Beast* (Yasuzô Masumura, 1969), and *The Skin I Live In* (Pedro Almodóvar, 2011) explicitly juxtapose and even equate the crafts of sculpture and surgery, using flesh or body parts instead of clay.

In this, sculpture becomes a token of a process of mortification. This is certainly not only the case in the many films that are built around a literal murder in the narrative. Represented on film, static sculptures seem to come alive, but they are always already regarded as dead matter when juxtaposed with living beings. The association of sculptures with death is, of course, also related to their function in the film's narrative as well as in reality: sculptures often memorialize luminaries or are funerary monuments. Moreover, the perennial association of sculpture with antiquity – as well as the idea that sculpture, as the non-ephemeral art *par excellence*, is somewhat at odds with the conditions of modernity – reinforces statues' invocation of the past, memories, and death.

Apart from its fascination with agalmatophilia or Pygmalion-like scenarios in which characters are juxtaposed with statues, cinema has also presented itself as a powerful instrument of Pygmalionism, mobilizing or animating statues by means of camera movements, light, and editing.

One of the most spectacular instances of cinema's Pygmalionist powers, no doubt, can be found in the dreamlike opening sequence of Leni Riefenstahl's *Olympia* (1938), in which classical statues of Greek gods morph into living athletes thanks to multiple camera perspectives, impressive tracking shots, atmospheric lap dissolves, chiaroscuro lighting, and the liberal use of Vaseline and smoke.[58] However, film's engagement with sculpture is often ambivalent. On the one hand, film mobilizes sculptures, animates them, and brings them to life. On the other, many filmmakers are unmistakably fascinated by the dead and dumb nature of sculptures, emphasizing their immobility; Surrealist films (Chapter 2) and post-war European modernist films (Chapter 6) in particular play upon the mysterious solidity and silence of statues, creating blockages in the flow of the narrative that result in a kind of enigma.[59]

In classical cinema, sculptures also come to life metaphorically in the sense that they become part of a narrative. They become objects of desire for the film's characters, not necessarily in the sense that characters want to love them but in the sense that they are craving to find, discover, see, touch, possess, conquer, steal, or destroy them. In narrative film, sculptures are often used as a Hitchcockian "McGuffin" motivating and directing the action. In *The Maltese Falcon* (John Huston, 1940) the hunt for the priceless,

Figure I.5 Olympia *(Leni Riefenstahl, 1938) – Production Still, Private Collection.*

titular statuette, which, apart from the opening credits, remains invisible until the very end of the film, marks the obsession and greed of the characters. In *North by Northwest* (Alfred Hitchcock, 1959), the pre-Columbian figurine eventually brings the characters to the surreal sculptural landscape of *Mount Rushmore*. Both renowned sculptures also seem to hide or conceal something for the characters, who are intrigued by a supposedly secret content: the gold hidden under a coat of black enamel in *The Maltese Falcon* and the piece of micro-film inside the statue in *North by Northwest*. These are just the two best-known of many films in which sculptures conceal and generate mystery.

TABLEAUX VIVANTS OR LIVING STATUES

In visualizing the contrast between life and death, and movement and stasis, many film scenes including statues suggest the tableau vivant, or living picture: a theatrically-lit composition, often based on a famous artwork or literary passage, of living human bodies that do not move throughout the duration of the display.[60] Since references to tableaux vivants arise in most chapters of this book, it is interesting to have a closer look at the origins and

history of the phenomenon. Tellingly, the tableau vivant tradition started out as a *statue vivant* practice and, in many cases, persisted in this manner. The phenomenon, anchored in Ancient Greek mythology and mime traditions, came into being as a liturgical and ceremonial event in the eleventh and twelfth centuries and flourished in the late medieval and early Renaissance period.[61] This is confirmed by the presence of "living statues" in the literature of the time, as well as on the streets, in the form of actors replicating famous statues.[62] From the fourteenth century on, the tableau vivant also became part of official ceremonies, such as a king's entry into a city, but it was not until the 1760s that specific paintings were recreated on stage.[63] A play that duplicated a Jean-Baptiste Greuze painting, for instance, perfectly matched Denis Diderot's proto-cinematic idea that "the spectator at the theatre should find himself before a screen where different pictures would succeed one another as if by magic."[64] In his writings on the theater, Diderot advocated a new kind of dramaturgy that dismissed the *coup de théâtre*, the sudden turn of the plot.[65] Instead, in order to create emotional and moral effect, stage productions should orient themselves toward the best painting of the day to find inspiration for the inclusion of deliberate tableaux at crucial moments in the drama. Tableaux thus represent fixed moments that halt the narrative development of the story and introduce stasis into the movement of the play. During a brief suspension of time, the action is frozen at a point of heightened meaning, a point at which the actor's gestures are especially capable of expressing the full significance and implications of the story.

Diderot's schema not only makes clear the hybrid and heterogeneous nature of the tableaux, combining theater with aspects of painting and sculpture; it also emphasizes the dialectic between movement and immobility and the play upon the relation of the living body to the depicted or sculpted one. These considerations can also be found in several other popular cultural expressions of the late eighteenth century. In Naples, Emma Hart, the future Lady Hamilton, famously assumed frozen "attitudes" after figures on Greek vases and classical statuary. In a passage dedicated to Lady Hamilton's dramatic poses in his *Italian Journey*, Johann Wolfgang von Goethe noted that Lady Hamilton's "attitudes" are based on artistic precedents such as "the most famous antiques," while her embodiment of these famous artworks itself became the basis of a new series of depictions, such as those by the painter Wilhelm Tischbein.[66]

Undoubtedly, Goethe, who prominently featured the phenomenon in his 1808 novel *Die Wahlverwantschaften* (*Elective Affinities*), influenced the development of a veritable fashion for tableaux vivants in early nineteenth-century European culture.[67] In many domestic settings, tableaux vivants developed into a parlour game involving the embodiment of famous paintings by

costumed actors who posed in stillness. Apart from this amateur drawing room venture, it also developed into more professional variants on the theatrical stage, from the German art historian Aloys Hirt's "Dädalus und seine Statuen" at the Berlin Court to the French Professor Flor's reproductions of famous paintings, and the German Quirin-Muller (or Müller)'s statuary groups with their "Tableaux Plastiques, Bibliques & Mythologiques."[68] In America, Andrew Ducrow became popular in the 1830s with his "Grecian statues," in which he imitated a series of statue-like poses depicting Homeric heroes, athletes, and gladiators, seemingly taking on the appearance of marble.[69] One of Ducrow's followers, a Mr. Frimbly, integrated the living statue act into a narrative sequence, which was usually quite loose, rapidly evolving into a show of poses. In the production *Raphael's Dream: or, the Artist's Study*, the painter Raphael pauses his painterly activities on stage to judge a (living) statue and, as the artist speaks, the statue takes on the specified poses.[70] Also popular were the shows of Adam Forepaugh and Sells Brothers, who put on massive spectacles, in which whitewashed women in bodysuits depicted classic, chaste, and fascinating "perfect" facsimiles of master marble groups and pictures. This whitewashed appearance in skin-tight clothing was intended to simulate the appearance of marble or plaster as realistically as possible, but it gave rise to serious concern later when it came to female practitioners of the genre. The music hall entertainment of the *pose plastique*, for instance, was considered by many a debased art form. Since English stage censorship generally forbade actresses to move when nude or semi-nude on stage, tableaux vivants became a risqué entertainment. Even in the early years of the twentieth century the German dancer and artist model Olga Desmond caused scandals with her *Schönheitsabende*, or *Evenings of Beauty*, in which she posed nude (or wearing only body paint) as a living statue, imitating ancient classical works of art.[71]

Tableaux vivants were certainly not always reproductions of famous paintings, and they could be integrated into a play as well as stand on their own. In the latter case, they were billed as entertainments by a range of terms, evoking a range of media: living pictures, living statues, attitudes, *poses plastiques*, *statues vivants*, Venetian statues, Grecian statues, living statuary, tableaux, and *marbres vivants*. A lot of these terms were, and still are, used synonymously. By the end of the nineteenth century, tableaux vivants had become popular forms of spectacular entertainment, often supported by rotating platforms or other sophisticated machines transporting motionless groups or organizing the transitional intervals between tableaux in a way that suggest cinematic editing.

Right from its inception, film displayed an interest in the phenomenon of living pictures. As the first chapter of this book demonstrates, early cinema's fascination with the effect of frozen movement goes hand in hand with a

predilection for its opposite – the picture or statue coming to life. Many films made shortly before and after 1900 make explicit the contrast between the new medium of film and the traditional arts, not only by means of the motif of a sculpture but specifically with the sculpture coming to life. And tableaux vivants remained a significant motif throughout film history. Not coincidentally, tableaux vivants abound in models of cinema that also feature sculptures, such as Surrealist films and European modernist cinema. A film such as Resnais' *L'Année dernière à Marienbad* (1961) not only contains many scenes involving a sculpture, but also presents its human characters as sculptural forms in tableaux vivants-like settings. In such films, both sculptures and tableaux vivants are in keeping with an interest in de-dramatization, duration, slowness and stillness. In addition, when they are evoked in a film, tableaux vivants create, in the words of Brigitte Peucker, "a moment of intensified intermediality."[72] Because of their heterogeneity, tableaux vivants in film can acquire a mysterious density.

Unsurprisingly, tableaux vivants pervade this book, which consists of two parts. The first part comprises seven chapters and a coda, each dealing with film's engagement with sculpture at a specific moment in history. Focusing on the trick films by Georges Méliès and the erotic films by the Viennese Saturn film company, the first chapter reveals the importance and continuity of nineteenth-century tableaux vivants for early cinema. Furthermore, early cinema contains many examples of statues coming to life, making explicit the contrast between the new dynamic medium of film and the stillness of the arts of sculpture and painting. This chapter also demonstrates that, right from cinema's inception, statues often take on magical qualities when they are represented on film.

This is also a key topic of the second chapter, which deals with sculptures in films of the late 1920s and early 1930s inspired by Surrealism. Focusing on three films financed by the Vicomte de Noailles – *Les Mystères du Château de Dé* (Man Ray, 1929), *Le Sang d'un poète* (Jean Cocteau, 1930), and *L'Âge d'or* (Luis Buñuel, 1930) – this chapter illustrates Surrealism's fascination with the uncanny properties of statues and their potential for troubling boundaries. In line with Surrealism's interest in such quasi-sculptural entities as mannequins and dolls, these films also deal with several forms of interaction between people and statues: characters becoming sculptures, statues coming to life, and varieties of agalmatophilia.

Chapter 3 deals with some striking art documentaries on sculpture made during the 1940s and 1950s, in particular *Thorvaldsen* (Carl Theodor Dreyer, 1949) and *L'Enfer de Rodin* (Henri Alekan, 1957). Carefully studying the human figure, volume, texture, space, and light, these films also reflect on

the moving position of the beholder through the use of viewpoints, camera movements, light effects, and editing. Situating these films in the oeuvre of their directors as well as in the context of contemporaneous debates on the art documentary, this chapter demonstrates how cinematic evocations of the art of sculpture were presented as highly self-reflexive attempts to explore the boundaries between the moving and the static image, between the two- and the three-dimensional, and between the gravity of volumes and the ephemeral projected film image. In addition, this chapter connects certain cinematic procedures to nineteenth-century display techniques of sculpture, such as rotating pedestals and the praxis of looking at statues at night with flickering candles or torchlights.

Reconnecting with the idea of a statue coming to life as well as with the opposing thought that the statue was once something living, Chapter 4 examines the tropes of the wax museum, the wax artist, and the wax statue in cinema. Discussing, among others, the French Grand Guignol picture *Figures de Cire* (Maurice Tourneur, 1913), the seminal Hollywood classic *Mystery of the Wax Museum* (Michael Curtiz, 1933), and the Italian *giallo* horror film *Maschera di cera* (Sergio Stivaletti, 1997), this chapter deals with the presence of living sculptures, Pygmalionism, and death in and around the wax museum.

Pygmalionism also haunts the fifth chapter, dealing with the American cinema of the 1940s and early 1950s. Strikingly, Pygmalion variations can be found in some seminal Hollywood productions of the era, particularly a number of films starring Ava Gardner, but also in the contemporaneous so-called "trance films" by avant-garde filmmakers such as Hans Richter, Maya Deren, Kenneth Anger, Sidney Peterson, James Broughton, and Gregory Markopoulous. Both the noirish commercial films and many of the experimental trance films feature oneiric protagonists wandering through incomprehensible and menacing environments. In these psychodramas, classical (and neo-classical) statuary, which refers to Greek mythology, is an iconographic mainstay.

Focusing on *L'Année dernière à Marienbad* (Alain Resnais, 1961) and *Viaggio in Italia* (Roberto Rossellini, 1954), Chapter 6 deals with European modernist cinema and its many key scenes involving statues. In these films from the mid-1950s to the mid-1960s, characters are often shown in the vicinity of statues and their juxtaposition or approximation results in an enigmatic situation. In addition, the characters themselves are often shown in static poses and they evoke a certain sculptural quality or sculptural presence, which is often emphasized by a highly mobile camera. The presence of sculpted human figures emphasizes the subtle balances between visual, narrative, and psychological forms of movement and stasis as well as life and death. Strikingly, modernist cinema favors old, fragmented, depatinated classical

statues, which denote the passing of time, the weight of history, and the imperfections of memories, connecting with these films' interests in duration, slowness, and *temps morts*.

The statues and sculptural metaphors of classical antiquity are also the subject of Chapter 7, which looks at the myths of the living statue – Pygmalion's Galatea, Hephaistos's deadly automatons, the petrifying gaze of the Medusa, et cetera – as they originated in classical Greco-Roman literature and found their way to the screen. In particular, this chapter investigates how mythological tropes involving sculpture were appropriated in the cinematic genre of the sword-and-sandal or peplum film, in which a Greco-Roman or ersatz classical context provides the perfect backdrop for spectacular special effects, muscular heroes, and fantastic mythological creatures in films such as *Jason and the Argonauts* (Don Chaffey, 1963), *Clash of the Titans* (Desmond Davis, 1981), and *Percy Jackson & the Olympians* (Chris Columbus, 2010).

The eighth chapter, a coda, approaches the relation between film and sculpture from a different perspective. While the previous chapters focus on the representation of sculptures *in* film (although many filmmakers have shown an interest in the "sculptural" qualities of their cinematic images), the last chapter investigates how artists from the 1960s onwards began to deconstruct the cinematic apparatus and to employ it sculpturally. In the period of structural and expanded cinema, artists used projection to create representational and abstract sculptures in time and space while video sculptures incorporated moving images. Later, artists engaged the cinematic mechanisms that create the illusion of movement and, since the turn of the century, the obsolescence of the film medium has given rise to a range of practices that employ the material detritus and surplus of the age of film.

The book also contains a second part consisting of a "sculpture gallery" comprising 150 entries, each dealing with a film in which a sculpture plays an important part in the plot or the mise-en-scène. This selection represents the major themes and tropes that frame the encounter of sculpture and film: the cinematic exploration of spatial shapes, the tensions between volatile filmic images and stable sculptural volumes, juxtapositions and confrontations between human bodies and statues, instances of agalmatophilia, the powerful attraction of sculptural idols, statues coming to life and petrified humans, the use of tableaux vivants, and many of the other topics addressed in this volume.

Notes

1. Vachel Lindsay, *The Art of the Moving Picture* (New York: The Modern Library, 2000 [1915]), 74.
2. Charles Baudelaire, "Pourquoi la sculpture est ennuyeuse" [Salon de 1846], in *Ecrits esthétiques* (Paris: Union générale d'éditions, 1986), 177.
3. Rudolf Arnheim, "Sculpture: The Nature of a Medium," in *To the Rescue of Art: Twenty-Six Essays* (Berkeley: University of California Press, 1992), 83.
4. On the photography of sculpture, see Rainer M. Mason and Hélène Pinet, *Pygmalion photographe: La sculpture devant la caméra 1844–1936* (Geneva: Editions du Tricorne, 1985); Geraldine Johnson (ed.), *Sculpture and Photography: Envisioning the Third Dimension* (Cambridge: Cambridge University Press, 1998), and Roxana Marcoci, *The Original Copy: Photography and Sculpture, 1839 to Today* (New York: The Museum of Modern Art, 2010).
5. See Jens Thiele, *Das Kunstwerk im Film: Zur Problematik filmischer Präsentationsformen von Malerei und Grafik* (Bern/Frankfurt: Herbert Lang/Peter Lang, 1976), 14. Early examples are films such as *Brunnen und Denkmäler der Kunstmetropole München* (1917), or *Die weltberühmten Bauschöpfungen des Mittelalters in Sevilla, Spanien* (1917).
6. Thiele, *Das Kunstwerk im Film*, 15–18, 35–40, 45–54, and 302–9. See also Reiner Ziegler, *Kunst und Architektur im Kulturfilm 1919–1945* (Konstanz: UVK Verlaggesellschaft, 2003), 35–40, 45–54, and 302–9.
7. Alex Potts, *The Sculptural Imagination: Figurative, Modernist, Minimalist* (New Haven: Yale University Press, 2000), 40.
8. Henri Focillon, "The Cinema and the Teaching of the Arts," *The International Photographer* (February 1935), 3.
9. Johann Gottfried Herder, *Plastik: Einige Wahrnehmungen über Form und Gestalt aus Pygmalions bildendem Traume* (Riga and Leipzig: Hartknoch & Breitkopf, 1778). See also Potts, *The Sculptural Imagination*, 28–34.
10. Adolf Hildebrand, *Das Problem der Form in der Bildenden Kunst* (Strassburg: Heitz & Mündel, 1893).
11. Heinrich Wölfflin, "Wie man Skulpturen aufnehmen soll," *Zeitschrift für Bildende Kunst* VII (1896), 224–8; VIII (1897), 294–7; and XXVI (1915), 237–44.
12. André Malraux, *Le Musée imaginaire de la sculpture mondiale* (Paris: Gallimard, 1952–4). See also Henri Zerner, "Malraux and the Power of Photography," in Geraldine Johnson (ed.), *Sculpture and Photography: Envisioning the Third Dimension* (Cambridge: Cambridge University Press, 1998), 116–30.
13. André Malraux, *Psychologie de l'art* (Genève: Skira, 1947), 17.
14. Malraux, *Psychologie de l'art*, 24.
15. *Diderot on Art, Volume I: The Salon of 1765 and Notes on Painting* (New Haven: Yale University Press, 1995), 156–62. See also Potts, *The Sculptural Imagination*, 27–8; and Jacqueline Lichtenstein, *The Blind Spot: An Essay on the Relations between Painting and Sculpture in the Modern Age* (Los Angeles: Getty Publications, 2008), 55–98.

16. On Hegel's aesthetics and the discussions on sculpture and painting, see Michael Podro, *The Critical Historians of Art* (New Haven: Yale University Press, 1982), 17–30; Beat Wyss, *Hegel's Art History and the Critique of Modernity* (Cambridge: Cambridge University Press, 1999); and Stephen Houlgate (ed.), *Hegel and the Arts* (Evanston, IL: Northwestern University Press, 2007).

17. Lindsay, *The Art of the Moving Picture*, 66.

18. Alex Potts, "Introduction: The Idea of Modern Sculpture," in Jon Wood, David Hulks and Alex Potts (eds.), *Modern Sculpture Reader* (Leeds: Henry Moore Institute, 2007), xvi.

19. William Tucker, *The Language of Sculpture* (London: Thames & Hudson, 1974), 17.

20. Joris-Karl Huysmans, "Le Salon de 1879," in *L'art moderne, Certains* (Paris: Union générale d'editions, 1975), 93–4.

21. Baudelaire, "Pourquoi la sculpture est ennuyeuse," 177. Ad Reinhardt, quoted in Lucy Lippard, "As Painting Is to Sculpture: A Changing Ratio," in Maurice Tuchman (ed.), *American Sculpture of the Sixties* (Los Angeles: Los Angeles County Museum of Art, 1967), 31.

22. Théophile Gautier, quoted in Lichtenstein, *The Blind Spot*, 151.

23. Arturo Martini, "Scultura, lingua morta" (1945), in *La Scultura Lingua Morta e altri scritti* (Milan: Abscondita, 2001). An English translation is included in Jon Wood, David Hulks, and Alex Potts (eds.), *Modern Sculpture Reader* (Leeds: Henry Moore Institute, 2007), 165–79.

24. Penelope Curtis, *Sculpture 1900–1945* (Oxford: Oxford University Press, 1999), 215.

25. Curtis, *Sculpture 1900–1945*, 107–39.

26. Potts, *The Sculptural Imagination*, 61–158.

27. Peter van der Coelen and Francesco Stocchi, *Brancusi, Rosso, Man Ray: Framing Sculpture* (Rotterdam: Museum Boijmans van Beuningen, 2013).

28. Yve-Alain Bois, *Painting as Model* (Cambridge, MA: MIT Press, 1990), 75.

29. Theo van Doesburg, "Licht- en tijdsbeelding (Film)," *De Stijl* VI, 5 (1923), 62. See also Theo van Doesburg, "Abstracte Filmbeelding," *De Stijl* IV, 5 (1921), 72.

30. Sergei M. Eisenstein, "Montage and Architecture" (1938), *Assemblage* 10 (December 1989), 116–31. See also Anthony Vidler, *Warped Space: Art, Architecture, and Anxiety in Modern Culture* (Cambridge, MA: MIT Press, 2000), 118–22.

31. Edward Dimendberg, "Toward an Elemental Cinema: Film Aesthetics and Practice in G," in Detlef Martins and Michael W. Jennings (eds.), *G: An Avant-Garde Journal of Art, Architecture, Design, and Film 1923–1926* (London: Tate Publishing, 2010), 53–70.

32. Erwin Panofsky, "Style and Medium in the Motion Pictures" (1936), in Gerald Mast, Marshall Cohen, and Leo Braudy (eds.), *Film Theory and Criticism: Introductory Readings* (New York: Oxford University Press, 1992), 235.

33. László Moholy-Nagy, "Space–Time and the Photographer" (1943), in Steve Yates (ed.), *Poetics of Space: A Critical Photographic Anthology* (Albuquerque: University of New Mexico Press, 1995), 155.

34. László Moholy-Nagy, *Vision in Motion* (Chicago: Paul Theobald, 1947), 219.

35. Moholy-Nagy, *Vision in Motion*, 237.

36. Jack Burnham, *Beyond Modern Sculpture: The Effects of Science and Technology on the Sculpture of This Century* (New York: George Braziller, 1978), 285–311.

37. Tucker, *The Language of Sculpture*, 107.

38. See Carola Giedion-Welcker, *Moderne Plastik: Elemente der Wirklichkeit; Masse und Auflockerung* (Zürich: Girsberger 1937); Eduard Trier, *Form and Space: The Sculpture of the Twentieth Century* (New York: Frederick A. Praeger, 1961); Herbert Read, *A Concise History of Modern Sculpture* (New York: Frederick Praeger, 1964); A. M. Hammacher, *The Evolution of Modern Sculpture: Tradition and Innovation* (London: Thames & Hudson, 1969); Tucker, *The Language of Sculpture*; Rosalind Krauss, *Passages in Modern Sculpture* (New York: Viking Press, 1977); Burnham, *Beyond Modern Sculpture*; Curtis, *Sculpture 1900–1945*); Arnheim, "Sculpture;" and Potts, *The Sculptural Imagination*.

39. Arnheim, "Sculpture," 85.

40. Arnheim, "Sculpture," 88.

41. Krauss, *Passages in Modern Sculpture*, 267.

42. Michael Fried, "Art and Objecthood," *Artforum* 5, 10 (June 1967), 12–23. On anthropomorphism in Minimal Art, see Frances Colpitt, *Minimal Art: Critical Perspectives* (Ann Arbor: UMI Research Press, 1990), 67–70.

43. Krauss, *Passages in Modern Sculpture*, 203–4.

44. Tucker, *The Language of Sculpture*, 145.

45. Arnheim, "Sculpture," 85.

46. George L. Hersey, *Falling in Love with Statues: Artificial Humans from Pygmalion to the Present* (Chicago: University of Chicago Press, 2009), 14–15 and 93–6.

47. See Francis Haskell and Nicholas Penny, *Taste and the Antique: The Lure of Classical Sculpture, 1500–1900* (New Haven: Yale University Press, 1981), 316–33.

48. Theodore Ziolkowski, *Disenchanted Images: A Literary Iconology* (Princeton: Princeton University Press, 1977), 46.

49. See Alastair J. L. Blanshard, "Nakedness without Naughtiness: A Brief History of the Classical Nude," in Michael Turner (ed.), *Exposed: Photography and the Classical Nude* (Sydney: Nicholson Museum, The University of Sydney, 2011), 14–29; and Ana Carden-Coyne, "Intimate Encounters with the Classical Body: Social Provocations in Photography," in Michael Turner (ed.), *Exposed: Photography and the Classical Nude* (Sydney: Nicholson Museum, The University of Sydney, 2011), 22–30.

50. Barbara Johnson, *The Feminist Difference: Literature, Psychoanalysis, Race, and Gender* (Cambridge, MA: Harvard University Press, 1998), 132.

51. Victor Stoichita, *The Pygmalion Effect: From Ovid to Hitchcock* (Chicago: University of Chicago Press, 2008).

52. Jean Cocteau, "Good Luck to Cinémonde" (1953) and "The Myth of Woman" (1953), in André Bernard and Claude Gauteur (eds.), *Jean Cocteau: The Art of Cinema* (London: Marion Byars, 1992), 34 and 123.

53. Jean Cocteau, "Salut à Breker," originally published in *Comoedia* (23 May

1942), 1. The text was later included in the 23 May 1942 entry of Cocteau's journals.

54. James S. Williams, *Jean Cocteau* (London: Reaktion Books, 2008), 183.

55. Susan Felleman, *Art in the Cinematic Imagination* (Austin: University of Texas Press, 2006), 56–73.

56. See Shana G. Lindsay, "Mortui Docent Vivos: Jeremy Bentham and Marcel Broodthaers in *Figures of Wax*," *Oxford Art Journal* 36, 1 (March 2013), 93–107.

57. Kenneth Gross, *The Dream of the Moving Statue* (Pennsylvania: Pennsylvania State University Press, 2006), 15 and 75.

58. See Brigitte Peucker, *The Material Image: Art and the Real in Film* (Stanford: Stanford University Press, 2007), 56–63.

59. See Pascal Bonitzer, "Le Plan-tableau," in *Décadrages: Peinture et cinéma* (Paris: Cahiers du cinéma, 1985), 29–41.

60. On tableaux vivants and film, see Steven Jacobs, "Tableaux Vivants 1: Painting, Film, Death, and Passion Plays in Pasolini and Godard," in *Framing Pictures: Film and the Visual Arts* (Edinburgh: Edinburgh University Press, 2007), 88–120; and Daniel Wiegand, *Gebannte Bewegung: Tableaux vivants und früher Film in der Kultur der Moderne* (Marburg: Schüren Verlag, 2016).

61. David Wiles, "Theatre in Roman and Christian Europe," in John Russell Brown (ed.), *The Oxford Illustrated History of the Theatre* (Oxford: Oxford University Press, 2001), 77.

62. Lex Hermans, "Consorting with Stone: The Figure of the Speaking and Moving Statue in Early Modern Italian Writing," in Sarah Blick and Laura D. Gelfand (eds.), *Push Me, Pull You: Physical and Spatial Interaction in Late Medieval and Renaissance Art – Volume Two* (Leiden and Boston: Brill, 2011), 117–22.

63. Jack W. McCullough, *Living Pictures on the New York Stage* (Ann Arbor: UMI Research Press, 1983), 1–6; and Stijn Bussels, "Making the Most of Theatre and Painting: The Power of Tableaux Vivants in Joyous Entries from the Southern Netherlands (1458–1635)," in Caroline van Eck and Stijn Bussels (eds.), *Art History: Theatricality in Early Modern Art and Architecture* (Oxford: Wiley-Blackwell, 2011), 156–63.

64. Kirsten Gram Holmström, *Monodrama, Attitudes, Tableaux Vivants: Studies on Some Trends of Theatrical Fashion 1770–1815* (Stockholm: Almqvist & Wiksell, 1967), 217–18.

65. Suzanne Guerlac, "The Tableau and the Authority in Diderot's Aesthetic," *Studies on Voltaire and the Eighteenth Century* 219 (1983), 183–94; Peter Szondi, "Tableau und Coup du Théâtre: Zur Sozialpsychologie des bürgerlichen Trauerspiels bei Diderot," *Schriften*, Vol. II. (Frankfurt am Main: Suhrkamp, 1978), 205–32.

66. Cf. Johann Wolfgang von Goethe, *Italian Journey* (London: Penguin, 1962), 207–8; August Langen, "Attitüde und Tableau in der Goethezeit," *Jahrbuch der deutschen Schillergesellschaft* 12: (1968), 194–258; Waltraud Maierhofer, "Goethe on Emma Hamilton's 'Attitudes': Can Classicist Art Be Fun?" in Thomas P. Saine (ed.), *Goethe Yearbook: Publications of the Goethe Society of North America* (Columbia:

Camden House, 1999), 222–52; Gisela Brude-Firnau, "Lebende Bilder in den *Wahlverwandtschaften*: Goethes Journal intime vom Oktober 1806," *Euphorion: Zeitschrift für Literaturgeschichte* 74, 4 (1980); Brigitte Peucker, "The Material Image in Goethe's *Wahlverwantschaften*," *The Germanic Review* 74, 3 (1999), 195–213; Kirsten Gram Holmström, *Monodrama, Attitudes, Tableaux Vivants: Studies on Some Trends of Theatrical Fashion 1770–1815* (Stockholm: Almqvist & Wiksell, 1967), 110.

67. Cf. Johann Wolfgang von Goethe, *Die Wahlverwandtschaften* (Cologne: Anaconda Verlag, 2007). See also Bettina Brandl-Risi, *BilderSzenen: Tableaux vivants zwischen bildender Kunst, Theater und Literatur im 19. Jahrhundert* (Freiburg: Rombach Verlag, 2007); and Birgit Jooss, *Lebende Bilder: Körperliche Nachahmung von Kunstwerken in der Goethezeit* (Berlin: Reimer, 1999).

68. Henk Gras, *Een stad waar men zich koninklijk kan vervelen: De modernisering van de theatrale vermakelijkheden buiten de schouwburg in Rotterdam, circa 1770–1860* (Hilversum: Verloren, 2009), 193.

69. McCullough, *Living Pictures on the New York Stage*, 8.

70. McCullough, *Living Pictures on the New York Stage*, 15.

71. Karl Toepfer, *Empire of Ecstasy: Nudity and Movement in German Body Culture, 1910–1935* (Berkeley: University of California Press, 1997), 27.

72. Brigitte Peucker, *The Material Image*, 26.

Part I

The Sculptor's Dream: Living Statues in Early Cinema

VITO ADRIAENSENS AND STEVEN JACOBS

In its earliest years of existence, cinema seems to have been fascinated by stasis and stillness. As if emphasizing its capacity to represent movement, early cinema comprises many scenes in which moving people interact with static paintings and sculptures. Moreover, films made shortly before and after 1900 often make explicit the contrast between the new medium of film and the traditional arts by means of the motif of the statue or the painting coming to life. In so doing, early film continued a form of popular entertainment that combined the art of the theater with those of painting and sculpture, namely the tableau vivant, or living picture. Focusing on the trick films of Georges Méliès and the early erotic films by the Viennese Saturn Company, this chapter reveals the importance and continuity of nineteenth-century motifs and traditions with regard to tableaux vivants as they were presented on the legitimate stage, in magic, in vaudeville, and in burlesque.

LIVING STATUES IN MOVING PICTURES

Tableaux vivants were certainly not always reproductions of famous paintings, and they could be labeled with a variety of terms when billed, even if this meant a change in medium (from painting to sculpture), such as: living pictures, living statues, attitudes, *poses plastiques*, *statues vivants*, Venetian statues, Grecian statues, living statuary, tableaux, or *marbres vivants*. Many of these terms were, and still are, used synonymously. "Tableau vivant" is most commonly and generally used to denote the freezing of movement in a scene or on itself, be it on a stage or on a screen, to create an image that possesses the static qualities of a painting, whether symbolically, metaphorically, narratively, aesthetically, or all of the above. Despite its variety, McCullough identified a few established conventions. Classic statuary and familiar paintings were top subjects, but these were complemented by recreations of literary and historical scenes. The arrival of specialized troupes, then, saw more stage

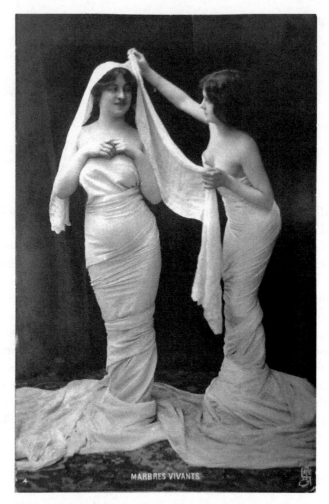

Figure 1.1 *Marbres Vivants (c.1900–5) – postcard, Private Collection.*

pictures and scenes than individual statues, placing more emphasis on light-ing, scenery, and costume.[1]

The second half of the nineteenth century was especially marked by an overwhelming theatrical proliferation of tableaux vivants, due to the efforts of stage producers such as Edward Kilanyi.[2] Kilanyi's methods proved to be highly pre-cinematic in their execution; not only did he use illusionary matte techniques and lighting to perform his "Venus de Milo" act (making his model's arms disappear against a black backdrop), but he also took out a patent on an "Apparatus for Displaying Tableaux Vivant" [*sic*], which was a turntable platform that allowed for an uninterrupted series of tableaux, or

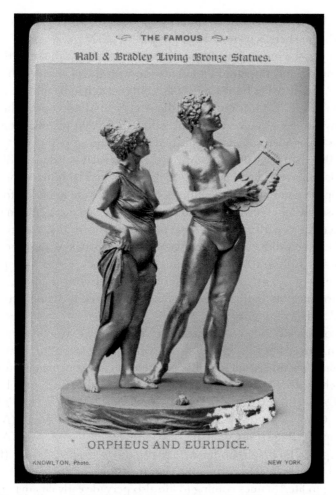

Figure 1.2 *The Famous Rahl & Bradley Living Bronze Statues (c.1895) – Library of Congress Prints and Photographs Division.*

"Kilanyi's Living Pictures."[3] This revival can also be linked to a high demand for classicism on the stage.

The Famous Rahl & Bradley were, for instance, two performers putting on a neo-classicist living statue act at the turn of the century covered entirely in bronze paint – an alternative to the more prevalent whitewash – to imitate mythical figures such as Orpheus and Eurydice. In the early twentieth century, vaudeville performers like the famous La Milo, the Australian Pansy Montague, continued in the same vein. La Milo gave evidence of the period's fascination with the "perfect female body" – that of the *Venus de Milo* – with whom she identified herself. She posed in alabaster whiting to achieve a

marble effect as she performed statues of goddesses, with a performance that walked the line between art and voyeurism.[4]

Strikingly, the success of tableaux vivants coincided with the birth of film, which immediately displayed its fascination with the phenomenon of living pictures,[5] and there has been a surge of recent research into tableaux vivants in film.[6] In the late 1890s, for instance, the American Mutoscope and Biograph Company produced numerous film versions of living pictures, joining the craze for living pictures that dominated the American popular stage in the mid-1890s, when stage directors and impresarios such as Edward Kilanyi and Oscar Hammerstein had become popular with their tableaux vivants based on European paintings and sculptures. Such films were intended for vaudeville houses, where spectators could compare living pictures on film either to living pictures as performed on stage or to the artwork that was evoked (or more likely a reproduction of it). According to Charles Musser, both living pictures and Edison's motion pictures "offered their respective spectators similar kinds of pleasure as each produced a cultural work (painting, sculpture or performance) in another medium, encouraging comparison between the 'original' and its reproduction."[7]

Moreover, early cinema's fascination with tableaux vivants and the effect of frozen movement goes hand in hand with a predilection for its opposite – the picture or statue coming to life. Numerous early trick or transformation films such as *The Devil in the Studio* (Robert Paul/Walter R. Booth, 1901), *An Artist's Dream* (Edison Company/Edwin S. Porter, 1900), *The Artist's Dilemma* (Edison Company/Edwin S. Porter, 1901), *The Artist's Studio* (American Mutoscope & Biograph Company, 1903), *Animated Picture Studio* (American Mutoscope & Biograph Company, 1903), and *Animated Painting* (Edison/Edwin S. Porter, 1904) create spectacular visions of enchanted paintings that come to life.[8] Statues coming to life also pervade early cinema in, among others, *La Statue* (Gaumont/Alice Guy, 1905), *L'Homme de marbre* (Gaumont, 1908), *Mephisto's Affinity* (Lubin, 1908), *The Sculptor's Nightmare* (American Mutoscope & Biograph Company/Wallace McCutcheon, 1908), *Amour d'Esclave* (Pathé Frères/Albert Capellani, 1907), the artistic ensemble tableau vivant demonstration film *Meissner Porzellan! Lebende Skulpturen der Diodattis im Berliner Wintergarten* (Gaumont, c.1912–1914), and *Il Fauno* (Febo Mari, 1917). The films dealing with statues coming to life are usually marked by similar tricks, effects, and narratives as the ones that feature animated paintings, but there are also some crucial differences. In contrast to two-dimensional paintings, which evoke another world within the limits of their frames, three-dimensional sculptures are part of the same world as the film's characters. In addition, within the context of the film medium, which precisely animates or mobilizes static objects, the different associations evoked by the arts of paint-

ing and sculpture regarding life and death are highly relevant. Cinema, after all, originated at a time when painting itself attempted to evoke life and movement. With its fascination for the contingencies of the everyday and its preference for movement and the play of light, modernist painting, for instance, has frequently been associated with "filmic" qualities. While the pictorial innovations of impressionism were often explained by referring to the vividness and flux of cinema, sculpture was regularly associated with history, the past, eternity, and death. The tableau's inherent oscillation between movement and stillness is therefore often used as a metaphor for the tension between life and death. Tableaux vivants invert (and therefore hypostasize) the age-old fascination with the inanimate statue, like Pygmalion's Galatea magically coming to life. It is no coincidence that the Pygmalion motif became important in the arts of the eighteenth century, which also saw the rise of tableaux vivants as a popular art form.[9] Early cinema continued this "Pygmalionism" that marked the legitimate and the popular stage throughout the nineteenth century.

THE MAGIC OF MÉLIÈS

The first extant instances of the cinematic living statue can be found in the short and frenetic presentations of the photographic talents of Georges Méliès. In 1898, Méliès produced his first living statue shorts, *Le Magicien* and the recently rediscovered *Pygmalion et Galathée*. Méliès embodied the figure of mythical sculptor Pygmalion as no other, willing life into the lifeless by virtue of his magical apparatus. Tracing the echoes of the myth in what he calls the "Pygmalion effect," Victor Stoichita describes the blurring of boundaries that occurs between model and sculpture – between original and copy – in Ovid's original tale and those of his many successors, most of which operate, like Méliès, within the connected realm of aesthetics, magic, and technical skill.[10]

For his feverish expression of Pygmalionism in *Le Magicien*, Méliès chose a decidedly non-narrative approach that let cinematographic trickery mesh with his own brand of performance against a cardboard stage backdrop resembling a medieval wizard's lair and featuring a very large matted-out "entrance," indicative of the superimposition effects that will follow.[11] At a certain moment in the film, a nobleman grabs a Pierrot character by the shoulder. Thanks to the simple but effective stop-camera technique, the setting suddenly changes, with the Pierrot disappearing and the nobleman turning into what appears to be a bearded ancient Greek or Roman sculptor in a toga. He picks up a marble-looking bust of a woman, places it on a sculpting stand, and goes to work with a hammer and chisel. The bust comes to life, however, and throws away the sculptor's tools with newly sprouted arms. The sculptor cries out in disbelief,

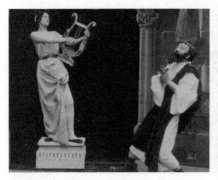

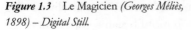

Figure 1.3 Le Magicien *(Georges Méliès,* ***Figure 1.4*** La Statue Animée *(Georges Méliès,*
1898) – Digital Still. *1903) – Digital Still.*

while the woman's bust changes into a fully-fledged statue on a pedestal before
his eyes – though we are actually looking at a motionless woman, performing
a *pose plastique*. She is clad in a long tunic, seems slightly whitewashed, and is
holding a harp at arm's length. Utterly delighted, the sculptor tries to grab the
statue, but it vanishes and reappears behind his back in a different pose, hands
now held skyward. The same thing happens again, and the statue is now in
a seated position on a stool with its legs crossed, holding a pitcher above its
head and a cup in the other hand. When the sculptor tries to go for it again,
the statue vanishes into smoke and the nobleman reappears, kicking him in the
behind. It is immediately apparent from *Le Magicien* that the magician's stage
tradition was assimilated in the new film medium, with Méliès actively playing
the part of the newly formed *cinémagicien*, who brought to life a multitude of
imagery such as paintings, posters, and playing cards, and often also working
with typical stage types such as the Chinese conjurer, the drunk clown, the
medieval jester, and the Pierrot figure.

The living statue trope was particularly prevalent in Méliès's work, appear-
ing in no fewer than seventeen of his (extant) films between 1898 and 1911.[12]
Twelve of these are mostly non-narrative acts,[13] often with the conjurer char-
acter as protagonist, while five of the films provide a more plot-driven context
for the living statue,[14] with two of those five placing it in an (even more) fan-
tastical or dreamlike setting.[15] A common thread in all of these films is the
period setting, with a prevalence of the medieval setting and the "Antique"
backdrop – referring to either a general Greco-Roman style or an eighteenth-
century revival version of it. A wide variety of transformations occurred in
Méliès's work, often within the same film, but in most cases the statues them-
selves were represented by (wax) mannequins or women in togas posing as
living statues. In spite of the stage traditions, however, these women did not
seem to be whitewashed in any way; a possible explanation for this might be

the time frame Méliès was working with, as the length of most of his (statue) films was limited. The longer narrative films did not set out to show a single living statue act unfurling slowly, as it would on the stage, but rather Méliès's craft with regard to the creation of fantastical imagery through special effects, set and costume design. His shorter trick films were equally jam-packed showreels filled to the brim with special effects and jokes that the audience was bombarded with at a near murderous pace, thus creating a strong contrast with the immobility and tranquility of statuary. Furthermore, these living statues were certainly not always whitewashed on the stage, and Méliès might not only have thought his live models to be convincing enough for the short period of time that they were on screen, which sometimes amounted to mere seconds, but might also have found the appearance of "live flesh" preferable, as this revealed certain titillating details such as ankles, partly bared chests and, of course, underarm hair, which was considered quite intimate and sexually suggestive.[16] The latter was highly visible in several statuesque poses in *Le Magicien*, and the scantily dressed woman reappears in the 1903 *La Statue animée*,[17] in which an eighteenth-century-clad and periwigged gentleman jokester conjures up a living statue in a white dress, wearing and holding a veil, out of thin air to play a joke on a visiting drawing class. The professor of the class marvels at the beauty of the statue, making rather explicit hand gestures with regard to its female contours, and checking on the work of his students vigorously. When he passes the statue, it comes to life and takes off his hat, lifting it high into the sky in a new pose that reveals its underarm hair. The class reacts in a baffled way at the statue's lively gesture, but before they realize what has happened the living statue has turned into a statuesque fountain with a dragon's head, and the jokester returns to dump the professor into the water. The female body reappears in similar ways in the 1906 stage trick film *Les Bulles de savon vivantes*, subtitled *Illusion mystérieuse*, the narrative féerie *La Bonne Bergère et la Mauvaise Princesse* (1908), and in the lengthy hallucinatory dream sequence that makes up most of the 1911 *Les Hallucinations du Baron de Munchausen*. In *Les Bulles de savon vivantes*, for instance, the film's magician (Méliès again) uses smoke, bubbles, and good old-fashioned hand gestures to bring to life women in white, toga-like dresses that he posits in statuesque poses on pedestals before a black background, making them disappear and reappear at will in several poses. A fascinating color variation on the living statue conjurer short can be found in *Sculpteur moderne* (1908) by Méliès's Spanish heir apparent and competitor at Pathé, Segundo de Chomón. Having already displayed his affinity with clay in the lightning sculpture trick film *Le Sculpteur Express* (1907), de Chomón experiments with the illusion of marble in *Sculpteur moderne*, in which a female conjurer displays a number of (miniature) statuary groups that change positions on a rotating pedestal in front of

an ornamental frame against a black background. The film goes on to show-case an elaborate stop-motion number in which a block of clay evolves into several different (living) sculptures.

The use of mannequins brought an even more visceral edge to Méliès's work, as his cinematic magic sees them being taken apart and built up quite violently at times. His living statue films demonstrate not only the malleabil-ity of bodies – be they mannequin, bronze, marble, cardboard, or flesh – but also the strength and violence with which the filmmaker enforces his own Ovidian metamorphoses; as Stoichita so aptly put it, "the myth of Pygmalion challenges the visual in the name of the tactile."[18] We can also draw a parallel between Ovid and Méliès following Philip Hardie's notion of Ovid's "illu-sionist aesthetics," that displayed the "verbal artist's power to call up before the eyes of his audience or readership a vivid vision [that] has its analogue in the visual arts in the challenge to a painter or sculptor so successfully to imitate reality as to elide the boundary between art and nature through the illusion of an immediate presence."[19] The presence of mannequins furthers this elision of the boundary between art and nature, as the mannequin is by definition artificial and real. The mannequins made their appearance almost exclusively in Méliès's non-narrative films such as *Guillaume Tell et le Clown* (1898), *L'Illusionniste fin de siècle* (1899), and the 1903 *Illusions funambulesques* and *Tom Tight et Dum Dum*, among others.[20]

A more conventional interpretation of the living statue trope can be found in Méliès's narrative films, where we see that the living statue is employed as a religious or mythological occurrence. In *La Tentation de Saint Antoine* (1898), for instance, the French filmmaker explores the famous liter-ary and art-historical motif of the temptation of Saint Anthony the Great, who was said to have experienced supernatural temptations upon his pil-grimage into the desert.[21] The motif is widely known via sixteenth-century paintings by Hieronymus Bosch, who depicted the saint as an old man in a monk's habit sporting a large beard, surrounded by demons. Méliès presents him in the same way, taking inspiration from an episode in the life of Saint Anthony where he hides from demons in a cave. The film shows the hermit in a cave before a large crucifix holding a life-sized statue of Christ on a pedestal, but before long he is bothered by scantily clad women who seem to appear out of thin air. When he prays to his crucifix, the statue of Jesus is transformed into a real woman, stepping down from the cross to taunt him. Anthony is finally released from his misery when an angel appears who rids him of the women and makes Jesus reappear on the cross. A divine interven-tion similarly ends a medieval couple's plight in *Le Diable géant ou le Miracle de la Madonne* (1901), when a wax Madonna statue comes to life to banish a hyperactive devil.

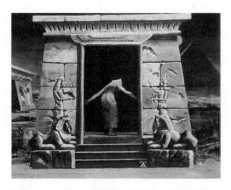

Figure 1.5 L'Oracle de Delphes *(Georges Méliès, 1903) – Digital Still.*

Méliès tackles the same trope from a mythological angle in *L'Oracle de Delphes* (1903), but although Delphi and its Oracle were very much part of Greek culture, the setting is nevertheless an Egyptian one. We see a small temple in the foreground, guarded by two stone male sphinxes on pedestals, while the background shows a large pyramid and another temple featuring an Egyptian mural. A thief attempts to steal the shrine in the temple but stops in dread when a priest-like apparition summons him to give back the shrine. The thief begs for mercy, but the priest then transforms his two male sphinxes into two female helpers who turn the thief's head into that of a donkey, before returning to their pedestals and turning back into sphinxes.[22]

THE ATTRACTION OF SATURN

The transformative aspect of the Pygmalion myth is inherently visceral and magic, with its many expressive interpretations appropriating the myth's duality between life and death, movement and stasis. The transition from inert matter to live flesh is also fundamentally charged with eroticism. This is already present in Ovid's own sensual description of Pygmalion's ivory statue slowly coming to life under the sculptor's warm touch as he senses her racing vein and his lips feel a kiss returned. Indeed, there is more to this moment than the artist's fantasy of his work coming to life, laying bare, among others, the key simile between the creation of a work of art and the creation of man, and the implications that such a tactile process entails. Lest we forget, tactility is of course one of the main attractions of the three-dimensional art form that is sculpture, particularly when nudes are involved; for to touch a sculptural work requires a violation of the code of conduct with regard to art – this is exemplified by R. W. Paul's 1898 film *Come Along, Do!*, in which a man is ogling a classical nude sculpture in a museum intensely, before being

pulled away by his wife. It is no surprise, then, that the inherent eroticism of the (living) statue saw itself transported from the page to the stage, especially so in the latter half of the nineteenth century. *The New-York Tribune*'s George G. Foster stated in 1850 that the tableau vivant form was mostly a male pre-occupation at first, until the English Dr. Robert H. Collyer introduced the female "model artists" on the American stage. Though announcing "repre-sentations of scriptural and classic pictures," Foster held Collyer responsible for debasing the art form, introducing obscenity by staging "lank-sided, flabby-breasted" women "whose attitudes were about as lascivious as those of a new milch cow," but causing an impressive increase in the number of saucy "model artist" performances which "numerous and popular as ever . . . carried on with perfect immunity from municipal inspection or opposi-tion."[23]

Nudity hit the vaudeville stages under the cover of art, with many per-formers going entirely nude, partially covered, clad in white or flesh-colored skintight outfits, or coated with white dust to approach the look of classi-cal statuary, providing their acts with artistically sound titles as diverse as "Persecution of a Virgin," "The Awakening of Galatea," and "The Death of a Dancing Girl." But although they were served up as a "high-brow form of cultural enrichment," these acts drew large crowds in the late nineteenth and early twentieth century not because they were seeking to elevate the public, but rather because sex always sells.[24] Attempts at organized censorship did not pull through in the way they did when moving pictures hit the scene, however. Erotic and pornographic content was found in motion pictures from the very beginning, with the Edison Company's *Fatima's Coochee-Coochee Dance* (James H. White, 1896) as one of the earliest extant examples. The film was famously censored by adding white bars that obscured the performer's most racy shaking parts, and, according to Charles Musser, the Edison Company frequently filmed this sort of dancer but kept the resulting films off the catalogue books, indicating the presence of a clandestine circuit fed by major, minor, and underground production companies.[25] A 1915 article in *The New York Clipper* entitled "The Nude in Pictures" reveals that nudity was a hot topic in cinema at the time, and the author makes a point of clearly distinguishing between the nude as it functions in a visual arts context and the nude in film, stating that the nude in the studio is "dressed in the form of art and not in the guise of amusement." Art aims to educate a mature audience and can thus lay claim to the nude body, pronounced the author, whereas movie theaters and vaudeville houses serve to amuse the motley masses and therefore lead to the sexualization and commodification of the nude body.[26]

Early film's fascination for the nude statue unmistakably played on these tensions and ambivalences. While male nudes mainly connoted a classical

ideal connected to a modern notion of physical strength and bodily health,[27] female nudes oscillated between the sublime and the obscene. As Lynda Nead demonstrates, the female nude connoted "Art" more than any other subject, and it was a "symbol of the pure, disinterested, functionless gaze and of the female body transubstantiated."[28] However, Nead also noted that the exemplary function of images of the female body depended only partially on the content of the image itself; it was equally a question of who saw these images, where, and how.[29] In contexts other than the art gallery, similar depictions of the female nude were labeled pornographic, thus belonging to a mass cultural realm where sensual desires are stimulated and gratified, unlike in "pure Art." A medium of mass culture that presented movement as its essence, film complicated the matter since the purity of the female nude depended highly upon stasis. As Nead notes, a moving nude almost automatically began to "toy with the possibilities of obscenity."[30] Early cinema's preference for tableaux vivants, which neutralize natural movements, should definitely be seen in the light of these discussions.

There was one studio that took the latter to heart and devoted itself solely to putting out what can best be described as "nudie cuties," to borrow a generic term first applied to the films of Russ Meyer in the 1950s and 1960s. This was the Vienna-based Saturn Company, Austria's first film production company, which, led by former nude photographer turned director Johann Schwarzer, released a number of erotic films between 1906 and 1910. These were advertised in local papers and shown on so-called "*Herren Abende*" or "gentlemen evenings" in Vienna, but were also quite popular in the whole of Europe. Even though the films' content was geared toward innocent, but full, nudity with a comic or artistic bent, the Saturn film company was the victim of a government crackdown on pornography in 1909, leading to the destruction of a lot of material and the effective termination of the company in 1911. Three Saturn films survive that feature the living statue trope: *Der Traum des Bildhauers* (*The Sculptor's Dream*) (1907), *Das eitle Stubenmädchen* (*The Vain Maid*) (1908), and *Lebender Marmor* (*Living Marble*) (1910). Judging from their title in the Saturn catalogue, the artist-model theme persisted in other films as well, namely *Das unruhige Modell* (*The Restless Model*) (1907), *Im Atelier* (*In the Studio*) (1911), *Der Kunstmäzen* (*The Patron of the Arts*) (1911), *Die lebenden Marmorbilder* (*The Living Marbles*) (1911), and *Modelle* (*Models*) (date unknown), showing that eight out of 52 Saturn films dealt with an artistic context.[31]

Der Traum des Bildhauers was the first of these, and is a sculptural variation on a theme that sees the painter falling asleep in his studio and dreaming of, for instance, a beautiful ballerina, as in the 1899 *The Artist's Dream* (American Mutoscope & Biograph Company), or two painted female subjects stepping out of their frames, as in *An Artist's Dream* (Edwin S. Porter, 1900). In *Der*

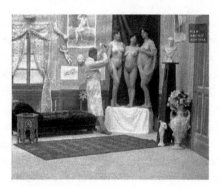

Figure 1.6 Der Traum des Bildhauers *(Johann Schwarzer, c.1907) – Digital Still.*

Traum, a sculptor is working on three life-sized female statues in his studio – that is, three actual nude women. The sculptor chisels away at his creations, and when he is pleased with the result, he breaks out the champagne, lights a cigarette, and falls asleep. While he is asleep, the statues come to life and one graces his cheek with a kiss, before they return to their joint pedestal. The sculptor wakes euphorically, throwing kisses at the statues before falling asleep once more. When waking a final time, he realizes that it has all been a dream and starts chiseling away again. No special care went into making the female nude models look like actual statues here, even the pedestal is a draped box, and no cinematic tricks were employed at all with regard to either the statues coming to life or the sculptor's dream. The intended audience would have bought into the artistic context, but would have surely been most interested in the full frontal nudity that is on display here, without the impediments of make-up or flesh-colored skin suits.

In *Das eitle Stubenmädchen* and *Lebender Marmor*, a more elaborate joke narrative replaces the simple setup of *Der Traum*. The former displays the title's vain chambermaid entering a well-dressed bourgeois room that showcases a reclining nude. The nude is a whitewashed model with a white wig lying on an improvised pedestal made of sheets and supporting her head with her right arm, while covering herself below with her left hand. As the maid is dusting the room, she compares her own measurements with those of the sculpture, and starts to undress until fully naked. She then lays herself next to the work of art in a corresponding pose, only to be caught by her employer, who chases her into the next room as she runs away. The reclining sculpture in this short film plays a more classical role, in that the actress is not only whitewashed, but also holds her pose for the entirety of the narrative. The duplication that occurs is interesting, for it shows us how the nude sculpture was indicative of what was considered the corporal feminine beauty ideal, while also playing on the erotic dichotomy between live flesh and inert matter. In *Lebender*

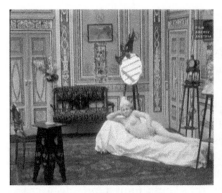
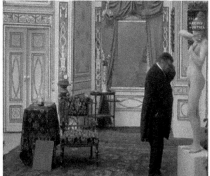

Figure 1.7 Das eitle Stubenmädchen
(Johann Schwarzer, c.1908) – Digital Still.

Figure 1.8 Lebender Marmor *(Johann
Schwarzer, c.1910) – Digital Still.*

Marmor, a group of friends are out to surprise an acquaintance of theirs by tricking him into touching a nude statue that is really a living woman. They hire a girl to strip down, whitewash herself, don a white wig and assume a pose on a pedestal in which her right arm covers her mouth while her left arm conceals part of her breasts. When the acquaintance is left alone with the living statue, he is very quickly impressed with its beauty and proceeds to close all the doors and curtains, so that he can quietly grope what he perceives to be a statue. When he raps the statue's wrist, however, the model jumps off the pedestal and pats him on the cheeks, while his friends storm in laughing. The film shows the taboo involved in touching a nude statue, but also the promise of what this could result in, making this short film into a true disciple of the Pygmalion myth. George L. Hersey linked the tactility of Ovid's work to the "sensuousness of the Hellenistic sculptures," implying that the true work of art "awakens keen physiological sensations in the viewer's body."[32]

CASTING CONCLUSIONS

For all of the bawdiness that the Saturn films were charged with, they were relatively innocent at heart, laying bare some of the cultural clichés that art had to deal with. The story of the artist preying on his models is as old as art itself, while the controversial status of the female (nude) model was also a historical given. As Sarah R. Phillips has pointed out, with the exception of England, academies only started using female life models in the latter part of the nineteenth century, using male substitutes or even barring students under the age of twenty from attending unless they were married. Moreover, nude models were perceived to be women of a questionable nature, and bestowed

with the same social status as prostitutes, which, granted, a number of them were.[33] This status gradually changed, even seeing the rise of some celebrity models and muses such as Audrey Munson, the "modern Venus" who modeled for countless statues and buildings in New York and embarked on a short-lived film career.[34]

Not to be overlooked, however, is the comic potential of the statue. Most, if not all, of the Méliès and Saturn films were comedies that played on the possibilities offered by the trope of the living statue: people mistaken for statues; people pretending to be statues; statues striking back; surprising visitors who are violating the taboo against touching a statue of a human, ridiculing their maker, or just running off. These films represent a cross-fertilization of popular vaudevillian entertainment with the magic of cinema, foreshadowing marked instances of slapstick statues in films such as *The Goat* (Buster Keaton and Malcolm St. Clair, 1921), *Roaming Romeo* (Lupino Lane, 1928),[35] *Animal Crackers* (Victor Heerman, 1930), and *City Lights* (Charles Chaplin, 1931). Both Méliès and Saturn's Schwarzer employ a satirical take on the figure of the sculptor, but where Méliès stuck to stagey backdrops and caricature, banking also on his explosive and erratic stage presence for most of his trick work, the Saturn film company went for a more upscale bourgeois setting in which older men had a jolly good time with nudes, be they flesh or marble. As such, the statuary illusion seems to have been of scant importance to Saturn, whose aim was to provide bourgeois eroticism. In Méliès's work, of course, the switch from inert dead matter to living flesh and back was a key component of his act, as it demonstrated his skill and strengthened the illusionary aspect of his oeuvre.

His films also exemplify the conflation of media (theater, painting, and sculpture) that defined the tableau vivant, while also showing the early twentieth century's fascination with classicism and illusionism – Méliès's camera made for the ultimate illusionary machine, while the Saturn films showed the use of whitewash makeup. Equally striking is that the character of the artist is more often replaced with that of the conjurer or ecstatic saint, for instance, when confronted with a living statue in the work of Méliès, even though the former seemed to have been far more common on the stage. Furthermore, the three-dimensionality of the statues forms a sharp contrast with the two-dimensional cardboard backdrops in Méliès's work. Interestingly, however, the presence of a (living) statue did not halt the narrative in the work of Saturn or Méliès, but rather accelerated or started it. We can see that in these films, a very fluid approach is taken to notions of life and death, one that sees statues come to life and revert back, and has characters pulled apart and put back together again, all with great ease. This connects with Gross's view that the statue is a transitional form, retaining the idea of both past and future

life.[36] This view is of course prompted by the particularity of the medium, as sculpture has been imbued with both magic vivification and mortification from the earliest mythological texts onwards, the trope of Pygmalion being one of the foremost examples. In this tradition, sculpture is easily equated with magic, witchcraft, or alchemy, not coincidentally in the same vein as cinema. As such, we can state that the living statue trope was surely one of the most interesting dialectical forms of its time, combining high- and lowbrow art in popular entertainment, and living on in the newest of media. The living statue in early cinema was thus comic and erotic, explosive and visceral, often *unheimlich*, and inherently intermedial.

Notes

1. Jack W. McCullough, *Living Pictures on the New York Stage* (Ann Arbor: UMI Research Press, 1983), 16.
2. McCullough, *Living Pictures*, 101.
3. McCullough *Living Pictures*, 104.
4. See Andrew L. Erdman, *Blue Vaudeville: Sex, Morals and the Mass Marketing of Amusement, 1895–1915* (Jefferson and London: McFarland, 2004), 106; and David Huxley, "Music Hall Art: La Milo, Nudity and the Pose Plastique 1905–1915," *Early Popular Visual Culture* 11, 3 (2013), 218–36.
5. Kristin Thompson in David Bordwell, Kristin Thompson and Janet Staiger, *The Classical Hollywood Cinema: Film Style and Mode of Production to 1960* (London: Routledge, 1985), 159.
6. Ivo Blom, "Quo Vadis? From Painting to Cinema and Everything in Between," in Leonardo Quaresima and Laura Vichi (eds.), *La decima musa. Il cinema e le altre arti/The Tenth Muse. Cinema and other arts* (Udine: Forum, 2001), 281–96; Valentine Robert, "La pose au cinéma: film et tableau en corps-à-corps," in Christine Buignet and Arnaud Rykner (eds.), *Entre code et corps. Tableau vivant et photographie mise en scène* (Pau: Presses Universitaires de Pau et des Pays de L'Adour, 2012), 73–89; Daniel Wiegand, "'Performed Live and Talking. No Kinematograph': Amateur Performances of Tableaux Vivants and Local Film Exhibition in Germany around 1900," in Scott Curtis, Frank Gray, and Tami Williams (eds.), *Performing New Media, 1890–1915* (New Barnet: John Libbey, 2014), 373–87.
7. Charles Musser, "A Cornucopia of Images: Comparison and Judgment across Theater, Film, and the Visual Arts during the Late Nineteenth Century," in Nancy Mowll Mathews and Charles Musser (eds.), *Moving Pictures: American Art and Early Film 1880–1910* (Manchester and Vermont: Hudson Hills Press, 2005), 8.
8. Lynda Nead, *The Haunted Gallery: Painting, Photography, Film c.1900* (New Haven and London: Yale University Press, 2008); Nancy Mowll Mathews, "Art and Film: Interactions," in Nancy Mowll Mathews and Charles Musser (eds.), *Moving Pictures: American Art and Early Film 1880–1910* (Manchester and Vermont: Hudson Hills Press, 2005), 145–58.

9. See Victor Stoichita, *The Pygmalion Effect: From Ovid to Hitchcock* (Chicago and London: The University of Chicago Press, 2008); Kenneth Gross, *The Dream of the Moving Statue* (Philadelphia: The Pennsylvania State University Press, 2006); and Nead, *The Haunted Gallery*.

10. Stoichita, *The Pygmalion Effect*, 5.

11. Ron Miller, *Special Effects: An Introduction to Movie Magic* (Minneapolis: Twenty-First Century Books, 2006), 13.

12. These are: *Le Magicien* (1898); *Pygmalion et Galathée* (1898); *Guillaume Tell et le Clown* (1898); *La Tentation de Saint Antoine* (1898); *L'Illusionniste fin de siècle* (1899); *Le Diable géant ou le Miracle de la Madonne* (1901); *La Statue animée* (1903); *L'Oracle de Delphes* (1903); *Tom Tight et Dum Dum* (1903); *Illusions funambulesques* (1903); *Le Baquet de Mesmer (*1904); *La Chaise à porteurs enchantée* (1905); *Les Bulles de savon vivantes* (1906); *Le Tambourin fantastique* (1908); *La Bonne Bergère et La Mauvaise Princesse* (1908); *Les Illusions fantaisistes* (1909); and *Les Hallucinations de Baron de Munchausen* (1911).

13. Respectively: *Le Magicien* (1898); *Pygmalion et Galathée* (1898); *Guillaume Tell et le Clown* (1898); *L'Illusionniste fin de siècle* (1899); *La Statue animée* (1903); *Tom Tight et Dum Dum* (1903); *Illusions funambulesques* (1903); *Le Baquet de Mesmer* (1904); *La Chaise à porteurs enchantée (*1905); *Les Bulles de savon vivantes* (1906); *Le Tambourin fantastique* (1908); and *Les Illusions fantaisistes* (1909).

14. *La Tentation de Saint Antoine* (1898); *Le Diable géant ou le Miracle de la Madonne* (1901); *L'Oracle de Delphes* (1903); *La Bonne Bergère et La Mauvaise Princesse* (1908); and *Les Hallucinations de Baron de Munchausen* (1911).

15. *La Bonne Bergère et La Mauvaise Princesse* (1908); and *Les Hallucinations de Baron de Munchausen* (1911).

16. Francesca Berry, "Bedrooms: Corporeality and Subjectivity," in Georgina Downey (ed.), *Domestic Interiors: Representing Homes from the Victorians to the Moderns* (London and New York: Bloomsbury Academic, 2013), 132–3.

17. Though there is a somewhat narrative aspect to this film – as one can argue there is to almost all films – its obvious stage setting and simple trick and gag set-up have made us categorize it as non-narrative with regard to Méliès' living statue films.

18. Stoichita, *The Pygmalion Effect*, 203.

19. Philip Hardie, *Ovid's Poetics of Illusion* (Cambridge and New York: Cambridge University Press, 2002), 7.

20. Mannequins were used in *Guillaume Tell et le Clown* (1898); *L'Illusionniste fin de siècle* (1899); *Le Diable géant ou le Miracle de la Madonne* (1901); *Tom Tight et Dum Dum* (*1903); *Illusions funambulesques* (1903); *La Chaise à porteurs enchantée* (1905); and *Les Illusions fantaisistes* (1909).

21. David M. Gwynn, *Athanasius of Alexandria: Bishop, Theologian, Ascetic, Father* (Oxford and New York: Oxford University Press, 2012, 15).

22. Almut-Barbara Renger, *Oedipus and the Sphinx: The Threshold Myth from Sophocles through Freud to Cocteau* (Chicago and London: University of Chicago Press, 2013), 33. Méliès' choice to turn male sphinxes into rather scantily clad females is not

surprising, but it is interesting to note that the Egyptian sphinxes were indeed mostly male, whereas the Greek sphinx was predominantly female.

23. George G. Foster and Stuart M. Blumin (eds.), *New York by Gas-Light and Other Urban Sketches* (Berkeley: University of California Press, 1990), 80–2.

24. Andrew L. Erdman, *Blue Vaudeville: Sex, Morals and the Mass Marketing of Amusement, 1895–1915* (Jefferson and London: McFarland, 2004), 5 and 38–9.

25. Charles Musser, quoted in Dave Thompson, *Black and White and Blue: Adult Cinema from the Victorian Age to the VCR* (Toronto: ECW Press, 2007), 21.

26. Erdman, *Blue Vaudeville*, 39.

27. Tamar Garb, "Modeling the Body: Photography, Physical Culture, and the Classical Ideal in Fin-de-Siècle France," in Geraldine Thomson (ed.), *Sculpture and Photography: Envisioning the Third Dimension* (Cambridge: Cambridge University Press, 1998), 86–99.

28. Lynda Nead, *The Female Nude: Art, Obscenity and Sexuality* (London and New York: Routledge, 1992), 85.

29. Nead, *The Female Nude*, 83–108.

30. Nead, The Female Nude, 85.

31. Michael Achenbach and Paolo Caneppele, "Born Under the Sign of Saturn: The Erotic Origins of Cinema in the Austro-Hungarian Empire," *Griffithiana: Journal of Film History* 65 (1999), 126–39.

32. George L. Hersey, *Falling in Love with Statues: Artificial Humans from Pygmalion to the Present* (Chicago and London: University of Chicago Press, 2009), 90.

33. Sarah R. Phillips, Modeling Life: Art Models Speak about Nudity, Sexuality, and the Creative Process (Albany: State University of New York Press, 2006), 5–6.

34. Diane Rozas and Anita Bourne Gottehrer, *American Venus: The Extraordinary Life of Audrey Munson, Model and Muse* (Los Angeles: Balcony Press, 1999). Munson starred in *Inspiration* (George Foster Platt, 1915); *Purity* (Rae Berger, 1916); *Girl O' Dreams* (American Film Company, 1917); and *Heedless Moths* (Robert Z. Leonard, 1921).

35. See Bryony Dixon, "The Good Thieves: on the Origins of Situation Comedy in the British Music Hall," in Tom Paulus and Rob King (eds.), *Slapstick Comedy* (New York and London: Routledge, 2010), 21–36.

36. Gross, *The Dream of the Moving Statue*, 130.

The Mystery . . . The Blood . . . The Age of Gold: Sculpture in Surrealist and Surreal Cinema

SUSAN FELLEMAN

Figurative sculpture had a special status within the visual universe of Surrealism. Iconographically, statues are a prominent element in the dream-like spaces of Giorgio de Chirico's paintings of 1913–14 that so enchanted André Breton and friends after the end of the war and became among the first and most paradigmatic images associated with the movement. Statues appear in many other Surrealist paintings, including those of Salvador Dalí, where, although they might stand on plinths or pedestals, they equivocate between the appearance of inanimate and living bodies, through the impression of liquidity and putrefaction that infects all his visions. In Surrealist collages, too, bodies are often rendered equivocally sculptural through fragmentation, for instance in photographic or printed images of the female nude rendered headless or otherwise dismembered to resemble antiques, in the works of Max Ernst and others. René Magritte, Paul Delvaux, Man Ray, Pierre Boucher, Picasso, and Jean Cocteau, among others associated with Surrealism, also incorporated statuary into their paintings, drawings, and photographs.

In the period of the second manifesto – 1929 and after, when Surrealist filmmaking intensified – two trends emerged as especially salient: the object, with its inherently sculptural presence, and photography. The Surrealist object was a distinct category of Surrealist visual culture and a special sort of artifact – something found, modified, or assembled – whose significance derived from the concept of objective chance. Some objects incorporated or altered sculptural prototypes (Man Ray's 1936 *Venus Restaurée*, for instance). Such quasi-sculptural entities as mannequins (showcased in the 1938 Exposition Internationale du Surréalisme at the Gallerie des Beaux-Arts in Paris) and dolls (especially Hans Bellmer's *Puppe*) were favorite photographic subjects. The same sort of public statuary that had resonated in the paintings of de Chirico also occupied the marvelous, uncanny Paris in pictures by Atget and other photographers associated with the movement, including Joseph Breitenbach, André Kertész, Jacques-André Boiffard,

and Brassaï. Gradiva, a Surrealist gallery opened on the Left Bank in 1937, was named for an Antique bas-relief at the center of a novella that was the subject of a Sigmund Freud essay. Due to a delusion, Gradiva in Wilhelm Jensen's *Gradiva: A Pompeiian Fancy* (1903) refers to both a dead antiquity and a living, breathing object of erotic fascination, a trope which resonated with the Surrealists, who were fascinated with the uncanny properties of statues and their potential for troubling boundaries: between that which is alive and that which is not, between subject and object, art and life. This fascination is the stage for the recurring scene of sculpture in Surrealist cinema.

In 1929 and 1930, Vicomte Charles de Noailles and his wife Marie-Laure, patrons of the arts, famously sponsored three film productions: Man Ray's *Les Mystères du Château de Dé/The Mysteries of the Chateau of Dice*, or *The Mysteries of Die Castle* (1929), Jean Cocteau's *Le Sang d'un poète/The Blood of a Poet* (1930), and Luis Buñuel and Salvador Dalí's *L'Âge d'or/The Age of Gold* (1930). These three films were to become the most ambitious and renowned films associated with Surrealism, after Man Ray's ciné-poem, *L'Étoile de Mer* (1928), and Buñuel and Dalí's *Un Chien Andalou* (1929), two notable previous forays into cinematic Surrealism. A significant motif in each, sculpture's manifold associations and auras in the Noailles films exemplify its roles and its future in an avant-garde cinema that arose around and followed from Surrealism.[1]

LES MYSTÈRES DU CHÂTEAU DE DÉ (1929)

Man Ray's *Mystères* – a cinépoetic account of a trip from Paris to, and an exploration of, the titular château (the Villa Noailles in Hyères) – begins with a close-up of a mannequin's hand passing dice to another. A type of utilitarian sculpture, the mannequin (artists' prop and dressmakers' dummy, as well as the familiar figure of fashion display) is strongly associated with the 1938 *Exposition Internationale du Surréalisme* but also with de Chirico's paintings and Atget's photographs, two touchstones of an earlier surrealist sensibility. Due to their functional resemblance to living bodies, mannequins possess an uncanniness that is overdetermined, deriving from their displacement from dressmaker's shop, window display, or studio prop into Surrealist tableaux, often erotic, strange, and magical. In addition, their uncanny characteristics are the result of the disturbances caused by their "interactions" with, substitutions for, and impressions upon living people. When Les *Mystères'* two travelers – according to the credits, played by the filmmakers themselves – are then shown, they are at the bar of a Paris café rolling dice, so we infer that the mannequin hands were theirs.[2] Their faces are obscured, veiled by

stockings, as are all the other players' in the film, lending them a dehuman-
ized anonymity.

Reminiscent of Magritte's 1928 painting *The Lovers*, the players' stocking-
covered heads underscore the obscure and vaguely ominous, albeit whimsi-
cal, atmosphere of the scenes set at the villa, which appears devoid of souls
when first entered by the travelers. The disembodied visitors explore the
house, rolling, flitting and swooping erratically in and out and from room to
room, finally encountering four stocking-hooded figures lying on the floor
in a neglected corner, throwing dice. The scenario thus triply – in word (an
intertitle asks, "Existe-t'il des fantômes d'action?"), image, and movement –
invokes the eponymous, often masked or hooded villain of *Fantômas*, Louis
Feuillade's popular crime serial, a favorite of the Surrealists. While the
phantom is a vivid metaphor for all film actors, who are traces of absent
physical beings, it also occupies a semantically intermediate space, some-
where between living and dead, like the mannequin and other sculptures that
trouble the boundary between animate and inanimate.

Beyond the mystery and mystique of phantoms and the evocation of
Fantômas, there is a slightly kinky aura around the players' hooded heads. In
this respect, they echo photographs by both Man Ray and Boiffard of bound
and masked figures, some of which appeared in *Documents*, echoing the influ-
ence of the Marquis de Sade on the Surrealists and especially the dissident
group around *Documents* editor Georges Bataille. The prehistory and phenom-
enology of the mask is fraught with erotic thrills and social transgression (and
the filmmakers must have been aware that their hostess, the Vicomtesse de
Noailles, née Marie-Laure Henriette Anne Bischoffsheim, was descended on
her mother's side from the Marquis de Sade).[3]

Man Ray had been invited to Villa Noailles to "shoot some sequences
showing the installations and art collections" and the Vicomte and "his guests
disporting themselves in the gymnasium and pool."[4] By the time he and his
assistant Boiffard left for their journey to Hyères in January 1929, Man Ray
had conceived a title for his film, *The Mysteries of the Chateau of Dice*, one that
alludes to Stéphane Mallarmé's poem "Un coup de dés jamais n'abolira le
hasard" (A Throw of the Dice Will Never Abolish Chance) – a Surrealist
favorite – and was inspired by the cubist appearance of the modernist villa,
designed in 1923 by Robert Mallet-Stevens, and its garden, designed by
Gabriel Guevrekian.

Just as a mannequin – a subcategory of "useful" sculpture – troubles the
opposition between animate and inanimate, and a phantom the opposition
between living and dead, an anonymity (his term) such as one of Man Ray's
masked players blurs the boundary between known and unknown. These
troubled sets of oppositions correspond loosely to the cryptic categories of

convulsive beauty, which, according to Breton, "will be veiled-erotic, fixed-explosive, magic-circumstantial, or it will not be."[5] "The veiled-erotic is uncanny primarily in its in/animation, for this suggests the priority of death, the primordial condition to which life is recalled. The fixed-explosive ... is uncanny primarily in its im/mobility."[6] The third category of convulsive beauty, the magic-circumstantial, according to Hal Foster, is closely connected to the Surrealist concept of objective chance, per Breton, "the problem of problems," the fortuitous encounter between external thing or event and internal impulse (the unconscious). The experience of objective chance echoes that of the uncanny, a phenomenon understood by Freud to be a function of repression; what seems eerie, chilling (or, to use the Surrealist term, *marvelous*), is, paradoxically, at the same time familiar (*heimlich*) and strange (*unheimlich*), known (unconsciously) and unknown (consciously).[7] The erotic aura around anonymity depends upon this uncanniness, as well as upon social and cultural taboos: those suspended by carnival and masking.[8] License and fantasy are aided and abetted by the anonymity provided by the mask. Surrealism generally, according to Foster, cultivates the tension between these seeming oppositions as part of an oscillating fascination with "fantasies of maternal plenitude and paternal punishment, between the dream of a space-time before bodily separation and psychic losses and the trauma of such events."[9] Such oscillation indeed characterizes *Les Mystères*. The taboo, vaguely erotic, and illicit associations of the anonymities (fantasies of paternal punishment) are found in a poetic and disorienting exploration of space, light and water (fantasies of maternal plenitude), especially the wonderful sequences set in the Villa pool ("Piscinema," according to a neologistic intertitle).

There is more to the relationship between sculpture and cinema in the film than the evocative use of mannequins and "anonymities." In fact, the first and last images of Die Castle are images of sculptures. Coming up around a curve, we (with the Parisian travelers) glimpse a modern sculpture, prominently elevated upon a pylon. The three progressively closer traveling shots that follow feature an improbable dynamism: the camera seems repeatedly to circle the abstract sculpture and simultaneously track up it (and in the third shot, back down). The weirdly levitating, balletic camerawork reflects the meeting of two machines. Jacques Lipchitz's *La Joie de Vivre/The Joy of Life*, a cubist bronze of 1927, was mounted high on a rotating mechanism at the apex of Guevrekian's garden for the Villa Noailles.[10] That glancing establishing shot from outside the garden walls was too brief to reveal that the sculpture itself was in motion.

This sequence marks an important juncture in the film. Both its documentary mandate and its narrative trajectory are served by the encounter

Figures 2.1 and 2.2 Les Mystères du Château de Dé *(Man Ray, 1929). Jacques Lipchitz's sculpture,* La Joie de Vivre *(1927), seen from within and without the Villa Noailles – Digital Stills.*

with the sculpture. While the journey to that point has featured single shots of sights taken along the way from a moving car, suddenly the camera has not only left the car but has taken on a rather inhuman subjectivity: aerial and cubist. The repetition and simultaneity of movement and shifting perspective are cinematic correlatives to cubist pictorial strategies. Of the sculpture's novel kinetic properties George Heard Hamilton notes, "the now familiar device of a piece of sculpture revolving on a turntable before the spectator's eyes was as new in 1927 as the intensity of these figures animated by the frenetic energy of modern jazz".[11] The Lipchitz sculpture, a highlight of the Noailles art collection, becomes a leitmotif in *Les Mystères*, seen in other scenes – viewed from within and without – that reinforce its cubist characteristics. This seemingly inhuman, first-person camera work initiated by the encounter with Lipchitz's sculpture continues throughout the remaining sequences, as a restless, wandering lens explores the eerily unoccupied house. The film is half over before the dice-throwing humanoids are introduced and enter the pool room. The subsequent "Piscinima" sequence features numerous swimmers, including – according to Man Ray – his hostess, Marie-Laure herself, as "La femme . . . la jongleuse . . . Eve sous-marine," here the only player seen briefly without a stocking-covered head; in a few shots her head is submerged as she juggles and combs her hair underwater, her unveiled face glimpsed fleetingly. In the subsequent sequence, on a terrace, in footage shown in slow-, fast- and reverse-motion, the anonymities arrange themselves into sculptural tableaux: they stand like caryatids, spaced along architectural sections of pool wall; three circle together, holding a large ball overhead, while two others are posed in backbends, perhaps in imitation of Jean-Baptiste Carpeaux's sculpture *The Four Parts of the World* on the Fontaine de l'Observatoire in the Luxembourg Gardens.[12] After their frolic, indoors, four anonymities roll together on mats in the long shadows,

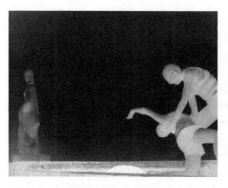 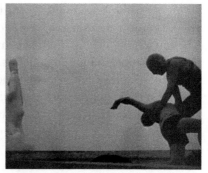

Figures 2.3 and 2.4 Les Mystères du Château de Dé *(Man Ray, 1929). Henri Laurens's sculpture,* Femme à la draperie *(1927), and visitors becoming sculpture upon the roof of the Villa Noailles – Digital Stills.*

until they fit together closely, side by side and head to foot, like sardines, and then slowly disappear (a photographic dissolution that reifies sleep). After a poetic intertitle, the film cuts to a low angle view of a corner of the garden wall, high above which we see a large, white sculpted female figure. At this distance, the figure recalls images of the Virgin sometimes seen atop Catholic churches, but it is actually a modernist nude, the other major sculpture from the Noailles collection featured in the film: *Femme à la draperie*, a monumental sculpture made for the roof of the villa by Henri Laurens in 1927.[13]

The last section of the film shows the arrival of two more travelers, a couple, who approach the Château on foot, past the now unmoving Lipchitz sculpture. The two find themselves within the garden walls, where they encounter a large pair of dice on the lawn. A kick of the dice determines they will remain and they walk toward the house. "But on the second night," according to an intertitle, after a 360-degrees shot from above, the couple appears on the roof terrace near the giant *Femme à la draperie*; they drop their coats, revealing bathing costumes, and begin grappling with one another in an awkward sort of tango. After a few moves, the couple freeze in the middle of a dip, screen right. They hold the strange pose for ten or more seconds, as the film contrast increases and they become silhouettes against the pale sky, then reverses, further flattening the depth of field and turning the figures into a white sculptural mass against a black ground, like the Laurens nearby. The last intertitle – "QUI RESTERENT" – emphasizes the conceit. "Their bodies take on the physical qualities of the white statue with which they share the frame: the animate becomes inanimate, and the mortal immortal."[14] The couple will remain forever; they have become sculpture.

Mortified and seemingly turned to stone atop the Villa Noailles, the couple form a melancholic coda to the spirited exploration of the place. The long static take as they become sculpture is a rare still moment in a deeply dynamic film. It highlights the essential nature of the encounter between sculpture (an art of stillness in space, around which the viewer moves) and cinema (an art of motion in time, before which the viewer is still) and also recollects those equivocal images that have flickered across the ludic surface of the film, images that reflect the Surrealist fascination with the "veiled-erotic" and "fixed-explosive," limning the boundary between animate and inanimate, living and dead. Moreover, it suggests an ontological problem around statuary that arises not only in Surrealism and in cinema, but in life: that which Kenneth Gross has explored. Discussing a range of uncanny figurations of sculpture, Gross observes that "such stoniness has its attractions. It is a fate we may desire as much as fear ... In many instances, the life assumed by a dead statue reveals itself as the most fragile of gifts, even a wound, the product of a living person's strange complicity with a thing that lacks life."[15] Such "strange complicity" between people and statues – and the ontological unease to which it gives form – are vividly enacted in the subsequent two films financed by the Vicomte de Noailles.

LE SANG D'UN POÈTE (1930)

The Noailles' next act of cinematic patronage produced Jean Cocteau's first film, *Le Sang d'un poète*. Set in the dark corridors of an artist's psyche – what Cocteau called "the night of the human body" – the film unfolds at an oneiric pace. Although the timelessness of the unconscious and the film's narrative action are signified by a framing device, the titular protagonist moves effortfully through the Baroque spaces of the film, almost in slow motion; he is a ponderous somnambulist, as opposed to the restless, disembodied phantoms who seem to narrate Man Ray's film. *Le Sang* is a reflexive passage into psyche, memory and artistic identity – its spaces mythic and imaginary – while Man Ray's is a ludic, improvisatory and documentary exploration of the material domain of Villa Noailles. For all the convulsive beauty of its imagery, the poetry and mystery of its elusive narrative, Man Ray's film has no protagonist: no individual identity, memory or psyche to be plumbed. Yet the two films share mystery, poetry, masking and, of course, sculpture. At the end of *Les Mystères*, people become sculpture. Near the beginning of *Le Sang*, a statue comes to life.

After a prelude in which Cocteau himself appears as something of a sculptural hybrid,[16] and the framing image of a collapsing smokestack, a fable

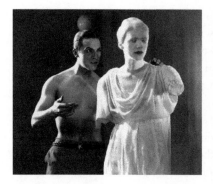 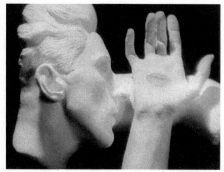

Figures 2.5 and 2.6 Le Sang d'un poète *(Jean Cocteau, 1930). Enrique Riveros and Lee Miller as the poet and his sculptural muse – Digital Stills.*

begins, as once told by Cocteau: "The solitude of the poet is so great, he lives out his own creations so vividly that the mouth of one of his creations is imprinted on his hand like a wound; that he loves this mouth, that he loves himself, in other words; that he wakes up in the morning with this mouth against him like a chance acquaintance; that he tries to get rid of it, that he gets rid of it on a dead statue – that this statue comes to life."[17] That statue, which appears spontaneously in his room the morning after the poet's autoerotic reverie, is a female figure in classical drapery; she stands in a *contrapposto*, her arms broken – a respectable pastiche of a classical or Hellenistic marble. She is animated, acquiring the face of Lee Miller, when "the poet walks around and, with a sudden movement, like an assassin gagging his victim, he puts his hand right over its mouth."[18] Cocteau's voiceover inquires, *"is it not crazy to wake up statues so suddenly from the sleep of centuries?"* Then, with the mouth that has been transferred from drawing to hand to statue, she speaks: "Do you think it's that simple to get rid of a wound, to erase the mouth of a wound?" The poet attempts to escape, but suddenly the room has no windows and where the door was there is now a mirror. The living statue – the poet's censorious muse – urges him to traverse it.

Trepidatiously, the poet approaches the mirror and its reflective surface turns liquid as he is drawn through. He finds himself in the corridor of a seedy hotel, the *Hôtel des Folies-Dramatique*, where he explores "a series of rooms, accessible only to sight through the keyhole. In each, a principle of cinematic illusionism is illustrated."[19] The magic of this *Hôtel*, though, is morbid, obsessive, endless. Another sculpture, a small figurine of the Virgin Mary, stands on a grotto-like hearth in a room with a figure dressed like a Mexican revolutionary. As the poet peeps through the keyhole, shots are fired; the figurine is shattered as the Mexican is executed. As soon as he has fallen the sequence is reversed: he stands and the Virgin is magically restored, a double action that

repeats, apparently endlessly. This image of death by gunfire and sculptural shattering, done and undone, foreshadows further action.

On the wall at the end of the hallway in the *Hôtel des Folies-Dramatique* appears the turning shadow of a suspended head – a skeletal sculpture or three-dimensional line drawing made of pipe cleaners, seemingly a portrait of the poet – that had hung in his room. This immaterial shadow sculpture signals the nature of the relationship between this netherworld on the other side of the mirror and the room in which the artist lives and struggles. The latter is certainly not more "real" than the former, but what occurs there is an allegorical representation of the artistic *agon*, while the hotel is the site of its unconscious sources. A proffered pistol induces a fantasy act of suicide and *"glory forever,"* but then the poet refuses the dream of posthumous glory and flees. Expelled back through the mirror into his room, he is furious and approaches his muse – the sneering statue – with his fist raised. With a hammer he smashes her to smithereens.

As Cocteau's voice admonishes, *"by breaking statues one risks turning into one oneself,"* the scene changes to a city street in winter. And here we find that the poet has indeed become a statue himself. His sculptural likeness sits upon a snow-covered base, soon surrounded by schoolboys having a snowball fight. The fight turns fatal for the poet-statue, destroyed for ammunition, and for a boy, hit hard in the face. Over the child's dead body appear the reborn poet and his statue-muse – now a contemporary society woman – both elegantly dressed in evening clothes, playing cards at table, accompanied by a masked friend in Louis XV costume. A black angel – shining, lame, and winged – descends a staircase and magically bears away the casualty but not before secreting away the ace of hearts from the poet's hand. The poet loses the game, pulls a pistol from his jacket and shoots himself in the temple. Blood pours from the star-shaped wound.[20]

The victorious woman stands up from the table and resumes her statuesque form; she wears long black gloves where she had no arms previously, and is blind, or so it seems (Cocteau drew sightless eyes on Miller's eyelids and she performed these last scenes with eyes shut).[21] She walks to a "golden door" and stands on a landing, between two busts (one of Diderot), and seems to beckon a taxi (a whistle sounds). A cow appears with a torn map of Europe on its side. The statue steps down beside the cow; a close-up of horns yields to a shot of a lyre, and she walks away from the camera holding a globe in her left arm and the lyre in her right, receding into myth.[22] A pair of alternating shots – one a close-up of the statue's supine head, with its features outlined "in the author's style," the other a long shot of the statue motionless on the studio floor, another ruin, with the globe and lyre – repeats as Cocteau's voice utters *"the mortal tedium of immortality."*[23] The smokestack completes its collapse.

The conclusion of *Le Sang d'un poète* and the utterance *"the mortal tedium of immortality"* express the protagonist's struggle with his muse, memory, his conflict between mortal desires and posthumous glory, but also the phenomenological aura of statues. The mute immortality, immobility, and imperviousness of these "stone mirrors" is the source of both the fantasy of movement and its opposite, the fantasy of petrification, as Gross observes.[24] Such fantasies are evident throughout human history, although, as Theodore Ziolkowski notes in his study *Disenchanted Images*, tropes such as Cocteau's walking statues, haunted portraits, and magic mirrors now appear more commonly in genres such as comedy, fantasy, and horror, in which we knowingly suspend our disbelief.[25] This observation obviously pertains to cinema, too, where such re-enchantment is encountered at least as often in the mainstream, commercial movie (*One Touch of Venus*, 1948, for example) as it is in the avant-garde film, as will be discussed in Chapter 5.

L'ÂGE D'OR (1930)

Re-enchantment was, of course, a central element of the Surrealist creed. But Surrealism, under the aegis of psychoanalysis and revolution, stripped the *marvelous* of convention and of its supernatural and mythological aura. It relocated the source of the marvelous to the psyche and a material reality (surreality) enlivened by the force of unconscious desire and, for dissident Surrealism, troubled by violence, abjection, and formlessness.[26] Thus did André Breton and friends disdain Cocteau's allegorical voyage to emotional and artistic depths, psychologically penetrating though it may have been.[27] Buñuel and Dalí's previous film, *Un Chien Andalou*, was an obvious influence on Cocteau, however, and the uncanny of his film is neither so tame nor so terribly remote from theirs. Eroticism, cruelty, sadomasochism, suicide, and abjection are currents in both *Le Sang d'un poète* and *L'Âge d'or*, and there is an iconography common to both: the magic mirror, pictures deformed by desire, the perversion of gravity, a hypocritical high society, the cow, and, of course, statues. In *L'Âge d'or*, however, statues are neither re-enchanted stone nor petrified souls. They retain all the chill, mute immobility of statues amid narrative events deformed by lust, violence, and absurdity.

The film's first statue is an obscenely incipient one. *L'Âge d'or* unfolds in six disconnected chapters. In the third, a delegation of dignitaries arrives by boat at the coast where four Majorcan bishops were last seen sitting upon rocks "muttering a mysterious liturgy" as a small gang of miserable bandits schemed, bickered, and expired. Now the Majorcans are but skeletons and the delegation has come to honor them and mark the site of their demise. It is in this scene that the amorous couple (Gaston Modot and Lya Lys) – who are

Figures 2.7 and 2.8 L'Âge d'or *(Luis Buñuel, 1930). Mimesis à la Dalí – Digital Stills.*

the nearest *L'Âge d'or* has to protagonists – are introduced, interrupting the solemn, pompous ceremony with their animal cries as they grope each other in the mud nearby. They are forcibly separated and a sequence of shots as the woman is led away suggests the man's ecstatic fantasy, connecting the mud in which he writhes to a volcanic explosion of her excrement. Thus when the ceremony has resumed and a "little pile of mortar" has been "ceremoniously laid" upon a plinth, it "looks suspiciously like a turd."[28] A blob upon a pedestal more suitable for a statue, this is an inauspicious monument to the abject. It is also, quite absurdly, said to be the foundation stone for "IMPERIAL ROME," the supposed location of the film's fourth section, which features an array of statuary, including a bronze Triton and nymph in a fountain, and a monument to an unknown luminary (of the eighteenth century, to judge by the evidence of his garb) shown only from behind, in the short touristic sequence showing "various picturesque aspects of the great city."

These scenes among others at the beginning of this sequence employ bits of a grainy Pathé and Éclair newsreel, according to Paul Hammond, and parody city symphonies of the period. A brief scene that Buñuel uncharitably later claimed was Dalí's only real contribution to the film (this is certainly not true, as Hammond and others persuasively maintain[29]) features a bourgeois gentleman in an overcoat and bowler, walking past a statue in a park. Both the gentleman and the statue, which Buñuel claimed was in the Jardin du Luxembourg and represented the seventeenth-century cleric, bishop and orator Jacques-Bénigne Bossuet, balance large stones – or possibly loaves of bread – on their heads.[30] Following Buñuel, these absurd crowns are always referred to as stones, and might indeed be; stones appear to be the objects upon the heads of bicyclists in Dalí's contemporary painting, *Illuminated Pleasures* (1929). The unwieldy objects might instead, however, be loaves of bread, a motif which appears often in Dalí's work – including, increasingly after 1930, crowning human heads – and which had manifold meanings and

associations, including the most obvious, the sacramental.[31] "Bread," Dalí wrote in 1945, "has always been one of the oldest fetishistic and obsessive subjects in my work, the one to which I have remained the most faithful."[32]

Dalí and Buñuel subscribed, ultimately, to different degrees of anti-clericalism and enjoyed different varieties of blasphemy. It is certain, however, that bourgeoisie and clergy are both ridiculed by the film's simple and absurd tableau of man and statue. Interestingly, there is not and seems never to have been a statue of Bossuet in the Luxembourg Gardens. The only public sculpture of him in Paris is on the Fontaine Saint-Sulpice, which portrays Bossuet seated, with four other seventeenth-century religious figures. The pose of the statue in the film is similar to that of a known sculpture of Bossuet by Augustin Pajou (now in the Louvre, and the basis of a figurine made as part of a series of great men by Sèvres) but the facial features and details of the figure are notably different. Its material is not ascertainable on film; it may be a purposely placed prop rather than a found sculpture: perhaps a plaster pastiche, created by set designer Pierre Schildkraut or one obtained from the property department of one of the film studios where Buñuel shot.[33] In any case, Buñuel despised everything Bossuet, tutor to the Dauphin, Bishop of Meaux, stood for: most forcefully, political absolutism and the divine right of kings. The film's sophomoric gag is irreverent, but it also gestures toward eternal questions about art generally and statues particularly. Does art imitate life or is it the other way round? On film, is the silly man in the bowler hat more "real" than the silly stone Bishop in robes? What do statues stand for? Those featured in *L'Âge d'or* are conventional fixtures of Western culture. They stand for cultural tradition and posterity: patrimony, power, stature, and status. In antiquity, statues were imbued with magic. Elements of cults, of rituals, they had aura, as Walter Benjamin has famously observed. By the early modern period, however (and entirely in the age of mechanical reproduction), that aura had withered. The statues of yesteryear – Greek and Roman gods, Christian idols, and civic monuments all – became disenchanted in the late nineteenth and early twentieth centuries when public space was subjected to a veritable *statuomania* that fascinated several Surrealists.[34] Both Louis Aragon, in his 1926 novel *Le Paysan de Paris*, and Robert Desnos, in his 1930 *Documents* article "Pygmalion et le Sphinx," ridiculed the moral seriousness of the statues of great heroes in an age marked by the new fetishes of consumerism.

Indeed, it is the statue's simultaneous high culture "status" and lack of aura that Buñuel and Dalí deploy in *L'Âge d'or*, nowhere more subversively than in the film's most iconic and infamous use of statuary, in the film's fifth section, where, in the garden at the villa of the Marquis de X, two lovers tryst. The villa is adorned with sculpture that is used decoratively and that signifies

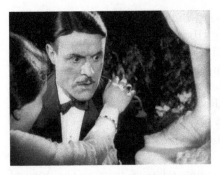

Figure 2.9 L'Âge d'or *(Luis Buñuel, 1930).*
Lya Lys, Gaston Modot, and base distractions –
Digital Still.

Figure 2.10 L'Âge d'or *(Luis Buñuel, 1930).*
Reaction shot – Digital Still.

wealth and stature. In the concert scene, architectural caryatids and busts and urns on pedestals properly situate the high society party guests in the manicured patio and garden, while around a private corner, the impassioned lovers separated in section three are finally reunited beside a classical statue. This statue, often referred to as Venus, has never to my knowledge been properly identified.[35] It does not represent the goddess of love; the iconography is wrong. The statue is a copy of a famous antiquity generally agreed to represent Artemis (known to Romans as Diana, the huntress), the so-called Diane de Gabies from the Borghese collection, now – as when *L'Âge d'or* was made – in the Louvre. Long attributed to Praxiteles (an uncertain attribution), she is identified as Artemis on the basis of her garment, a short chiton. The statue was very popular in the nineteenth century; copies were made in terracotta and porcelain in various sizes.[36] So, this statue stands in the garden of the Marquis de X, really, as a realist herald of class, not of love – mad or otherwise – or the hunt.

 The lovers' tryst over which Diana presides is one of the most shockingly funny, dysfunctional, and polymorphously perverse ever put on film. Intercut with shots of the concert underway, it shows Modot and Lys sucking one another's hands with teeth bared, an act that yields to the impression (or fantasy) that she has bitten off his digital members, as his suddenly fingerless stump of a hand caresses her face. Distracted by the music of the orchestra – the "Liebestod" from Wagner's *Tristan and Isolde* – he turns as she moves in for a kiss and they knock heads. A romantic lift turns into an awkward tumble. No sooner have they finally kissed, than he is distracted again by *art*: this time by the foot of the statue, which seems almost to cry out to him, near his head. He pulls away from his lover and stares, captivated by the inanimate foot, as Lys follows his gaze, bewildered. His reverie is interrupted by a cut to

three hurrying monks on a nearby footbridge. Returning his attention to Lys, Modot tenderly, then passionately, picks her up and lays her awkwardly on the ground, and lies down with her. They are on the very verge of love when interrupted by a servant, notifying Modot of an important phone call. When he has angrily departed, Lys, left alone with her head near the very foot that distracted her lover, turns her attention to it. She touches the big toe with her tongue, licks it, and then proceeds to suck.

There is more absurd and abject lovemaking upon Modot's return, but the role of the statue ends here, with several increasingly close-up shots of the big toe of her unfeeling foot "fellated" by Lya Lys, with parallel cuts away to the concert, as well as a droll "reaction shot" to Diana's impassive idealized face and blank eyes. This perverse act has been interpreted along a number of lines, stemming principally from Sigmund Freud and Georges Bataille. "If eros works so impersonally, the choice of love object is indifferent," Dudley Andrew observes. "Like the Surrealist unconscious, eros passes through those who stand in its path, like an overflow of electric current."[37] While Andrew focuses on the indifference of the object and the transference of erotic investment from one object to another, others focus on the fact that it is the statue's foot that attracts and distracts the frustrated lovers. According to Freud, the foot, of course, is one of the most common fetishes, objects necessary for sexual arousal in order to allay castration anxiety induced by the perception of the missing penis: of the female genital as wound.[38] One irony here is that a statue, although female, does not lack in the way a mortal female does; indeed a statue can be regarded as itself a fetish. Another is that, for Freud, the foot fetishist is implicitly male. Of course, there are perversions other than fetishism and we can trust Buñuel and Dalí to entertain these. They have already by this point in the film showcased coprophilia and various oral, sadistic, and onanistic propensities. Agalmatophilia, a sexual attraction to statues, may be extremely rare in the clinical sphere but has a robust legacy in literature and the other arts, where it can stand for ekphrastic passions as well as psychosexual ones.[39] Indeed, as is discussed in the introduction, agalmatophilia is an undercurrent in very many cinematic stagings of encounters between people and statues.

The particular investment in the foot of the sculpture, of course, recalls one of Freud's most influential essays on culture, "Delusion and Dream in Jensens's *Gradiva*," his 1907 analysis of Wilhelm Jensen's novella about a scholar who develops an obsessive and ultimately delusional fascination with an Antique bas-relief of a young woman walking. Norbert Hanold, a classic example of sublimation – his sexual energies are transferred to the study of archeology – is preoccupied with the unusual position of the figure's foot. While in the novella, and Freud's analysis, her unusual gait synecdochically

recalls Zoë Bertgang – the young woman, a childhood playmate, who resembles Gradiva (as Hanold calls his ancient stone love object), the memory of whom Hanold has repressed – the fascination with the foot and the sculpture conjures both foot fetishism (as Freud acknowledged) and agalmatophilia.[40] In the 1930s, Gradiva became not only an art gallery, but also a veritable muse, for Breton, Dalí, and other Surrealists.[41]

There is yet more, however, to foot fixations in the orbit of Buñuel and Dalí at the time of *L'Âge d'or.* The filmmakers had recently become acquainted with Georges Bataille, editor of a new journal, *Documents.* André Breton condemned this "dissident" surrealist, calling him an "excremental philosopher." Bataille praised transgressive, abject aspects of *Un Chien Andalou* and published an admiring analysis of Dalí's painting *Le Jeu lugubre* (*Lugubrious Game*), then in the Noailles collection. In those first issues of *Documents*, published during the very months *L'Âge d'or* was being prepared and filmed, Bataille was working out concepts related to his idea of base materialism, which illuminate much of the excessive imagery of the film. "For Bataille, human existence is a perpetual exchange between the spiritual and the material, between the high and the low, between garbage and the ideal," notes Allen Weiss regarding the essay "Le gros orteil" ("The Big Toe"); "the foot, the big toe, is the sign par excellence of material baseness." Pointing out, however, that a statue's foot – a cold, cultural artifact – is very different from that base, mortal part of the human body, Weiss concludes that the statue's foot is not a fetish object, but "the simulacrum of a fetish, a typically Surrealist conflation of the high and the low."[42]

A simulacrum of a fetish, neither its toe, nor its foot, nor the sculpture of Diana itself in fact bespeaks the uncanniness that I have claimed characterizes sculpture in Surrealist and surreal cinema. It is really the animate, living beings in *L'Âge d'or* who are uncanny. Deformed by desire, marked by abjection, compelled by a return of the repressed (psychosexual and antisocial urges), people are paradoxically familiar and unspeakably strange, while the statue remains unchanged. She is uncanny only in her muteness and immutability – inasmuch as she is treated sexually as an unmoved object of desire and cinematically as a frozen player in the scene – as a foil to *l'Amour fou.* So too, actually, in *Les Mystères du Château de Dé*, it was the veiled human countenances – people seemingly in the process of becoming sculpture – that were uncanny, and the disembodied film eye itself. The veritable sculptures – modernist works by Jacques Lipchitz and Henri Laurens – catalyzed the uncanniness of the narration and the lens; they were not themselves uncanny. Only in *Le Sang d'un poète* does a statue possess an uncanniness such as infuses legends and images of living statues going back to Pygmalion and beyond. In "the night of the human body," Cocteau uses cinematic magic to mimic

"the mechanism of the dream without sleeping," to construct "a descent into oneself."[43]

This somnambulistic current marks one of the primary legacies of surreal cinema in the coming decades: in Cocteau's own subsequent films – *L'eternel retour*, a 1943 film he wrote that was directed by Jean Delannoy, *La Belle et la bête* (1946), and *Orphée* (1950) – as well as the genre of American art cinema that comes to be known as the "trance film." But, as we shall see, if this oneiric journey inward expresses the project of psychodramas by Maya Deren and others, various aspects of the encounter between people and sculpture seen in Man Ray's and Buñuel's films are also to be found in films of the next generation, in Europe (Marcel Carné's 1942 *Les Visiteurs du soir*, for instance) and the USA.

Notes

1. The term "surrealism" (*surréalisme*) has had a wide range of applications. For our purposes, Surrealism and Surrealist (with the capital "S") will refer to the historical movement, while (lower-case) surreal connotes the more diffuse meaning. Although Jean Cocteau's cinema – especially *Le Sang d'un poète* – has been widely regarded as surreal, it does not properly belong to Surrealism. Cocteau was not a member of the Surrealist group and did not adhere to its principles or objectives. Distinguishing between Surrealism – as well as the exceedingly varied artistic practices connected to it – and the "surreal," a word often used to denote visual strangeness or incongruity, Michael Richardson quite correctly insists that Surrealism neither is nor has a "style" (*Surrealism and Cinema*, Berg, 2006, 3). However, as others observe, Cocteau's films are "deeply marked by a surrealist uncanny" (Robert Short. *The Age of Gold: Surrealist Cinema*. Creation Books, 2003, 185). As the uncanny potential of sculpture is its common value in the Noialles films, and Cocteau's early film a major influence on an avant-garde tradition (the psychodrama or trance film, discussed in Chapter 5), I cautiously engage the more expansive terminology, especially as it signifies the common engagement of psychoanalytic concepts: the unconscious, dream logic, and the uncanny.
2. The bar that represents that of a Paris café is in fact the one that Djo-Bourgeois designed for the Villa Noailles. See Richard Becherer, "Chancing It in the Architecture of Surrealist Mise-en-Scène," *Modulus* 18 (1987): 62–87.
3. "Marie-Laure's maternal grandmother, the acid-witted Comtesse de Chevigné, born Laure de Sade, was the Marquis's great-granddaughter," according to Francine du Plessix Gray, "The Surrealists' Muse: Marie-Laure de Noailles's outrageous example." *The New Yorker* (September 24, 2007): <http://www. newyorker.com/magazine/2007/09/24/the-surrealists-muse> (last accessed March 14, 2017). On masquerade, see Efrat Tseëlon, ed. *Masquerade and Identities: Essays on Gender, Sexuality and Marginality* (Routledge, 2003).
4. Man Ray, *Self Portrait* (Boston: Little, Brown, 1988), 226.

5. André Breton, *Mad Love* (*L'Amour fou*), translated by Mary Ann Caws (Lincoln: University of Nebraska Press, 1987), 19.
6. Hal Foster, *Compulsive Beauty* (Cambridge, MA: MIT Press, 1993), 25.
7. Sigmund Freud, "The Uncanny" (1919), in *Studies in Parapsychology*, ed. Philip Rieff (New York: Macmillan/Collier, 1963).
8. Valerie Steele, "Fashion, Fetish, Fantasy," in Efrat Tseëlon (ed.), *Masquerade and Identities: Essays on Gender, Sexuality and Marginality*, (London: Routledge, 2003), 73–100.
9. Foster, 25.
10. See George Dodds, "Freedom from the Garden: Gabriel Guévrékian and a New Territory of Experience," in John Dixon Hunt and Michel Conan (eds.), *Tradition and Innovation in French Garden Art: Chapters of a New History* (Philadelphia: University of Pennsylvania Press, 2002), 187–8; and Jacques Lipchitz, *My Life in Sculpture*, with H. H. Arnason (New York: Viking, 1972), 96, where the artist relates, "because of the location and the problem of seeing the sculpture in the round, I suggested installing a machine so that it could rotate."
11. George Heard Hamilton, *Painting and Sculpture in Europe, 1880–1940* (New Haven: Yale University Press, 1993), 277.
12. Imogen Racz, *Henri Laurens and the Parisian Avant-Garde*, Ph.D. dissertation (University of Newcastle, 2000), 173; <https://theses.ncl.ac.uk/dspace/bit stream/10443/425/1/Racz00.pdf.> (last accessed March 14, 2017).
13. Anisabelle Berès *et al.*, *Henri Laurens, 1885–1954* (Paris: Galerie Berès, 2004), 130.
14. Kim Knowles, "From Mallarmé to Mallet-Stevens: Reading Architectural Space in Man Ray's *Les Mystères du château de dé*," *French Studies* 65, 4 (2011): 470.
15. Kenneth Gross, *The Dream of the Moving Statue* (University Park: Pennsylvania State University Press, 2006), xi–xii.
16. A shot of "the author, masked except for his eyes, holding a plaster hand in his hand, this real hand and the wrist of the other covered by draped cloth, announces that the film is beginning, against a background of studio lamps." Jean Cocteau, *Two Screenplays*, translated by Carol Martin-Sperry (Baltimore: Penguin, 1968), 9.
17. Cocteau, 1968, 65.
18. Cocteau 1968, 18.
19. P. Adams Sitney, *Visionary Film: The American Avant-Garde, 1943–2000* (3rd ed.) (Oxford University Press, 2002), 29.
20. The star, which appeared on the poet's shoulder at the outset of the film and as a leitmotif throughout, is "Cocteau's 'trademark' stylistic mark that also adorns the body of many of his works." Daniel Gercke, "Ruin, Style and Fetish: The Corpus of Jean Cocteau," *Nottingham French Studies* 32, 1 (March 1993), 11.
21. Cocteau 1968, 63.
22. This iconography suggests that if the statue represents a muse, she is a hybrid one, as the cithera – a lyre-like instrument – symbolizes Erato, the muse of lyric poetry, while the globe is one of the symbols of Urania, the muse of astronomy.
23. Cocteau, 1968, 60.

24. Gross, 17.

25. Theodore Ziolkowski, *Disenchanted Images: A Literary Iconology* (Princeton: Princeton University Press, 1977), 233.

26. See Foster, *Compulsive Beauty* and David Hopkins, "Re-enchantment: Surrealist Discourses of Childhood, Hermeticism, and the Outmoded," in *A Companion to Dada and Surrealism* (John Wiley, 2016).

27. Surrealist contempt for Cocteau was certainly not evenly shared. Breton, a notorious homophobe, may have demanded it but there is considerable evidence of mutual artistic influence, social exchange and support in the rarified circles of the Parisian avant-garde at this time.

28. Linda Williams, *Figures of Desire: A Theory and Analysis of Surrealist Film* (Berkeley: University of California Press, 1981), 116.

29. Already during production and the notorious immediate aftermath of *L'Âge d'or*, Buñuel and Dalí's relationship was coming to its bitter end, over the Aragon affair and other political as well as personal differences. Paul Hammond, *L'Âge d'or* (London: BFI, 1997), 67.

30. Hammond, 28.

31. Julia Pine, "Breaking Dalinian Bread: On Consuming the Anthropomorphic, Performative, Ferocious, and Eucharistic Loaves of Salvador Dalí," University of Rochester, 2010; <http://www.rochester.edu/in_visible_culture/Issue_14/pine/> (last accessed May 29, 2015).

32. Salvador Dalí, *Dalí* (New York: The Bignou Gallery, 1945), n.p.

33. Studios de Billancourt and Studios de la Tobis, according to Hammond, 72.

34. See Simon Baker, *Surrealism, History and Revolution* (Oxford: Peter Lang, 2007), 147–230.

35. Paul Hammond is probably responsible for the proliferation of this misidentification. "A statue of Venus, the Roman goddess of love, presides over their farcical and prolonged coitus interruptus," he claims in his BFI monograph on *L'Âge d'or*, 47.

36. On the Diana, see Francis Francis and Nicholas Penny, *Taste and the Antique: The Lure of Classical Sculpture, 1500–1900* (New Haven: Yale University Press, 1981), 198–9. A version of the Diana also briefly appears in Cocteau's *Orphée* (1950). I am indebted to Linda Phipps for help in identifying the statue.

37. Dudley Andrew, "L'Âge d'or and the Eroticism of the Spirit," in Ted Perry (ed.), *Masterpieces of Modernist Cinema* (Bloomington: Indiana University Press, 2006), 119.

38. Sigmund Freud, "Fetishism" (1927), in Philip Rieff (ed.), *Sexuality and the Psychology of Love*" (New York: Macmillan/Collier, 1963), 214–19.

39. Murray J. White, "The Statue Syndrome: Perversion? Fantasy? Anecdote?," *The Journal of Sex Research* 14, 4 (November 1978), 246–9.

40. Sigmund Freud, *Delusion and Dream and Other Essays*, ed. Philip Rieff (Boston: Beacon Press, 1956).

41. Dalí is said to have used "Gradiva" as a nickname for his wife Gala, his relationship with whom had just begun during the summer of 1929 (she was

married to his friend Paul Éluard) at the time of work on *L'Âge d'or*. See Dawn Ades and Michael Taylor, *Dali* (Philadelphia Museum of Art, 2004), 479.

42. Allen Weiss, "Between the Sign of the Scorpion and the Sign of the Cross: *L'Âge d'or*," in Rudolf E. Kuenzli (ed.), *Dada and Surrealist Film* (New York: Willis, Locker & Owens, 1987), 166.

43. Jean Cocteau, *The Difficulty of Being*, trans. Elizabeth Sprigge (New York: Da Capo Press, 1995), 48.

Carving Cameras on Thorvaldsen and Rodin: Mid-Twentieth-Century Documentaries on Sculpture

STEVEN JACOBS

"An object in space is a better proposition for a film on art than a two-dimensional work like a painting, an illuminated manuscript, or a goblin,"[1] Josef Paul Hodin wrote in his review of *Looking at Sculpture* (Alexander Shaw, 1949), a film focusing on statues in the Victoria and Albert Museum. Indeed, cinema has consistently been presented as the perfect instrument with which to document sculpture. "Short of a field trip, the best way to teach sculpture is with cinematic visual aids," Sally Chappell wrote in 1973:

> The flow of images and the inherent motion of changing camera distance and angle simulate the live three-dimensional experience of sculpture better than a series of front, side, and back view slide reproductions. The cinema can also reproduce the movement of light, so important in rendering the material of sculpture – the shifting reflections in Brancusi's metals, for example, or the glowing transparencies in Pevsner's plastics.[2]

Given this perspective, it is not a coincidence that the earliest examples of "art films," which date from the first two decades of the twentieth century, had monuments and public sculptures as their subject. While often being actualities showing inaugurations of public statues, many of these films focus on the social event of the ceremony rather than the sculptures themselves, but some films did give attention to the plastic qualities of the sculptures in natural light.[3] While a cinematic reproduction of a painting seemed useless or redundant, the medium of film was considered perfect for visualizing three-dimensional artworks, which necessitate a moving approach to grasp their different angles and spatial dimension. Likewise, German art film pioneer Hans Cürlis, who founded the *Institut für Kulturforschung* in 1919 in order to develop and propagate film as a mediator for art, considered paintings highly "unfilmic."[4] Throughout the 1920s, Cürlis made several films that consist of static shots of sculptures rotating on their axis, grouped under titles such as "Heads," "Negro Sculpture," "Old-German Madonnas," "German Saints," "Kleinplastik," "Indian Crafts," or "East-Asian Crafts." Other landmark

art documentaries produced before the Second World War also focused on sculpture. *Steinerne Wunder von Naumburg* (*Stone Wonders of Naumburg*) (1935) by Rudolph Bamberger and Curt Oertel has been described as the first film "that suggested the possibility of granting an art experience through the medium of motion picture," as verbal information is restricted to a minimum and the film first and foremost delivers its message visually with the help of a highly mobile camera.[5] Instead of elaborating on the cathedral and its history, the film resolutely focuses on the visual exploration of the building and its sculpture.

A few years later, Oertel made *Michelangelo: Das Leben eines Titanen* (1940), another milestone art film. The film tells the story of the dramatic life of Michelangelo simply by showing a succession of locations and artworks, without actors. With the help of sound effects, skillful lighting, and impressive (often subjective) camera movements, Oertel turned the contemplation of art into a thrilling cinematic experience. In addition, he succeeded in evoking the plasticity of Michelangelo's sculptures and the texture of their marble surfaces. In 1950, the film was recut under the supervision of Robert Flaherty and Robert Snyder and rereleased as *The Titan*, consecutively winning the Academy Award for Best Documentary Feature.

The involvement of a major director such as Flaherty in the production of an art documentary and its critical acclaim indicate the blossoming of the genre of the art documentary, both qualitatively and quantitatively, in the 1940s and 1950s.[6] Many art documentaries of that era can rather be described as experimental shorts, marked by a highly poetic and subjective approach. They eschew any didacticism and they are first and foremost visual essays focusing on the formal characteristics of the artworks or on the ways these artworks interact with their beholders. Mostly shown in art museums and ciné-clubs, these art documentaries are in fact essay films; they are far more personal, experimental, and reflexive than many later documentary films on art mostly made for television.[7] Landmark 1940s art documentaries by Luciano Emmer, Alain Resnais, Henri Storck, and Paul Haesaerts play self-consciously on the shifts between two and three dimensions, stasis and movement, and the artificial and the real. Filming paintings and sculptures was not only part of an investigation of these traditional media; it was also a means to explore the cinema itself.

The 1940s and 1950s saw a veritable wave of documentaries on sculpture. Apart from the aforementioned *The Titan*, the most interesting examples include *Aristide Maillol, sculpteur* (Jean Lods, 1943), *Alexander Calder: Sculpture and Constructions* (Hartley Productions for MoMA, 1944), *Visual Variations on Noguchi* (Marie Menken, 1945), *Looking at Sculptures* (Alexander Shaw, 1949), *Forms in Space: The Art of Sculpture* (Sidney Lubow and Arthur Swerdloff,

1949), *Thorvaldsen* (Carl Theodor Dreyer, 1949), *Henry Moore* (John Read, 1951), *Les Pierres vives* (Fernand Marzelle, 1951), *Jacques Lipchitz* (Frank Stauffacher, 1951), *Works of Calder* (Herbert Matter, 1951), *Les Statues meurent aussi* (Alain Resnais and Chris Marker, 1953), *Figures in a Landscape* (Dudley Shaw Ashton, 1953), *The Gates of Hell* (Albert Elsen, 1954), *L'Enfer de Rodin* (Henri Alekan, 1957), *Gyromorphosis* (Hy Hirsch, 1958), and *A Sculptor's Landscape* (John Read, 1958). None of these films, with the exception of *Les Statues meurent aussi*, has received major critical or scholarly attention. This list comprises a wide variety of titles, ranging from didactic documentaries (Shaw, Lubow and Swerdloff) that attempt to explain the quintessence of sculpture, over artists' films (Menken, Hirsch) that use sculptures to create abstract visual studies, to poetic film essays by major filmmakers (Dreyer, Alekan, Resnais and Marker). Arguably coming closest to the format of the essay film is *Les Statues meurent aussi* (*Statues Also Die*) by Resnais and Marker. Dealing with African art and expressing vehement criticism of colonial politics, this famous film is marked by the self-reflexivity characteristic of essay films. As Resnais and Marker focus on the sculptures' eyes, on beholders looking, and on practices of museum display, the film is a meditation on the cinematic gaze and how it visualizes or represents sculptures. In so doing, the film definitely reflects on the encounter between film and sculpture. This dimension also marks other documentaries made in the 1940s and 1950s, and the following paragraphs of this chapter focus on two exquisite examples, Dreyer's *Thorvaldsen* and Alekan's *L'Enfer de Rodin*, to examine this paradigm.

DREYER AND THORVALDSEN

Thorvaldsen (1949) is a film by the Danish director Carl Theodor Dreyer, who also directed several feature films in which a statue plays an important part. Situated in the art world, his early masterpiece *Michael* (1924) comprises a remarkable scene in which a statuette of a female nude embodies the erotic desires of the main characters.[8] In *Gertrud* (1964), his very last film, Dreyer uses frame compositions to situate characters near sculptures that express or inform on their state of mind – in the scenes in the park, for instance, Gertrud and her young lover are in the vicinity of a copy of the Medici Venus. In addition, the stasis and long-take aesthetics of Dreyer's later works are worked into a series of tableaux vivants that give the characters a statuary presence.[9] His films play on a certain monumentality of the human figure, that is fixed. In so doing, the characters in *Gertrud* can be compared with the sculptures that Dreyer filmed for *Thorvaldsen* and of which he wrote: "I liked it. The statues couldn't object to anything I wanted to do. No protest."[10]

 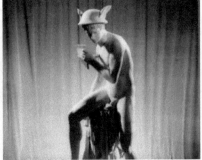

Figures 3.1 and 3.2 Thorvaldsen *(Carl Theodor Dreyer, 1949) – Digital Stills.*

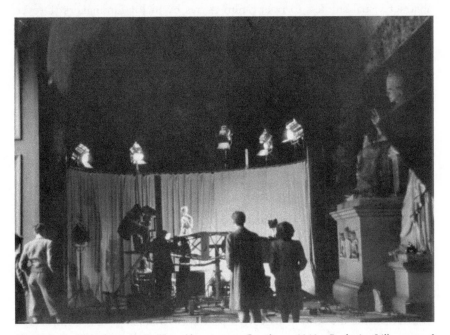

Figure 3.3 *Dreyer filming in the Thorvaldsen museum, Copenhagen, 1949 – Production Still, courtesy of the Danish Film Institute.*

Thorvaldsen was part of a series of shorts that Dreyer dedicated to Denmark's cultural heritage, including films on traditional Danish church architecture, the Stostrom bridge, and the castle of Kronborg.[11] The film *Thorvaldsen* deals with Bertel Thorvaldsen (1770–1844), one of the most important Danish artists and a key figure of European neo-classicism. The oeuvre of this Danish sculptor was considered a model of sculptural perfection until late in the nineteenth century. Moreover, Thorvaldsen had always been interested in the display of his sculptures. He worked in Rome

in the early nineteenth century, his studio with original plaster sculptures becoming a veritable place of pilgrimage for prominent travelers and young artists.

The trigger for the production of the Thorvaldsen film was the centennial of the Thorvaldsen museum in Copenhagen, which had opened in 1848, only a few years after the artist's death in 1844. Apart from the sculpture group of Christ and the Apostles, which was filmed in situ in the Copenhagen cathedral, the film was entirely shot in the premises of the Thorvaldsen museum. Designed by Michael Gottlieb Bindesboll, the museum stages every statue in a masterful way, utilizing, among other things, its stained glass windows that project spotlight-like effects. Dreyer, however, filmed only Thorvaldsen's wall-mounted reliefs on their original location in the various rooms of the museum. The free-standing sculptures, which had not been moved since the museum's opening, were taken from their pedestals and filmed in the grand hall. While the museum is rather characterized by a compact display, in the film the sculptures are isolated against a gray curtain – a practice in line with neo-classicist ideas on sculpture that favor the clear legibility of closed forms over the complex spatial interactions of baroque art. The new display also enabled Dreyer to carefully light the sculptures in a way reminiscent of the skillful treatment of light in many of his other films. In his documentary on Thorvaldsen, Dreyer demonstrates that the manipulation of light is a perfect tool with which to render relief and texture and therefore to evoke a sense of touch. In several passages of the film, Dreyer alternates between a haptic visuality and an optic one. Master shots showing the entire statue are followed by extreme close-ups that focus on its material qualities. As Claire Thomson noted, Dreyer's film on Thorvaldsen does not attempt to recreate the usual museum experience; instead it appeals to the desire of beholders to touch marble and plaster. This desire is aroused, in the institutional context of the museum, by the prohibition on touching artworks. Unfortunately, Dreyer's film shows that film cannot satisfy this longing by merely substituting the camera eye for the feeling hand.[12] Dreyer's preoccupation with tactility partly contradicts Thorvaldsen, who was precisely criticized because of the "cool character" of his white sculptures, which seem to lack texture. With their polished surfaces, Thorvaldsen's plaster sculptures seem to impede any haptic experience.[13] His human figures consequently seem completely stilled and immobilized. His cool nudes unmistakably resonate with the figures of late Surrealism of the 1930s and 1940s, as can be found in the paintings by Paul Delvaux or in *Le Sang d'un poète* (1932) by Jean Cocteau, discussed in the previous chapter. Indeed, the voiceover in Dreyer's film underlines the surreal dimension of these figures when it states that several works by Thorvaldsen seem to originate from a dream. To Dreyer, Thorvaldsen was

not a mere creator of cool statues, he was also melancholic. Although his works do not evoke the sensuality of, for instance, the sculptures of Antonio Canova (a contemporaneous sculptor whose work was regularly compared to Thorvaldsen's), for the Danish filmmaker they give off an introverted intimacy. This aspect came more to the fore, according to Claire Thomson, in the original scenario, which was drastically abbreviated by the producer Dansk Kulturfilm.[14] Dreyer's opinions on Thorvaldsen's sculptures contradict the judgments of many art critics, but are in line with the ideas of art historians such as H. W. Janson, who noted that Thorvaldsen's severe Greek style was combined with an interest in sentiments and religious feelings that can also be found among the painters of the contemporaneous Nazarene movement.[15]

For Dreyer, this religious and sentimental dimension was perfectly expressed in the rhythm and dynamism of the compositions and postures of Thorvaldsen's statues. Dreyer emphasized the complex design by literally setting the statues in motion on a rotating platform. In so doing, he contradicts Thorvaldsen's neo-classicist aesthetics, which precisely privileged a single specific viewpoint and abolished the baroque idea that a sculpture should be seen from multiple perspectives. What's more, Dreyer combined the rotating pedestal with cinematic forms of motion, resulting in a complex interplay of moves. Sometimes a static camera registers a sculpture on a rotating pedestal. In other instances, Dreyer combines the rotating sculpture with vertical camera movements, forward tracking shots, or smooth overlap dissolves. The camera movements first and foremost emphasize the silhouette of the statues and thus their postures. This tallies with a characteristic of Thorvaldsen's sculptures noted by the voiceover commentary: in Thorvaldsen's oeuvre, emotions are evoked by the postures and suggested movements of his figures rather than by their facial expressions. In contrast with the famous scene in Roberto Rossellini's *Viaggio in Italia* (1953), discussed in Chapter 6, in which a highly mobile camera turns around the static sculptures, Dreyer seems to derive the movement from the sculptures themselves – although Thorvaldsen's statues in fact look much more serene than the sensual Hellenist nudes in Rossellini's film.

ALEKAN AND RODIN

The relation between sculpture, light, and motion is also important in Henri Alekan's *L'Enfer de Rodin* or *The Hell of Rodin*, a fourteen-minute film on the works of the famous sculptor Auguste Rodin (1840–1917). Before the film's release in 1957, Alekan had already established himself as one of the great cinematographers of film history. Having started his career

as a camera operator in the early 1930s, Alekan assisted Eugen Schüfftan while the latter was working on the photography of Marcel Carné's films. Later, Alekan worked as a cinematographer with leading directors such as Jean Cocteau, Julien Duvivier, Abel Gance, Joseph Losey, and William Wyler. Schüfftan's non-naturalist approach also characterized Alekan's own camera style, which was unmistakably marked by German expressionism.[16] Skillful and subtle mastery of light is his signature style – Pierre-Alexandre Schwab calls Alekan a veritable "goldsmith of light."[17] The cinematic handling of light is also the focus of Alekan's *Des Lumières et des ombres* (1996), his book on light in cinema and painting.[18] Illustrated by dozens of reproductions of paintings and film stills, this book reconstructs forms and associations of sunlight, nocturnal light, and many variations of artificial illumination, as well as their representations or evocations in painting and cinema. It comes as no surprise, then, that light also plays an important part in the cinematic exploration of Rodin's sculptures. Strikingly, with films such as *La Belle et la bête* (Jean Cocteau, 1946) and *Der Himmel über Berlin* (Wim Wenders, 1982), Alekan worked on several feature films in which sculptures play a major part. In addition, Alekan, as a director, dedicated one other film to a famous statue: almost thirty years after *L'Enfer de Rodin*, he made *La Petite danseuse de quatorze ans d'Edgar Degas* (1986) focusing on the eponymous 1881 sculpture by Degas of a young student from the Paris Opera Ballet dance school.[19]

The title of *L'Enfer de Rodin* refers to Rodin's magnum opus, the so-called *La Porte de l'enfer* or *The Gates of Hell*, which the sculptor developed from the early 1880s until his death in 1917.[20] Inspired by Dante's *Divina Commedia*, this group of statues is conceived as part of a monumental door of a never-realized Museum of Decorative Arts in Paris. Many of the approximately 180 figures of the door were further developed and enlarged, and became famous works in their own right, such as *The Thinker*, *The Kiss*, *Fugit Amor*, *Paolo and Francesca*, *Meditation*, and *Eternal Springtime*. Showing dozens of Rodin's statues, Alekan's film is vaguely structured around a gradual shift in theme and tone. While the first minutes of the film are dedicated to the theme of life, expressed by images of sensuality, joy, and passion, the latter part of the film focuses on death, with evocations of pain, degeneration, and old age. In a press release for the film, Alekan states that the film "animates the world of Rodin in function of the two principal sources of inspiration of the sculptor: Love and Pain."[21] Alekan divides *L'Enfer de Rodin* into four parts: a prelude entitled "The Creation," two sections respectively entitled "Love and Human Passions" and "Fall and Descent to Hell," and a coda called "Finale: Hymn to Life."[22]

Right at the beginning of the film, Alekan states his ambition in a title insert: "This film wants to illustrate the meeting of two dreams, the one

of Dante and the one of Rodin." The next shot shows another title insert with a Rodin quotation: "Life, that wonder." About eight minutes into the film, Alekan inserts a famous quotation from Dante: "You who enter, leave all hope behind." These three textual inserts are the sole elements of verbal information offered in this film, which further consists only of a visual exploration of Rodin's works. Lacking the explicatory voiceover commentary characteristic of many art documentaries, the film, in the words of Alekan, "does not attempt to be a classical documentary on Rodin's oeuvre. It pretends to affect rather than to explain or describe. Eschewing every didacticism, it attempts, by means of the intimate fusion of music and image, to relapse the viewer into the poignant emotion coming from Rodin's oeuvre."[23] The film consists entirely of shots showing Rodin statues or details of them. Most of the approximately 120 shots succeed one another by means of straight cuts; only occasionally are overlap-dissolves used. However, the transitions between the shots are usually fluent thanks to a complex interplay of movements – a vast majority of the film's images are forward and backward tracking shots of rotating sculptures. Apart from the bravura camera work done by Alekan himself in collaboration with Billy Villerbue and Raymond Menvielle, the film is also remarkable because of its use of light. In Alekan's film, Rodin's works of plaster, marble, and bronze are not only rendered as three-dimensional volumes interacting with the surrounding space: the changing or shifting light also mobilizes or animates the statues. In addition, a wide variety of chiaroscuro effects present the sculptures of cramped, tormented, or intertwined bodies as part of Dante's infernal vision. Last but not least, Rodin's statues are animated by Jacques Lasry's score, performed by the composer himself together with Yvonne Lasry playing on instruments developed by the Baschet brothers, who created many sound sculptures and invented various experimental musical instruments in the 1950s. Since the visually striking Baschet instruments were crafted out of steel and aluminum and amplified by large curved conical sheets of metal, it is appropriate to state that this film on sculpture was accompanied by music produced by sculptural instruments.[24]

CINEMATIC RODIN

Rodin was one of the first major artists registered by the film camera in *Ceux de chez nous* (1915) by Sacha Guitry, and indeed, his art is perfectly suited to photographic and cinematic reproduction. First of all, as Rosalind Krauss has demonstrated, Rodin accepted the modern logics of reproduction and multiplicity.[25] Of many of his works, Rodin made several plasters (which are casts and thus copies themselves) and he was hardly interested or involved

Figures 3.4 to 3.7 L'Enfer de Rodin *(Henri Alekan, 1957) – Digital Stills.*

in the personal execution of bronze copies of his works. The conflation between original and copy is particularly telling in the case of *The Gates of Hell* since all existing casts of the doors are "examples of multiple copies that exist in the absence of an original."[26] Moreover, several of the sculptures that are part of *The Gates of Hell*, such as *Two Dancers* or *Three Nymphs*, are made of two or three identical casts of the very same model. In addition, in many other instances, the same figure is "compulsively repeated, repositioned, recoupled, recombined."[27] Alekan draws attention to this. He not only films statue groups such as the aforementioned *Three Nymphs* or *Two Dancers*, but he also emphasizes that cinema adds to the logic of doubling. A statue is emphatically shown together with its shadow, for instance. Or the camera pans hectically from right to left and back again between two versions of the same figure. Or a split screen reveals the same figure or two similar figures rotating in opposite directions.

Apart from its uncomplicated way of dealing with reproduction and doubling, Rodin's oeuvre also relates to photographic and cinematic representation in other ways. As Rosalind Krauss has noted, "in its final version *The Gates of Hell* resists all attempts to be read as a coherent narrative" and many of its figures "are intentionally fragmented and necessarily

incomplete . . . For the first time, in the *Gates*, a relief ground acts to segment the figures it carries, to present them as literally truncated, to disallow them the fiction of a virtual space in which they can appear to expand."[28] Alekan, clearly, plays upon this, using film's capacity to fragment objects and to disconnect them from their spatial surroundings. Furthermore, Rodin's works are perfectly fit for film because, as most if not all of Rodin's critics have noted, they seem to evoke movement. The suggestion of movement of stable forms as well as the animation of inanimate matter is a key topic in the famous interpretations of Rodin's work by prominent critics such as Rainer Maria Rilke and Georg Simmel, who both presented Rodin as the exemplary modern artist. Simmel emphasized Rodin's unclassical sense of movement as well as the apparently "unsculptural" dissolution of fixed substance in a fluidity of form. This fluidity, for Simmel, was the result of an inner psychological apprehension of things. As a result, for Simmel, Rodin's art perfectly evoked the split between a purely sensual apprehension of materials on the one hand and the image as a symbol of expression of modern subjectivity on the other.[29] Rilke, too, noted how Rodin's statues seem to dissolve their fixity and boundedness.[30] Rilke remarked how the surfaces of Rodin's statues seemed to break out beyond their literal boundaries to penetrate the surrounding space – a feature that would become a key element in many accounts and theories of modernist sculpture. Furthermore, Rodin is often interpreted as an artist who introduced into sculpture innovations inherently linked to the novel optical paradigms of photography and film. Not only did he attempt to implement temporality in the art of sculpture but his work also has often been presented as a redefinition of sculpture in a world that was increasingly fragmented by speed and movement.[31] Movement, in Rodin's work, was closely connected to the ways in which certain irregular textures of surfaces create subtle effects of light. The plasters and bronzes in particular directly transfer the crudities of the clay model and show surfaces marked by degrees of sheen, flicker of light, and pools of shadow. László Moholy-Nagy noted that "Rodin, with an ingenious chisel-cut, introduced transparent shadows and soft contours which made his sculptures appear ethereally light."[32] These surface renderings and the play of light were particularly important for the activation of the viewer's response to Rodin's sculpture – something the artist consciously played upon as he recognized the importance of artificial light for the presentation of his sculptures.

That Rodin was well aware of these aspects of his work is evident in the photographs he ordered of his sculptures.[33] He used photography extensively as "he recognized the importance of the image, especially since, in this period, photography was replacing the drawn image as the regular method of art reproduction."[34] The medium of photography particularly inspired him to

reconstruct his statues in fragmentary ways and to reconceptualize the rela-
tion between sculpture and movement. Instead of capturing one specific
segment of a movement, Rodin tried to catch a complete movement into a
single stable form. Rodin's understanding of the specific nature of the pho-
tography of sculptures was undoubtedly stimulated by his intense collabora-
tion with several leading photographers. In the 1890s, Eugène Druet made
a series of photographs of Rodin sculptures in changing light conditions, at
different moments in a single day, or from slightly shifting camera positions.
These photographs not only make us aware of the mobile perspective imple-
mented in these sculptures, but also point at the ways a statue's appearance
changes dramatically under varying light conditions. Shortly after the turn
of the twentieth century, several sculptures by Rodin were photographed
by preeminent pictorialist photographers such as Gertrude Käsebier, Alvin
Langdon Coburn, and Edward Steichen. In their images, Rodin's sculptures
seem to dissolve into atmospheric effects of light and tones of gray.

In a way reminiscent of these photographic experiments, Alekan some-
times only shows the silhouette of a figure or confuses our look at a sculpture
with its shadow. At other moments in the film, flashes of light evoke infernal
lightning bolts. As Alekan describes extensively in *Des Lumières et des ombres*,
both natural and artificial light in film not only visualize the varied texture of
uneven surfaces, they also create volume and depth. For Alekan, light in film
first and foremost contributes to the formation of a plastic language, creating
a "cineplastic atmosphere."[35] In addition, light is an inherent component of
the composition of the cinematic image. It organizes the architectural struc-
ture of the shots and it directs and guides the gaze of the viewer. In many
scenes, Alekan places Rodin's figures in an indistinct space against a bright
or dark background. Both the light and the framing often obfuscate a clear
distinction between foreground and background or a correct sense of scale.
In line with the pictures by Steichen and other pictorialists Alekan uses light
and shadow effects abundantly, thereby dissolving the sculptural forms into
shadowy shapes.

Not coincidentally, Alekan's book on *Des Lumières et des ombres* includes
a still of *L'Enfer de Rodin* in its chapter on the "Dynamism of Light."[36] In
that chapter, Alekan emphasizes that the passing of shades and lights and
the change of contrasts, densities, and surfaces are able to create feelings.
Moreover, the movement of light not only enables a filmmaker to modulate
space and actions, but also evokes the passing of time. In addition, Alekan
notes, the movement in particular of artificial light creates "surnatural"
effects.[37] In a 1981 interview, Alekan states that in all of his films, "it is not
the truth of light that I am looking for, it is the revelation of sentiments. In
other words, I am in favor of an interpreted light . . . One can play not only

with natural light but also with a surnatural light, rethinking it, remodeling it to add something to it."[38] This "surnatural" dimension of light is, of course, perfectly suited for his evocation of Dante's *Inferno* by means of an uncanny animation of static figures of clay, plaster, bronze, or marble.

In Alekan's film on Rodin, statues are animated not only by light but also by all kinds of movement. The film presents itself as a complex puzzle of forward and backward tracking shots, sometimes gentle and at other times dramatic camera movements, hectic panning shots jumping back and forth between two sculptures, split screens of two figures rotating in opposite directions, images of heads loosely wobbling on torsos, and hanging, spinning, falling, or floating bodies without base. Some contemporary critics judged Alekan's bravura camerawork excessive. For Beatrice Farwell, "sculpture and architecture, unlike painting, do not necessarily fight with the film medium. There are many good sculpture films, but sometimes filmmakers go overboard with the movement suggested by sculpture. A case in point is the tasteless swimming and whirling of the works of Rodin on film."[39] Nonetheless, all cinematic devices used by Alekan result in a feeling of spatial disorientation and weightlessness, which is completely in line with the works of Rodin, who, as many critics remarked, had a predilection for falling figures or figures that seem to "lean" on an invisible space – particularly in the case of the works of the *Porte de l'Enfer*.[40] On more than one occasion in the film, Rodin's sculptures are turned into free-floating shapes that are only vaguely connected. Throughout the entire film, not a single long shot of *The Gates of Hell* is to be seen. Alekan's fragmentary approach, however, tallies perfectly with *The Gates of Hell* itself since many of its torsos and figures were torn from their context, enlarged, and transformed into free-standing sculptures. As a result, Rodin's figures, in the words of Alex Potts, "ceased to be motifs in a cosmic drama and became isolated objects displayed in the empty space of the studio or gallery."[41]

At the time of Rodin's death, *The Gates of Hell* stood in his studio "like a mammoth plaster chessboard with all the pieces removed and scattered on the floor."[42] Moreover, the figures were even too numerous to fit into the frame and wings of *The Gates of Hell*. Without showing *The Gates of Hell* in their entirety, Alekan unites the scattered pieces again by means of the medium of cinema. Rodin's swarm of figures and profusion of bodies are integrated in a greater context – that of a cinematic evocation of Dante's *Inferno*. In so doing, *L'Enfer de Rodin* is as much a film about Dante's vision as it is one about the art of Rodin. Alekan himself said that he produced the film like a "ballet-film" instead of a documentary.[43] He simply took Rodin's works and Lasry's music as his inspiration for a film marked by movement and light. Nonetheless, Alekan's film perfectly illuminates the specificities of Rodin's sculptural art:

its fragmentary nature, the way it deals with light and movement. These characteristics are preeminently "cinematic" and are therefore the perfect ingredients for a "sculptural film."

ROTATION, LIGHT, AND THE OPTICAL DILUTION OF SCULPTURE

Dreyer and Alekan play on the contrast between stable sculptural forms and the elusiveness and dynamics of the film medium. In their films on Thorvaldsen and Rodin respectively, they introduce movement in front of the camera using rotating pedestals. This not only refers to the revolving base in a sculptor's studio at the time of creation, but also to nineteenth-century exhibition practices.[44] Throughout the nineteenth century, sculptures by contemporaries of Thorvaldsen such as Antonio Canova or Johann Heinrich von Dannecker were displayed on revolving pedestals. Dannecker's *Ariadne on a Panther* (1812–14), for instance, was installed on a rotating pedestal at the Bethmann museum in Frankfurt.[45] Canova even used rotating platforms to make motion an integral part of many of his compositions. The inherent "balletic quality" of his famous statue of the *Three Graces* (1817) must have been enhanced when the group was turned despite the fact it favors a frontal view.[46] In the later nineteenth century, the practice became more important and world exhibitions as well as major museums such as the Louvre used rotating platforms in sculpture displays.[47] In addition, theatrical displays of tableaux vivants also frequently involved the use of rotating platforms.

In the cinematic exploration of sculpture, rotating pedestals have been used earlier by the aforementioned Hans Cürlis, who, in the 1920s, produced a series of films consisting of static shots of about fifty sculptures.[48] Filmed in natural light, each piece of sculpture was placed on a pedestal, which rotated slowly on its axis. As a result, the statue could be observed scrupulously as a fully three-dimensional object. Both Dreyer and Rodin used rotation to emphasize the three-dimensionality, materiality, and tactility of the sculptures but they took it one step further. Filming the rotating sculptures by means of forward and backward tracking shots, Dreyer and Alekan created a complex play of movement, transforming the sculptures into a cinematic experience.

Likewise, Dreyer and Alekan also use light to mobilize and transform the statues of Thorvaldsen and Rodin respectively. Also, their skillful handling of light can be linked to nineteenth-century exhibition practices. Dannecker's *Ariadne on a Panther* was not only put on a rotating pedestal: its marble surfaces were lit by a window of colored glass that variously tinted the sculpture rose, pink, or purple and offered the illusion of human flesh. Intriguingly, Thorvaldsen's and particularly Alekan's light effects also evoke a much

older praxis of looking at statues in sculpture galleries or ruins at night with torchlights, which was particularly popular in the late eighteenth and early nineteenth centuries.[49] Rodin himself loved to contemplate his sculpture at night in flickering candlelight and guided visitors with a lamp to show off his creations in surprising ways.[50] The effect is almost proto-cinematic – something that Sergei Eisenstein was aware of, as indicated in his descriptions of nocturnal museum visits. In his memoirs, Eisenstein wrote that "museums are at their best at night when there can be a merging with the display, rather than simply a viewing."[51] He also mentions that during the filming of *October* (1927), the Greek statues in the Hermitage seemed "to come alive and float in the blue gloom."[52] In addition, he recalls the animistic potential in his description of a 1931 nocturnal visit, equipped only with matches and a candle, to a museum that displayed statues of Mayan gods during the production of *Que viva Mexico!* (1932). As Ian Christie noted, Eisenstein is evoking the museum as "offering potentially . . . a pro-filmic animation of the inert."[53] As for Eisenstein, for Dreyer and Alekan film inherits and enhances the animistic qualities of sculpture.

By means of movement and light, Dreyer and Alekan transform the sculptures of Thorvaldsen and Rodin into a pure optical experience reminiscent of Moholy-Nagy's *Ein Lichtspiel: Schwarz Weiss Grau* (1930). Although Moholy-Nagy's film can be considered a "documentary" that describes his *Light/Space-Modulator* (1921–30), it is, rather, a cinematic extension or a transformation of the kinetic sculpture. Likewise, between 1923 and 1939, Constantin Brancusi made films of his sculptures, using framing, shadows, incident light, and refraction in order to activate the plastic properties of his sculptures.[54] Like Brancusi and Moholy-Nagy, Dreyer and Alekan illustrate how the boundaries between sculpture and film can be blurred, creating a new construction consisting of light, time, and space. Alekan in particular merges Rodin's sculptural volumes with their surrounding space. Masses and volumes seem to dissolve in a spatial continuum. By means of abstracting close-ups and an alternation between direct and indirect light, Alekan transposes Rodin's sculptures into a creation of light and shadow itself. *L'Enfer de Rodin* may be a documentary on Rodin's art and craft; it is definitely also an attempt to translate the aesthetic apprehension of Rodin's spatial, fragmentary, and undulating sculptures into the medium of film.

As David Getsy has demonstrated, discussions about the optical aspects of statues dominated the debates on modern sculpture in the 1950s, when Dreyer and Alekan made their films on Thorvaldsen and Rodin. This is clearly illustrated by the debate about the specificity of the medium of sculpture between the two leading Anglo-Saxon art critics of the day, Herbert Read and Clement Greenberg.[55] Cherishing a form of sculpture consisting of carved and

biomorphic forms (as exemplified by the art of Henry Moore), Read emphasized tactility and a sensitivity to physicality and weight. Read (whose son John made several seminal art films on Henry Moore in the 1950s) favored a haptic approach to sculpture. Having little to do with actual touching and fondling of works of art, this haptic approach was rather "a complex perceptual affair in which the visual aspects of form were coordinated with a relative sense of the object's physical traits such as weight, volume, and mass."[56]

Greenberg, by contrast, emphasized and appreciated opticality in sculpture. Preferring the combined and linear structures in the works of David Smith, Greenberg advocated that modern sculpture had precisely the task to "overcome its obdurate objecthood in order to offer a compelling visual experience."[57] For Greenberg, true modernist sculpture left behind its solidity, mass, gravity, and roundness. Consequently, in 1948 he argued that a modernist sculptural construction is "no longer a statue, but rather a *picture* in three-dimensional space."[58] Filmic representations of sculpture, of course, completely reset the conditions of such discussions. On the one hand, film transforms sculpture into pure optical phenomena. Even the heaviest and most solid volumes are turned into floating, airy shapes on the screen. Moreover, film disconnects the sculpture from the viewer; it gives to sculpture a kind of imaginative field quite apart from the viewing subject, that is akin to painting. On the other hand, film also enables us to "feel" the three-dimensionality, weight, and even texture of sculptures. What is more, with its possibility of changing or shifting points of view, film perfectly answers to what Alex Potts defines as a crucial feature of sculptural viewing: the "interplay between a relatively stable apprehension of the overall shape of a work and an unfixed close viewing of the modulations of form and play of light on the surface."[59] Film makes this "haptic" approach possible. Although a detailed discussion of "optic" and "haptic" forms of visuality falls outside the scope of this chapter, the distinction throws an interesting light on the encounter between sculpture and film. Inspired by the theories of Alois Riegl as well as Deleuze and Guattari, film scholars such as Vivian Sobchack, Laura Marks, and Jennifer Barker recognize haptics and texture as essential components of the film medium.[60] They have convincingly demonstrated that specific film practices are able to appeal to an intimate, embodied, and multisensory viewing. Both Dreyer's and Alekan's films on sculpture precisely play on this oscillation between haptic and optic models of visuality, echoing the opposition between the definitions of sculpture by Herbert Read and Clement Greenberg. Although unmistakably interested in the ephemeral qualities of light, Dreyer clearly emphasizes much more the solidity and gravity of Thorvaldsen's sculptural forms. To a certain extent Alekan does this as well, but he also uses movement and

light to "immaterialize" Rodin's sculptures, evoking more radical attempts to dissolve sculptural forms such as Moholy-Nagy's *Ein Lichtspiel* or Marie Menken's *Visual Variations on Noguchi*, in which the sculptures are transformed into a play of light and shadow. Both Dreyer and Alekan's films, no doubt, are still fascinating today because of their successful combination of optic and haptic modes of cinematically exploring sculptural surfaces.

Notes

1. J. P. Hodin, "Two English Films," *Films on Art* (Brussels/Paris: Les Arts Plastiques/Unesco, 1951), 22.
2. Sally A. Chappell, "Films on Sculpture," *Art Journal* 33, 2 (Winter 1973–4), 127–8.
3. See Valentine Robert, "L'histoire de l'art prise de vue," in Valentine Robert, Laurent Le Forestier, and François Albera (eds.), *Le film sur l'art: Entre histoire de l'art et documentaire de création* (Rennes: Presses universitaires de Rennes, 2015), 45; and Jens Thiele, *Das Kunstwerk im Film: Zur Problematik filmischer Präsentationsformen von Malerei und Grafik* (Bern/Frankfurt: Herbert Lang/Peter Lang, 1976), 14.
4. Thiele, *Kunstwerk im Film*, 15–18, 35–40, 45–54, and 302–9. See also Reiner Ziegler, *Kunst und Architektur im Kulturfilm 1919–1945* (Konstanz: UVK Verlaggesellschaft, 2003), 35–40, 45–54, and 302–9.
5. Arthur Knight, "A Short History of Art Films," in William McK. Chapman (ed.), *Films on Art 1952* (New York: The American Federation of Arts, 1953), 10. See also Ziegler, *Kunst und Architektur im Kulturfilm*, 290–1 and 315–17.
6. See Steven Jacobs, *Framing Pictures: Film and the Visual Arts* (Edinburgh: Edinburgh University Press, 2011), 1–37.
7. On essay films, see Phillip Lopate, "In Search of the Centaur: The Essay-Film," in Charles Warren (ed.), *Beyond Document: Essays on Nonfiction Film* (Wesleyan University Press, 1998), 243–70; Laura Rascaroli, *The Personal Camera: Subjective Cinema and the Essay Film* (London: Wallflower Press, 2009); and Timothy Corrigan, *The Essay Film: From Montaigne, After Marker* (New York: Oxford University Press, 2011).
8. Tom Milne, *The Cinema of Carl Dreyer* (London: Zwemmer, 1971), 72. See also David Heinemann, "Michael and Gertrud: Art and the Artist in the Films of Carl Theodor Dreyer," in Steven Allen and Laura Hubner (eds.), *Framing Film: Cinema and the Visual Arts* (Bristol: Intellect, 2012), 149–64.
9. Suzanne Liandrat-Guigues, *Cinéma et sculpture: Un Aspect de la modernité des années soixante* (Paris: L'Harmattan, 2002), 44–5.
10. Letter of Carl Theodor Dreyer quoted in Dale D. Drum, "Carl Dreyer's Shorts Were As Conscientiously Done as His Feature-Lengths," *Films in Review* (January 1969), 39.
11. Drum, "Carl Dreyer's Shorts," 34–41. On *Thorvaldsen* by Dreyer, see Charles Tesson, "Dreyer et la sculpture ou le corps interdit: *Thorvaldsen* (1949) de Carl Theodor Dreyer," in Michel Frizot and Dominique Païni (eds.), *Sculpter-*

Photographier: Actes du colloque organisé au Louvre (Paris: Marval, 1993), 121–31; Claire Thomson, "A Cinema of Dust: On the Ontology of the Image from Dreyer's Thorvaldsen to Ordrupgaard's Dreyer," presented at the symposium *Film and the Museum*, University of Stockholm, 2007, see http://discovery. ucl.ac.uk/4963/ (last accessed March 15, 2017); and Claire Thomson, "The Artist's Touch: Dreyer, Thorvaldsen, Venus," see <http://english.carlthdreyer. dk/AboutDreyer/Visual-style/The-Artists-Touch-Dreyer-Thorvaldsen-Venus. aspx> (last accessed March 15, 2017).

12. Thomson, "The Artist's Touch."

13. Thorvaldsen was known for the use of plaster – his work is typical for the late eighteenth and early nineteenth centuries, when plaster copies of classical sculptures became a veritable fashion and when plaster was considered to be the best material for original creations, since on this basis later copies in marble could be produced. See H. W. Janson, *Nineteenth-Century Sculpture* (London: Thames & Hudson, 1985), 10.

14. Thomson, "The Artist's Touch."

15. Janson, *Nineteenth-Century Sculpture*, 57.

16. "Entretien avec Jean Douchet," in Pierre-Alexandre Schwab, *Henri Alekan: L'Enfant des lumières* (Paris: Hermann éditeurs, 2012), 79.

17. Pierre-Alexandre Schwab, *Henri Alekan: L'Enfant des lumières* (Paris: Hermann éditeurs, 2012), 29–30.

18. Henri Alekan, *Des Lumières et des ombres* (Paris: Editions du collectionneur, 1996).

19. Henri Alekan, *Le Vécu et l'imaginaire: Chronique d'un homme d'images* (Paris: Source La Sirène, 1999), 126.

20. Albert E. Elsen, *The Gates of Hell by Auguste Rodin* (Stanford: Stanford University Press, 1985).

21. Press message (1 page) of the film released by Mondial Productions, Paris, dated 26 September 1963.

22. Press message (3 pages) of the film released by Mondial Productions, Paris, dated 28 October 1963, containing the director's rationale for the film.

23. Press message (1 page) of the film released by Mondial Productions, Paris, dated 26 September 1963.

24. Danièle Frauensohn and Michel Deneuve, *Bernard Baschet: Chercheur et sculpteur de sons* (Paris: L'Harmattan, 2007).

25. Rosalind Krauss, "The Originality of the Avant-Garde," in *The Originality of the Avant-Garde and Other Modernist Myths* (Cambridge, MA: MIT Press, 1986), 151–70. See also Joan Vita Miller (ed.), *The Sculpture of Auguste Rodin: Reductions and Enlargements* (New York: B. G. Cantor Sculpture Center, 1983).

26. Krauss, "The Originality of the Avant-Garde," 152.

27. Krauss, "The Originality of the Avant-Garde," 154.

28. Rosalind Krauss, *Passages in Modern Sculpture* (New York: Viking Press, 1977), 15 and 23.

29. Simmel's interpretation of sculpture in general and Rodin in particular can be found in "Über die dritte Dimension in der Kunst" (1906), in *Aufsätze und*

Abhandlungen 1901–1908 (Frankfurt am Main: Suhrkamp Verlag, 1993), II, 9–14; and "Rodin mit einer Vorbemerkung über Meunier" (1911), in *Philosophische Kultur: Gesammelte Essays* (Berlin: Kiepenheuer, 1983), 139–53.

30. Rilke wrote two essays on Rodin. The first is "Rodin's Plastik und die Geistesrichtung der Gegenwart" (1902). The second essay, "Rodin: Ein Vortrag" (1907), was originally conceived as a lecture. For an English translation of Rilke's two Rodin essays see Rainer Maria Rilke, *Rodin and Other Prose Pieces* (London: Quartet Books, 1986). See also Alex Potts, "Dolls and Things: The Reification and Disintegration of Sculpture in Rodin and Rilke," in John B. Onians (ed.), *Sight and Insight: Essays on Art and Culture in Honour of E. H. Gombrich at 85* (London: Phaidon, 1994), 354–78.

31. Rebecca Sheehan, "The Time of Sculpture: Film, Photography and Auguste Rodin," see <http://tlweb.latrobe.edu.au/humanities/screeningthepast/29/ film-photography-rodin.html> (last accessed March 15, 2017).

32. László Moholy-Nagy, *Vision in Motion* (Chicago: Paul Theobald, 1947), 226.

33. For Rodin and photography, see Hélène Pinet (ed.), *Rodin et la photographie* (Paris: Gallimard/Musée Rodin, 2007). See also Jon Wood, *Close Encounters: The Sculptor's Studio in the Age of the Camera* (Leeds: Henry Moore Institute, 2002), 14–15; and Roxana Marcoci, *The Original Copy: Photography and Sculpture, 1839 to Today* (New York: The Museum of Modern Art, 2010), 84–95.

34. Penelope Curtis, *Sculpture 1900–1945* (Oxford: Oxford University Press, 1999), 115.

35. Alekan, *Des Lumières et des ombres*, 64–83. Alekan, no doubt, knew that the concept of *cinéplastique* goes back to Faure in the 1920s. See Elie Faure, "De la cinéplastique" (1922), in *Fonction du cinéma: de la cinéplastique à son destin social* (Genève: Editions Gonthier, 1964), 16–36.

36. Alekan, *Des Lumières et des ombres*, 247.

37. Alekan, *Des Lumières et des ombres*, 248.

38. Henri Alekan, quoted in P. Le Guay, "Entretien avec Henri Alekan," *Cinématographe* 68 (June 1981), 28.

39. Beatrice Farwell, "Films on Art in Education," *Art Journal* 23, 1 (Autumn 1963), 39–40.

40. Bernard Champigneulle, *Rodin* (London: Thames & Hudson, 1967), 151.

41. Potts, *The Sculptural Imagination*, 76.

42. Krauss, "The Originality of the Avant-Garde," 151.

43. Henri Alekan, quoted by Russell Maliphant, on <http://rodinproject.blogspot. be/p/participant-inspiration-pack.html> (last accessed March 15, 2017).

44. Potts, *The Sculptural Imagination*, 40.

45. Heinrich von Dannecker's *Ariadne on a Panther* (1812–14) was installed on a rotating pedestal at the Bethmann museum in Frankfurt. See Thayer Tolles (ed.), *Perspectives on American Sculpture Before 1925* (New York: Metropolitan Museum of Art, 2004), 70.

46. Lauren Keach Lessing, *Presiding Divinities: Ideal Sculpture in Nineteenth-Century American Domestic Interiors* (Ph.D. thesis, Indiana University, 2006), 64.

47. A general study on rotating platforms for sculptures is still to be written. I was able to find references to rotating pedestals in the case of *The White Captive* by Erastus Dow Palmer at the New York gallery of William Schaus in 1859; *The Greek Slave* by Hyram Powers at the Great Exhibition in 1853; and *The Borghese Mars* at the Louvre (as sketched by Cézanne). See Catherine Hoover Voorsanger and John K. Howat, *Art and the Empire City: New York, 1825–1861* (New York: Metropolitan Museum of Art, 2013), 165; Douglas Murphy, *The Architecture of Failure* (Zero Books, 2012), 32; and Theodore Reff, *Paul Cézanne: Two Sketchbooks* (Philadelphia: Philadelphia Museum of Art, 1989), 147.

48. See Hans Cürlis, "Das Problem der Wiedergabe von Kunstwerken durch den Film," in Georg Rhode *et al.* (ed.), *Edwin Redslob zum 70. Geburtstag: Eine Festgabe* (Berlin: Wasmuth, 1955), 172–85; Thiele, *Das Kunstwerk im Film*, 15–18; Ziegler, *Kunst und Architektur im Kulturfilm*, 35–40, 45–54, and 302–9.

49. Germain Bazin, *Le Temps des musées* (Paris: Desoer, 1967).

50. See Champigneulle, *Rodin*, 205–6; Wood, *Close Encounters*, 14.

51. Sergei Eisenstein, *Beyond the Stars: The Memoirs of Sergei Eisenstein* (London: BFI, 1995), 307.

52. Eisenstein, *Beyond the Stars*, 316.

53. Ian Christie, "A Disturbing Presence? Scenes from the History of Film in the Museum," in Angela Dalle Vacche (ed.), *Film, Art, New Media: Museum Without Walls?* (New York: Palgrave Macmillan, 2012), 250.

54. Philippe-Alain Michaud, *Brancusi Filming 1923–1939* (Paris: Centre Pompidou, 2011).

55. David J. Getsy, "Tactility or Opticality, Henry Moore or David Smith: Herbert Read and Clement Greenberg on *The Art of Sculpture*, 1956," *Sculpture Journal* 17, 2 (2008), 75–88.

56. Getsy, "Tactility or Opticality," 79.

57. Getsy, "Tactility or Opticality," 81.

58. Clement Greenberg, quoted in Getsy, "Tactility or Opticality," 82.

59. Potts, *The Sculptural Imagination*, 98.

60. Vivian Sobchack, *The Address of the Eye: A Phenomenology of Film Experience* (Princeton: Princeton University Press, 1992), Laura U. Marks, *In The Skin of Film: Intercultural Cinema, Embodiment, and the Senses* (Durham, NC: Duke University Press, 2000), and Jennifer M. Barker, *The Tactile Eye: Touch and the Cinematic Experience* (Berkeley: University of California Press, 2009).

Anatomy of an Ovidian Cinema: Mysteries of the Wax Museum

VITO ADRIAENSENS

There's poetry in wax. From Pygmalion's ivory Galatea turning waxen to the touch, to the anatomical Venuses strewn erotically across the halls of La Specola in Florence, or wax mannequins melting slowly on celluloid, the haptic nature of the medium is intrinsically uncanny. Lifelike statues have been haunting our visual history for centuries, and as Kenneth Gross has aptly remarked, the idea of a statue coming to life could be bound to the opposing thought: that the statue was once something living. It is precisely this tension that lies at the heart of a number of films inspired by the wax museum and its mostly static inhabitants. This cultural phenomenon was made most famous by Madame Tussaud, who by the end of the eighteenth century had risen to fame crafting wax counterparts of notorious individuals. The wax creations' semblance of life has unnerved visitors ever since, and cinema was quick to pick up on the mysteries of the wax museum, trying its best to transfer the magic of the medium to celluloid.

This chapter deals with the adaptation of the wax museum and its wax models to cinema, analyzing how the specificity of the medium and its visceral tropes have enjoyed a popular second life on the silver screen, in films such as Maurice Tourneur's eerie 1914 *Figures de Cire*, Michael Curtiz's canonical 1933 *Mystery of the Wax Museum* and Sergio Stivaletti's gore-filled *giallo, M.D.C. – Maschera di cera (The Wax Mask,* 1997). Featuring the recurrent character of the mad artist, these films play with the tensions between flesh and wax and turn death and sexuality into an inherent part of the sculptural process.

SHAPING THE MUSEUM

The visceral qualities that wax possesses were not first ascribed to it by its incorporation in the horror genre, nor are they indebted solely to the efforts of Madame Tussaud; rather, they can be found in the organic material itself since it is secreted by plants and insects – most notably bees. Wax modeling

was an ancient practice dating back as far as 3000 BC, but it only started to take on a more figurative shape in Florence between the thirteenth and seventeenth centuries, when a true cult of votive offerings created an industry in wax. This meant that healthy or unhealthy body parts and organs were reproduced in wax and presented as offers, and Florentine noblemen even commissioned life-sized *bóti*, copies of themselves in colored wax, which were dressed up and given to churches as a sign of their devotion. Guerzoni notes that *scultore in cera*, or wax sculptor, was a recognized profession as early as the sixteenth century.[1] The Basilica della Santissima Annunziata in Florence claimed to have made a public attraction out of its collection of organs, parts, and noble bodies in wax, possibly instituting it as the world's first wax museum.[2] Offering up wax in the shape of body parts or organs still persists in some southern European countries, such as Portugal, and it is interesting to see how wax was recognized early on as providing an excellent verisimilitudinous substitute for the human body and its contents. Anatomists such as Felice Fontana (1730–1805) and Louis Thomas Jérôme Auzoux (1797–1880) acknowledged this potential as well, and the relationship that had already been established between the medium of wax and the minutiae of life, death, and afterlife through religious offerings was not only expanded and (partly) secularized in the course of the seventeenth and eighteenth centuries, but also to a certain extent sexualized and most certainly refined as an art form.[3] Wax sculptures will generally not inhabit the same museum space as their bronze or marble counterparts, and have historically been relegated to the realms of religion, science, and spectacle, rather than art. Wax figures therefore get their own museum and a number of films play heavily on this tension between art and spectacle. This is not to say, of course, that wax is entirely missing from the respectable museum; indeed, we find it in sculptors' wax studies, wax portraiture and, more recently, even in figurative statues.

By the end of the seventeenth century, anatomical waxes were being created to replace the use of actual human corpses in anatomical theaters, the latter being popular practice socially and scientifically in the seventeenth century as represented in paintings such as Rembrandt's *The Anatomy Lesson of Dr. Nicolaes Tulp* (1632). Bologna and Florence were the two epicenters of anatomical modeling in this period, with both male and female wax artists at work. The most prominent wax artists were perhaps Gaetano Giulio Zumbo, Giuseppe Ferrini and Clemente Susini, whose work has been well-preserved at the Museo di Storia Naturale di Firenze, or La Specola. The Florence museum opened its doors in 1775[4] and amassed an impressive collection of anatomical waxes, striking not only in their uncanny "lifelike" states of anatomical exposure but especially in their poses. These waxen

women, known as anatomical Venuses, could be found in similar poses and states in other museums, including the Josephinum in Vienna, from the late eighteenth century on. The models for these waxes were corpses, naturally, and thus most wax artists teamed up with anatomists who would dissect beside them, as the outcome needed to be precise and anatomically correct. As they lay sensually reclining on soft bedding, their eyes were usually half open in a dreamlike gaze, which is the case with Susini and Ferrini's *Medici Venus* (1782) in La Specola. These Venuses were often very healthy-looking young women and were dismountable: one could take them apart and look inside. Ballestriero notes that the famed sculptor Antonio Canova was a fan of Susini's work, and that "as an artist Susini could not avoid being influenced by the neoclassical taste whereby the predominant perception of beauty was a smooth, refined, and sensual expression such as that portrayed by Canova."[5]

The unmistakable eroticization of the Venuses makes being around them an almost necrophiliac experience, especially given the fact that the statues' faces and hands were often cast off actual corpses to ensure a realistic result, and that visitors of wax museums were sometimes allowed to touch the waxes, or were reportedly even spending private time with them – though the latter would undoubtedly cost extra.[6] The craftsmanship and artistry of these waxes still impresses today, shining beyond what Madame Tussaud went on to produce in the nineteenth century. They were also considerably more gruesome than what consequent Chambers of Horrors would present to the public, but this reflects their scientific purpose. As Bloom notes, although there was a separation between the two kinds of wax museums – corresponding to La Specola and Madame Tussauds – based on "an undesirably rigid divide between art and science,"[7] both types provide entertainment and fascination; their differences lay mostly in the dramatic presentation and the link to history or actuality, rather than constituting a difference between "art" and "science." While Gaetano Giulio Zumbo had already created a number of dramatic multi-figure wax tableaux that were showcased in La Specola, the Parisian Musée Grévin (1882) and Madame Tussaud's London establishment (1835) incorporated current events and famous (historical) figures that people still go see because of their likeness to the original. The latter's Chamber of Horrors featured murderers whose wax faces were often "taken from life," in the sense that they were cast from death masks taken by Tussaud herself, and was updated to be in keeping with the newspapers – much as the museum is now updated to keep up with the latest celebrities. Sandberg has noted that the 1880s and 1890s saw a real boom of these museums after the opening of Musée Grévin, with every major city wanting its own touch of Parisian refinement,[8] and it was this nineteenth-century

popularization of the wax museum that found its way into fiction, where the museum's static inhabitants would be brought to life in more ways than one. As perhaps the most mimetic mode of sculpture, wax was excluded from the traditional arts on the basis of hyperrealism – much in the same way as photography and film were once thought to be mere mechanical reproductions of reality, rather than synthesizing it artistically. At the same time, however, craftsmanship in wax continues to be lauded, and this tension is a frustration we recognize in the figure of the wax museum's mad artist on screen.

The wax museum may seem like an outdated and commercially hollow concept today, but not only do the various Tussauds establishments still attract multitudes, but a number of contemporary artists are finding new-fangled inspiration in the medium of wax and its potential for hyperrealism, as evident in exhibitions like the 2011 Danish "WAX – Sensation in Contemporary Sculpture,"[9] showcasing work from artists including Gavin Turk, Maurizio Cattelan, Andro Wekua, Christian Lemmerz, John Isaacs, and Robert Gober. Among other well-known sculptors working in the wax museum mode are the Belgian artist Berlinde de Bruyckere and Australians Ron Mueck, who impresses with his over- and undersized scale versions of human life, and Patricia Piccinini, whose animal–human hybrids can be extremely disconcerting. The focus on human decay, visceral (ab)normality and death is unmistakable in such work, with Christian Lemmerz veering into depictions of necrophilia and suicide, and John Isaacs giving new meaning to the term "morbidly obese."

BELDEN'S BLUEPRINT AND BEYOND

The French theater of horrors Le Théâtre du Grand Guignol (1897) was probably among the first to pick up on the gruesome possibilities of the wax museum through André de Lorde and Georges Montignac's 1912 stage play *Figures de Cire* (*Wax Figures*). Inspired by Edgar Allan Poe, de Lorde became the theater's main playwright, cranking out hundreds of short visceral tales concerned with murder, torture, and other "terror-inspiring" situations that gained him notoriety abroad as the Prince of Terror.[10] The play was adapted to film in 1913/1914 by French-American director Maurice Tourneur, who had also shot de Lorde's Guignol play *Le système du docteur Goudron et du professeur Plume* (after Poe) in 1912. The film featured acclaimed Grand Guignol actor Henri Gouget as the wax museum's proprietor, for the first time introducing the wax artist as a key figure in the fictional imagining of the wax museum trope. As an actor, Gouget had been described as "living in that borderland between life and death, where terror is king,"[11] and his screen introduction speaks volumes to this: after the title card with his name

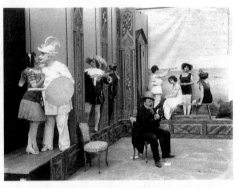

Figure 4.1 *Actor Henri Gouget of the*
Théâtre du Grand Guignol as the silver
screen's first wax museum proprietor in
Figures de Cire *(Maurice Tourneur,*
1913/1914) – Digital Still.

Figure 4.2 *The Wax Museum comes alive at night in*
Christian Schrøder i Panoptikon *(director unknown,*
1911) – courtesy of the Danish Film Institute.

at the start of the film, Gouget turns slowly and looks at the camera with a
sinister stare while his head dissolves into a skull. The short film plays on
the scenario of entrapment, as it revolves around a friendly wager between
two bourgeois gentlemen, Pierre and Jacques, on whether or not fear will
get the best of Pierre when he has to spend the night in a wax museum by
himself. Pierre is locked in by Jacques and the museum's proprietor but
immediately finds himself unsettled by the many tableaux vivants allud-
ing to violence and murder. In the middle of the night, as the wind rustles
through the museum and knocks over a wax mannequin, Pierre begins to
lose his nerve. He starts bumping into the waxes and completely loses it
when he thinks one of the statues has gotten a hold of him. It is at this
time that his friend Jacques decides to drop in for a little prank, but unfor-
tunately Pierre is overcome with fear and spotting a shadow he stabs it
violently. When daybreak comes, the police find Pierre out of his wits and
Jacques's body "the latest addition to the museum," as the intertitle so elo-
quently puts it.

Figures de Cire renders the museum as a crime scene, a place where your
senses can deceive you and insanity and murder could be the unpleasant
results of your stay. In Pierre's imagination, Jacques's shadow was a wax
statue come to life to get him, a conceit that follows from the many films
from the silent period in which living statues are to be found (cf. Chapter 1);
this includes a Danish predecessor, and perhaps the first wax museum
film, *Christian Schrøder i Panoptikon* (*Christian Schrøder at the Panoptikon*; direc-
tor unknown, 1911). This film plays the entrapment scenario for comedy,
with comedian Christian Schrøder taking on the role of the country rube

who falls asleep at Copenhagen's famed Panoptikon wax museum at closing time. When he wakes up, he explores the room and starts feeling up the female mannequins (actresses posing motionlessly) but is then shot at with a cannon from a neighboring display, as the tableaux have come to life. Sandberg finds the idea that the wax mannequins would wake at night to be a quintessential part of the museum's mystery and sees late night viewing as allowing "expression of behaviors repressed at the museum during waking hours by the conventions of voyeuristic viewing."[12] As has already been discussed in Chapter 3, nocturnal visits to sculpture galleries were part of common praxis early on, with the light of the torches eerily animating the marble and bronze works.

The true blueprint for the wax museum horror film had yet to come, however, and it did in the guise of writer Charles Spencer Belden's unpublished story *The Wax Works*. Belden was a writer for Warner Bros. and fashioned a story that was heavily influenced by Gaston Leroux's *The Phantom of the Opera*. The plot put forth the wax museum's artist as its protagonist and compounded the formula with the Pygmalion myth, creating a horror recipe that is still being reproduced today. The story was turned into the early Technicolor gem *Mystery of the Wax Museum* (Michael Curtiz, 1933) and would be adapted once more in 1953 as *House of Wax* (André De Toth), this time in 3D.[13] Belden's story takes the implied horror of the wax museum one step further than its original fictionalizations by sculpturally merging wax with flesh. Sandberg has noted[14] that the element of horror is always already present in the voyeuristic model of the wax museum, in the mere idea that the realistic models might return spectators' looks, but this plot usually centers around dream or confusion, without touching the integrity of the wax mannequins.

The advertisement for *Mystery of the Wax Museum* already plays handily to the fact that this film will push the trope of the wax museum beyond mere suggestion or dream. The first two adaptations of Belden's story by Warner Bros. were highly influential. They depict the wax artist as a Pygmalionesque genius who, embittered by the loss of his beloved wax dolls in a crippling fire, starts rebuilding his collection by covering murdered lookalikes of his favorite figures, as well as his enemies, in a thin layer of wax and placing them in his museum.

The film begins in 1920s London and recounts the story of renowned wax artist Ivan Igor (Lionel Atwill), who runs a wax museum with his business partner. Igor lives for his work and sees his wax statues as living and breathing offspring of his creative energy. He boasts a collection that exhibits historical figures such as Voltaire, Joan of Arc, and his crowning achievement, Marie-Antoinette. Some of his esteemed visitors want to reward his

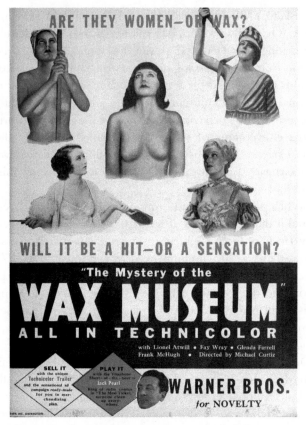

Figure 4.3 Mystery of the Wax Museum *ad in* The Motion Picture Herald *(February 18, 1933) – courtesy of the Media History Digital Library.*

exceptional skill and devotion by submitting his work to the Royal Academy, but this is where his business partner sees things differently. He criticizes Igor for his belief in "artistic nonsense" and his refusal to build a crowd-pleasing Chamber of Horrors. All artistic differences aside, the business partner mostly wants a quick return on his investment and sees fit to torch the museum for the insurance money. A fight ensues and Igor ends up locked inside the burning museum with his wax creations. Years later in New York, a crippled Igor opens a wax museum and nosy reporter Florence Dempsey (Glenda Farrell) investigates the disappearance of the corpse of Joan Gale. It turns out Igor stole Joan's body and coated it with wax because, to him, she made a perfect Joan of Arc. The mad artist sees Florence's friend Charlotte Duncan (Fay Wray) as the next addition to the museum, for she is his Marie-Antoinette incarnate. Luckily, Florence and the police manage to stop him from "immortalizing" her. In the struggle that ensues, it is revealed that Igor

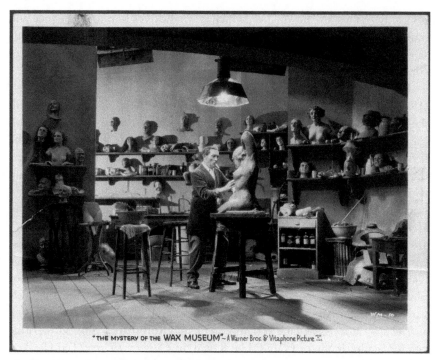

"THE MYSTERY OF THE WAX MUSEUM"– A Warner Bros. & Vitaphone Picture

Figure 4.4 *Lionel Atwill as Ivan Igor in his studio in* Mystery of the Wax Museum *(Michael Curtiz, 1933) – courtesy of the Margaret Herrick Library, Academy of Motion Picture Arts and Sciences, Los Angeles.*

wears a wax mask to hide his horribly disfigured face. The artist tries to escape but tumbles into his own boiling vat of wax.

CRIPPLING ARTISTRY

Mystery of the Wax Museum does its best to foreground the artistry involved in the making of wax figures. We see Ivan Igor sculpting in his workplace, talking to his mannequins as if they were living, and even proclaiming his love for Marie-Antoinette. As a sculptor, his peers recognize him for his extraordinary talent, and we find that the degree of verisimilitude is the measure for greatness. Igor proclaims that he "could reproduce the warmth and flesh and blood of life far more better in wax than in cold stone." In the 1953 *House of Wax*, sculptor Henry Jarrod's (Vincent Price) work is described by a critic as "dimensional paintings of the old masters . . . not only a great show, [but] an art exhibit." Henry Jarrod further praises his own creations by explaining the painstaking work that went into creating them. The fire started by the investor in the Belden plot robs the artist of his life's work, his artistic recognition,

his sanity *and* his artistic abilities, which is what drives him to vengeance and murder. An interesting twist on this plot in later films dealing with murderous artists is that murder can also lead to artistic recognition, fueling the artist to continue his methods.

In Roger Corman's intelligent pastiche on beat culture, *A Bucket of Blood* (1959), schlemiel Walter Paisley (Dick Miller) only succeeds at fitting in with the artistic elite when he accidentally kills a cat and tries to cover it up with clay. The result is a hyperreal sculpture, aptly titled *Dead Cat*, that garners the favor of his beatnik pals. Needless to say, human "models" follow, and when the truth finally catches up with Paisley, he puts an end to his successful run with a stunning "self-portrait." A similar artistic appropriation of the human body leads to critical success for painter Adam Sorg (Gordon Oas-Heim) in Herschell Gordon Lewis's *Color Me Blood Red* (1965). When Sorg's paintings are criticized for their unimaginative use of color, the painter accidentally discovers that blood makes a vivid pigment, and a few young girls have to pave his road to artistic fame with their lives. In the 1960s and 1970s, a number of films continued this trope of the artist as a villainous madman, most notably vampiric painter Antonio Sordi (William Campbell) in *Blood Bath* (also known as *Track of the Vampire*; Jack Hill and Stephanie Rothman, 1966); sociopathic painter/sculptor Victor Clare (Mike Raven) in *Crucible of Terror* (Ted Hooker, 1971); and hole-punching painter Reno Miller (Abel Ferrara) in *The Driller Killer* (Abel Ferrara, 1979).

Interestingly, the sculptors in *Mystery of the Wax Museum* and *House of Wax* also have an artistic change of heart after their harrowing confrontation with the cruel business side of their undertaking. They turn their back on "mere beauty" by finally following the erstwhile advice of their business partners and investing in a commercially interesting Chamber of Horrors. The sculptors' id takes over and changes them from perceived effete artists into homicidal monsters. Not surprisingly, the first addition to this Chamber is their former investor, "taken from life."

The story is infused with the Pygmalion myth from the start as we witness Ivan Igor's love for his masterpiece, Marie-Antoinette, clearly already embodied by Fay Wray in costume. Igor's creation later comes to life in the guise of a double: Charlotte Duncan in *Mystery of the Wax Museum* and Sue Allen (Phyllis Kirk) in *House of Wax*. The moment of recognition is a truly cinematic one, for when we see the artist look at the girl, a reverse shot shows her dissolving into the wardrobe of Marie-Antoinette and back to emphasize the likeness. The artist subsequently tries to transform the girl into a wax sculpture (again) so that her beauty is immortalized and he can be with her forever. Like Kenneth Gross,[15] the artist sees the statue as a "once living thing whose life has been interrupted . . . a body or a pose arrested in time, arresting time itself" and he

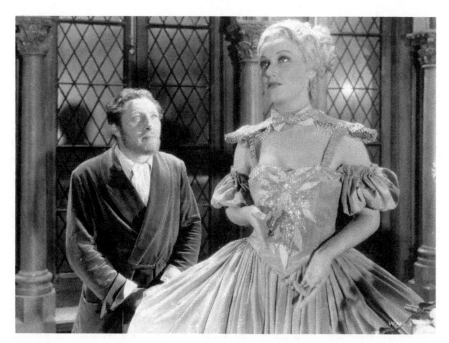

Figure 4.5 *Ivan Igor (Lionel Atwill) admires his waxen Marie-Antoinette (Fay Wray) in* Mystery of the Wax Museum *(Michael Curtiz, 1933) – courtesy of the Danish Film Institute.*

intends to keep it that way. The absence of an original model for the Marie-Antoinette sculpture not only stresses the seemingly magical revival that takes place in the films with the arrival of the double, it also emphasizes the plot's adherence to Ovid's Pygmalion, whose ivory maid was crafted entirely according to his imaginary ideal and was then bestowed with the gift of life. In *House of Wax*, the idea of the double is amplified by the character of the sculptor's strong mute apprentice Igor, an early role for Charles Bronson, whose pieces are crafted using himself as a head model. This confusion is played out in the museum when people start snooping around, allowing the real Igor to hide himself among his wax counterparts, such as the one portraying him as a criminal on the electric chair.

In later cinematic incarnations of the wax museum theme, such as the 1969 *Nightmare in Wax* (Bud Townsend), the 1988 *Waxwork* (Anthony Hickox), the 1997 *M.D.C. – Maschera di cera* (Sergio Stivaletti), or the 2005 *House of Wax* (Jaume Collet-Serra), the plot still features the wax museum's artist as a key figure, but the focus on artistry is all but left out in favor of gruesome slayings and bodies dipped in wax. *Nightmare in Wax* keeps the museum's ties to actuality by seemingly presenting wax copies of stars from the fictional Paragon studios who have mysteriously disappeared.

The museum's proprietor and artist Vince Renard (Cameron Mitchell) is a disgruntled and disfigured former Paragon special effects man, however, and those statues are not what they appear. *Waxwork* takes a cue from *Das Wachsfigurenkabinett* (*Waxworks*; Paul Leni and Leo Birinsky, 1924) in that every gruesome tableau it presents is really a preamble to a little universe with its own plot. In true 1980s fashion, genre bending without much sense for logic, the wax museum's proprietor David Lincoln (David Warner) is a strange timeless wizard whose tableaux draw people in. Once they step past the velvet rope, they are in a different universe and end up as part of the tableau to the outside world.

A similar alchemical twist in the artisanal process is the one that occurs in *M.D.C. – Maschera di cera*, where director Stivaletti and writers Dario Argento and Lucio Fulci seem to have been inspired by anatomist, sculptor, and plastination pioneer Gunther von Hagens for their artist, though the film takes place at the very beginning of the twentieth century. A cross between Joseph Beuys and Dr. Nicolaes Tulp himself, von Hagens founded his Institute of Plastination in 1993 and set up his first *Körperwelten* (Body Worlds) show with actual preserved and posed cadavers in 1995. The crude idea of replacing the body's liquids with an agent that freezes it temporarily is one that we see alchemically pursued in *M.D.C.*, and one that also shows up in *Santo en el museo de cera* (Alfonso Corona Blake and Manuel San Fernando, 1963), in which the museum's proprietor uses injections to keep an army of frozen zombies that he can activate at will, circumventing the burdensome wax casting process. In *M.D.C.*, the wax artist takes on the shape of multiple characters through his various wax masks, but he is ultimately revealed to be barely human at all as his flesh melts away in the climax to reveal a robotic skeleton. In the 2005 reimagining of *House of Wax*, the artist (Brian van Holt) is presented as a twisted serial killer with a problematic childhood, much in the same vein and setting as *The Texas Chain Saw Massacre* (Tobe Hooper, 1974), but the film does try its best to stress the artistic process that is involved with turning live humans into wax sculptures in the film, gory details and all. For one, most of the museum is fashioned out of wax, which not only speaks to the wax artist's abilities, but also delivers in the film's fiery finale.

Perverse Pygmalions

By now we have established that cinematic wax artists want to immortalize their subjects. Ironically, this usually entails killing them first. Though the specific discourse differs from film to film, it is remarkable to see that the presence of a doppelgänger in the Belden plot instigates a reversal of the Pygmalion pattern in the wax artist. The double does not instigate a

love affair for the artist, who might cheer on the fact that his sculptures seem to have sprung to life. Instead of being overjoyed at the occasion of finding his figures come to life in a sense, the artist wants to preserve them in wax, a process of mortification that keeps the artist in control of his own work. He sees an opportunity to recreate his static masterpiece, which he only then paradoxically considers to be alive. Crippled by the fire, the artist is so bent on restoring his works of art that he becomes homicidal. He finds his perfect woman alive, but literally wants to objectify her. The reverse Pygmalion motif of wanting to turn your beloved into wax, stone or marble was a prominent feature of Belden's story for *Mystery of the Wax Museum*, and turns up in a number of later films inspired by this one. The original Ovidian account of Pygmalion tells of a Cypriot sculptor who, frustrated with the vices of the Propoetides (women driven to prostitution by a vengeful Venus[16]), decided to create his own perfect female out of ivory. The beauty of the virtuous statue was so breathtaking that the sculptor fell in love with his own creation and beseeched Venus to bestow it with life. The artist's wish was granted and the cold ivory turned to warm flesh at his touch:

> He kisses her white lips, renews the bliss,
> And looks, and thinks they redden at the kiss;
> He thought them warm before: nor longer stays,
> But next his hand on her hard bosom lays:
> Hard as it was, beginning to relent,
> It seem'd, the breast beneath his fingers bent;
> He felt again, his fingers made a print;
> 'Twas flesh, but flesh so firm, it rose against the dint:
> The pleasing task he fails not to renew;
> Soft, and more soft at ev'ry touch it grew;
> Like pliant wax, when chasing hands reduce
> The former mass to form, and frame for use.
> He would believe, but yet is still in pain,
> And tries his argument of sense again,
> Presses the pulse, and feels the leaping vein.[17]

Actual cinematic retellings of the Pygmalion myth in a classical or mytho-logical context seem to be nonexistent, since most adaptions such as *My Fair Lady* (George Cukor, 1964) turn to the social reworking of the Pygmalion myth by George Bernard Shaw in 1912 instead, but in horror and science fiction the idea of turning inorganic matter into human flesh was never far away. The realistic statue's relation to death is inherent in the idea of the immobilized body, implying that its well-crafted matter was perhaps once alive, or, better yet, might still one day break loose from its bronze, marble, or stone constraints. The horror film's predilection for visceral effects related

to the manipulation and violation of the human body lent itself perfectly to the figure of the insane sculptor and his creations, trapping living beings inside sculptures, transforming them into sculptures, or using body parts as primary source material, as we have seen. Evidently, the confusion that occurs between the real and the ideal when a statue comes to life is not an opportune one in the horror film.[18] In the films that follow Charles Belden's storyline in invoking the Pygmalion plot, the artist is a godlike creator who does not want to see his artwork come to life if not by his own hand. He thus "reverses" the procedure and turns people into wax sculptures that he can shape and control. Michelle Bloom borrows Dubois' term "thanatography"[19] to refer to the process of human beings being transformed into sculptures, a trope that originates from the Belden storyline but one that we find in many different horror films.

This Pygmalionesque reversal, or "thanatography," is often described by the artist characters as an attempt to immortalize the beauty of their subjects. Interestingly, Ovid's description of the transformation of Pygmalion's Galatea from ivory into flesh involves an intermediary state in which the ivory is softened into wax before turning into flesh. Victor Stoichita describes wax as "a symbolic material balancing precariously between two reigns, life and death."[20] In this respect, the wax artist's victims as well as his creations are bound to the same corporeal purgatory. In Ovid's narrative, it is touch that triggers the Cypriot sculptor's wish for life. His kiss on Galatea's white ivory lips consummates his love for her and triggers Venus's magical transformation.

The difference between this transformation and the double is clear in Belden's story: she is not the statue come to life. The artist recognizes the difference since he has not consummated his love. He wants to turn the double back into his beloved Marie-Antoinette or Joan of Arc, and, first and foremost, this involves a physical change from flesh into wax. Despite the artists' recognition of the double as another person, however, they are compelled to encase the person instead of making a wax sculpture from scratch, for their artistic quest lay in the realm of hyperrealism. Sculptor Henry Jarrod (Vincent Price) puts it best in *House of Wax*, when eerily presenting Sue Allen, his Marie-Antoinette come to life, with a wax effigy of her own head. The head was cast from a bust made by the character's boyfriend Andrew, and though Sue thinks it a very good likeness, Jarrod explains to her that it won't do: "Andrew is clever but like all modern sculptors he has too much imagination. He would improve on nature. What I need for my Marie-Antoinette is you. The real you. Nothing less will satisfy me." The focus on immortalizing the subjects seems strange given the nature of the material at hand, especially since every self-respecting wax museum film features a show-stopping scene in which the wax models are destroyed in a fire.

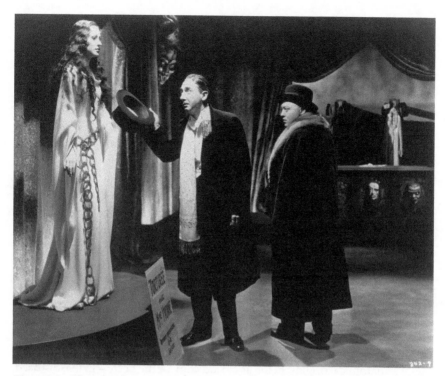

Figure 4.6 *The "wax effigy" of Yvonne Orlac (Frances Drake) with Dr. Gogol (Peter Lorre) and pointing drunkard in* Mad Love *(Karl Freund, 1935) – courtesy of the Margaret Herrick Library, Academy of Motion Picture Arts and Sciences, Los Angeles.*

Similarly, in the 1935 *Mad Love* by Karl Freund, Peter Lorre's character Dr. Gogol is rejected by famous actress Yvonne Orlac (Frances Drake). He ends up taking comfort in a wax effigy of her at the theater, addressing it as Galatea and taking it home with him. When a mix-up brings Yvonne to Gogol's house, however, she is startled by the sight of her wax likeness and accidentally destroys it. She tries to pose as her wax counterpart when Gogol comes home, but when Gogol believes that the statue has come to life he tries to kill it, egged on by an inner voice saying "each man kills the thing he loves."

THE LEAPING VEIN

The common belief in the high degree of verisimilitude and organic tactility that can be achieved with wax is crucial for the horror film dealing with the wax museum. As it was with Pygmalion, it is touch that reveals the true nature of the sculpture. More often than not, however, touching sculptures in these films reveals death instead of life. It is the unsuspecting touch of an

art gallery visitor, for instance, that brings about the discovery that there are dead people inside the stone statues in *A Bucket of Blood*. Jaume Collet-Serra's 2005 *House of Wax*, then, presents a wax casting process of a different ilk, as the cast has already been filled with a living person. One of its most iconic scenes hinges on a rescue attempt that goes terribly wrong. When Dalton (Jon Abrahams) enters the House of Wax in search of his friends, he discovers his buddy Wade (Jared Padalecki) sitting at the piano inside. The audience has seen Wade fall prey to the murderous museum proprietor and subjected to his wax process, but what we don't know is that he is still alive. We can see Wade's eyes move, but when Dalton tries to remove what seems like a small layer of wax on his skin, the flesh comes off with it. Wade's eyes start to tear as we are confronted with a gaping wound, and while Dalton tries to fix his mistake, the murderous madman catches up to them and slashes half of Wade's face. This form of brutal viscerality is echoed in scenes in which wax sculptors Ivan Igor and Henry Jarrod lose their wax masks in *Mystery of the Wax Museum* and *House of Wax* (1953), revealing their horribly disfigured faces, as well as in the key scenes of the wax museum burning, with their haunting images of melting wax faces – Peter Dockley's 1971 short film *Cast* thematizes this haptic poetry, as it is made up entirely of human wax figures slowly melting. It is in these moments that we are reminded most of the wax figure's anatomical origins, being as close a copy of the body – living, diseased, or dead – as we can find.

The wax sculptor's initial close working relationship with a doctor of medicine also opens up a comparison between the two artisans that the horror genre echoes; one employs his skills on flesh, the other on wax, but often lines between doctor and sculptor begin to blur. In Jennifer Chambers Lynch's *Boxing Helena* (1993), for instance, a mad surgeon becomes a sculptor by amputating the limbs of the woman with whom he is obsessed, trapping her in his mansion and treating her as his very own *Venus de Milo*. Similarly, in *Taxidermia* (György Pálfi, 2006), a depressed taxidermist takes the surgical route and turns his own body into an embalmed statue, decapitating himself as part of the artistic process. Nowhere are lines between sculpture and flesh blurred more than in Yasuzô Masumura's *Môjû* (*Blind Beast*, 1969), however. A blind sculptor kidnaps a model, whom he introduces to his artistic lair, and the two develop an unhealthy relationship. In a scene reminiscent of *Spellbound* (Alfred Hitchcock, 1945), we see walls of sculpted eyes, breasts and limbs in all sizes, showcasing the blind sculptor's far-reaching obsession with the human form. The film's climax showcases an almost indescribable scene in which the two make love on a giant statue of a naked woman until the sculptor consensually rids the model of her limbs with a knife. The limbs then turn to stone and fall on the ground while the sculptor commits

hara-kiri. The wax statue holds precisely this promise of blurred lines within itself. As Panzanelli notes, while "waxes document arrested life: a body fixed, observed, remembered," there is always that "uncanny moment of cognitive uncertainty" known as the "waxwork moment," which is the time it takes for the spectator to realize that he is looking at a crafted object instead of a real human being.[21]

Notes

1. Guido Guerzoni, *Apollo and Vulcan: The Art Markets in Italy, 1400–1700* (East Lansing: Michigan State University Press, 2011), 247.
2. Roberta Ballestriero, "Anatomical Models and Wax Venuses: Art Masterpieces or Scientific Craft Works?," *Journal of Anatomy* 216 (2010), 224.
3. Elizabeth Hallam, *Anatomy Museum: Death and the Body Displayed* (London: Reaktion Books, 2016), 294.
4. Though the museum only opened its doors to the public in 1775, it collected anatomical waxes by famed wax artist Gaetano Giulio Zumbo (1656–1701) that predate its grand opening by more than 70 years.
5. Ballestriero, "Anatomical Models and Wax Venuses," 230.
6. Pamela Pilbeam, *Madame Tussaud and the History of Waxworks* (London and New York: Hambledon Continuum, 2003), 26.
7. Michelle E. Bloom, *Waxworks: A Cultural Obsession* (Minneapolis: University of Minnesota Press, 2003), xviii.
8. Mark Sandberg, *Living Pictures, Missing Persons – Mannequins, Museums, and Modernity* (Princeton and Oxford: Princeton University Press, 2003), 26.
9. The exhibition "WAX – Sensation in Contemporary Sculpture" took place at Kunstforeningen GL Strand – Gallery of Modern and Contemporary Art in Copenhagen, Denmark between February 5 and May 15, 2011 and moved to the KUNSTEN Museum of Modern Art in Aalborh, where it was on display from May 28 to September 11, 2011.
10. F. Irvin, "The Little Theatres of Paris," *The Theatre: Illustrated Monthly Magazine of Dramatic and Musical Art* Vol. V (1905), 202–4.
11. F. Irvin, "The Little Theatres of Paris," 204.
12. Sandberg, *Living Pictures, Missing Persons*, 110.
13. Interestingly, H. P. Lovecraft also published a short story taking place in a wax museum in 1933 known as *The Horror in the Museum*. The plot was very akin to that of André de Lorde's *Figures de Cire*, with a bet to spend the night and the promise of entrapment, but in a Lovecraftian twist, a supernatural force kills one of the protagonists and turns him into a part of a tableau.
14. Sandberg, *Living Pictures, Missing Persons*, 95.
15. Kenneth Gross, *The Dream of the Moving Statue* (Pennsylvania: The Pennsylvania State University Press, 2006), 15.
16. Since Ovid, full name Publius Ovidius Naso, was a Roman poet, the goddess of love known as Aphrodite was called Venus.

17. *Ovid's Metamorphoses, in fifteen books. Translated by Mr. Dryden. Mr. Addison. . . . and other eminent hands. Publish'd by Sir Samuel Garth, M.D. Adorn'd with sculptures. . . . The third edition* (Ann Arbor: Gale ECCO, 2007), 343–4.
18. Paula James, *Ovid's Myth of Pygmalion on Screen – In Pursuit of the Perfect Woman* (London and New York: Continuum International, 2011), 91.
19. Bloom, *Waxworks*, 124.
20. Victor Stoichita, *The Pygmalion Effect: from Ovid to Hitchcock* (Chicago: University of Chicago Press, 2008), 18.
21. Roberta Panzanelli, "Introduction: The Body in Wax, the Body of Wax," in Roberta Panzanelli (ed.), *Ephemeral Bodies: Wax Sculpture and the Human Figure* (Los Angeles: Getty Research Institute, 2008), 2.

The Night of the Human Body: Statues and Fantasy in Postwar American Cinema

SUSAN FELLEMAN

Although it is conventional, and perhaps logical, to regard the avant-garde and the commercial cinemas separately, major new developments in each arose concurrently in the USA during the Second World War and, to some extent, in response to it. The dark Hollywood trend that was retrospectively dubbed film noir could be seen, as Paul Arthur and David James have observed, as an industrial form of an equally dark trend in the new genre of art cinema that came to be known as the trance film: "both modes feature a somnambulist protagonist who enters a menacing, often incomprehensible environment in a search for sexual, social, or legal identity, and both states are characterized by the same deadened affect, increased capacity for absorbing or inflicting violence, iconographies of entrapment, and the dissolution of geographic boundaries."[1]

Influenced by the German Expressionist cinema, film noir was artier than the general Hollywood studio product. And the trance film, inaugurated by Maya Deren and Alexander Hammid with *Meshes of the Afternoon* (1943) – in the tradition of works by such European filmmakers as Germaine Dulac, Jean Epstein, Dmitri Kirsanoff, the Surrealists and, especially, Jean Cocteau – was more narrative than the archetypal avant-garde film. Among the common attributes and imagery of noirs and their contemporary avant-garde cousins, sometimes referred to as psychodramas, are dream sequences – often characterized by abstract imagery and special effects – and narratives featuring subjective formal devices such as first-person voiceover and complex flashbacks. And in a number of noir thrillers and melodramas such as *The Maltese Falcon* (1941), *Three Strangers* (1946), *The Dark Corner* (1946), and *Stolen Face* (1952), as often in the trance film, sculpture appears, as overestimated object of desire and as enigma.

Two films illuminate the poles of this historical nexus: Albert Lewin's MGM highbrow horror film, *The Picture of Dorian Gray* (1945), which is a reflexive blend of noir atmosphere, stylized period mise-en-scène, and

art en abyme, and *Dreams That Money Can Buy*, a noirish quasi-narrative
feature, punctuated by experimental dream sequences, produced in 1947
with the help of art world friends and independently directed by émi-
nence grise of the European avant-garde, Hans Richter. The latter is a
hybrid film, "a story of dreams mixed with reality," as its opening narra-
tion declaims. Its framing narrative partakes of many noir conventions
(including voiceover narration, as well as Joe, a hard-boiled, poker playing,
fedora wearing, cigarette smoking, private detective-like protagonist) while
the dreams that Joe envisions for his clientele are avant-garde films con-
ceived by artist-friends of the director.[2] Sculpture figures in several of
the dream scenarios and a bust of Zeus (Otricoli) is a prominent feature
of Joe's office decor, along with a small figurative sculpture on his desk
and several other artworks, including pieces by Fernand Léger and Man
Ray. "Desire," the first sequence, includes a striking image of the small
desk sculpture in wax melting. The Léger sequence, "The Girl with the
Prefabricated Heart," is enacted entirely by mannequins and the two con-
secutive Alexander Calder sequences consist of footage of his kinetic sculp-
tures. At the end of the story, in Richter's own dream sequence, "Narcissus,"
the bust of Zeus that has presided over the office scene, becomes an
important prop in Joe's dream confrontation with himself, bursting into
flames and then falling and breaking apart when he escapes through a
window with it.

This use of sculpture as an index of narcissism is seen, too, in *The Picture
of Dorian Gray*. Although the titular artwork – a portrait that magically ages,
while its subject does not – is pictorial, sculpture abounds in the film's mise-
en-scène. One scene is composed such that a mirror before which Dorian
stands reflects a copy of Verrocchio's *David*, a Renaissance image of beaute-
ous youth, reinforcing the narcissism and duplicitous visuality central to the
plot. Among studio productions of the postwar period, *The Picture of Dorian
Gray*, due in part to the uncannily restrained and affectless performance by
Hurd Hatfield in the title role, is among the closest to the trance film. It
shares with Cocteau's *Le Sang d'un Poète*, the veritable ancestor of the trance
film, not only a somnambulistic title character and a magic mirror but also
an enchanted sculpture. None of the statues comes alive, but an Egyptian
cat, which is added to Wilde's story to enhance the supernatural element
of the story, it is suggested, has magical powers.[3] Like *Dreams That Money
Can Buy*, *The Picture of Dorian Gray* uses art to reify fantasy. Functioning
realistically, as indices of class, taste and sensibility, magically, as wish ful-
fillments or images of talismanic power, and as objects of desire, sculpture
rounds out the baroque field of vision in this dark, cautionary tale about
the difference between truth and beauty. Lewin incorporated non-Western,

as well as classical and neo-classical, art into *The Picture of Dorian Gray* not only to express his own wide-ranging sensibilities as an aesthete and collector and to underscore the epicurean ambiance of the mise-en-scène, but also to associate art with the ritual aura that attended it in ancient, exotic, and aboriginal cultures, thereby enhancing the supernaturalism of the scenario.[4]

Ritual and ritual aura are characteristic, too, along with dance, of the films of Maya Deren, "mother of the American avant-garde." In the same year as *The Picture of Dorian Gray* (1945), after her initial forays into film with *Meshes of the Afternoon* (1943) and *At Land* (1944),[5] Deren produced her independent short, *A Study in Choreography for the Camera* (1945), with the dancer Talley Beatty. While this is not exactly a trance film, the dancer's journey in this short experiment in movement across space and time has some of the same qualities as the oneiric trajectories of the psychodrama; Beatty's movements are continuous across discontinuous locations, intimate and grand, including a forest glen, a bohemian apartment, a gallery at the Metropolitan Museum, and the precipice of the Palisades. In her first explicit incorporation of sculpture into film, Deren invokes the talismanic aura of Asian statuary, along with the expressive power of dance, as had Lewin, who included a gamelan orchestra and Buddhist dance performance in *Dorian Gray*. In Deren's film, Beatty is shown in close-up performing repeated pirouettes in a sculpture gallery, before a stone bust of the Buddhist deity Hevajra.[6] The turns begin in slow motion and gradually accelerate, according to the filmmaker, creating a movement that "begins with a dream-like quality and ends up with the blurring of a machine part."[7] The increase in speed and blurring creates a visual effect suggestive of the almost mystical merging of the dancer's face with the multi-headed sculpture, vivifying the ritualistic intermediality of the film: the art of cinema is used to draw dancer and sculpture together in a way that expresses Deren's convictions about the sacred origins and transcendental meaning of art.

This ritualistic intermediality was also explored in Deren's never completed collaboration with Marcel Duchamp, *Witch's Cradle* (1943), the surviving fragments of which transform childhood games (alluding to cat's cradle and related string games that are common to many different cultures) into a mysterious occult adventure, featuring Duchamp, Roberto Matta, and Matta's then wife, Anne Clark (credited as Pajorita Matta). Shot in Art of This Century, the modernist gallery designed by Frederick Kiesler and recently opened by Peggy Guggenheim on West 57th Street, the film was inspired by both the architecture of the space itself and the art works it contained. Deren used her camera to delineate the magic of what she called these "cabalistic symbols of the twentieth century." Modernist sculptures are

Figure 5.1 Ritual in Transfigured Time ***Figure 5.2*** Ritual in Transfigured Time
(Maya Deren, 1946). Rita Christiani and Frank *(Maya Deren, 1946). Rita Christiani in the*
Westabrook in the "Statue Game" sequence – *"Statue Game" sequence – Digital Still.*
Digital Still.

among these obstacles and magical mysteries amid and against which action is staged.

In *Ritual in Transfigured Time* (1946), Deren continued her formal exploration into the ritual possibilities of statues, dance, and games. "The pattern, created by the film instrument, transcends the intentions and the movements of individual performers, and for this reason I have called it *Ritual*," Deren wrote.[8] "I base myself upon the fact that, anthropologically speaking, a ritual is a form which depersonalizes by use of masks, voluminous garments, group movements, etc., and in so doing, fuses all individual elements into a transcendent tribal power towards the achievement of some extraordinary grace."[9]

Ritual in Transfigured Time plays with the transfiguration of living people into statuary and vice versa, here as a stage of an initiation or rite. The film represents a divided protagonist's journey from widow to bride in three sections. The first introduces the two faces of the protagonist (the bright and lively Deren and the dark and brooding Rita Christiani), who together collect a skein of yarn (in imagery that recalls *Witch's Cradle*), and a third figure, a sibyl (Anaïs Nin) who beckons the widow to a party. In the shadowy domestic setting of this first sequence, there is a looping, gestural, abstract sculpture that quietly echoes their motions.[10] The second sequence, a party scene, translates conventional social behaviors into round-dance-like rituals with repeating formal patterns. A suitor emerges out of the pattern, and when he speaks intimately into the widow's ear, they are suddenly in an idyllic garden, where most of the third and last sequence plays out. Here, the relationship between dance and statuary is explored extensively in the pastoral setting of a park. Footage of Frank Westbrook, Christiani, and three other

dancers, originally shot in the sculpture court of the Museum of Modern Art, was replaced by these scenes shot at the walled gardens of Greystone, the Yonkers estate of Samuel Untermyer.[11]

This setting forms a mythical background to a scene in which stop-motion photography and optical printing are employed to repeatedly freeze and release figures that seem to equivocate between sculptural and human status. Three women dance, like the Three Graces, as Walter Schott's bronze *Nymphenbrunnen* (*Nymph Fountain*) seems to come to life.[12] The now satyr-like and shirtless suitor (Westbrook) dances with each of them before they return to statuesque poses, then perplexes the widow, whom he has charmed, as he is petrified upon a pedestal, then comes haltingly to life, briefly embodying poses of classical statuary, then – from the pose of the famous bronze athletes uncovered at the Villa of the Papyri in Herculaneum – leaps down and pursues her. A shot of Rita Christiani, frightened by the sudden animation of the figure, strikingly anticipates one of Ingrid Bergman responding to the vivid lifelikeness of one of those bronzes in the museum scene of Rossellini's *Viaggio in Italia* (1954), discussed in Chapter 6.

In Deren's scenario this sequence is called "The Statue Game," referring to a children's game (known by a number of names and variants, including "statues," "statue maker," or "red light, green light") in which players must run to catch up with and tag whoever is "it," but must freeze whenever "it" turns around to look.[13] The game is serious stuff in this world of adult society and sexual pursuit. The transfiguration of the film's title refers to an altered temporality, although clearly other transfigurations occur, including of identity and space. In this sense, the implied movement between the ritualized behaviors of the contemporary New York party scene and the magical idyll in the garden is not entirely unlike Leni Riefenstahl's movement between classical statuary and contemporary athletes in the prologue to *Olympia* (1938), in which the classical marble Discobolus (a Roman copy of a bronze original by Myron from the fifth century BC) comes alive as it dissolves into footage of a contemporary discus thrower. Both artists were interested in exploring the relationship between dance, sculpture, ritual, myth and cinema. But, as Brigitte Peucker has demonstrated, Riefenstahl staged a fantasy of origins, implicitly connecting, along a historical lineage, the idealized figures of antiquity to the (Aryan) athletes of the Third Reich (although the Olympiad is international).[14] In contrast, Deren's approach in her work at this time, including writings and projects proposed for a Guggenheim Foundation grant, is ahistorical or trans-historical, as well as transcultural, informed by anthropology, seeking a universal "ethics of form," which can convey to audiences a sense of "ritual participation in art . . . as antidote to a modernity hollow of meaningful ritual."[15]

Kenneth Anger, only seventeen years old when he made his psychodrama, *Fireworks* (1947), conjured rather different psychosocial currents and ritual associations in his "dream of a dream" in which, he wrote, "a dissatisfied dreamer awakes, goes out in the night seeking a 'light' and is drawn through the needle's eye." Before the dreamer, played by Anger himself, awakens from a homoerotic dream in which he is carried in the arms of a sailor, there is a cutaway to a nearby object, a sculpted hand with broken fingers; then the dreamer, as he stirs, appears to have an enormous erection – the sheet protrudes above his pelvis – but it is revealed to be a figurine, a Mesoamerican or African idol that he draws out from beneath the covers. Fascinated with the occult and already an astute critic of popular cultural myths, Anger exposes the ambivalence of subcultural fantasies of psychosexual abjection and constructs double entendres and sexual innuendo with imagery such as the broken hand and fetishistic idol, as well as giving form to figures of speech (a shot of a "flaming faggot," for instance: a bundle of branches set alight).

Humor and irony, more prominent elements of Anger's trance films than they were of Deren's, are also characteristic of the work of their contemporaries, Sidney Peterson and James Broughton, who brought an overtly playful spirit to their psychodramas. The two produced one film together: *The Potted Psalm* (1946), loose, disjunctive, very indebted to Surrealism, in which a sculptural bust, mannequins, and masks make obscure albeit rather Freudian appearances amid elliptical narrative fragments, often shot anamorphically, creating wiggy effects reminiscent of André Kertész's photographic *Distortions* of the1930s. In the wake of *The Potted Psalm*, Peterson and Broughton each went on to make films separately. A twisted and discombobulated adventure in art and perception, Peterson's *The Petrified Dog* (1948), made with students in his film workshop at the California School of Fine Arts, had sculpture as its central motif. The film "takes its title from the statue of a lion seen repeatedly throughout the film and from an allusion to the freezing of the camera's motion, which we first see in the background of the film's title."[16] There may be a secondary allusion to Buñuel and Dalí's *Un Chien Andalou*, another film in which a titular dog is nowhere to be seen. *Alice in Wonderland* is another intertext. "The heroine Alice climbs out of a hole in a park with her characteristic broad Victorian child's hat into a world where we have already seen a painter working within an empty frame, a slow motion runner hardly getting anywhere, a lady in fast motion eating her lipstick, and a photographer who sets his camera up with a delayed shutter so that he can stand on pedestals and be snapped as a statue."[17] This last motif, of the pedestal occupied by a "living statue," echoes Deren's *Ritual in Transfigured Time*, of course, and anticipates a favorite trope of Peterson's erstwhile collaborator, the poet James Broughton.

THE DEBRIS OF WESTERN CIVILIZATION

Broughton's first independent film, *Mother's Day* (1948), begins with a memorable shot of a man cradled like a baby in the sculptural lap of a monumental goddess (a personification of Plenty).[18] Perhaps a homage to the opening shot of Charlie Chaplin's *City Lights* – Broughton remarked that "the wonderland of silent movies" was his "sensory home" – this low angle shot has a more profoundly Oedipal aura.[19] The grown man (painter Lee Mullican) rests his head upon the goddess's breast and the tableau is isolated against the sky. There is no unfolding narrative directly connected to this emblematic image, whereas Chaplin's little tramp sleeps and awakes into social chaos and comedic narrative. "Rather than film an autobiographical report of my own mother complex," wrote Broughton of *Mother's Day*, "I visualized a mother-complexity of many boys and girls conspiring against the strictures of an impervious widowed goddess."[20] His strategy was simple. Broughton had properly dressed and coiffed grownups behave like children. In sequences sometimes reminiscent of Deren's *Ritual in Transfigured Time*, they play children's games and act out, giving form to the timelessness of the unconscious. "The impression of an animated family album, heightened by the nostalgic music of Howard Brubeck, written for the film, is immediately apparent," according to Sitney.[21] The figure of a cold, narcissistic Mother organizes the different sections, each inaugurated with the recollection of Mother's platitudes. The opening image of the grown man, infantilized in the lap of the monumental bronze divinity, expresses the film's thematic preoccupation with the enduring effects on the child of his beautiful mother's self-absorption and hauteur.

In two later films, Broughton returned to the statue motif in a more

Figure 5.3 Mother's Day *(James Broughton, 1948). Lee Mullican in the lap of Plenty – Digital Still.*

Figure 5.4 Four in the Afternoon *(James Broughton, 1951). "Living Statues of Twelve Ideal Suitors" – Digital Still.*

lighthearted mood. *Four in the Afternoon* (1951), a series of four vignettes derived from his poems, he noted in his memoir *Coming Unbuttoned*, "gratified another of my passions: statuary both sculpted and posed."[22] "Little Gladys," Broughton wrote of the first, "trots down most of the outdoor staircases on Telegraph Hill till she comes to her dreaming place: the foundations for a yet unbuilt housing project. On these pedestals she summons with her jump rope living statues of twelve ideal suitors."[23] Stop-motion is used to conjure and dispel Gladys's statuesque imaginary lovers. "The Gardener's Son hoses down replicas of classical goddesses in Sutro Gardens, still in those days an unmanicured remnant of a once private estate overlooking the Pacific. My Aunt Esto had first taken me there when I was boy. That initial encounter with sculptures of the gods haunted my life for years and deeply affected all my work in cinema."[24] The suggestive encounters between the young gardener and a number of famous classical statues, including copies of three renowned marbles in the Louvre, Aphrodite of Melos (*Venus de Milo*), Diana of Ephesus ("Chasseresse"), Aphrodite of Frejus, and a reclining Pan or satyr, among others, speak to the paradoxical eroticism of statues. In one scene, the gardener espies three women dancing in a clearing. They are, it is suggested, as was the case in Deren's *Ritual*, Graces come to life. Relief statuary is part of the architectural background to the third vignette, "Princess Printemps," a commedia-style pantomime with dancers Anna Halprin and Welland Lathrop, staged around the neo-classical façade of the Palace of Fine Arts.

Broughton found an even richer sculptural setting for *The Pleasure Garden* (1953), a short, 35mm feature produced by Lindsay Anderson. Living in London with his partner Kermit Sheets, Broughton was taken by friends to Sydenham to see the ruined grounds of the Crystal Palace:

> The park had been closed to the public since 1937 when the great glass building had come crashing down in a fire. Its abandoned public gardens had been enclosed in such a high wall that it was necessary to climb a tree in order to behold the surprises it contained. Before me extended a dilapidated splendor ready-made for a flight of fancy: acres of dislodged statuary, fallen urns, lichened balustrades and great staircases going nowhere, the whole place overgrown and awry. As a setting it suggested nothing less than the debris of Western civilization.
>
> When I learned that the Duke of Edinburgh headed a committee planning to level the Gardens into a community playing field, I resolved to exploit this enchanted ruin before it disappeared forever.[25]

The Pleasure Garden, according to Broughton's voiceover, is "a midsummer afternoon's daydream." The winner of a special prize (the prix de fantasie poètique, perhaps cooked up by juror Jean Cocteau) at the 1954 Cannes Film Festival, the film tells a (subtly queer) story about the victory of pleasure over

prudery, and eccentricity over conformity. "One at a time," Broughton narrates, "come the curious strangers seeking what pleasure they can."

We enter the gardens with Bess (Diana Maddox), who arrives with her Aunt Minerva (Jean Anderson), both clad in black, fresh from a funeral, the former's curiosity repressed by the dismal severity of the latter, who bestows upon her niece a heavy rulebook before taking her leave. Inside the garden, a motley assortment of initially solitary characters is introduced, each shown engaged in more or less silly, sensual, imaginative, whimsical, and almost always kinetic escapades with and among statuary: among others, a thin man with a silly makeshift bonnet who runs and runs, another who strikes callisthenic poses atop pedestals, a woman bicyclist, a birdwatcher with field glasses, and a modern sculptor named Michael-Angelico (played by Lindsay Anderson), who exclaims, "art is a hard mistress; art is real; can I ever make something I really feel?" and lies down upon a broken and fallen nude in the grass – probably a Venus – embracing her as if for inspiration. Michael-Angelico's counterpart is a young woman who seems to aspire to be a sculpture; she wanders about striking the poses of classical and neo-classical statues, among them personifications of Love and Mirth from one of the ruined fountains, and a dancer by Antonio Canova. Meanwhile, Colonel Pall K. Gargoyle (John Le Mesurier), the Minister of Public Behavior – in black Victorian top hat, coat and dark glasses – arrives and tries in vain to stay a step ahead of the pleasure seekers; he goes about censoring the sensual statues and prohibiting play, laboriously applying a fig leaf to the genitals of the handsome Discophoros, although not without lingering a moment, and placing warning signs upon other statues. He scolds the statue imitator, who has stripped down to her slip for mimetic purposes. Cowboy Sam, a freewheeling and friendly American satyr (played by Broughton's

Figure 5.5 The Pleasure Garden *(James Broughton, 1953). The mimetic girl and a copy of Antonio Canova's* Dancer *(1812) – Digital Still.*

Figure 5.6 The Pleasure Garden *(James Broughton, 1953). The censorious Colonel Pall K. Gargoyle at work – Digital Still.*

partner Kermit Sheets), arrives and enlivens things by actually approaching other pleasure seekers, arousing the disapproval of Aunt Minerva and Colonel Gargoyle, who arrange to have him locked up. Ultimately, Sam and pleasure are liberated by the arrival of Mrs. Albion (Hattie Jacques), a formidable fairie with a magic shawl, who "proceeds to tear down prohibiting signs, gives confidence, grants wishes, and does all the wonderful acts good fairies do."[26]

Complications ensue when the magic shawl is stolen and Gargoyle and Minerva round up all the revelers, attempting to sort them into normative gender categories and govern their behavior with an official rulebook. After a tug of war over the shawl, all ends well as Mrs. Albion consigns the censors to "be as dead as official art and the rest will live for the heart" – in another invocation of the statue game, she freezes her adversaries – and the pleasure seekers pair off into couples and trios of various orientations.

The extravagant centrality of classical and neo-classical statuary in *The Pleasure Garden* reinforces what a prominent element of public iconography such sculpture was, especially in the nineteenth century in which these gardens originated, and therefore how available this imagery was as an association with cultural patrimony and as a symbolic language denoting class, education, and memory, as with any number of the garden settings featured in avant-garde films of the twentieth century (*L'Âge d'or*, *Ritual in Transfigured Time*, and Broughton's own *Four in the Afternoon*, among others). Thus, particular statues recur in these films. The *Diana of Gabii* whose toe is sucked in *L'Âge d'or* appears again in *The Pleasure Garden*, with a broken nose and a wire wrapped like a leash around her neck; in between she had appeared, in slightly smaller scale, in Jean Cocteau's *Orphée* (1950). The Farnese Hercules is seen from behind in both Deren's *Ritual* and *The Pleasure Garden*. Venus in her various incarnations is the goddess of the pleasure park, denoting high-minded classical culture and mythical sexual potency. Yet, neglect and time having conspired to close the distance between nature and culture in Broughton's *Pleasure Garden*, the distance between the living and the marmoreal bodies, too, seems closed, the aura of the statues diminished, their ancient cultic or ritual authority to have leaked from their cracked and broken limbs into the atmosphere of the film such that the characters are enchanted around the slumbering, moldering gods.

James Broughton's friend Kenneth Anger also exploited the mystical and sensual atmosphere of the pleasure garden, producing that same year his *Eaux d'Artifice* (1953). This short, lyrical film was shot at the Villa d'Este in Tivoli and follows a tiny woman dressed in eighteenth-century costume about the garden fountains by night. Freestanding statuary is scant in the oneiric setting, but sculptural details of the classical fountains achieve the

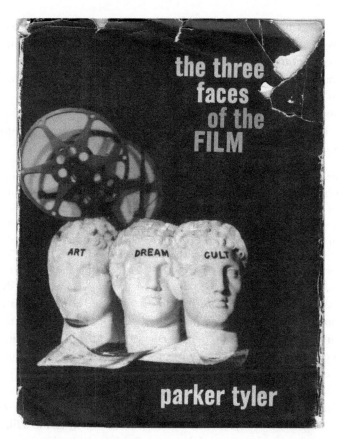

Figure 5.7 *Dust cover of Parker Tyler's* The Three Faces of the Film *(1960), with photograph by Marie Menken.*

same sort of timelessness conjured by Deren and Broughton. Critic Parker Tyler was probably the first to note how central sculpture and statuary were to avant-garde cinema (in particular, it is implied, to that of gay filmmakers, including, in addition to Anger and Broughton, Willard Maas and Gregory Markopoulos[27]), locating its origins in Cocteau's *The Blood of a Poet* and creating a sort of photo essay around it in his *The Three Faces of the Film*. The cover of the first edition of that book in fact underscores the salience of classical sculptural imagery, not only in avant-garde film but in all cinema. It features a photograph by Marie Menken of three marble Roman heads, with the words "ART," "DREAM," and "CULT" (those being the three faces of film according to Tyler) written across their respective foreheads, with a film reel and its shadow hanging above the "ART" head like a halo. And Tyler begins the book with his recollection of the performances of two Italian movie actresses of the second decade of the century, seen in a screening of early

cinema at the Cinémathèque française. They "persistently took fluid postures alternatively smacking of pagan statues and the inmates of sanitariums in their less tranquil moments."[28] Tyler sees the mimicry of the attitudes of statuary as a component of cinema's origins, its artistic aspirations, and a paradoxical aspect of its achievement.[29]

Picking up on Tyler's observation about the iconography of statues for the American avant-garde, if not the ironic afterthought, P. Adams Sitney remarks that

> behind all the employments of the statue in the trance film, however obliquely, is the myth of Pygmalion. In his revival of that myth in the terms of a "magical" illusionism of cinema, Cocteau initiated a cinematic ritual that a whole generation of American film-makers felt sufficiently vital to restate in their own terms.[30]

This ritual, revival of myth in terms of a magical illusionism of cinema, however, was not the exclusive purview of the trance film. The Pygmalion effect has marked cinema from its earliest days and in the postwar period was simultaneously to be found in Hollywood fantasy and in the trance film's commercial cousin, film noir, as suggested at the outset of this chapter. When the title character (Gene Tierney) – thought to be dead – walked in on Detective McPherson (Dana Andrews), slumbering beneath her portrait in *Laura* (Otto Preminger, 1944), or Alice Reed (Joan Bennett) appeared magically by her portrait in *The Woman in the Window* (Fritz Lang 1944), or *The Picture of Dorian Gray* and its subject exchanged temporalities in Lewin's film (1945), the painting manifesting age and decrepitude while the body remained young and beautiful, the myth was much the same.[31] The night of the human body is one in which art, dream, and cult merge. Sculptures, too, are part of the Pygmalion variations of 1940s and early 1950s Hollywood productions. Films such as *One Touch of Venus* (William A Seiter, 1948) and *The Barefoot Contessa* (Joseph Mankiewicz, 1954), for instance, deal with the theme of impossible love involving the fetishized statue of an ideal or idealized woman.[32]

Playing the leading part in both films, Ava Gardner also starred in Lewin's *Pandora and the Flying Dutchman* (1951), which, like his *The Picture of Dorian Gray*, exemplified the common ground between avant-garde and Hollywood tendencies in the postwar period. Lewin himself bridged the two domains. An informed collector and lover of the arts, Lewin counted among his friends a number of European artists in exile, including Duchamp, Ernst, and most especially, Man Ray, who consulted on and contributed to *Pandora and the Flying Dutchman*.[33] A more independent and original picture than *Dorian Gray*, *Pandora*, like Broughton's *Pleasure Garden* and some of the trance films of the 1950s discussed by Sitney, is set among the debris of Western civilization.

Figure 5.8 Pandora and the Flying Dutchman *(Albert Lewin, 1951). A jazz band among the ruins – Digital Still.*

Figure 5.9 Pandora and the Flying Dutchman *(Albert Lewin, 1951). The Dutchman, Pandora, and a bronze bacchante – Digital Still.*

Art, dream, and cult – Tyler's three faces of film – perfectly expresses the mystical story and atmosphere constructed around Ava Gardner and the Costa Brava in *Pandora*, a film that writer-director Lewin claimed was inspired by the Surrealist possibilities of a particular image: a "racing car on the beach – a modern machine being driven at great speed past the statue of a Greek goddess standing on the sands."[34] The juxtaposition of antiquity and modernity that inspired *Pandora and the Flying Dutchman* sometimes has a whimsical aspect, a disenchanted aura similar to that of Broughton's *Pleasure Garden*, as for instance in a party scene where jazz musicians and revelers play and dance among fragments of antiquities in the sands of Costa Brava on the Mediterranean Sea. A saxophone is played above a monumental head of Neptune; a trombonist lies on his back in the sand playing with his head resting upon the hip of a sculpture of a sleeping hermaphrodite; dancers step around a half-buried bas-relief. More often, though, a more magical and mystical effect is sought in this story of Pandora Reynolds (Gardner), a 1930s chanteuse and femme fatale who turns out to be a revenant: an incarnation of the murdered bride of the legendary Flying Dutchman (James Mason).

Phoenician, Greek, and Roman sculpture (most of it evidently pastiches crafted for the film) is used to lend an aura of eternity to a location (Tossa de Mar) Lewin prized for its antiquity and association with the Surrealists (parts of *L'Âge d'or* were shot in and around nearby Cadaqués, also the source of many Dalí landscapes). In addition to the headless goddess in the sands who is accorded a strange subjectivity by a vivid camera movement (tracking with the race car, the shot pivots around the sculpture, stops behind her, then pans from her point of view), *Pandora* features a monumental ancient head that sometimes seems to watch the "action under the aspect of eternity."[35] And

in the more serious coda to the party scene, Pandora's interaction with an ancient bronze bacchante on the beach during a portentous encounter with Hendrick, the Dutchman – along with the rather deific treatment of Gardner by scenario, costume, lighting and photography – imparts a mystical, eternal, statuesque aura to the movie goddess.

Even in as rarefied a spectacle as *Pandora*, the function of the classical statue in Hollywood diverges from that of the avant-garde. While it is equally true of avant-garde and classical cinema that the spatial properties of sculpture mobilize the spatiotemporal properties of the cinema and that statues seem to emphasize the corporeal, even carnal problematics around cinematic bodies, for Hollywood statues also signify the classicism and fetishism that are among its central attributes.[36] *Pandora and the Flying Dutchman* equivocates between such Hollywoodish concerns and those of the art cinema, illuminating (or forging) a gray area between these unfixed categories. The *nuit américaine* of *Pandora*'s Tossa is rather like the *nuit américaine* of Anger's Tivoli in *Eaux d'Artifice*; its encounters between people and statues find echoes in Broughton's *Pleasure Garden*. This hybridity was significant for an emerging generation of filmmakers, especially those in Europe who responded to *Pandora*'s strange, heady mixture of Surrealism, myth and glamour. A very wordy, cerebral film, its silently eloquent sculptures, like those in Rossellini's *Viaggio in Italia*, Cocteau's *Orphée*, and Resnais's *Marienbad* – objects that collapse history, transfiguring time and space: the debris of Western civilization – are idols for an art cinema to come.

Notes

1. David E. James, *The Most Typical Avant-Garde: History and Geography of Minor Cinemas in Los Angeles* (Berkeley: University of California Press, 2005), 176.
2. Autonomous dream segments were designed by Max Ernst, Fernand Léger, Man Ray, Marcel Duchamp, Alexander Calder, and Richter and their scores include some by modernist composers, including Darius Milhaud, David Diamond, Paul Bowles, and John Cage.
3. Based on a Late Period (664–332 BC) bronze in the St. Louis Art Museum (object number 5:1938). See Susan Felleman, *Botticelli in Hollywood: The Films of Albert Lewin* (New York: Twayne, 1997), 53, and note 29, 132.
4. Albert Lewin was an MGM unit producer turned writer-director but somewhat unusual in his background and friendships among the literati and avant-garde. In fact, Lewin, who was especially close to Man Ray during the war years, knew a number of the artists involved in *Dreams That Money Can Buy* and attended its New York premiere. Photographs from the premiere are among the Albert Lewin Papers at the University of Southern California's Cinema-Television Archives.

5. *Meshes of the Afternoon* and *At Land* were, of course, the original American trance films, made with Deren's first husband, Alexander Hammid, the latter also with Hella Heyman.

6. Bust of Hevajra, Angkor period, late twelfth–early thirteenth century, Cambodia. Metropolitan Museum of Art accession number: 36.96.4.

7. Deren's *Dance Magazine* article, "Choreography for the Camera" (October 1943), as republished in Clark *et al.*, *The Legend of Maya Deren: A Documentary Biography and Collected Works* (New York: Anthology Film Archives/Film Culture, 1984), 265–7.

8. Deren's invokes ludic imagery and anonymities reminiscent of Surrealism, particularly of May Ray's *Les Mystères du Château de Dé* (see Chapter 2), and *Ritual* ends with a negative image similar to that near the end of Man Ray's; the widow flees to the sea and her dark hair and costume are now white against a dark watery ground as she sinks below the surface. However, this figure is in motion and doesn't take on the marmoreal, sculptural quality of his.

9. Vèvè A. Clark *et al.*, *The Legend of Maya Deren*, Vol. I, Part 2, 459.

10. The unidentified sculpture is not dissimilar to work of the 1940s by Herbert Ferber, and certain other sculptors associated with Abstract Expressionism.

11. The gardens were designed by William Welles Bosworth, an École des Beaux-Arts-trained architect and landscape designer, in 1915 and inspired by ancient Indo-Persian gardens, but also incorporated Mycenaean and Greco-Roman architectural features as well as statuary (a reproduction of the monumental Farnese Hercules is visible in the background of some of Deren's shots).

12. Also known as *Three Dancing Maidens*, this *Untermyer Fountain* was donated to the Garden Conservatory in Central Park, after Untermyer's death.

13. Clark *et al.*, *The Legend of Maya Deren*, 459.

14. Brigitte Peucker, "The Fascist Choreography: Riefenstahl's Tableaux," in *The Material Image: Art and the Real in Film* (Stanford University Press, 2007), 49–67.

15. Maureen Turim, "The Ethics of Form: Structure and Gender in Maya Deren's Challenge to Cinema," in Bill Nichols (ed.), *Maya Deren and the American Avant-Garde* (Berkeley: University of California Press, 2001), 88. See also P. Adams Sitney, *Visionary Film: The American Avant-Garde, 1943–2000* (3rd edn.) (Oxford University Press, 2000), 232–5.

16. Sitney, *Visionary Film*, 59.

17. ibid.

18. I have identified the sculpture as *Plenty* (or *Agriculture*), an allegorical figure (with cornucopia and wreath) from the *Pioneer Memorial*, also known as the *Pioneers Monument* and *the James Lick Memorial*, San Francisco Civic Center, completed 1894 by sculptor Frank Happersberger (1859–1932).

19. James Broughton, *Coming Unbuttoned: A Memoir* (San Francisco: City Lights, 1993), 85.

20. Broughton, *Coming Unbuttoned*, 89.

21. Sitney, *Visionary Film*, 55.

22. Broughton, *Coming Unbuttoned*, 96. The four poems were among those published in Broughton's *Musical Chairs: A Songbook for Anxious Children* (San Francisco: Centaur Press, 1950).

23. Broughton, *Coming Unbuttoned*, 96.

24. Broughton, *Coming Unbuttoned*, 96–7.

25. Broughton, *Coming Unbuttoned*, 106. After its original six-month exhibition in London in 1851, the Crystal Palace had been moved to suburban Sydenham in 1852 and a magnificent park built around it, with gardens designed by Edward Milner and a statuary program for the terraces and fountains designed by Raffaele Monti, both under the supervision of Sir Joseph Paxton. It was the remains of this part of the park that provided the setting for *The Pleasure Garden*, which features footage of dozens of statues in various states of disrepair, including sculptures created for the setting by Monti and others (e.g. personifications *South America*, *India*, and *California*, and of *Flora* or *Spring*, *Love*, *Hope*, and *Mirth*) and copies of famous classical statues (among others, the Farnese Hercules, the Apollo Belvedere, the Venus of Arles, the *Ares Borghese*, the Diana of Gabii, a Discophoros, portraits of Aristides and Plutarch, and an Egyptian Sphinx, like many of the others copied from an original in the Louvre), as well as nineteenth-century neo-classical masterpieces by Bertel Thorvaldsen (*Adonis*, *Psyche with the Jar of Beauty*, *Venus with the Apple*, *Mercury*, *Shepherd Boy*), Antonio Canova (two *Dancers*), and Luigi Bienaimé (*Telemachus*). Although sections of the park have changed and much of the statuary is gone (most of what could be recovered was sold in 1957), the Italian Terraces have been conserved and some sculpture seen in *The Pleasure Garden* remains, the giant bust of Sir Joseph Paxton, for instance.

26. Terry Sheehy, "Celebration: Four Films by James Broughton," *Film Quarterly* 29, 4 (Summer 1976), 7.

27. Along with Cocteau's *Orphée* (1950) and Maas's *Narcissus* (1956), Tyler illustrates a still from *Serenity* (1961) but might have used stills from any number of Markopoulos's films, especially the trilogy *Du sang, de la volupté et de la mort (Of Blood, of Pleasure and of Death): Psyche, Lysis, Charmides* (1947–8). Greek classical culture was an especial touchstone for Markopoulos.

28. Parker Tyler, *The Three Faces of the Film: The Art, the Dream, the Cult* (New York: Thomas Yoseloff, 1960), 17.

29. "Of all the arts, the movies are assumed – or at least hoped – to express the sensibility of a 'great aesthetic collective': the 'great,' of course, defining *quantity* rather than *quality*. Cocteau's last Myth film, *Orpheus* (1950), super-telescoped the chamber drama of his earlier 'Experimental' *Blood of a Poet* by tracing, as it were, his own history as an avant-garde artist who became a member of the French Academy. At last, he might enter the Museum by the front, rather than the back, door – and that is what he did. The irony remains that the Museum has come to have only illusive walls; indeed, as such, it parallels *The Blood of a Poet*'s last scene when his muse, an armless statue, solemnly proceeds out of the art salon, where he has shot himself, into the indefinably open space of the stars – the 'stars,'

one might add, of the movies as well as of the universe." Tyler, *The Three Faces of the Film*, 21.

30. Sitney, *Visionary Film*, 29–30.

31. See Susan Felleman, *Art in the Cinematic Imagination* (Austin: University of Texas Press, 2006), Ch. 1; and Steven Jacobs and Lisa Colpaert, *The Dark Galleries: A Museum Guide to Painted Portraits in Film Noir, Gothic Melodramas, and Ghost Stories of the 1940s and 1950s* (Ghent: AraMER, 2013).

32. Felleman, *Art in the Cinematic Imagination*, 61–73.

33. See Felleman, *Botticelli in Hollywood*.

34. In a 1964 letter to Yves Kovacs. See Felleman, *Botticelli in Hollywood*, 96, 137 n. 55.

35. This phrase from a 1941 letter of Lewin's to a science journal expresses his theory of aesthetic "radiance," the effect of "subjective time" in a "relative world." See Felleman, *Botticelli in Hollywood*, 96, 137 n. 50.

36. "The signification of the statue, for Hollywood, merges into the movies' perennial concern with class and status (etymologically and morphologically, statue and status are virtually the same word). As an undisputed emblem of Western culture, the (neo)classical statue signifies both Hollywood's claim to culture and, paradoxically, its association of classicism with suspect, effete qualities of the 'old world' ... And then there is the common 'classicism' of such statues and of the Classical Hollywood films that they stand for and in: legible, legitimate, made with regular proportions and smooth, seamless contours, according to long-established canons. Overdetermined – magical idol, fetish object, memorial portrait, status symbol, bearer of cultural patrimony, classical canon – the statue somehow embodies many of the conflicts and contradictions effortly suppressed by the classical Hollywood film," Felleman, *Botticelli in Hollywood*, 72. This analysis pertains to other classical Hollywood uses of sculpture, especially in relation to stars, for instance those figural works used in *The Song of Songs* (Rouben Mamoulian, 1933), a Marlene Dietrich vehicle I have discussed in the first chapter of my *Real Objects in Unreal Situations: Modern Art in Fiction Films* (Bristol: Intellect, 2014).

From Pompeii to Marienbad: Classical Sculptures in Postwar European Modernist Cinema

STEVEN JACOBS AND LISA COLPAERT

MEN, WOMEN, AND STATUES

The statue is a significant motif in many key films of the European modernist cinema of the 1950s and 1960s. Famous examples are *Les Statues meurent aussi* (Alain Resnais and Chris Marker, 1953), *Viaggio in Italia* (Roberto Rossellini, 1953), *L'Année dernière à Marienbad* (Alain Resnais, 1961), *La Jetée* (Chris Marker, 1962), *Jules et Jim* (François Truffaut, 1962), *Méditerranée* (Jean-Daniel Pollet, 1963), *Le Mépris* (Jean-Luc Godard, 1963), *Il Gattopardo* (Luchino Visconti, 1963), *Une Femme mariée* (Jean-Luc Godard, 1964), *Gertrud* (Carl Theodor Dreyer, 1964), and *Vaghe stelle dell'orsa* (Luchino Visconti, 1965).[1] Focusing on Rossellini's *Viaggio in Italia* (*Journey to Italy*, 1953) and Resnais' *L'Année dernière à Marienbad* (*Last Year in Marienbad*, 1961) as cases in point, this chapter not only traces the fascination for sculpture in modernist cinema but also explains it by examining the ways in which statues are presented as tokens of death, time, history, myth, memory, the human body, and strategies of doubling – important topics for many of the leading modernist directors working in the 1950s and 1960s.

Roberto Rossellini's *Viaggio in Italia* tells the story of Katherine and Alexander Joyce (Ingrid Bergman and George Sanders), an uptight English couple whose troubled marriage reaches a crisis when they travel to Naples to settle the estate of a deceased relative. The film's loose plot is structured around a series of excursions Katherine takes to famous tourist sites, among which is the National Archaeological Museum that hosts an extensive collection of Greek and Roman statues. As Bergman remembers in her autobiography, the first two weeks of shooting consisted of her "staring at ancient statues in the Naples Museum while an equally ancient guide bumbled on about the glories of Greece and Rome."[2] The guide in fact shows Katherine world-renowned masterpieces of classical sculpture such as several of the so-called Farnese marbles, a Venus statue, busts of Roman emperors, and some bronze sculptures from Herculaneum.

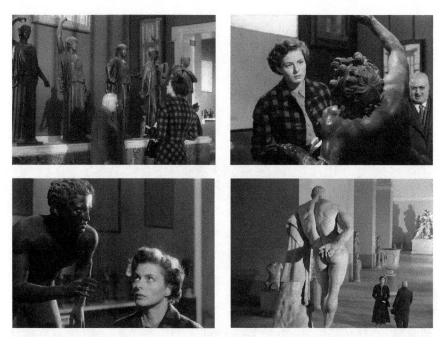

Figures 6.1 to 6.4 *Katherine Joyce (Ingrid Bergman) looking at the the Danaids of the Villa dei Papiri, the Drunken Faun, and the Runner of Herculaneum as well as at Farnese Hercules at the Archaeological Museum of Naples,* Viaggio in Italia *(Roberto Rossellini, 1953) – Digital Stills.*

In *L'Année dernière à Marienbad* a sculpture is almost one of the pro-tagonists; the film tells the story of a man (called "X" in Alain Robbe-Grillet's screenplay) who tries to convince a woman ("A") that they have met a year before in the garden of a chateau, near a sculptural group of a man, a woman, and a dog.[3] In contrast with the famous pieces of sculp-ture belonging to a prominent museum featured in *Viaggio*, the statue in *Marienbad* was specially made for the film. The sculpture was created under the supervision of set designer Jacques Saulnier in collaboration with artist Claude Garache, at huge expense and with huge effort.[4] It was made "from *papier-mâché*, which was light, something that anybody could move from one spot to another" to facilitate changing its location in the course of shooting the film.[5]

In *Viaggio* and *Marienbad* the sculptures appear at significant moments, giving form to existential troubles arising from the narrative. In both cases the visitations are punctuated by the soundtrack, albeit in opposite ways. In *Viaggio*, Renzo Rossellini's music starts when Katherine enters the museum, whereas in *Marienbad* the haunting organ music suddenly stops with the first exterior shot of the film showing the statue. The music and the silence in

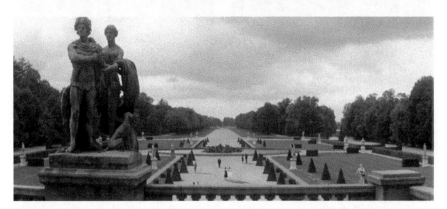

Figures 6.5 and 6.6 L'Année dernière à Marienbad *(Alain Resnais, 1961) – Digital Stills.*

Rossellini's and Resnais's films respectively contribute to the creation of a dramatic and somewhat eerie tension in the scenes involving the statues. Furthermore, the scenes are charged with feelings of uncertainty and mystery. In *Viaggio*, both the music and the restless camera movements that track the sculptures and Katherine create a feeling of unquiet. However, in line with Rossellini's characteristic preference for "dedramatization," every tension is immediately suppressed. For Peter Bondanella, the museum scene is "one of the most important sequences in the film" because it perfectly makes apparent the "deficiencies" of Rossellini's work when compared with conventional film practices.[6] After all, "nothing happens" in the museum – we are only watching a character that is watching. Despite the historical comments of the museum guide (including gruesome stories about Roman emperors killing their own family members) and despite the "animating" camera movements, the sculptures remain harmless, mute, incomprehensible, and enigmatic. In addition, this feeling of uncertainty affects Bergman's

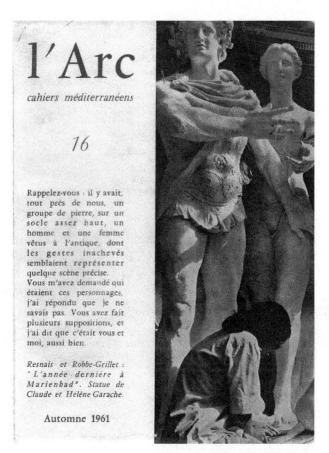

Figure 6.7 *Cover of* L'Arc *16 (Autumn 1961) with a photograph of artist Hélène Garache working on the statue featuring in* L'Année dernière à Marienbad *(Alain Resnais, 1961).*

character as well as the viewer as both become gradually aware of the "meaning" of the sculptures. Only later, it becomes clear why the visit to the sculpture gallery is a pivotal moment in the film. It is in the museum that Katherine is for the first time confronted with the raw physicality of the classical statues (on which we will elaborate in a following paragraph) and that she starts to realize that her previous Romantic and spiritualist preconceptions about Italy and classical antiquity were incorrect. Moreover, the confrontation with the Italian landscape and the sculptural remnants of classical antiquity also make her aware of her own situation. In particular the sensual and hedonistic nudes remind Katherine of her own unhappy and cold marriage.

While in *Viaggio* the sculptures invoke both death and desire, in *Marienbad*, the uncertainty about the "meaning" of the statue is fundamentally

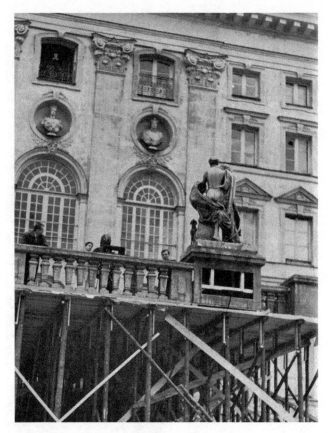

Figure 6.8 *Set photograph showing the statue and the balustrade in* L'Année dernière à Marienbad *(Alain Resnais, 1961). Published in* L'Arc *31 (1967).*

embedded in the plot. In a scene set in a shooting gallery, X (Giorgio Albertazzi) reminds A (Delphine Seyrig) that

> we were near a stone statue on a tall pedestal. A man and woman in classi-
> cal dress. Their pose seemed to represent something definite. You asked me
> who they were. I said I didn't know. You tried to guess, and I said that they
> might as well be you and I . . . Someone named the statue. He said they were
> mythological figures, gods or heroes from ancient Greece. Either that, or an
> allegory of some sort.

Furthermore, X mentions that both of them interpreted the gestures of the figures in the sculpture differently. For X, the gestures denote the awareness of danger and protection whereas A interprets them as a feeling of surprise. X and A had also discussed the names of both figures. A interpreted them as Pyrrhus and Andromache, or Helen and Agamemnon, whereas X said that

the statue represented himself and A, or . . . anybody. For M (Sacha Pitoëff), the third main character in the film,

> the statue represents Charles III and his wife, but it does not date from that period, naturally. The scene is that of the oath before the Imperial Diet, at the moment of the process of treason. The classical costumes are mere convention.

Resnais and Robbe-Grillet, in short, have deliberately blurred the meaning of the statue, its very form scattered over different art-historical periods, styles, and figures.

AGALMATOPHILIA

The fascination with the interaction between characters and statues is not only to be found in *Viaggio* and *Marienbad*: it marks most of the masterpieces of European modernist cinema dealing with sculptures. *Le Mépris (Contempt*, Jean-Luc Godard, 1963) seems an important exception as the world of its characters and those of the gods (represented by means of replicas of famous Greek statues) are strictly separated. Rotating on their axis (as in Dreyer's documentary on Thorvaldsen discussed in Chapter 3), the gods display their panoptic gaze overlooking the characters in a story about a film adaptation of the *Odyssey*, which is filled with references to Rossellini's *Viaggio in Italia* – the all-encompassing gaze of the gods is emphasized by showing them against the clouds or a blue sky reminiscent of the opening sequence featuring a crane dolly.

In *Marienbad* and *Viaggio*, by contrast, characters and statues seem to belong to the same realm, their physical confrontation a theme elaborated by both Rossellini and Resnais. In *Marienbad*, the statue seems to exemplify the cool eroticism that typifies the relations between the characters. In *Viaggio*, Katherine's encounter with the statues is presented as a series of profound, intimate, and physical confrontations. Katherine is not only dwarfed by the Farnese marbles: she is also deeply moved by the powerful rawness of the stone and bronze statuary, which evokes an overtly physical and sexual presence – already in the 1780s, when it was sent to Naples, the Farnese Hercules was notorious for disconcerting many ladies with its "large brawny limbs."[7] Katherine's tourist guide specifically dilates on the sensuality of the nudes and makes a connection with the state and age of the visitor. "This is the Venus I like most, she is not as young as the others, she is more . . . mature. Don't you agree, lady?" The museum guide's comments help to emphasize the contrast between classical civilization's acceptance of the nude body and Katherine's puritanical sexual repression.[8] Tellingly, the guide starts

his tour by referring to the so-called secret cabinet, the collection of erotic or sexually explicit finds from Pompeii, which were locked away in separate rooms in the Archaeological Museum.

By focusing on the physical interaction between the sculptures and their beholders, Rossellini joins a long tradition of humans falling in love with statues – a phenomenon harking back to the Hellenistic era, in which Greek figure sculpture first began to embody a divine beauty by means of a heightened sensuousness and evocation of tactility. Hellenistic sculptures, such as the ones admired by Katherine in *Viaggio*, represent human bodies caught in the midst of a sudden motion and seem to be animated by a surge of life that goes well beyond the stately traditions of earlier cult statues. Physical sensations seem to fill the work of art, also reflecting its carnality on the beholder. As George Hersey demonstrated in his fascinating book on the topic, Hellenistic writers even wrote stories involving the act of sexual intercourse with statues.[9] Outlandish examples of a love for statues, or agalmatophilia, can also be found in the modern age – in the eighteenth century, for instance, several Venus sculptures, such as the "more mature" one celebrated by the museum guide in *Viaggio*, became the object of the most impassioned form of agalmatophilia.[10] Furthermore, throughout the nineteenth and early twentieth centuries, classical statues and their graphic and photographic reproductions often had erotic powers (both heterosexual and homosexual) as they were for a long time the only open or public sources of nudity. Remnants of a culture not bound by Christian or bourgeois morality, classical nudes often provided an alibi for those seeking to avoid prosecution for obscenity.[11]

PYGMALIONISM

Tellingly, Rossellini focuses on some masterpieces of Hellenistic sculpture, which aspired to create the illusion of a frozen movement. The sculptures convey movement in stillness; they are images of life in inanimate stone. Caught on film, as if Pygmalion were handling the camera instead of the chisel, the statues relive this inner life. Although Ingrid Bergman stated that Rossellini "wanted to show . . . the laziness of all the statues,"[12] they seem to come to life thanks to the highly mobile camera that trails the sculptures as well as Bergman's character who contemplates them. According to Laura Mulvey, Rossellini celebrated the way these Hellenistic sculptures transferred movement in stillness as he tried to imitate the sculptor's attempt to create the appearance of an action caught in suspended animation.[13]

Several commentators have noted that in the Naples sculpture gallery scene, camera movements often start at an art work and end up, without intercutting, at Bergman's facial expressions, taking both objective and subjective

viewpoints into one single sliding whole. In so doing, these pronounced camera movements stand in opposition to the earlier point-of-view shots that have kept her visually, and thus psychologically, dissociated from what she is seeing and experiencing.[14] By employing uninterrupted long takes, Peter Bondanella notes, "Rossellini forces the spectator into an active, rather than a passive, role because the audience must search in the photographic image of the art work for clues to the character's reaction."[15] Moreover, Rossellini's crane and tracking shots create a bond between sculpture and beholder, situating statues and human beings in the same spatial continuum. Pedestals are abolished or off-frame, flesh and bronze occupy the same space. Encircling the statues with his mobile camera, Rossellini expresses Katherine's physical attraction to them and presents the camera as a magic means that brings life to the blocks of stone and the shapes of bronze.

In *Marienbad*, the camera also animates the statue, albeit very differently. Resnais shows the sculpture in different locations, against different backgrounds, and from different angles, echoing the diverging narrative perspectives on the sculpture. First and foremost, the statue is brought to life thanks to Sacha Vierny's bravura camera movements, rendering the sculpture as a plastic object and linking it to its surroundings as well as to the bodies and gazes of its beholders. We make the acquaintance of the sculpture in the first exterior shot in the film, which is punctuated as the haunting music accompanying the previous tracking shots suddenly stops. The silence and the statue's immobility resonate with its setting, a French garden, an image of nature subjected to geometrical order. Nothing seems to move in this garden – an effect that is emphasized by the notably static camera, which contrasts with the fluent camera movements of most of the previous scenes and which, at the time of *Marienbad*'s release, had already become a hallmark of Resnais' style. Later in the film, Resnais uses his typically mobile camera in a sequence in which the statue is explored extensively. In one single shot, the camera gradually and successively reveals a balustrade, the garden, and A, who guides our look along the central axis into the endless vista. Finally, as the camera continues the movement and starts to climb, it frames the statue against the clouds. This long take is followed by upward and laterally tracking camera movements, as well as with a series of low-angle and high-angle shots, showing different sides of the statue and framing its details against the water of the pond, the central axis of the garden, the trees, and the sky. Meanwhile, the voice-over of X explicitly draws attention to the statue. First, X states that he saw how A turned toward him and how he told her that she had an "*aire vivante*" – emphasizing that she moves and that she has a lively expression, X in fact affirms that A is *not* a statue.

Strikingly, *Marienbad*'s sculpture in the round is never fully explored by means of one single, continuous take. Unlike the mobile camera in *Viaggio*,

Resnais' camera does not turn around it. The many tracking shots only show the front *or* the back of the sculpture. In the one scene in which the statue is explored extensively, we see the different sides only in separate shots. The view is interrupted, and various angles are combined through montage, perfectly in line with the "classicist baroque" style of the sculpture. Since the statue presents itself resolutely as a three-dimensional object, protruding into space by means of gestures and postures, it entices us to look from different viewpoints. In line, however, with the classicist tradition and with Adolf von Hildebrand's influential theories on sculpture, it privileges multiple views that can be combined with other single views but cannot be rendered in one single comprehensive perception. Also, in this respect, the statue exemplifies the plot and theme of *L'Année dernière à Marienbad.*

The Art of Petrification and Mortification

For both Rossellini and Resnais, cinema is a Pygmalion-like or an animistic agent that breathes life into the static art of sculpture. But, as in many other modernist films featuring sculptures, cinema's magical powers also work in the opposite direction as the human characters acquire sculptural presence. While cinema mobilizes or animates the statues, the actors seem petrified. Rossellini's mobile camera explores not only the classical statues but also the body and face of Ingrid Bergman, who seems to be in a state of stillness and absorption. In *Marienbad*, this is taken a step further as the garden sculpture connects with the statue-like characters and extras in the film. In particular, Delphine Seyrig assumes statue-like poses (hand on the shoulder, arms against the body, twisted torso), offering her body to be seen in a particular way, like posing for a photograph, and also evoking even art-historical precedents such as the Hellenistic *Crouching or Kneeling Venus*. Also, the images of A that emerge from X's verbal descriptions constantly seem to fix her body into a specific position: "Vous étiez assise," "le bras étendu sur la balustrade," et cetera. Apart from transforming Seyrig into a sculpture-like appearance, Resnais also staged most scenes of the film as tableaux vivants, a practice that can be found in major works by prominent modernist directors such as Pier Paolo Pasolini, Jean-Luc Godard, or Raul Ruiz, who were fascinated by the oppositions of movement versus stasis, pictorial or sculptural space versus cinematic space, iconic immediacy versus filmic duration, and so forth.[16] In their films, tableaux vivants acquire a mysterious density. The aestheticization of immobility creates blockages that result in a kind of enigma or uncanny mystery.

With their restlessly moving camera Rossellini and Resnais situate the immobile characters in a long tradition of fantasies in which living beings are

turned into stone whether through love, grief, terror, or jealousy. Examples include such mythological figures as Niobe, Aglauros, Echo, and Atlas.[17] In addition, contemplating and mirroring actual statues, the petrified characters are perfectly in line with the aesthetics of modernist cinema that firmly resist the notion of speed so crucial to action-based "conventional" or "classical" cinema. Mute sculptures and petrified characters populate the long takes and open-ended narratives of modernist cinema, evoking alienation and boredom. For a cinema of duration "in which nothing seems to happen" or a model of film that Andrey Tarkovsky tellingly defined as a form of "sculpture in time," the stillness and immobility of sculptures make a perfect match.[18]

Furthermore, the ultimately commemorative art, sculpture, is inherently connected to the past, history, and memory – themes that are particularly important in the oeuvre of Alain Resnais. In addition, sculpture is also the funerary art *par excellence*. With their fixity and "strange opacity making them seem at once so ghostly and so familiar," as Kenneth Gross reminds us in his *Dream of the Moving Statue*, sculptures turn out to be "so well fitted to our mourning."[19] In *Viaggio*, the ancient bronzes and marbles are tokens of mortification as the sculpture gallery in the archaeological museum is part of an entire collection of landmarks that denote death, including the Fontanelle catacombs with its piles of bones and skulls, and, of course, the buried city of Pompeii. *Viaggio in Italia* has been described as a "journey into the realm of the dead" or as "a story of the living and the dead in which . . . the dead are more alive than the living."[20] According to Sandro Bernardi, "it is death that Katherine continually encounters on her path, or rather the cohabitation of life and death, by which one germinates the other and vice versa."[21] Rossellini himself stated that he wanted to show "Naples, this strange atmosphere in which a very real, direct, and profound feeling is fused with a sentiment of eternal life."[22] Accompanied by eerie music, the guide of the sculpture gallery tells gruesome stories about mythological figures, like the ones involved in the legend of the Farnese Bull, or about Roman emperors killing their own family members. Furthermore, Rossellini compares the muscular and sensual sculptures in the museum with the broken bodies venerated at other Naples tourist sites, such as the skeletons at the catacombs and, particularly, the excavated and fossilized bodies of Pompeii. In the penultimate scene of the film, archaeologists slowly and gradually reveal the plastered imprints of a man and a woman wrapped tightly in each other's arms, who were instantly killed by the great eruption of Vesuvius in AD 79. The sculpture-in-the-making strongly affects Katherine and Alex (who earlier flirts with a girl with a plaster leg). In *Marienbad*, too, sculpture is a token of mortification. Resnais' film has even been interpreted in its

entirety as an Orphic descent in the hereafter.[23] The guests of the palace are like living dead. Automatons with frozen faces, they seem stone-like figures dismounted from their pedestals.

The link between sculpture and death is a recurrent topic in many modernist films of the 1950s and 1960s. It is even emphasized in the title of *Les Statues meurent aussi* (*Statues also Die*, 1953) by Alain Resnais and Chris Marker. Dealing with African art and a vehement criticism of colonial politics and of the way sculptures are removed from their original contexts and turned into museum objects, the film emphasizes the association between sculpture and death as the opening shots of demolished bas-reliefs and fractured statues in gothic ruins are accompanied by the following words: "When men die, they enter into history. When statues are dead, they enter the realm of art. This botany of death is what we are calling culture." Marker included also imagery of decomposing statues and fractured faces of sculptures in *La Jetée* (1963), a film reflecting on the tension between static and moving images as its story is told by means of photographs. Sculptures, for instance, reside in the underground spaces among the survivors of an apocalyptic war. In so doing, these statues function as a token of a lost civilization or as a reminder of a mankind that has been eradicated. Tellingly, sculptures are the subject of the first image that the protagonist remembers during his time travels, indicating statues' capacity to fix elusive memories. Likewise, statues also abound in *Si j'avais quatre dromadaires* (1966), another Marker film only consisting of still images. For Marker, sculpture not only evokes the fixity of time, it also hypostasizes the relation between the still and the moving image. Along similar lines, in his poetic essay film *Méditerranée* (1963), Jean-Daniel Pollet links shots of sculpted relics, fractured Egyptian busts, and sarcophagi to an image of a comatose girl – uncertain whether they are alive, asleep, or dead, they all are represented as fossilized beings equipped with the mysterious and petrified gaze from a distant past.

CLASSICISM

As the sculptures in both *Viaggio* and *Marienbad* are connected to the themes of death, memory, and the passing of time, it is also telling that both Rossellini and Resnais, in their stories about alienation in the modern world, use old (or old-looking) statues instead of contemporaneous pieces of modern sculpture. More specifically, the statues in *Viaggio* and *Marienbad* are pieces of classical sculpture or they evoke classical associations. As mentioned, the museum visit in *Viaggio* focuses on famous, even canonical masterpieces of Greek and Roman antiquity, many of them already admired in the eighteenth century.[24] Rossellini, for instance, filmed the contemplation by Ingrid Bergman's

character of the bronze statues from the Villa of the Papyri at Herculaneum, among which are a satyr, a group of Danaids, a young athlete, and a life-size Drunken Faun. In addition, the museum visit also includes a look at the *Venus pudica* and the busts of Roman emperors Caracalla, Nero, and Tiberius. Last but not least, Rossellini's camera explores the famous so-called Farnese Hercules and the Farnese Bull, which are monumental Roman copies of Hellenistic sculptures that had been excavated in the Baths of Caracalla in Rome in the sixteenth century.

The statue that was specially made for *Marienbad* also displays classical characteristics in an inconsistent genealogy. Initially, the filmmakers thought of using a sculpture from a repository of academic statues that Robbe-Grillet had seen in the vicinity of Versailles.[25] According to prop artist Saulnier, the statue was eventually inspired by the works of the seventeenth-century neo-classical painter Nicolas Poussin[26] – the influence is certainly visible in the physiognomy of the characters, their costumes based on classical antiquity ("de convention pure" according to M), and their gestures. In particular, the gesture of one figure holding or halting another is a recurrent motif in Poussin's oeuvre. Poussin's so-called classicism is also echoed in his preference for order and dignity, the clear and legible compositional structures that underscore the narrative meaning, and the somewhat "frozen" depiction of movement. In a 2006 interview, Resnais stated that "only one figure was based on Poussin, the rest of the statue was made after drawings by [Théodore] Géricault, perhaps, or ... I don't remember. It is a collage of figures in drawings."[27] Apart from Poussin, more seventeenth- and eighteenth-century artists combined classicist and baroque elements and can be mentioned as possible stylistic sources of inspiration. A plausible candidate, for instance, is Dominik Auliczek, who made the statues in the garden of the Nymphenburg Palace where parts of the film have been shot. Furthermore, the statue's stylistic ambiguity is enhanced by its echoes of 1930s monumental Beaux-Arts classicism, which marks the sculptures that feature in the films by Jean Cocteau and are inspired by Cocteau's admiration for the hyper-muscular, neo-Grecian male figures of "Nazi" sculptor Arno Breker. As M states, the statue "does not date from that period, naturally." Its art-historical complexity corresponds with the intertwined time frames and layered histories of the film's narrative. According to Liandrat-Guiges,

> the statue is ageless. Its existence is recent. It is a simulacrum, a copy (like the statuary in *Le Mépris*), and it is clearly an adaptation of a detail from a pictorial work. Its function in the film seems to be to encourage interpretation or identification, to incite the characters to imagine things. It helps make the film a consistently open work.[28]

This fascination for classical sculpture is a recurrent topic in European modernist cinema. Practically all of the sculptures featuring in modernist cinema are classical statues. This fascination is a striking trope for a model of cinema that is more readily associated with modernist art and the *nouveau roman*. Despite its preference for *temps morts*, extended stretches of silence, long takes that situate figures in empty landscapes, and geometric shot compositions, modernist cinema of the 1960s does not prefer art pieces of contemporaneous abstraction. At a moment when the age-old tradition of sculpting human figures has been exchanged for minimal art or phenomena such as "Land Art," site-specific installations, and what Rosalind Krauss called "Sculpture in the Expanded Field,"[29] modernist filmmakers are increasingly attracted to the marble and bronze nudes of classical antiquity. When Jean-Luc Godard includes several shots of modern sculpture in his *Une Femme mariée* (1964), he tellingly inserts shots of the nudes of Aristide Maillol, no doubt the most "classical" of modern sculptors.

Several reasons can be invoked to explain this fascination with classical sculpture among modernist filmmakers. First and foremost, as Elizabeth Prettejohn has demonstrated convincingly, the rediscovery of classical sculpture is in itself a modernist endeavor and the history of modern art includes important flares of classicist styles and practices, as demonstrated by works by artists such as Von Hildebrand, Rodin, Cézanne, Puvis de Chavannes, and Maillol. Even Pablo Picasso, who was struck by the colossal figures among the Farnese marbles on his trip to Naples in 1917, had a "Classicist" phase in the 1920s and 1930s.[30] Classical sculpture was also called into play in works by Surrealist artists. In line with their fascination with mannequins, dolls, and automatons, artists such as Man Ray, Salvador Dalí, René Magritte, Paul Delvaux, Jean Cocteau, and Giorgio de Chirico presented classical statues to designate concepts such as Justice, Beauty, Art, or as bodies sexualized through Surrealist practices like combinatorics, veiling, and exposure. As is demonstrated in Chapter 2, classical statues also abound in mid-twentieth-century films inspired by Surrealism. With its Pygmalionism, oneiricism, and morbid fascination with lifeless bodies, *Marienbad* is certainly marked by a Surrealist influence. Resnais initially even thought of Max Ernst for the production of the statue, having realized a short film showing Ernst at work in 1947, but he eventually ended up creating a classical sculpture reminiscent of the figures on a Poussin painting.[31] In its eerie tableau-like imagery, *Marienbad* particularly reminds us of the paintings by Delvaux, who also dealt explicitly with the theme of Pygmalionism – in particular, the actress of the theater play in the opening sequence seems to step out of a Delvaux painting. What's more, as Raymond Durgnat noticed earlier, *Marienbad* recalls Henri Storck's 1946 experimental documentary *Le Monde de Paul Delvaux* "with its Surrealist

canvasses of sad-eyes nudes and aimless men straying against ruins and crumbling statues."[32]

As was mentioned in the introduction, up to the 1960s, many trends in modern sculpture were marked by a restrained and archaizing classicism, which was inherently connected to the representation of the human figure, which remained, in the words of Penelope Curtis, an evident "vehicle for allegorical decoration, commemoration, material innovation, and Surrealist symbolism."[33] According to Curtis, this kind of "figurative sculpture represented one of the more tangible links with this past, in the very real form of surviving ancient statuary."[34] This phenomenon was particularly important in France, where it was part of a larger trend of "Mediterraneanism" marking French modernism reaching back to Cézanne and Matisse and perfectly visualized by the sculptures of Maillol.[35] Key French modernist films with statuary imagery such as *Le Testament d'Orphée* (Jean Cocteau, 1960), *Le Mépris* (Jean-Luc Godard, 1963), and *Méditerranée* (Jean-Daniel Pollet, 1963), as well as Rossellini's *Viaggio in Italia*, unmistakably relate to this "Mediterraneanism" conveyed by an interest in classical statues expressing a kind of "gravitas." This gravitas answered perfectly to the slowness and silence cherished in modernist cinema – qualities that have also been attributed to the modernist classicism of Maillol.[36]

Furthermore, many of the masterpieces of classical art, such as the *Venus de Milo*, the Elgin marbles, the temple sculptures of Aegina, or the statues by Praxiteles and Polykleitos, appeal to the modern art lover as they survived only in a fragmentary and fractured condition. This brings a sense of the untimely or a notion of time effaced as well, but it also transforms the aesthetic ideal of classical antiquity into something very modern. As a result of their fragmentary and fractured condition, many ancient sculptures promote values strangely at odds with the classical ideals of physical perfection. Marguerite Yourcenar has written about the attraction of old statues as a paradoxically modern sensibility.[37] It is the modern eye that discovers the beauty of the porous fragility of depatinated stone. Time itself has become a kind of second sculptor, transforming the statues as they are being marked by alternating phases of adoration, admiration, love, hatred, and indifference, and successive degrees of erosion and attrition. Statues have often been so shattered that out of the debris a new work of art has been born. Sometimes they are in the process of returning to the state of unformed mineral mass out of which their sculptor created them. For Yourcenar, the statues of the Parthenon are turned into cadavers and ghosts, and it is precisely our predilection for abstract art that causes us to like these lacunae and fractures. They appeal to the modern eye accustomed to the deformed bodies of Alberto Giacometti or Francis Bacon. John Maybury's biopic of Bacon, *Love Is the*

Devil (1998), makes exactly this connection in the scene in which the painter contemplates a fragmented torso in the Parthenon sculptures. An art of framing and editing, film, like photography, plays perfectly on this sensibility. As Mary Bergstein noted, "the pathos of the fragment speaking from the past . . . is suggested through the traditional discipline of the photographer's craft: lighting, framing, cropping, selective depth of field."[38]

Mediated by the cinematic gaze, classical statues are almost presented as the pieces of 1950s and 1960s modern European and American figurative sculpture by artists such as George Segal, Marino Marini, Germaine Richier, Henry Moore, or Alberto Giacometti, favoring fragmentation and weathered surfaces. In particular the attenuated forms of Giacometti's isolated figures came to be seen as reflecting the modernist and existentialist view that modern life is increasingly empty and devoid of meaning. In Jean-Paul Sartre's often-cited 1948 essay on Giacometti's sculptures, the sculptor's long, indistinct silhouettes that move against the horizon are interpreted as sketchy forms halfway between nothingness and being.[39] This Sartrean nothingness also marks modernist cinema with its preference for stories about estranged people who have lost the ability to fundamentally connect to others and to the world.[40] For modernist directors, cinema had precisely the task of expressing the emptiness that hides behind the surface of physical reality.[41] In *Viaggio* and *Marienbad* as well as in many other instances of European modernist cinema, long shots situating "statuary" characters against large empty spaces, often framed in sophisticated wide-screen compositions, are screen versions of Giacometti's lost figures.

CONCLUSION

In both *Viaggio* and *Marienbad*, sculptures refer to the weight of history (of classical antiquity) or simply to a time that has past (since last year in Marienbad). However, the sculptures in these films also denote time in the sense of duration, epitomized by the open-ended narratives and the preference for slowness and *temps morts* in the films' plots. *Viaggio* and *Marienbad* are thus marked by two opposing forces: static statues are turned into something dynamic by means of the power of cinema, but the living characters are changed into immobile beings as a result of the cinema of the "time-image" (Deleuze) that eschews movement. While a highly mobile camera animates the historically-informed classical statues, the characters are petrified into an enduring state of absorption that is perfectly in line with the fascination with stasis and duration of modernist cinema. This double dynamics reaches back to many precedents. Kenneth Gross has demonstrated that the "fantasy of a statue coming to life is always joined with the opposing fantasy of a living

being turned to stone."[42] For Gross, this is related to the fact that the fantasy of a living statue is usually not a projection of a perfected mimetic illusion but is rather "generated by the real or imaginary situation of a living person standing before the statue. Belonging properly to neither, the idea of animation translates the relational life that emerges in the space between the two."[43] In other words, not the statue itself but its physical interaction with the beholder suggests and engenders the idea of animation. After all, the art of sculpture lacks the purely fictional or representational realm of painting – it exists in "real" space. That is why the human body is so important in sculpture and why its "substantial presence" invites, in the words of Rudolf Arnheim, a "bodily intercourse."[44] Cinema presents the statue and its beholder as part of the same world and structures, by means of camera angles, editing, and camera movements, the way we apprehend the sculpture.

The confrontation of the statue with the beholder can also be seen as an act of doubling. As nearly all the sculptures in the stated cases represent human figures, they duplicate the bodies of the actors who are shown in the vicinity of the statues: Katherine facing the Herculaneum bronzes in *Viaggio*, X and M in front of the garden statue in *Marienbad*, the female protagonist meeting her lover in the vicinity of a Medici Venus in *Gertrud*, the bust of the young woman in *Jules et Jim*, the character touching the face of a statue in the MoMA sculpture garden in John Cassavetes's *Shadows*. What's more, favoring strategies of self-reflection, modernist filmmakers are attracted by statues since they are objects that already are representations. *Marienbad* takes this to the extreme as the main garden statue is mirrored by many other sculptures in the film, such as numerous statues in the corridors of the palace, the cardboard figures in the shooting gallery, the other statues displayed in the garden, and the empty pedestals that show up in the vicinity of A when she is wearing the fluttering robes reminiscent of classical statues. In addition, the garden sculpture is echoed by the petrified actors in the tableaux vivants and by the various graphical replicas or representations of statues, such as the cardboard version of a garden statue in the theater play in the opening sequence, the drawn depiction of the sculpture that decorates a wall of the interior of the palace, and the statues represented on the various photographs A is looking at. Because of its prominent visual presence throughout the film as well as on account of the numerous references in the dialogue or voice-over lines, the statue can even be seen as a *mise en abyme* of *Marienbad*: the various interpretations of the sculpture echo the contradictory accounts of the earlier encounter of the characters.

The main characters of the film each interpret the sculpture completely differently, thus illustrating one of the main themes of the film, which is the way reality is seen and remembered differently by various individuals.

According to David Bordwell and Kristin Thompson, "the statue resembles the film as a whole in several ways: its temporal and spatial situation shifts without explanation, and its meaning ultimately remains elusive."[45] James Monaco called *Marienbad* "an opera of statues."[46] Resnais himself stated that "we wanted to feel ourselves in the presence of a sculpture which one studies first from one angle, then from another, from nearer or farther away."[47] On another occasion, he declared that he wanted "to make a film which is looked at as if it were a sculpture."[48] In a *Cahiers du cinéma* issue comprising a photograph of Resnais looking at the statue through a lens, screenwriter Robbe-Grillet, finally, stated that "we can imagine that *Marienbad* is a documentary on a statue."[49] He even imagines a film entirely consisting of shots of a sculpture:

> Imagine a documentary that would succeed, with a statue of two people, by uniting a series of views taken from diverse angles and with the help of diverse camera movements, in telling in this way a whole story. And at the end you would see that you had come back to the point of departure, to the statue itself.[50]

Such a *pars pro toto* relationship between sculpture and narrative, between fragment and film, is, in fact, what *Marienbad* ultimately realizes.

Notes

1. Suzanne Liandrat-Guiges, *Cinéma et sculpture: Un aspect de la modernité des années soixante* (Paris: L'Harmattan, 2002).
2. Ingrid Bergman and Alan Burgess, *Ingrid Bergman: My Story* (New York: Delacorte Press, 1980), 307.
3. See Steven Jacobs, "Statues Also Die in Marienbad: Sculpture in *Last Year in Marienbad*," in Christoph Grunenberg and Eva Fischer-Hausdorf (eds.), *Last Year in Marienbad: A Film as Art* (Cologne: Wienand Verlag, 2015), 92–105.
4. According to Freddy Sweet, the cost of the statue was 200.000 francs. A footnote in a 1967 issue dedicated to Resnais of *L'Arc* mentions that the statue cost a million ancient francs. See Freddy Sweet, *Last Year at Marienbad: The Statues* (MacMillan Films, 1975), 33; and *L'Arc* 31 (1967), 40. On Saulnier's collaboration with Resnais see François Thomas, *L'Atelier Resnais* (Paris: Flammarion, 1989), 107–22. On Garache, see Alain Madeleine-Perdrillat, Florian Rodari, Marie Du Bouchet, *Entretiens avec Claude Garache* (Paris: Hazan, 2010), 41.
5. Suzanne Liandrat-Guiges and Jean-Louis Leutrat, *Alain Resnais: Liaisons secrètes, accords vagabonds* (Paris: Cahiers du cinéma, 2006), 224.
6. Peter Bondanella, *The Films of Roberto Rossellini* (Cambridge: Cambridge University Press, 1993), 102.
7. See Francis Haskell and Nicholas Penny, *Taste and the Antique: The Lure of Classical Sculpture, 1500–1900* (New Haven: Yale University Press, 1981), 230.

8. Bondanella, *The Films of Roberto Rossellini*, 104.
9. George L. Hersey, *Falling in Love with Statues: Artificial Humans from Pygmalion to the Present* (Chicago: University of Chicago Press, 2009), 14–15 and 93–6.
10. See Haskell and Penny, *Taste and the Antique*, 316–33.
11. See Alastair J. L. Blanshard, "Nakedness without Naughtiness: A Brief History of the Classical Nude," in Michael Turner (ed.), *Exposed: Photography and the Classical Nude* (Sydney: Nicholson Museum, 2011), 14–21; and William K. Zewadski, "Reflections of a Collector: The Classical Alibi, or How Nudity in Photography Found Cover in the Classics," in Michael Turner (ed.), *Exposed: Photography and the Classical Nude* (Sydney: Nicholson Museum, 2011), 132–9.
12. Robin Wood, "Ingrid Bergman on Rossellini," *Film Comment* 10, 4 (July–August 1974), 14.
13. Laura Mulvey, *Death 24x a Second: Stillness and the Moving Image* (London: Reaktion Books, 2006), 117.
14. See Peter Brunette, *Roberto Rossellini* (New York: Oxford University Press, 1987), 163.
15. Bondanella, *The Films of Roberto Rossellini*, 104.
16. See Steven Jacobs, *Framing Pictures: Film and the Visual Arts* (Edinburgh: Edinburgh University Press, 2011), 88–120.
17. See Kenneth Gross, *The Dream of the Moving Statue* (University Park: The Pennsylvania State University Press, 2006), 75.
18. Andrey Tarkovsky, *Sculpting in Time: Tarkovsky, The Great Russian Filmmaker Discusses His Art* (Austin: University of Texas Press, 1989).
19. Gross, *The Dream of the Moving Statue*, 36–7.
20. Sandro Bernardi, "Rossellini's Landscapes: Nature, Myth, History," in David Forgacs, Sarah Lutton, and Geoffrey Nowell-Smith (eds.), *Roberto Rossellini: Magician of the Real* (London: BFI, 2000), 58–9. See also Liandrat-Guigues, *Cinéma et sculpture*, 33–40.
21. Bernardi, "Rossellini's Landscapes," 58.
22. Roberto Rossellini in an interview with Maurice Scherer and François Truffaut, originally published in *Cahiers du cinéma* 37 (July 1954) and included in Alain Bergala (ed.), *Rossellini: Le Cinéma révélé* (Paris: Flammarion, 1984), 68.
23. See Emma Wilson, *Alain Resnais* (Manchester: Manchester University Press, 2009), 80–1.
24. See Haskell and Penny, *Taste and the Antique*, 165–7, 209, and 229–32.
25. Liandrat-Guiges and Leutrat, *Alain Resnais*, 223.
26. Jacques Saulnier, quoted in *L'Arc* 31 (1967), 55. See also Hubert Juin (interview), "Quatre de Marienbad," quoted in Jean-Louis Leutrat, *L'Année dernière à Marienbad* (London: BFI, 2000), 49–50. See also Jean-Pierre Berthomé, "Entretien avec Jacques Saulnier," *Positif* 329–30 (July–August 1988), 42.
27. Liandrat-Guiges and Leutrat, *Alain Resnais*, 224.
28. Liandrat-Guiges, *Cinéma et sculpture*, 43.
29. Rosalind Krauss, "Sculpture in the Expanded Field," *October* 8 (Spring, 1979), 30–44.

30. Elizabeth Prettejohn, *The Modernity of Ancient Sculpture: Greek Sculpture and Modern Art from Winckelmann to Picasso* (London: I. B. Tauris, 2012), 231. See also Alex Potts, *The Sculptural Imagination: Figurative, Modernist, Minimalist* (New Haven: Yale University Press, 2000), 66–7.

31. Jacques Saulnier, quoted in *L'Arc* 31 (1967), 55.

32. Raymond Durgnat, "Marienbad: Reviewed by Raymond Durgnat," *Films and Filming* (March 1962), 31.

33. Penelope Curtis, *Sculpture 1900–1945* (Oxford: Oxford University Press, 1999), 215.

34. Curtis, *Sculpture 1900–1945*, 215.

35. Curtis, *Sculpture 1900–1945*, 222.

36. Curtis, *Sculpture 1900–1945*, 220 and 224.

37. Marguerite Yourcenar, "That Mighty Sculptor, Time" (1954) in *That Mighty Sculptor, Time* (New York: Farrar, Straus & Giroux: 1982), 57–62.

38. Mary Bergstein, "We May Imagine It: Living with Photographic Reproduction at the End of Our Century," in Helene E. Roberts (ed.), *Art History Through the Camera's Lens* (Amsterdam: Gordon & Breach, 1995), 13.

39. Jean-Paul Sartre, "The Search for the Absolute" (1948), in Charles Harrison and Paul Wood (eds.), *Art in Theory, 1900–2000: An Anthology of Changing Ideas* (Oxford: Wiley-Blackwell, 2002), 599–604.

40. Andras Balint Kovacs, *Screening Modernism: European Art Cinema, 1950–1980* (Chicago: The University of Chicago Press, 2007), 66. See also Hamish Ford, *Post-War Modernist Cinema and Philosophy: Confronting Negativity and Time* (New York: Palgrave Macmillan, 2012).

41. Kovacs, *Screening Modernism*, 96.

42. Gross, *The Dream of the Moving Statue*, 128.

43. Gross, *The Dream of the Moving Statue*, 125.

44. Rudolf Arnheim, "Sculpture: The Nature of a Medium," in *To the Rescue of Art: Twenty-Six Essays* (Berkeley: University of California Press, 1992), 85.

45. David Bordwell and Kristin Thompson, *Film Art: An Introduction* (New York: McGraw Hill, 1993), 395.

46. James Monaco, *Alain Resnais* (New York: Oxford University Press, 1979), 63.

47. Peter Cowie, *Antonioni, Bergman, Resnais* (London: Tantivy Press, 1963), 148.

48. See Resnais in an interview with Nicole Zand in *France Observateur* (May 18, 1961). See also Leutrat, *L'Année dernière à Marienbad*, 51; and Claude Ollier, *Souvenirs écran* (Paris: Cahiers du cinéma/Gallimard, 1981), 50.

49. André S. Labarthe and Jacques Rivette, "Entretien avec Resnais et Robbe-Grillet," *Cahiers du cinéma* 123 (September 1961), 17.

50. Labarthe and Rivette, "Entretien avec Resnais et Robbe-Grillet," 17–18.

Of Swords, Sandals, and Statues: The Myth of the Living Statue

Vito Adriaensens

As sculpture is the classical art *par excellence*, statues abound in films set in Greek or Roman antiquity. Moreover, many of the mythological tropes involving sculptures that have persisted on the silver screen have their origins in classical antiquity: the Ovidian account of a Cypriot sculptor named Pygmalion who falls in love with his ivory creation and sees it bestowed with life by Venus, Hephaistos's deadly automatons, the petrifying gaze of the Medusa, and divine sculptural manifestation, or agalmatophany, for instance. This chapter investigates the myths of the living statue as they originated in Greek and Roman literary art histories and found their way to the screen. It will do so by tracing the art-historical form and function of classical statuary to the cinematic representation of living statues in a broad conception of antiquity. The cinematic genre in which mythic sculptures thrive is that of the sword-and-sandal or peplum film, where a Greco-Roman or ersatz classical context provides the perfect backdrop for spectacular special effects, muscular heroes, and fantastic mythological creatures. The 1960s and 1970s proved a fruitful breeding ground, with stop-motion wizard Ray Harryhausen contributing heavily to the successful animation of mythical statues in *Jason and the Argonauts* (Don Chaffey, 1963), *The Golden Voyage of Sinbad* (Gordon Hessler, 1973), *Sinbad and the Eye of the Tiger* (Sam Wanamaker, 1977), and *Clash of the Titans* (Desmond Davis, 1981); and after a second wave in the 1980s with sword-and-sorcery films such as *Conan the Destroyer* (Richard Fleischer, 1984), the trend surfaced once again in the 2010s with the action-packed Perseus chronicle *Clash of the Titans* (Louis Leterrier, 2010) and *Wrath of the Titans* (Jonathan Liebesman, 2012), and the teen updates *Percy Jackson and the Olympians: The Lightning Thief* (Chris Columbus, 2010) and *Percy Jackson: Sea of Monsters* (Thor Freudenthal, 2013).

DUST TO MARBLE

Lynda Nead has pointed out that the dream of motion has haunted visual arts from the classical period to the present, and the same can be said of the literature that spawned many of these visual representations.[1] The fascination for breathing life into the lifeless is, of course, as old as time itself. The most prevalent creational myths across different religions implicitly or explicitly employ the image of the deity as a sculptural artist who breathes life into a clay or dust effigy; more often than not, the statue is fashioned in the deity's own image, essentially making it a self-portrait.[2] The main literary sources for these myths are the writings of ancient Greek and Roman philologists such as Hesiod, Homer, Ovid, Pseudo-Apollodorus, and Apollonius of Rhodes, who not only speak of the sculptural marvel that is mankind, but of other significant statuary as well. It is the cinematic adaptation of these ancient Greek and Roman myths that I will focus on. In most accounts, it was Zeus, king of the Olympians, who commissioned the Titan Prometheus and the Olympian god of fire Hephaistos to create man.[3] Out of water and earth, Hephaistos sculpted man in the likeness of the gods. Prometheus then secretly instructed this new being in the arts of Athena and Hephaistos so that man might fend for himself. The Titan thus tricked the gods on several levels and topped things off by stealing fire from the heavens as a gift to humankind. Not only was Prometheus severely punished for his deeds, but mankind also suffered a great blow in the form of the second divine sculpture, Pandora, the first woman. Hephaistos sculpted this creature and her beauty and cunning were meant to be the ruin of man. She was gifted to Prometheus's brother, Epimetheus, and inadvertently unleashed evils from a Greek *pithos*, or storage jar, that was a wedding present from Zeus. These evils would plague mankind forever, but would not be able to extinguish the flame of hope.[4] In film, this last trope is perhaps most broadly recognized in Fritz Lang's *Metropolis* (1927), which has inventor Rotwang (Rudolf Klein-Rogge) build a robot in the guise of a woman (Brigitte Helm) – the so-called "*Maschinenmensch*" – who was created from the ground up with the sole mission of plunging the city into chaos. Incidentally, the robot is referred to as the "Whore of Babylon" in a title card.

The primordial Greek tale of sculptures coming to life was by no means restricted to a creationist context, however. Deborah Tarn Steiner has traced the function and form of statuary from Greek and Roman literary art histories, be they Homeric, Hesiodic, Ovidian, or Virgilian, to the art of archaic and classical Greece.[5] Her study lays bare a wide-ranging spectrum of representational strategies with regard to Greek statuary in both myth and reality. Steiner describes figurines and statues that doubled for the dead or

absent and preserved the talismanic properties of their originals, in what she calls an act of "presentification:" sculptures made to embody the presence of people or deities. This phenomenon is still widespread across many different world religions, such as Shinto, Buddhism, and Hinduism. In ancient Greece, these sculptures led to a symbolic use in rituals where the effigies would be honored or cursed, without dismissing the possession of other properties, for "combined in the single piece, several kinds of image 'magic' are at work."[6] The craftsmanship with which these statues were animated by late sixth- and early fifth-century sculptors is a case in point. Steiner rightly argues that the artistry and materiality of these sculptures elevated them from mere representational objects to vivified artifacts.[7] This animation was effectuated through inscriptions and ornamentation that highlighted its status as an object of craftsmanship, and, more importantly, through posture and anatomy. The development in Greek sculpture from the Archaic (800–500 BC) to the Classical (500–323 BC) period saw the hesitant *contrapposto* and stiffness of the *kouroi* give way to a more naturalistic freedom of movement of expression, or as Richard Neer describes it:

> The result was an amplified, hyperbolic version of the Archaic style. Classical *contrapposto* ratcheted up the internal inconsistencies of the kouros stance, and Classical movement bet everything on striking and awing the beholder. From the poise of the kouros to the headlong rush of the Tyrannicides is a natural evolution.[8]

The dynamic postures of the Classical period were, indeed, amplified. From Kritios and Nesiotes's threateningly advancing musclemen Harmodius and Aristogeiton, known as the Tyrannicides or tyrant killers (477–476 BC), and Polykleitos's athletically balanced Doryphoros in *contrapposto* (450–400 BC) to Myron's unnatural but compellingly dynamic discus-throwing Discobolus (460–450 BC) and Lysippos's monumental leaning Hercules, known to us as the Farnese Hercules (fourth century BC) discussed in Chapter 6, Classical Greek sculpture embraced movement to the extent that it sought to blur the lines between bronze and flesh. The illusion of life that exudes from these idealized frozen bodies was sometimes even complemented by an open mouth that not only fit a narrative context in which the subjects spoke or sang to one another, but could also indicate the process of breathing.[9] The magical qualities that these statues possessed by grace of their supreme craftsmanship came to fruition in the expansive mythology that put their subject in perspective and could make them come to life quite literally. It was these tales, situated in an almost timeless antique world populated with Olympian gods, demigods, monstrous creatures, and mysterious living statues, which found their way to the silver screen.

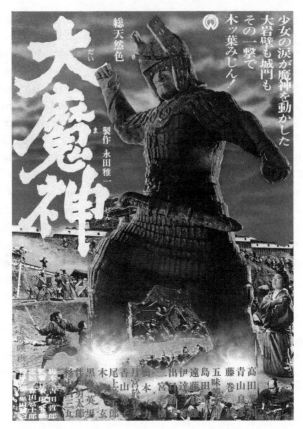

Figure 7.1 Daimajin (Majin the Hideous Idol; *Kimiyoshi Yasuda, 1966*) *poster – Private Collection.*

Not all of these settings were necessarily timeless, however, and some living statue mythologies also reflected a specific cultural or religious interpretation. The Judaic myth of the Golem is one of these. The word itself goes back to a biblical reference made in Psalms 139:16, wherein "golem" refers to Adam as a piece of clay yet unfinished by the sculpting deity. This would translate itself into the Talmud, and was most lastingly picked up in the legend of sixteenth-century Rabbi Loew of Prague, who was said to have created a golem to defend the Prague ghetto against anti-Semitic attacks. It was this tale that inspired Viennese writer Gustav Meyrink for his 1915 book *Der Golem*, and that spawned a number of films adapting this particular view to the screen.[10] The one we know best is *Der Golem: wie er in die Welt kam* (Paul Wegener and Carl Boese, 1920), a German Expressionist film that is actually the third part of a trilogy, preceded by the mostly lost *Der Golem* (Paul Wegener and Henrik Galeen, 1915), and *Der Golem und die Tänzerin* (Paul

Wegener and Rochus Gliese, 1917). Along with Otto Rippert's six-part serial *Homunculus* (1916), about an artificially created man without feelings that seeks to rule the world (Danish actor Olaf Fønss), *Der Golem* seems to have had a considerable influence on the early oeuvre of Fritz Lang.

On the other end of the cultural spectrum, perhaps, lies Japanese culture. Like the ancient Greeks, the Japanese worshipers of the Shinto and Buddhist religions honor a multitude of gods that in turn translate into a large number of statuesque icons, be they in human or animal form. Though the Japanese animal statues are most familiar to us, one trilogy from 1966 delved into a distant past to tell the story of *Daimajin* (*Majin, the Hideous Idol*; Kimiyoshi Yasuda, 1966),[11] a large stone idol that comes to life to fight for justice in what appears to be the Edo period. This film series combined the popular *jidaigeki* genre, or period piece, with that of the *kaiju*, or monster film, to bring a mythologized account of a large stone statue that is angered by the disrespect it gets from local villains. The figure is very similar to that of Talos, the metal giant who guarded the island of Crete in Greek myth, but is entirely rooted in Japanese religion and mythology. The look of the Daimajin idol was probably inspired by the *bujin* or *ikusa-gami*, gods of war that Japanese warlords prayed to for victory in battle, and that were characterized by an angry face and combat outfit.[12]

BUILDING BODIES

One myth that is strangely absent from films taking place in Greco-Roman antiquity is that of Pygmalion. As we have seen in the first chapter, the myth was a popular one in the neo-classicist revival that took place on the late nineteenth- and early twentieth-century stage, finding its way onto the screen in the work of Georges Méliès as early as 1898, when the filmmaker appropriated this classic trope of Greek mythology in *Pygmalion et Galathée* to demonstrate his own magical craftsmanship. As an illusionist, magician, and pioneer in cinematic special effects, Méliès, more than anyone, embodied cinema's Pygmalion syndrome. Actual cinematic retellings of this myth are rare, however, because George Bernard Shaw's 1912 play *Pygmalion* provided filmmakers with more fertile and realistic grounds upon which to build their stories. Shaw's update was inspired by the popularity of the myth on the stage,[13] but turned the story of a statue come to life into a social commentary on the class system by having a professor educate and edify a young Cockney woman in the ways of the upper class, shaping her to his demands like a sculptor would. The most famous incarnation of Shaw's play is undoubtedly *My Fair Lady*, the 1956 Broadway musical by Loewe and Lerner that was turned into an eponymous motion picture with Audrey Hepburn and Rex Harrison

in 1964 by George Cukor. Cukor had already explored the Shavian *Pygmalion* in *Born Yesterday* (1950) and *A Star Is Born* (1954), a plot that was explored indirectly in hundreds of films, from *The Red Shoes* (Michael Powell and Emeric Pressburger, 1948) to *Pretty Woman* (Garry Marshall, 1990). Pygmalion was not completely absent from film history as a sculptor breathing life into inert matter, though – far from it. As is apparent from Chapter 4, the horror genre proved to be an exceptionally fruitful breeding ground for all sorts of inversions and perversions of the Pygmalion myth.

Although the Pygmalion figure itself did not appear much in a classical mythological context on screen, production companies did not wait long to create the perfect setting for the rich collection of popular historical and mythological stories. From 1908 on, there was a sharp rise in the number of historically and mythologically themed films in Europe. Like their later counterparts of the 1950s, these films were billed as grand spectacles, uniting the best that the filmmaking business had to offer. The antique backdrop was an ideal way to draw in audiences through advances in film technology, screenwriting, and production design, creating what is known as the "historical epic." As Blanshard and Shahabudin have shown, the success of "cine-antiquity" was due not only to key technological advances, but also to the rise of nationalism and the popularity of nineteenth-century historical novels such as Edward Bulwer-Lytton's *The Last Days of Pompeii* (1834), Lew Wallace's *Ben-Hur: A Tale of the Christ* (1880) and Henryk Sienkiewicz's *Quo Vadis: A Narrative of the Time of Nero* (1895).[14] Historical and mythological subject matter was particularly well represented on the French and Italian silver screens.

The French had more of a penchant for the mythological, for instance in major productions at Gaumont by Louis Feuillade, who churned out a number of high-quality myth-inspired films, such as *La Légende de la fileuse* (1908), which deals with the story of the weaver Arachne, *Prométhée* (1908), *l'Amour et Psyché* (1908), *La Légende de Narcisse* (1908), *La Légende de Midas* (1910), *La Légende de Daphné* (1910), and *La Fiancée d'Éole* (1911). This was much to the dismay of French theater owners, who quickly grew tired of the "outdated" genre and publicly asked for more modern dramas.[15] The Italians, on their part, were keener on historical epics. It was the Itala Film and Società Italiana Cines film companies that truly established the genre conventions for the historical epic or, almost synonymous with it, the so-called "sword-and-sandal" or "peplum" films. At Itala, star director Giovanni Pastrone paved the way for American productions. When his 1911 effort *La Caduta di Troia* (The Fall of Troy) opened to full houses in the USA, it was named film of the week by *Moving Picture World*, which described it as a "great spectacular production" and a "masterpiece of art and human endeavor;"

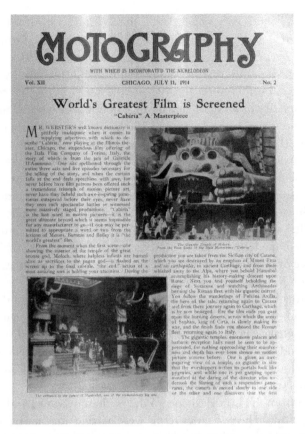

Figure 7.2 *"Cabiria, A Masterpiece" (*Motography, *July 11, 1914) – courtesy of the Media History Digital Library.*

the magazine furthermore admitted the European supremacy in the field of historical subject matter: "For historical productions like 'The Fall of Troy,' the European manufacturer has it all over the American producer. The old country is, of course, more full of opportunity, and its history is more prolific of incident."[16] While Cines was very productive with directors such as Enrico Guazzoni and Mario Caserini, it was not until Guazzoni's 1913 *Quo Vadis?* that the company could score an international hit. In the same year, Mario Caserino and Eleuterio Rodolfi made *Gli Ultimi Giorni di Pompeii* (*The Last Days of Pompeii*) for the Società Anonima Ambrosio, but all were blown out of the water when Giovanni Pastrone and Itala presented *Cabiria* in 1914. The famed Italian writer and poet Gabriele D'Annunzio wrote the film's titles and the film's heavy overseas promotion highlighted this fact. *Moving Picture World* devoted an entire spread to the film, entitled "Italia's [*sic*] Big New Twelve-Part Spectacular Masterpiece, a Worthy Successor to Illustrious

Predecessors,"[17] and *Motography* called it the "World's Greatest Film."[18] The film was a great influence on filmmakers such as D. W. Griffith, whose equally epic *Intolerance: Love's Struggle Throughout the Ages* (1916) was greatly indebted to *Cabiria* in terms of production design, camera movement, and subject matter. Furthermore, the Italian epic was responsible for creating one of the first, if not *the* first, Herculean action heroes who became a staple of the peplum genre in the 1950s and 1960s. The Italian strongman's name was Maciste (Bartolomeo Pagano) and his muscular physique and rugged good looks made him a hit – so much so that the character spawned almost fifty films between the 1910s and the 1970s. *Cabiria* was inspired by ancient Greco-Roman reports of child sacrifice in Carthage, and references are also made to similar civilizations and gods in the Bible; this includes the figure of "Moloch," a deity represented by a large seated bronze statue in which sacrifices were made. As such, it comes as no surprise that *Cabiria* banks on the presence of monumental "antique" sculptures, making it an essential part of the decor and plot of the film. Not only does one enter the Temple of Moloch through the orifice of an enormous three-eyed head in the film, but the giant icon of the god Moloch is itself present inside. This winged seated statue is essentially a hollow bronze furnace in which children are sacrificed to the flames, and one of the film's crucial plot points involves saving the titular character Cabiria – a little Sicilian girl – from being sacrificed to Moloch. This is where the Herculean Maciste steps in.

The leap from the historical epic to the peplum or sword-and-sandal film is not a great one. The two latter terms were used in a somewhat derogatory sense, and while "sword-and-sandal" is rather self-explanatory, "peplum" refers to the Greek word (*peplos*) for robe or tunic,[19] garments that were worn in Greco-Roman times but which grew ridiculously short in the second wave of American and Italian antiquity films in the 1950s and 1960s. The main distinction, it seems, lies in the nature of the productions. In the 1950s, Hollywood's technological advances, but dropping attendance numbers, prompted a new wave of spectacular cinema that aimed to lure television viewers away from their tiny black and white screens and into the fully equipped color and widescreen cinemas, where they could enjoy epic films that sought to stimulate their imagination and astonish their senses. It was no coincidence, then, that the first Hollywood film to be shown in widescreen was a Roman Biblical epic fittingly named *The Robe* (Henry Koster, 1953). The film was second in a line of epic Roman prestige pictures that was initiated by the Technicolor rendering of *Quo Vadis* (Mervyn LeRoy, 1951) and followed by *Ben-Hur* (William Wyler, 1959), *Spartacus* (Stanley Kubrick, 1960), *Cleopatra* (Joseph L. Mankiewicz, 1963), and *The Fall of the Roman Empire* (Anthony Mann, 1964). These were all expensive productions that "were also associated

with the prestige and reputations of the studios, both because of their technical virtuosity and their economic scale. Their 'event' status made them ideal candidates for awards."[20] The flipside of the big-budget Hollywood epics could be found in Italy, where the subject matter was turned into the quickly made and cheap genre fare that is conventionally known as "peplum cinema," even though the generic codes often apply to American cinema as well. Blanshard and Shahabudin define this particular genre as referring to the

> large volume of films produced in Italy between the late 1950s and the mid-1960s that took as their subject matter a story involving a hero or adventurer from the ancient world. They have a number of distinctive elements. Muscular bodybuilders (often American) were cast as the heroic leads. Female love-interests were pretty, slim, and always in need of rescuing . . . and there was normally a sexually voracious, vampy female who tried to seduce the hero away from his task of overthrowing tyranny and rescuing his "true" love. Opponents tended to rely upon extra-natural resources (e.g. sorcery, mythical monsters, advanced technology) to advance their schemes, only to be thwarted by the natural strength and stout heart of the hero.[21]

The most famous of these statuesque bodybuilders in peplum cinema were Steve Reeves and Reg Park. They both played Hercules several times and were succeeded by Arnold Schwarzenegger and Lou Ferrigno in the late 1970s and 1980s, when a third wave[22] of peplum and peplum fantasy films – sometimes called sword-and-sorcery films – such as *Clash of the Titans* (Desmond Davis, 1981), *Conan the Barbarian* (John Milius, 1982), *The Beastmaster* (Don Coscarelli, 1982), *Hercules* (Luigi Cozzi, 1983), and *Conan the Destroyer* (Richard Fleischer, 1984) rolled into town. The fourth wave, finally, seems to have started with *Gladiator* (Ridley Scott, 2000) and has worked its way through the 2000s with films such as *Troy* (Wolfgang Petersen, 2004) and *300* (Zack Snyder, 2006) and TV shows such as *Rome* (2005–7), possibly culminating around 2010 with TV's *Spartacus: Blood and Sand* (2010–13), *Clash of the Titans* (Louis Leterrier, 2010), *Percy Jackson & the Olympians: The Lightning Thief* (Chris Columbus, 2010), *Immortals* (Tarsem Singh, 2011), *Wrath of the Titans* (Jonathan Liebesman, 2012), and Thor Freudenthal's *Percy Jackson: Sea of Monsters* (2013). These different waves of full-blown antiquity revivals are most interesting, for they encompass an incorporation of mythological and supernatural elements into a classical context that brings us back to the main focus of our chapter, namely the cinematic presence of mythological living sculptures.

FIRE FROM THE GODS

Perhaps most interesting among the many instances of statues coming to life in peplum cinema are those linked to the mythological master craftsman

himself, the Olympian god of blacksmiths, artisans, sculptors, metallurgy, fire, and volcanoes, Hephaistos. As opposed to Pygmalion, however, Hephaistos was never really deemed a screen-worthy character; it was mostly his legendary creations that made it onto film. This is strange, to say the least, for the mythological memoir of the god of blacksmiths makes for quite a read: he was cast from Mount Olympos on several occasions, created woman, bound Prometheus, was married to Aphrodite, and was responsible for creating the most renowned armor, weapons, temples, and statues in the whole of Greek mythology. In Homer's *Iliad*, for instance, the divine sculptor is even accompanied by female attendants, or *amphipoloi*, crafted out of gold.

It was Hephaistos's famed automatons, or self-operating machines, that became a staple of the fantasy variant of the peplum genre. Fittingly, these cinematic creations would themselves be remembered for their unmatched craftsmanship thanks to the many talents of visual effects wizard Ray Harryhausen. He combined expert matte painting and photography skills with believable rear and front projection and thrilling stop-motion model creation and animation to create fantastical worlds in which people interacted with hideous monsters, giant statues, and angry skeletons as never before.[23] It was the bronze giant Talos that launched Harryhausen headlong into Hephaistos's wake in *Jason and the Argonauts* (Don Chaffey, 1963), which tells the tale of the quest for the Golden Fleece. The film opens on a giant painted statue of Hera, Olympian queen of the gods, seated on a throne in one of her temples. When King Pelias (Douglas Wilmer) brutally murders one of Hera's praying devotees in her sacred temple, the goddess materializes and tells the warrior that his shameful deed will cause him to die by the hand of Jason. Twenty years later, Jason (Todd Armstrong) saves King Pelias from drowning and tells him of his plan to procure the Golden Fleece. A sturdy boat known as the Argo takes Jason and his ragtag band of adventurers, the Argonauts, on their mission. A painted wooden figurehead of Hera guides Jason through the hazardous waters, opening her eyes and whispering sound advice when it is most needed. The figurehead of Hera eventually leads the pack to the so-called Isle of Bronze, where the Greek god of sculpture Hephaistos was said to have resided. The Argonauts are advised to take nothing but food and water on the isle populated by gigantic bronze sculptures, but when Hercules (Nigel Green) and a friend approach the statue of Talos, they find its pedestal to be filled entirely with riches. When Hercules attempts to sneak a brooch out, the statue of Talos comes to life.

Hera's manifestation through sculpture is called agalmatophany, which, along with the appearance of a god, or theophany, was not only common

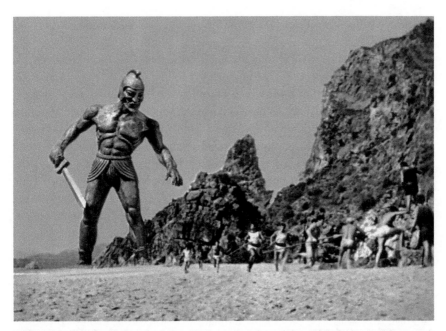

Figure 7.3 *Talos comes to life in* Jason and the Argonauts *(Don Chaffey, 1963) – courtesy of the Danish Film Institute.*

practice in *Jason and the Argonauts*, but also in Greek mythology. Gods were said to use statues as a go-between to communicate with mortals, for the latter would not be able to withstand the radiant presence of the actual deity.[24] In Pseudo-Apollodorus's *Bibliotheca* and Apollonius Rhodius's *Argonautica*, Talos was a bronze giant crafted by Hephaistos and gifted to Europa by Zeus, to protect his lover. Talos, depicted in ancient Greek vase paintings as a handsome, clean-shaven young man, would patrol the island of Crete and chase away unwanted visitors by throwing rocks or engaging in physical combat. He is said to have had one long blood vessel stretching from his neck down to his lower ankle containing the magical ichor, the golden blood of gods and immortals, which powered his movements. Harryhausen modeled the statue after a bearded Spartan warrior in a fighting stance, donning an Attic helmet, a very short peplos skirt and, of course, a sword and sandals. The stance and the figure were quite possibly inspired by ancient Greek frieze sculpture and statues of the great Spartan king Leonidas. The stop-motion magic of Harryhausen convincingly animates the bronze giant as it comes from its pedestal, wrecks the Argo and goes after its crew. It is the figurehead of Hera that advises Jason to defeat the murderous statue by going for its ankle, corresponding with the mythological account of the single vein from neck to ankle. It is thus that Jason opens a hatch on the ankle that releases a liquid,

seemingly suffocating Talos before his façade starts to crack and he keels over and falls apart.

Harryhausen's next foray into the mythological was Gordon Hessler's *The Golden Voyage of Sinbad* (1973), a long-awaited follow-up to Nathan Juran's *The 7th Voyage of Sinbad* (1958), for which Harryhausen had likewise created spectacular creature and visual effects. Much like the "ancient" or "classical" period in which the peplum genre situated itself, Sinbad the Sailor's realm equally provided filmmakers with a timeless, mythological context in which anything went, from dinosaurs to genies and Cyclopes. It is therefore not at all surprising that the sailing action hero has to face a sword-wielding statue of Kali, brought to life by an evil wizard in *The Golden Voyage of Sinbad*, and then an evil stepmother commanding a bronze bull and a saber-toothed cat in *Sinbad and the Eye of the Tiger* (Sam Wanamaker, 1977). The evil bronze bull that Sinbad faces in the latter is an automaton named Minaton, powered by a magical mechanical heart given to it by the wicked Zenobia (Margaret Whiting).

With ancient rituals such as bull leaping in Minoan society, the bull has held a special place in Greek society for a long time, especially on Crete, and

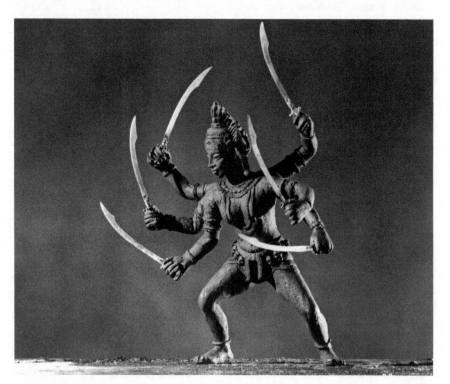

Figure 7.4 *Kali awakens in* The Golden Voyage of Sinbad *(Gordon Hessler, 1973) – courtesy of the Danish Film Institute.*

this is evidenced by its abundant presence on pottery and in sculpture, with bulls made entirely out of silver and gold as early as the Mycenaean period (*c*.1600–*c*.1100 BC). The Minaton creature in *Sinbad* could have been an actual minotaur, a mythical beast spawned from the congress between a bull and a human being, but Harryhausen opted for an automaton that not only echoes his own screen wizardry in its magical animation, but also harks back to Hephaistos, as he had created two bronze fire-breathing bull automatons, or *khalkotauroi*, and given them to King Aeëtes of Colchis.[25] Furthermore, the bronze bull was reputedly also turned into a torture device as early as the sixth century BC, when poor souls would be locked up in a hollow bronze bull, also called brazen bull or Sicilian bull, and left to roast inside as a fire was set up underneath it. The bull's sculptor was a metalworker named Perillos, who made it for the despot Phalaris, but the poor artist was allegedly the first one to test its effectiveness.[26] A popular trope, we also recently saw the bull automaton resurface in *Percy Jackson: Sea of Monsters*, where it appears to stage an attack on the teen demigods' (or half-bloods') training camp in its full mechanical glory.

GHOSTS IN THE SHELL

In the case of the automaton, the ghost in the shell was supposedly a combination of technical virtuosity and supernatural magic elements, such as the ichor that powered the Talos statue. Another case in point is the mechanical owl that accompanies Perseus (Harry Hamlin) on his quest in *Clash of the Titans* (Desmond Davis, 1981, with visual effects by Harryhausen), which is also ridiculed in a brief cameo in the 2010 *Clash of the Titans* (Louis Leterrier) and makes an even more ridiculous appearance as a mechanical pigeon in David Gordon Green's medieval quest parody *Your Highness* (2011).[27] In the film, the bird is meant to be a well-crafted replica of Athena's owl, Baubo, put together by Hephaistos to help guide the young Perseus. The Athenian owl was, in fact, a powerful symbol that was widespread in Classical Greek culture, but I have found no references to a mechanical creature devised by Hephaistos, not that one would expect Harryhausen's inspiration to be limited to literary sources, of course. In fact, true to his research methods, the cinematic shape of the little owl does mirror the artistic representation of Athena's own, which was traditionally called Glaukos, meaning "glaring eyes." It is these eyes that stand out in the images preserved on (Early) Classical Greek pottery, fifth-century BC silver tetradrachm coins, and the owl figurines that one is bombarded with when visiting Athens. Its diminutive frame and large eyes do give the little owl a very artificial appearance, especially on the flat surface of the silver tetradrachm coins.

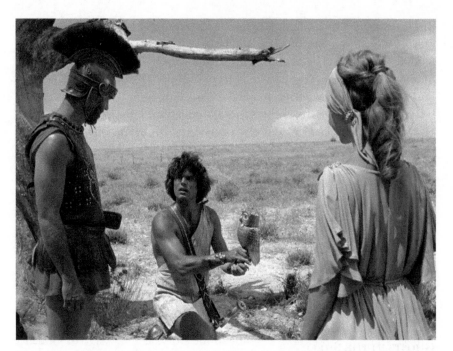

Figure 7.5 *Mechanical owl Bubo in* Clash of the Titans *(Desmond Davis, 1981) – courtesy of the Danish Film Institute.*

While the fantastical mechanical creatures obviously provided Harryhausen and his directors with an opportunity to dazzle viewers with state-of-the art special effects, the most common statuary vivification effects were achieved by simple mechanical or double exposure techniques, and represented the embodiment of a statue or icon by a deity – a *deus ex machina* of sorts. This is also in line with Greek mythology and culture, for, as was mentioned before, direct contact between humans and gods was problematic. The adoration of anthropomorphic icons, such as the hyperbolic sculptures of the Classical era, was a widespread phenomenon that saw statues painted, adorned with clothes and jewelry, and spoken to. The painted figurehead in *Jason and the Argonauts* is a good example of an iconic image that is used by a deity, in this case Hera, to remotely and covertly converse with her followers. As Steiner rightly points out, however, the sculpting of anthropomorphic icons was not unproblematic.[28] The art form posed some much-debated ethical dilemmas pertaining to the representation of the deities, who were, after all, immortal presences. While the statuary cult was obviously meant to bridge the gap between the Olympian rulers and the common people, it was also key to hold on to the gods' sublime aura. Steiner argues that an aniconic or semi-iconic approach was most respectful, and the proliferation of these representa-

tions in Greek cult practices certainly backs up the validity of this idea. Art-historically, however, Greek sculptors decided on the human form rather early on, in a sense elevating and democratizing the sculptural body throughout the Archaic, Classical, and Hellenistic periods. This was of course only true up to some point, for the evolution into hyperbolic or idealized forms of sculpture separated the divine body from the mortal one, even though the gods were represented in a human form.

It was also in this way that divine sculpture was most often depicted on screen, usually modeled after the actor playing the part. In the 1981 *Clash of the Titans*, sculpture plays an especially important role in the story. The narrative is overseen by the gods in their foggy, soft-focus Olympos – led by a campy Laurence Olivier as Zeus – and the earth is represented by a wall full of small clay figurines that stand for the characters of the story. The gods handle the figurines and manipulate them in a scaled amphitheater that symbolizes the arena of life. When King Acrisius of Argos (Donald Houston) disrespects Zeus, the god of gods starts off by crushing Acrisius's clay figurine, killing him instantly, and then has Poseidon flood the city, killing (almost) everyone and bringing down the giant statue of Zeus that graced the city. The clay figurines pop up frequently in the story, as they serve to influence characters such as Calibos and Perseus. A more prominent role is reserved for the statue of the vengeful goddess Thetis, which is modeled after the actress Maggie Smith. The statue of Thetis is portrayed in a Classical style and in keeping with its pictorial tradition, accompanied by a seahorse and holding a small statue of the winged goddess Nike in her outstretched hand as a sign of victory. The statue is brought to life in the film through the superimposition of the goddess's face onto her image, as she secretly converses with the monstrous Calibos, but also makes her own head fall off in a fit of anger at Andromeda and Perseus' wedding. Her severed head then goes off to threaten the couple.

Clash of the Titans also deals with another popular statuary trope concerning one of the most horrifyingly accidental sculptors in the whole of mythology; a monster whose petrifying gaze stood for instant mortification and whose hissing hairdo was quite successfully reproduced by Harryhausen's good modeling and beautiful stop-motion cinematography in *Clash of the Titans*. Medusa is generally regarded to be the only mortal of the three Gorgon sisters. The Gorgons were described by Hesiod as monstrous sea creatures but also portrayed as winged female figures with tusks and large eyes in ancient Greek vase paintings. Ovid describes Medusa as a fair young maiden who was violated by Poseidon in the temple of Athena. It was the jealous goddess Athena who then punished the beautiful Medusa by turning her hair into a nest of hissing snakes, making her so repulsive that anyone

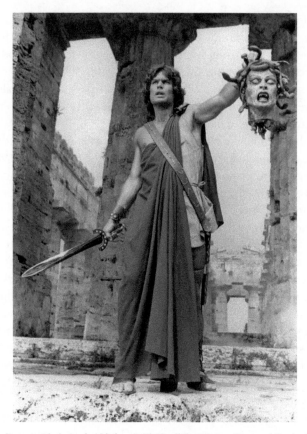

Figure 7.6 *Perseus with the head of Medusa in* Clash of the Titans *(Desmond Davis, 1981) – courtesy of the Danish Film Institute.*

who looked at her would turn into stone. Medusa was later slain by Perseus, who cut off her head. As Garber and Vickers rightfully argue, the tension between the beautiful and the monstrous is inherent in the visual and literary representation of Medusa.[29] This is apparent art-historically, where the Gorgon's portrayal ranges from barely human in its monstrosity to cursedly beautiful.

On film, its characterization is more streamlined, generally veering toward either beautiful women with snakes for hair or a Harryhausen-inspired animated monster with a gruesome face and snakelike body, or a combination of both, with varying results and different time frames. In Terence Fisher's Hammer Films horror flick *The Gorgon* (1964), the story takes place in a small German village in 1910 and builds up to a big reveal of the Medusa character (Prudence Hyman). Barring a man turning slightly and slowly gray, the transformation process is not shown and the viewer is left anticlimactically

with an image of a slightly older woman with wire-animated snakes for hair, poorly applied eye shadow and slightly scaly skin as Medusa. In *Clash of the Titans* (2010), once more in a mythologized ancient past, the Medusa effect manifests itself almost as a photographic flash going off, petrifying its victim. Actress Natalia Vodianova's appearance was molded with Harryhausen's model via CGI, giving the digital gorgon an enchanting face but a monstrous body. The teen genre-update *Percy Jackson & the Olympians: The Lightning Thief*, finally, sees the Medusa (Uma Thurman) turned into the owner of Auntie Em's Gnome Emporium, a sculptural garden shop in contemporary New Jersey. She is a leather-clad, sunglasses-brandishing baddie with CGI hair and a rather casual petrification stare. In lieu of a mirror or shield, the young Percy uses his smartphone to keep an eye on the furious sculptress.

From Olympos to Jersey, it remains clear that regardless of their setting or anachrony these myths continue to have a wide audience appeal. This is due in large part to their fantastical character and the fact that mythological tropes possess an enduring power. The mythological or magical animation of statues and the petrification of living matter not only speak to the imagination: the effect is also perennially renewed by evolving technological advances in cinematography. It is here that sculpture clearly distinguishes itself from painting, since the former is an art form that has lent itself far better to both representation and animation on the silver screen. Whether statues only possess limited anthropomorphic characteristics, or are hyperreal representations, their added dimensionality makes it easier for viewers to suspend their disbelief when they come alive. The stop-motion animation process employed in particular by Ray Harryhausen works to the advantage of this vivification, for it is known to give objects a jerky and somewhat mechanical motion, in keeping with what one would expect from a hard substance such as wood, stone, marble, or bronze. The ancient Greek, Roman, or ersatz antiquity context additionally endures because it ties into a large number of primal narratives and cuts across religions. Its polytheistic nature can be seen to belong to a distant past far enough removed to feature dashing demigods and mythical monsters, while still retaining enough of its religious fabric for it not to become wholly fantastical.

Notes

1. Lynda Nead, *The Haunted Gallery: Painting, Photography, Film c. 1900* (New Haven and London: Yale University Press, 2007), 45.
2. The prototypical sculpted man is known as Adam across various religions.
3. Like all myths, this one, too, came to us in many shapes and sizes. It is most famously mentioned in Aesop's *Fables* (via Themistius and Phaedrus), Plato's

Protagoras, Pseudo-Apollodorus's *Bibliotheca*, Ovid's *Metamorphoses* and Hesiod's *Works and Days*.

4. Cf. among others Hesiod's *Theogony* and *Works and Days*, Homer's *Iliad*, Aesop's *Fables*, Pseudo-Apollodorus's *Bibliotheca*.

5. Deborah Tarn Steiner, *Images in Mind: Statues in Archaic and Classical Greek Literature and Thought* (Princeton and Oxford: Princeton University Press, 2001).

6. Steiner, *Images in Mind*, 21.

7. Steiner, *Images in Mind*, 19.

8. Richard Neer, *The Emergence of the Classical Style in Greek Sculpture* (London and Chicago: The University of Chicago Press, 2013), 105.

9. Guy P. R. Métraux, *Sculptors and Physicians in Fifth-Century Greece: A Preliminary Study* (Montreal and Kingston: McGill-Queen's University Press, 1995), 48.

10. The book was first serialized in *Die Weissen Blätter* in 1913–14. Elizabeth R. Baer, *The Golem Redux: From Prague to Post-Holocaust Fiction* (Detroit: Wayne State University Press, 2012), 38–9.

11. The other two films are *Daimajin Ikaru* (*Return of Daimajin*; Kenji Misumi) and *Daimajin Gyakushu* (*Wrath of Daimajin*; Kazuo Mori); all were released in 1966. The character also spawned a TV series of its own quite recently in 2010, entitled *Daimajin Kanon*.

12. Yoshiko Okuyama, *Japanese Mythology in Film: A Semiotic Approach to Reading Japanese Film and Anime* (Lanham: Lexington Books, 2015), 132.

13. Harold Bloom, *George Bernard Shaw's Pygmalion* (New York, New Haven, and Philadelphia: Chelsea House, 1988), 88.

14. Alastair J. L. Blanshard and Kim Shahabudin, *Classics on Screen: Ancient Greece and Rome on Film* (London: Bristol Classical Press, 2011), 18.

15. Anon., "Les Films tels qu'ils sont" (*Le Courrier Cinématographique* 12, 30 September 1911, 16), in Alain Carou and Béatrice de Pastre (eds.), *Le Film d'Art & Les Films d'Art en Europe, 1908–1911* (*1895* no. 56, December 2008, Paris: AFRHC), 317.

16. Anon., "The Film of the Week," *Moving Picture World* 8 (April 29, 1911), 934.

17. W. Stephen Bush, "Cabiria," *Moving Picture World* 20 (April–June 1914), 1090–1.

18. Anon., "World's Greatest Film is Screened," *Motography* XII, 2 (11 July 1914), 37–9.

19. Claude Aziza (ed.), "Le Péplum: l'Antiquité au Cinéma," *CinémAction* 89 (Condé-sur-Noireau: Editions Corlet, 1998), 7.

20. Alastair J. L. Blanshard and Kim Shahabudin, *Classics on Screen: Ancient Greece and Rome on Film* (London: Bristol Classical Press, 2011), 36.

21. ibid., 58–9.

22. Michael G. Cornelius (ed.), *Of Muscles and Men* (Jefferson: McFarland, 2011), 5.

23. Harryhausen would later patent his combination of special effects that created an exciting mix between live action and animation as "Dynamation."

24. Steiner, *Images in Mind*, 135.

25. Cf. Pseudo-Apollodorus's *Bibliotheca* and Apollonius Rhodius's *Argonautica*.

26. George Grote, *A History of Greece: From the Earliest Period to the Close of the Generation Contemporary with Alexander the Great, vol.5* (London: John Murray, 1870), 58–9.

27. In spite of its rather medieval setting, *Your Highness* also features a minotaur and a hydra.

28. Steiner, *Images in Mind*, 81–92.

29. Marjorie Garber and Nancy J. Vickers (eds.), *The Medusa Reader* (New York and London: Routledge, 2003).

Coda: Returning the Favor (A Short History of Film Becoming Sculpture)

SUSAN FELLEMAN

This book has focused on the many manifestations and aspects of sculpture *in* cinema. We have demonstrated that sculpture – especially figural sculpture – engages the living figure in a range of intermedial ways in film, heightening tensions around motion and stasis, the animate and inanimate, life and death, presence and absence, as well as embodying narrative themes. This is in theory as true for sculptures that play a small role, as props or minor plot devices, as for those that are central actors. In *Rear Window*, for instance, the abstract sculpture on which a neighbor of Jeff's is shown working is seen briefly and intermittently but it is overdetermined. The lady artist is a Greenwich Village cliché and she is ridiculed along predictably sexist lines. Along with the dancer and the composer who are among Jeff's other neighbors, she exemplifies the bohemian milieu in ways both realist and comical. The sculpture itself, as with the ballerina referred to as "Miss Torso," is suggestive of – even almost a substitute for – the dismembered body of Mrs. Thorwald that cannot be shown: only imagined. Although it suggests an abstracted partial figure or bust, it consists primarily of a phallic form and a yonic one (protuberance and void), inserting into the scene psychosexual symbolism that underscores Hitchcock's voyeuristic and perverse themes.

If sculpture can contribute intermedial meaning and complexity to a film, is not the opposite equally true? While cinema often incorporated sculpture from early in film history, sculpture was slow to return the favor. In the 1920s and 1930s, sculpture began to move, with mobile and kinetic innovations such as the rotating Lipchitz sculpture discussed in Chapter 2, Alexander Calder's mobiles, László Moholy-Nagy's *Light-Space-Modulator* (discussed in the Introduction), and some constructivist works, incorporating movement and therefore change in time, dynamizing a previously static practice. Numerous artists, among them George Rickey, Jean Tinguely, Harry Bertoia, and artist-filmmakers Robert Breer and Len Lye, enlarged and energized the field of kinetic sculpture in the 1950s.[1] It was not until the period of the 1960s and 1970s, in the context of expanded cinema and structural-

materialist film, that sustained, varied and truly intermedial experimentation began to produce a critical mass of work incorporating the materials and methods of film itself with sculpture.[2] In one of the earliest such instances, Robert Whitman combined sculpture and the cinematic image in a voyeuristic tableau as reminiscent of Alfred Hitchcock's *Rear Window* (1954) as it is of Duchamp's *Étant donnés*. The architectonic, material setting of *Window* (1963) expands the pictorial frame into sculpture at the same time as it deconstructs (by reifying) the illusion of the cinematic image as a window. Built into a gallery wall, the sculptural elements comprise a "real," ordinary wooden window frame and glass, beyond which are actual tree branches. Beyond the branches is an "illusory" moving image: a rear-screen film projection of a forest glen, "where branches shift faintly in a gentle breeze, and a woman suddenly appears, remains for a moment, and then quickly vanishes."[3] Intermedially merging architectonic space and cinematic projection, "literally trespassing on the architectural boundary, it opens up a space beyond that is both physical and metaphorical. *Window* is not merely a hole, but an aperture."[4]

The next year, in another evident nod to Hitchcock – this time to *Psycho* (1960) – Whitman created *Shower* (1964) and deepened the sculptural and

Figure 8.1 *Robert Whitman,* Shower *(c.1964) – © Robert Whitman, courtesy of Pace Gallery. Photo: Howard Agniesti. Courtesy of the Dia Art Foundation, New York.*

ontological space upon which the cinematic image was projected. At the First New York Theater Rally in 1965, then during Billy Klüver and Robert Rauschenberg's "9 Evenings: Theatre and Engineering" in 1966, Whitman exhibited *Shower*, a real, working shower stall, with a film of a woman rear-projected on the frosted glass of its rear wall, and a translucent shower curtain in front (accounts often erroneously claim the film is projected on the real shower curtain).[5] Michael Kirby recalls that viewers felt some uncertainty as to whether the woman, seen through a "screen" of steam and vinyl, was "real" or not, although Uroskie notes that "an active suspension of disbelief is manifested not only in the historical descriptions . . . but in the photographic documentation that has accompanied the work's exhibition," since the film image not only included illusionistic shots of the life-sized showering nude but also discontinuous cuts to close-up views, including of the showerhead spraying variously colored water.[6] These bubble-bursting reflexivities underscore how "Whitman's expanded field of sculptural practice includes not only the material technology of cinema, but also the identificatory relations that have dominated the cultural history of that technology."[7] Whitman's cinema pieces implicitly interrogate scopophilic properties of movie going, creating unease by making present that which the viewer depends on to be absent: bringing the film object and viewing subject into physical co-presence.

With structural and materialist film, in the later 1960s and 1970s, it was the device itself that was bared, rather than the illusoriness of the cinematic object and the unconscious of the viewing subject. Insisting upon the materiality of the film, the camera, the projector, and the screen – interrogating and exposing mechanisms and process, deconstructing the apparatus – structural and materialist film sometimes converged with sculpture, architecture, and performance.

The 1971 *Cone Screen* by Arthur and Corinne Cantrill, for instance, turned the familiar yet immaterial volume of the cinema's cone of light into geometric solid and surface. The anamorphic attenuation of the film image upon this sculptural structure, one of several created by the Cantrills for their expanded cinema events, in a sense – as viewers have from the beginning of cinema occasionally experienced when a body has interposed itself between projector and screen – reifies the optical unconscious, that capacity of the photographic to reveal properties of matter, movement, space and time not visible to the naked eye.[8]

Two years after the Cantrills, Anthony McCall, whose own exploration of the sculptural aspects of the luminous cone is much more famous, created the first in a series of experiments in solid light projection. *Line Describing a Cone* (1973) creates a virtual sculpture in time and space using the volume of the beam of light, articulated in darkness by the simple, animated film "drawing"

Figure 8.2 *Arthur and Corinne Cantrill. Cone screen with projected animated textures from a handpainted and incised* Filed Film, *as seen during the* Expanded Cinema *exhibition for the National Gallery of Victoria at the Age Gallery, February 1971. Photograph: Fred Harden.*

Figure 8.3 *Anthony McCall,* Line Describing a Cone *(1973), during the twenty-fourth minute. Installation view, Musée de Rochechouart, 2007. Photograph: Freddy Le Saux.*

of a white circle on a black ground, as the beam from the projector gradually develops from a line into a large cone. The effect is ineffably magical: almost mystical. First realized as a sort of theatrical screening experience, *Line Describing a Cone* was followed by other "solid light projections."[9] "These pieces are visible in three-dimensional space," McCall notes, "because the projected light is reflected off tiny particles in the air." Recalling that lofts were early venues, McCall continues: "when I projected film then, I could rely on the dust particles in the air, which would often be augmented by a couple of smokers." Now, in cleaner venues where smoking is prohibited, his sculptural medium includes, instead of dust motes and smoke, a fog machine, which "does a far more effective job of making visible the planes of light."[10] After a hiatus of some decades, McCall resumed work with solid light projections in the early years of this century, but now using, in addition to fog machines, digital technology. "These solid light projections do have these two faces," McCall notes, speaking to the intermedial properties of his work. "They exist as a sculptural form – a three-dimensional, volumetric object – which you can walk around, go into, and explore. But when you turn around you also see that that volumetric form derives from a two-dimensional drawing." Continuing, McCall explicates the relationship between technology and the sculptural quality of the work:

> In the 'seventies, all my solid light works were horizontal. This was of course normal because they were works that came out of cinema. Film projectors were designed to sit flat on tables and produce horizontal images on the wall. But when I began working again, in the beginning of 2001 or 2 . . . of course I was working with new kinds of projectors – digital projectors – and I quickly realized they were not gravity-bound like a film projector. And I began to explore vertical projections and became increasingly interested by the way in which they aligned themselves much more with a sculptural tradition than with a cinematic tradition because one began to think of them as vertical figures – standing figures.[11]

Anthony McCall's digital turn (his twenty-first-century work, monumental, immaterial figures of paradoxically solid light, uses twenty-first-century tools, i.e. Quicktime movies and digital projection) raises the question of medium specificity, as of course did, thirty years earlier, another medium that arose in the era of expanded cinema and that also lent itself to becoming sculpture: video. Also time-based and, like film, vehicles for moving pictures and sound, television and video have (or *had*) medium-specific attributes that lend themselves to a somewhat different sort of intermedial practice: other ways of becoming sculpture. The relationship of video to television, its traditional common form a domestic furnishing, *gave* it (in the

period before flat-screens) an always already sculptural form. Television sets, unlike movie screens, were not only three-dimensional objects on a human scale, but were viewable in gallery spaces regardless of lighting conditions. Moreover, a common attribute of some TV and much video art was one that film lacked: liveness. Nam June Paik and others explored this liveness by incorporating the live feed into sculptural tableaux (e.g. *TV Buddha*, 1974, in which a Buddha figurine sits "contemplating" his live video image on a television set) and by playing with live signals and with the receiving and display mechanisms of the apparatus (e.g. *Zen for TV*, 1963, and *Magnet TV*, 1965). Unlike the film image, which was fixed (although it could be performed and screened at different speeds, in different directions, on different surfaces, and on space itself, as the Cantrills and McCall demonstrated), the live video image was essentially plastic in the moment of its reception. Even its recorded form – videotape, which is analog but not truly indexical – was usually employed differently, clearly making video art something other than cinema.

If the video display could be built into a cabinet or console, it could also be built into other three-dimensional structures and incorporated into sculpture and installations. Shigeko Kubota was one of many artists who created video sculptures, works in which the fluid moving image, often looped, was encased dialectically in sculptural stasis (e.g. *Duchampiana: Nude Descending a Staircase*, 1976). Video installation would become a new, expanded media practice of its own, or, it might be more accurate to say, was one of a number of practices that defied or rejected the concept of medium itself. "There is a distinction to be made between works that juxtapose elements of different disciplines in surprising ways that nonetheless maintain, if not reinforce, the distinctions between them," as Catherine Elwes observes, "and those in which, as filmmaker Michael Snow commented, we witness 'one medium eating another medium'":[12]

> To describe any component of these fabrications as "sculptures" might be a misnomer particularly when they are subjected to enforced co-habitation with live performers, sound, light, moving image and/or unpredictable interactions with an unrehearsed public. The special status of a sculptural artifact is also hard to maintain when it finds itself rubbing up against an assortment of everyday objects given equal weight and importance in the level playing field of installation.[13]

The development of video projection further expanded the possibilities of sculpting and performing in video and, perhaps ironically (or perhaps not, since what goes around comes around), due to the now again disembodied moving image, brought these around to experiences closely linked to the

cinematic. From the early 1990s, Tony Oursler, for instance, has used video loops and LCD projection onto soft sculpted forms to re-embody the ray of light, creating uncanny "video dolls" or "dummies."

In a further turn enabled by video projection, away from real-time bodily experiences and toward the "cinematic," many recent moving image installations are characterized by high production values, the use of narratives, character-viewer identification, and other hallmarks of the movies. Nonetheless, film installations by artists such as Eija-Liisa Ahtila, Bill Viola, Matthew Barney, Doug Aitken, Douglas Gordon, Pipilotti Rist and many others, although they clearly differ from the phenomenological preoccupations of 1970s expanded cinema and video art, yet retain certain sculptural aspects of installation, in which a spatial lay-out, the presence of the projector and the beam of light it produces, the form and size of the screen(s), and the spectator's viewing position are consciously taken into account.

The explosion of new digital technologies and possibilities in the 1990s that enabled these new uses of projection coincided, as it happened, with the centenary of cinema, contributing to a surge of nostalgia, rediscovery, and anxiety around the already seemingly obsolescent media of traditional film and photography. A renewal of scholarly and artistic interest in the prehistory of cinema, and early cinema, led to new intermedial objects inspired by old practices. Experimental filmmaker Kerry Laitala refers to her *Retrospectroscope* (1996) as a "kinetic sculpture, Gigantaurus Philosophical Toy." Made of a sheet of Plexiglass five feet in diameter, mounted on a motorized stand and illuminated from behind, the paracinematic object creates the illusion of movement utilizing large format still images accompanied by strobes and sound.

Gregory Barsamian began making stroboscopic sculptures in the early 1990s. His pieces dispense entirely with photographic imagery yet also return to the origins of cinema while expanding the zoetropic image into a third dimension. The same principles that animate motion pictures (the series, the interval, human perception) animate Barsamian's work, including *Feral Font* (1996), a stroboscopic zoetrope using 97 sculptures on a rotating armature. The American Museum of the Moving Image displays the spinning work by alternating normal gallery lighting conditions with strobe, so that viewers can partake of the illusion and its mechanism. Takeshi Murata's more recent stroboscopic sculpture, *Melter 3-D* (2014), substitutes slick, high-tech, twenty-first-century facture and documentation for the structure of feeling associated with Laitala's and Barsamian's more hand-crafted nineteenth-century proto-cinematic magic. But like theirs, Murata's kinetic sculpture also depends upon strobe lights for its wondrous liquidity. "Murata spent months configuring the object on a computer before making a physical incarnation with a master

fabricator and mechanical engineers who typically work on high-profile Hollywood CGI projects."[14]

While Murata's dazzling liquid sculpture is consistent with the technological wizardry characteristic of much mainstream cinema of the moment, there remains an obdurate commitment to the stuff of film among many artists and filmmakers, including among some working intermedially. Elizabeth McAlpine's *Square Describing a Circle* (2010), whose title is an implicit homage to Anthony McCall's *Line Describing a Cone* of nearly forty years earlier, is a sort of neo-Structural or Materialist film-sculpture, displayed in two forms. "[It] began with the notion of a shadow of a perfect square." McAlpine filmed the sunlight on a spot of gravel path in Hyde Park, London, moving the stencil a degree at a time during the course of twelve hours of a day. In the installation, a film loop runs through two Super8 projectors and two projected squares upon a shared glass screen merge into a flickering square beam of light that seems to turn in a circle. In a second material iteration of the same project, *Square Describing a Circle (Film Stack, 10th May)*, "McAlpine seeks to statically embody and represent the passage of that same twelve-hour time period." Each of the 181 cards held in place by a steel spine represents one degree (4 minutes) of the earth's rotation around the sun; on each, the shape of a cast shadow has been cut away.[15] Time-based materiality takes another form in *98m (the Height of the Campanile, San Marco, Venice, in Super 8mm Film)* (2005), for which McAlpine calculated the height of the tower and timed her photography of it so that the length of the film in meters is exactly that of the height of the tower. The 98 meters of film represents a space-time equivalent, shown in time (the projection of the film) and space (the recursive loop of film displayed in a Plexiglass case beneath the projector).

The investment in the material and materiality of film evident in the work of McAlpine and others working in the growing shadow of digital dominance has, since the turn of the twenty-first century, taken an elegiac turn. The possible (or likely) obsolescence of the medium has given rise to a range of practices that employ the material detritus and surplus of the age of film.

In Sandra Gibson and Luis Recoder's *Light Spill* (2005), a 16mm projector with no take-up reel projects and unspools discarded films into a sculptural heap that grows daily during the course of the installation. Here the controlled recursion of McAlpine's 98 meters of film swells into a mass of obsolescence and waste. Other artists employ discarded film as a mortal medium, recycling and repurposing it as they mourn. Sabrina Gschwandtner's *Film Quilts* (a series begun in 2009) hover between two- and three-dimensionality. The artist acquired 16mm textile documentaries discarded by the Fashion Institute of Technology. "After watching the movies, I cut them up and sew them together with my own, personal film footage," Gschwandtner relates.

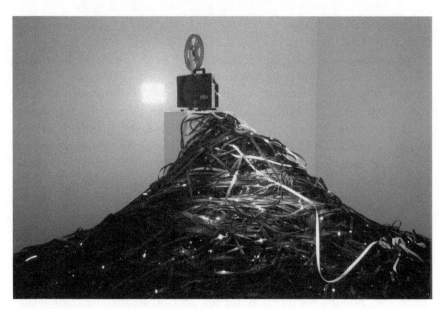

Figure 8.4 *Gibson+Recoder,* Light Spill *(2005), as installed at Robischon Gallery, Denver, Colorado, November–December 2007. Photograph: Gibson+Recoder.*

"I bleach, dye, scratch, draw, and paint onto some of the film."[16] These quilted films may be more flat than volumetric but their insistently crafted surfaces have nothing of the insubstantiality of the images these bits of film would once have had on screen. Film is also among the manifold materials that Arturo Alonzo Sandoval has incorporated into his multimedia quilts (e.g. *Pattern Fusion No.10–Motherboard 1*, 2008).

Lynn Cazabon's *Discard* series (2001–9), too, is perhaps arguably 2D, as it consists of photographs. But the photographs are of discarded films arranged into sculptural compositions featuring spills and swirls and ribbons of film plasticity, not imagery. Cazabon's are recursive intermedial images, as well: photographs of sculptures of films. Alexandra Zealand, too, recycles discarded film. Like Cazabon, McAlpine, and Gschwandtner, Zealand in *What Was and Is*, a 2010 installation of sculpted 16mm film, was drawn to the ribbon-like nature of the material, as well as its translucency. Her film objects not only salvage and transform the film strip into sculptural arabesque, they are also often installed as mobiles, suspended moving images in space, with a sensitivity to the medium's history and purpose as a material in motion and through which light and shadow dance: "the shadow and its shadow," to invoke the Surrealists by way of mourning a medium. For all these artists, the increasing and widespread perception of film's uselessness – and the resultant availability of reel upon discarded reel

of it – and a sensitivity to the particular plasticity of the medium result in a paradoxical sort of reincarnation.

On occasion, this plastic engagement with the filmstrip extends into space almost architecturally. In *Film as Sculpture*, a 2013 exhibition in Brussels, among other contemporary artists working intermedially, Zbyněk Baladrán and Jiří Kovanda installed *The Nervous System* (2011), in which film traverses space as nerves do the body, drawing upon film's status as both a communication medium and a plastic one.[17] Visitors to the exhibition seemed to have found themselves caught in the installation as if in a web, instantiating the tension between medium and metaphor.

Even more architectural than *The Nervous System* is Agnès Varda's *La Cabane de cinéma* (*Cinema's Shack*), made originally as *Ma cabane de l'échec* for her 2006 exhibition at the Cartier Foundation for Contemporary Art, Paris. Based on one of the beach huts at Noirmoutier, the island where she vacationed for many years with her late husband Jacques Demy and family, the house is made from salvaged prints of her 1966 film *Les Créatures*. The film, unsuccessful in its day, as she put it, now became "walls and surfaces, bathed in light. What is cinema?" Varda asked, rhetorically, in her film *Les Plages d'Agnès* (2008). "Light coming from somewhere, captured by images more or less dark or colorful. In here, it feels like I live in cinema. Cinema is my home." Varda's house made of film is a domestic act, an act of salvage, recycling (like

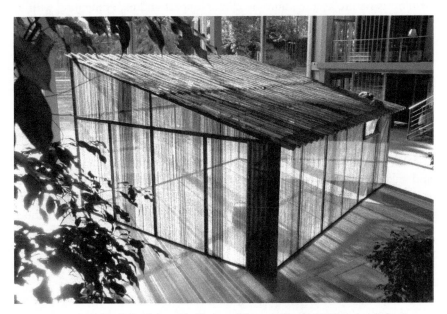

Figure 8.5 *Agnès Varda,* La Cabane de Cinéma *(Cinema's Shack, 2006), as installed at Los Angeles County Museum of Art, 2013 ©Agnès Varda.*

Gschwandtner's or Zealand's); also an act of imagination, resourcefulness, and, especially, of mourning: a memorial. In Varda's case, the cinema that is mourned is not just random, anonymous cinematic detritus: it is personal. Varda mourns her own failed film but also builds a house of retrospection, a tomb of light and beauty for herself, her no longer youthful stars, her late husband, Jacques Demy, for bygone days.

For Tacita Dean, it is the medium itself which is at stake. In the catalogue that accompanied *FILM*, her 2011 piece for the enormous Turbine Hall at Tate Modern in London, she wrote that it was inspired by "grieving the potential loss of [her] medium."[18] The screen onto which her *FILM* – a title that expresses Dean's commitment to the medium writ large – was projected was no mere surface but a colossal part of the work itself: a monumental object, thirteen meters high and one meter deep, in fact referred to as "the monolith," a term and an image that conjures Stanley Kubrick's *2001*, of course. Turned from the horizontal axis of the usual film, this vertical mono-lith attests to the monumentality of the medium for Dean but also recalls the format of a gravestone. Of course, as Anthony McCall pointed out, the vertical is a more sculptural or figural orientation than the horizontal. Is Tacita Dean turning medium specificity on its side? In an essay on the piece, Rosalind Krauss suggests otherwise. Noting that structural filmmak-ers had already endeavored to uncover among the heterogeneous apparatus of film its nature as a medium by taking it apart and experimenting with its parts (screen, beam of light, camera, projector, the film strip itself . . .), she observes that the sprocket holes prominent in Dean's *FILM* – "created using a custom-built aperture gate that functioned also as a mask" – "figure forth the filmstrip itself not only as the material support for the image but also as the apparatus for its very projection. In this figuring forth," Krauss con-tinues, "Dean asserts the specificity of her medium. *FILM* thus runs head-long against the contemporary conviction that there is no 'itself' to which a medium, of any kind, can be 'specific.'"[19] Krauss concludes that Dean's piece is a heroic bulwark against what she (Krauss) regards as the meretricious and vulgar notion of "the post medium condition."[20] This monument to the materiality of film is, ironically perhaps, profoundly medium-specific and *inter* medial at the same time. In a sense, there can be no intermediality without medium. By becoming sculpture, film has given form to itself.

Notes

1. Peter Selz, *Directions in Kinetic Sculpture* (Berkeley: University of California, Art Museum, 1966).
2. This period is characterized by manifold separate as well as intersecting

movements and practices that produced varied hybrid or intermedial works. See A. L. Rees's excellent introduction to A. L. Rees, Duncan White, Steven Ball, and David Curtis (eds.), *Expanded Cinema: Art, Performance, Film* (London: Tate, 2011).

3. Andrew V. Uroskie, *Between the Black Box and the White Cube: Expanded Cinema and Postwar Art* (Chicago: University of Chicago Press, 2014), 125.
4. Uroskie, *Between the Black Box and the White Cube*, 124.
5. Uroskie, *Between the Black Box and the White Cube*, 129.
6. ibid.
7. Uroskie, *Between the Black Box and the White Cube*, 128.
8. Walter Benjamin introduced his concept of the "optical unconscious" in his 1931 essay "Eine kleine Geschichte der Photographie," translated as "A Short History of Photography" by Stanley Mitchell, in *Screen* 13, 1 (Spring 1972), 7; he invokes the concept again in the better-known 1936 essay, "Das Kunstwerk im Zeitalter seiner technischen Reproduzierbarkeit" ("The Work of Art in the Age of its Technological Reproducibility"), section XIII.
9. These other solid light projections of the 1970s included a gallery installation, *Long Film for Four Projectors* (1974) and a time-based performance, *Four Projected Movements* (1975), consisting of four sequential iterations of one film on one projector. See Anthony McCall, "Line Describing a Cone and Related Films," in Jackie Hatfield (ed.), *Experimental Film and Video: An Anthology* (New Barnet: John Libbey, 2006).
10. Anthony McCall, "Line Describing a Cone and Related Films," 64.
11. Anthony McCall, "Anthony McCall – five minutes of pure sculpture at hamburger bahnhof.flv." YouTube video, 4:12. Posted by "haad vn," May 4, 2012.
12. Catherine Elwes, *Installation and the Moving Image* (London: Wallflower, 2015), in which Snow is cited, from a conversation with Elisabetta Fabrizi and Chris Meigh-Andrews, BFI Southbank, London, December 2008.
13. Elwes, *Installation and the Moving Image*, 40–1.
14. Zach Sokol, "Takeshi Murata Made An Animated Sculpture That Melts Into Itself," The Creators Project, May 15, 2014, <http://thecreatorsproject.vice.com/blog/takeshi-murata-made-an-animated-sculpture-that-melts-into-itself> (last accessed March 15, 2017).
15. Laura Bartlett Gallery, "Elizabeth McAlpine: Square Describing a Circle, Art Statements, Art Basel," 2010, Laura Bartlett Gallery, <http://www.laurabartlettgallery.com/exhibitions/art-statements-art-basel-2/press-release/> (last accessed March 15, 2017).
16. Sabrina Gschwandtner, "Film Quilts," <http://www.sabrinag.com/pages/quilts/00quilts.php> (last accessed March 15, 2017).
17. WIELS, "Film as Sculpture," WIELS, Brussels, 2013, <http://www.wiels.org/en/exhibitions/471/> (last accessed March 15, 2017).
18. Rosalind E. Krauss, "Close-Up: Frame by Frame," *Artforum International* (September 2012), 419.
19. Krauss, "Close-Up: Frame by Frame," 417.
20. Krauss, "Close-Up: Frame by Frame," 418.

Part II

Sculpture Gallery: 150 Statues from European and American Cinema

Vito Adriaensens and Lisa Colpaert

The following pages make up a sculpture gallery featuring a selection of 150 sculptures that play noteworthy parts in the plots or mise-en-scène of films. This selection of works and films represents the major themes and tropes that frame the encounter of sculpture and cinema. The gallery is not an exhaustive one, but rather a personal selection of works and films that we find especially interesting, chosen from a considerably longer list and focused on European and American cinema. These entries resonate with the first part of the book and also complement it, including some cinematic statues found in film genres and periods that were not the focus of previous chapters, thereby providing a historical overview of key sculptural motifs and cinematic sculptures. The gallery primarily includes many fictional sculptures that were made especially for films, but it also showcases a number of existing works. Some of these are the main subjects of canonical art documentaries and experimental films, including *Les Statues meurent aussi* (Chris Marker, Alain Resnais and Ghislain Cloquet, 1953), *L'Enfer de Rodin* (Henri Alekan, 1957), and *Ritual in Transfigured Time* (Maya Deren, 1946). Animating static artworks by means of camera movement, lighting, editing, and music, these films suggest that cinema is the perfect medium for the exploration and visualization of sculptural volumes, which can be perceived from various or shifting viewpoints.

This gallery also includes some "real" sculptures that play an important role in fiction films. Often, these are iconic statues, such as: Frédéric Bartholdi and Gustave Eiffel's 1886 *Statue of Liberty*, which is scaled in the epic closing scenes of Alfred Hitchcock's *Saboteur* (1942) and taken for a spin around Manhattan in *Ghostbusters II* (Ivan Reitman, 1989); Gutzon and Lincoln Borglum's *Mount Rushmore National Memorial* (1927–41), the location of another suspenseful altercation in Hitchcock's *North by Northwest* (1959); and the Vorontsov Palace marble lions (*c.*1830) – modeled in part after the Medici lions – that were immortalized and animated by Sergei Eisenstein's montage in *Battleship Potemkin* (1925). Such "real" statues retain their real

world connotations but are also somewhat fictionalized when integrated into cinematic narrative. The reality status of some works is unclear, for instance in the well-known opening scene of Federico Fellini's *La dolce vita* (1960), in which a large statue of Christ the Redeemer is flown into Rome by helicopter; and its corresponding echoes in Angelopoulos's *Topio stin omichli* (1988), in which a gigantic stone hand mysteriously emerges from the sea and is quietly helicoptered away over the city; and in Angelopoulos's *To vlemma tou Odyssea* (1995), in which a boat transporting a monumental fractured statue of Lenin is borne down the Danube. Real and fictional classical Greco-Roman statues are also a staple in film, more generally as decor or in particular as important plot ploys – this includes famous statues such as the *Farnese Hercules* or the *Medici Venus*.

Real sculptures (or their replicas) also figure in artist biopics such as *Camille Claudel* (Bruno Nuytten, 1988) and are often turned into props marking dramatic moments in the biography of the artist. Sculptures and other artworks also become fictionalized in film through parody or forgery, whereby filmmakers play with audiences' awareness to set up clever jokes and disrupt expectations. In *Dinner for Schmucks* (Jay Roach, 2010), for instance, an artist's work and image are meant to resemble those of Matthew Barney, and a spoof of César Baldaccini's monumental thumb sculpture *Le Pouce* (*The Thumb*, 1965) is featured alongside taxidermied mice. With the notable exception of Rossellini's *Viaggio in Italia* (1954), we chose not to include museum scenes set in real museums, such as the State Hermitage in Saint Petersburg in *Russian Ark* (Aleksandr Sokurov, 2002).

The vast majority of the statues in this gallery are fictitious ones, especially made for the film. While strolling through the gallery, visitors will discover a range of roles sculpture can play in a film's narrative and see what striking elements of decor statues have been throughout film history. They function as denotations of a certain era or culture, such as that of classical antiquity, or of social status, as their presence can be an indication of the characters' wealth or power. Statues and figurines are also noted objects of desire: precious in themselves, because of their secret content, or the embodiment of a riddle that needs to be solved – the falcon figurine in *The Maltese Falcon* (John Huston, 1941) is perhaps the most famous example. In *The Thomas Crown Affair* (John McTiernan, 1999), thieves are themselves the secret content as they sneak into New York's Metropolitan Museum of Art in a veritable Trojan horse sculpture, while in *Cronos* (Guillermo del Toro, 1993), a wooden cherub holds the key to eternal life. Desired statues can be idols, fetishized in the magical, religious, or Freudian sense. *The Golden Idol*, or *Chachapoyan Fertility Idol*, that Indiana Jones sets out to steal away from the native Hovitos in *Raiders of the Lost Ark* (Steven Spielberg, 1981) famously triggers a plethora

of booby traps and summons the wrath of the locals; in Albert Lewin's *The Picture of Dorian Gray* (1945), the protagonist's desire for eternal youth is made viable by an Egyptian cat statue that grants wishes; and in *Le Noël de Monsieur le curé* (Alice Guy, 1906), a worshiped Madonna statue comes to the aid of a local church to complete their Nativity scene. In a Freudian sense, the fetishization of statues can be synonymous with agalmatophilia, or the sexual attraction to figurative objects. Characters falling in love with statues are as old as literature itself. It is here that the difference between sculpture and painting becomes especially relevant, as statues are three-dimensional objects that are tangibly a part of the characters' world. They are lovingly caressed and adored, but also iconoclastically beheaded and destroyed, reappropriated to fit a different cause, and even weaponized.

It comes as no surprise, then, that cinematic variations on the Pygmalion myth are quite ubiquitous. Cinema is ideally suited to animate the idea of the statue coming to life and the concomitant physical interaction between flesh and marble. One of Georges Méliès's earliest trick films was not coincidentally named *Pygmalion et Galathée* (1898). This motif takes the idea of the magic of artistic creation and compounds it with creation itself, so to speak, turning the artist into a godlike figure and strangely propagating what must be one of the most superficial relationships possible – that between sculptors and their statues. While the Pygmalion myth hinges on the statue coming to life as an act of love, however, the relationship between people and living statues is not always a caring one in cinema. They also come to life to wreak havoc and extract revenge, usually with deadly consequences. Thus conversely, sculptures – and artworks in general – can be said to have a strong connection to death and transgression. The reversal of the conceit in which a statue comes alive might be called the Medusa syndrome, whereby people are turned into statues through magical and mythological petrification, or just plain artisanal craftsmanship. Statues can be good places in which to hide bodies. The gruesome discovery that a statue houses a dead human body is conventional in the wax museum film in particular, and an important horror trope in cinema generally, as exemplified by Roger Corman's *A Bucket of Blood* (1959), for instance. It is in this morbid sphere that we also find a parallel between the sculptor and the surgeon, and that the recurring figure of the mad sculptor reigns supreme. Although they do not necessarily work with the same raw materials, both work to craft bodies, and this equation is made in films such as *The Penalty* (Wallace Worsley, 1920) – in which a surgeon faces a former amputee patient who has become an evil mastermind and is posing for his daughter's sculpture – and *Stolen Face* (Terence Fisher, 1952), in which a female criminal marries the plastic surgeon who has given her a new face and a large bust is made to symbolize the occasion. Not surprisingly,

the surgeon character also appears in a number of wax museum horror films, such as *Mad Love* (Karl Freund, 1935) and *M.D.C. – Maschera di cera* (Sergio Stivaletti, 1997). Cinema often reduces sculpted portraiture to its origins in the death mask, representing busts of great men and women, both real and fictional. As is the case with painted portraits in film, there is often a gendered binary in the role of such busts. Male portraits are often of deceased patriarchs, while female portraits represent mysterious women from the past, unknown to both the character and the spectator but nevertheless present. What these male and female portraits have in common, however, is that they make absentees compellingly present, and that they are repeatedly tokens of death, past or imminent.

Sculptures more generally represent remnants of the past as they are closely connected to history, memory, and even melancholy. This is perhaps why antique sculptures trump modern ones on the screen by far. Historically, modern or avant-garde art has also been linked to insanity or eccentricity and can be the subject of mockery, and we see that this is also often the case on screen, where figurative works rule the roost. A classic example of modern art mockery is the abstract painting that is hung upside down, and in Tim Burton's *Beetlejuice* (1988), for instance, this happens to the abstract sculptures of mocked artiste Delia Deetz (Catherine O'Hara) that later come back to haunt the characters. Sculptors who do not receive the recognition they feel they deserve will sometimes turn to murder, which is the case in Jean Yarbrough's *House of Horrors* (1946), in which artist Marcel DeLange (Martin Kosleck) does not take kindly to bad reviews of his abstract works. Of course, when a sculptor's work is a little *too* figurative (i.e. lifelike), this is also not a good sign, because it usually means that the statue is, or was once, alive.

All the entries in this selection have in common that they somehow integrate material, three-dimensional, and generally static objects into a cinematic world, which produces immaterial, two-dimensional, kinetic, and fictional images and hereby mediates a range of magical, mystical and phenomenological interactions between the two media. Next to examining key sculptural motifs, this gallery then also explores how sculpture motivates cinematic movement and how the kinetic images of cinema visualize statues through camera movement and editing. Another aspect of intermediality is found in the interactions between actors and statues, which are often surprising, disturbing, taboo, or perverse. Two famous examples are the toe-sucking sequence in *L'Âge d'or* (Luis Buñuel, 1930) and the opening sequence of Chaplin's *City Lights* (1931), in which the tramp animates a group of statues by his clumsy movements. Furthermore, a number of Hollywood musicals such as *Top Hat* (Mark Sandrich, 1935) also integrate immobile statues into dance sequences – much as in Deren's *Ritual in Transfigured Time*. In most contexts,

artworks are not to be touched, and this status as forbidden fruit is naturally also what motivates such appealingly transgressive scenes. This transgression is a perfect premise for comedies, wherein precious sculptures are groped, accidentally altered, or smashed to smithereens. In this comic context, sculptures are also known to fight back.

First and foremost, the sculpture gallery serves to provide the reader with a selection of the most striking examples of the many issues broadly touched upon in this introduction. For more in-depth discussions with bibliographical references, we kindly point the reader to the first part of this book, in which cinematic statues will come alive and leap from the pages.

statue trope was immensely popular, and he served as both mythical sculptor and life-giving deity at once in his many trick films. In *Pygmalion and Galatea*, we are in the studio of a Roman sculptor, filled with empty pedestals and a cardboard backdrop that suggests a columned bathhouse. The toga-wearing sculptor is hammering away at a sculpture of a woman bearing a cup and pitcher. The statue appears to be cardboard and is placed in front of a black matte that facilitates the special effects to follow. When the sculptor finishes his work he marvels and directs his hands skyward as if to invoke the gods. The gesture immediately makes the statue come to life, and while he backs away, the newly born woman walks onto one of the empty pedestals to strike a new pose. The Roman sculptor is in awe and tries to grab his beautiful creation, but she is transported to another place again and again, before returning to her original pedestal in statuary form. The sculptor is left alone and in tears. (V.A.)

Pygmalion et Galathée (Georges Méliès, 1898)

Méliès was probably the first director to adapt the Pygmalion myth to the screen. Not only did the myth serve as an apt metaphor for cinema, which is essentially the animation of static bodies, but Méliès also embodied it himself. He came from a stage entertainment background in which the living

Le Magicien (Georges Méliès, 1898)

The Magician is a short and frenetic presentation that serves as a sibling to *Pygmalion et Galathée*. Méliès's trademark matte photography and stop-action camera techniques are employed to make a wizard conjure up objects out of thin air and transform himself. The pièce de résistance sees the wizard changed into a bearded and toga-clad image of an archaic sculptor, who goes to work on a bust of a woman. The bust comes to life and throws away the sculptor's chisel before turning into a full-length toga-clad sculpture holding a harp on a pedestal. The sculptor marvels and tries to hug the statue, but it teleports itself out of his way and ultimately vanishes into smoke. Interestingly, Méliès never seems to allow his Pygmalionesque sculptors the consummation of their creation. (V.A.)

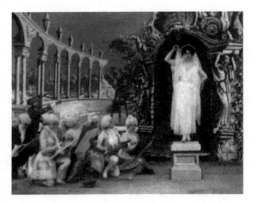

La Statue animée (Georges Méliès, 1903)

Set against an antiquated painted backdrop complete with ornamental columns, a man wearing a wig and sporting full eighteenth-century attire walks in with an easel, set to commence a drawing lesson in *La Statue animée*, also known as *The Drawing Lesson*. When he leaves for a second, a clown appears who conjures up a living statue dressed entirely in white, holding up a white handkerchief. When the teacher reappears with his students, they are stunned to find the statue of the woman and begin drawing intensely. When the drawing teacher stands under the statue, however, it suddenly comes to life and takes off his hat, before turning into an ornamental fountain that spurts him with a ray of water. (V.A.)

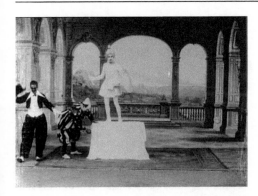

La Statue (Alice Guy, 1905)

Gaumont's Alice Guy takes the torch from Méliès in *The Statue*, which has two clowns bring a whitewashed statue to life by turning a crank handle on its pedestal. The statue quickly turns against them by instigating a fight, for after every crank the statue switches its position and hits the clowns. Annoyed by their buffoonery, the statue leaves the picture and one of the clowns takes its place. Early living statue shorts like this one are usually situated in the realm of trick effects and slapstick, with a solid dose of physical violence. (V.A.)

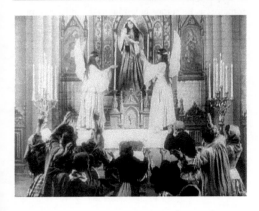

Le Noël de Monsieur le curé (Alice Guy, 1906)

The Parish Priest's Christmas is one of the first films to play with the animation of Christian iconography, in which weeping and bleeding statues and Marian apparitions are commonplace. In this short film, a poor priest cannot afford a doll to represent baby Jesus in his church's modest nativity scene. Through the power of prayer, however, a statue of a Madonna with Child miraculously comes to life on Christmas Eve. Two angels materialize to assist the Virgin Mary as she offers her own child for the nativity scene. The congregation rejoices at the Christmas miracle and Mary returns to her pedestal to assume a praying position. (V.A.)

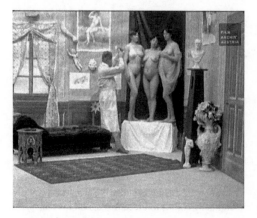

Der Traum des Bildhauers (Johann Schwarzer, 1907)

This silent "nudie cutie" was made by the Austrian Saturn studio. They specialized in blue movies and were rather quickly shut down because of it. In *The Sculptor's Dream*, a sculptor is working on three life-sized female statues (i.e. three nude women who try to remain motionless). While he is asleep, the statues come to life to grace his cheek with a kiss. The sculptor wakes euphorically, throwing kisses at the statues, but the affair turns out to be a dream. The film is interesting not only because it is the first in a series of erotic tableau vivant presentations by Saturn, but also because it represents the artist dreaming his creations to life, a popular trope in this period. (V.A.)

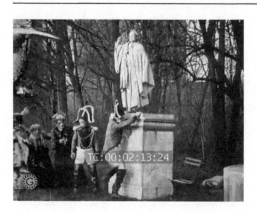

L'Homme de marbre (Étienne Arnaud, 1908)

In this slapstick chase film, *The Man of Marble*, a whitewashed tableau vivant performer in Roman garb is annoyed by one of the spectators and beats him across the head, but this gesture angers the crowd and he has to make a run for it. On his escape, he scares a few picnicking ladies; poses motionlessly on a pedestal to evade capture; and steals a number of sculpted body parts from a studio. Coming into an open space, the living statue performer spreads out the sculpted body parts and his captors are shocked by what they think are his remains, as he stands laughing to the side. A similar statuesque slapstick chase moment can be found in Buster Keaton's *The Goat* (1921) a little further down the gallery. (V.A.)

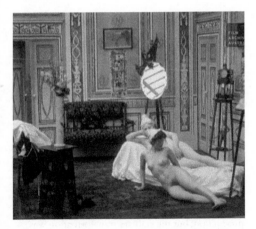

Das eitle Stubenmädchen (Johann Schwarzer, 1908)

The second in a series of nude tableau vivant shorts by the Austrian Saturn company, this short shows the titular *Vain Chambermaid* enter a room that has a reclining nude Venus statue in it. The statue is quite clearly a whitewashed model lying on a mattress that serves as a pedestal. The chambermaid first mocks the nudity of the statue and jokingly imitates its pose. Soon, however, she starts comparing measurements to the point where she lies down nude beside the statue in the exact same pose. Unfortunately, it is at this point that the master of the house catches her in the act. The film serves as a comedy, but it also aptly points out that Venus statues were deemed an important beauty ideal in the late nineteenth and early twentieth centuries. (V.A.)

Un Tic nerveux contagieux (Unknown, 1908)

Also known as *Contagious Nervous Twitching*, this Max Linder slapstick short by Pathé Frères follows a character afflicted with a nervous disorder as he tries to get to a wedding. Max's twitching is so contagious for all who lay their eyes upon him that it causes people to fall off ladders, tumble down steps, and act like fools. When Max walks through a park, he even passes his nervous twitch on to a statue, causing it to bend at the knees. Eventually it takes a doctor to straighten him out. The subject of nervosity seems to have been a popular one, as competitor Gaumont released a short named *Le Tic* (Étienne Arnaud) in the same year, this time with a woman who cannot stop winking at people. (V.A.)

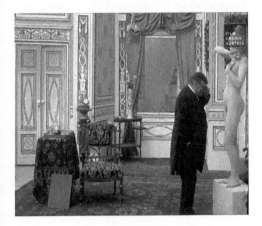

Lebender Marmor (Johann Schwarzer, 1910)

As part of an elaborate prank to fool a friend, a few chums hire a young girl to whitewash herself and pose nude as a marble statue on a pedestal in a private room, in *Living Marble*, a film by the Austrian Saturn company. When their friend is told to wait in the room, it isn't long before he notices the enticing nude statue. He draws the curtains, checks the door, takes off his toupee and goes in for a closer look. When he starts feeling up the statue, however, it comes to life to fend him off and his friends burst in laughing. The practice of ogling and groping statues is one that resurfaces throughout film history, with the first partially preserved example found in R. W. Paul's 1898 *Come Along, Do!* (V.A.)

The Miracle (Michel Carré, 1912)

From the 1911 Karl Vollmöller play that was staged by Max Reinhardt, *The Miracle* was adapted to film a number of times, most famously in the eponymous 1959 film. *The Miracle* tells the medieval legend of nun Megildis (Florence Winston), who leaves her convent because she is led astray by a knight and a minstrel, and the story was probably inspired by the legend of Beatrice. In Megildis's absence, a statue of the Virgin Mary comes to life to take Megildis's place. When Megildis eventually returns to the convent with a dying infant, the Virgin Mary forgives her sins and returns to statuary form. The film was a big, spectacular production, but the statuary transformation was not so grand, as it simply shows the statue get up from its seated position to don a nun's habit. The film featured Volmöller's own wife, Maria Carmi, as the Madonna. (V.A.)

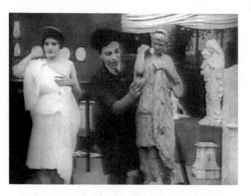

The Marble Heart (Unknown, 1913)

The Marble Heart was originally a play written by Théodore Barrière and known as *Les Filles de marbre* (1853). In this film adaptation by the Thanhouser Film Company, it tells the story of sculptor Raphael (James Cruze) who falls in love with Marco (Marguerite Snow), a woman he meets at an exhibition and who poses for his masterpiece – a half-sized statuette in Grecian dress. Unfortunately, Marco is said to have "no heart," and so while Raphael ignores the romantic attention he receives from another young girl, Marco flirts with a wealthy suitor. In an elaborate dream sequence that mirrors these events, Raphael imagines himself in ancient Athens. He falls in love with a marble statue that he has created, but then his wealthy Maecenas Diogenes comes along to claim it. Diogenes proposes to let the statue decide and leans in to ask, upon which the statue magically comes alive to nod affirmatively. Raphael wakes from his dream but his rejection follows him in real life. He takes ill and destroys his masterpiece with a hammer, erasing all memories of Marco. As in earlier films, the dream sequence serves as the ideal context for statuary animation here, providing an explanation for an otherwise inexplicable magic. (V.A.)

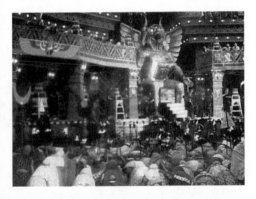

Cabiria (Giovanni Pastrone, 1914)

Inspired by ancient Greco-Roman reports of child sacrifice in Carthage, the epic *Cabiria* tells the tale of an eponymous little Sicilian girl (Carolina Cathena) who gets separated from her family and is then sold to Carthaginian barbarians. The high priest of Carthage intends to sacrifice her to the figure of Moloch, a deity represented by a large seated bronze statue with wings in which sacrifices are made. Monumental "antique" sculptures are a big part of *Cabiria*'s impressive decor and plot. Not only does one enter the Temple of Moloch through the orifice of an enormous three-eyed head in the film, but the winged seated statue of Moloch inside is essentially a hollow bronze furnace in which children are sacrificed to the flames. In one of the film's crucial scenes, Cabiria needs be to saved from being sacrificed, and this is where the herculean Maciste (Bartolomeo Pagano) steps in, truly making the film one of the first peplum epics. If the statues seem familiar, that might be because you have seen Fritz Lang's *Metropolis* (1927), which can be seen further down the gallery, or because you have recently visited Cinecittà World in Rome, where they are on display. (V.A.)

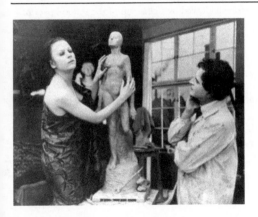

Die ewige Nacht (Urban Gad, 1916)

In this drama, *The Eternal Night*, photographed by Karl Freund, Asta Nielsen plays the blind Marta, a young girl who falls in love with sculptor Frank Norbert (Max Landa). Frank takes Marta for the ideal model, but when his sculpture of Marta wins first prize at a contest, he leaves her and marries a woman of nobility. A fellow sculptor takes Marta under his wing and she develops into a passionate harpist. Frank comes back to court her as a model, but when she gives in the same thing happens to her again, so Marta destroys Frank's sculpture. This plotline reflects a larger trope in which a finished work of art is equated with the end of a relationship, usually between artist and model, or the end of a life, usually that of the model's. In early Danish cinema, the sculptor was also a popular character. Danish director Robert Dinesen made two interesting films, for instance, in which he also played the part of the sculptor: *Djævelens Datter* (*The Devil's Daughter*, 1913) and *Den sidste Nat* (*The Last Night*, 1915). (V.A.)

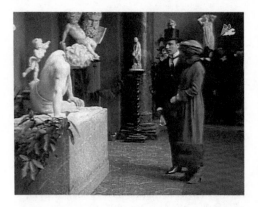

L'atleta fantasma (Raimond Scotti, 1919)

This strong man feature with Mario Guaita-Ausonia, *The Ghost Athlete*, foreshadows the trope of a superhero leading a double life, much like what we have seen in recent years from the Marvel or D.C. universe. Ausonia was part of a trio of strongmen, the "Gladiators of the Twentieth Century," who performed strongman acts and enacted famous paintings and sculptures on the popular stage. The actor rose to fame in Enrico Vidali's *Spartaco* (1913), making him a part of the first wave of beefy heroes to populate the peplum genre. Ausonia plays Harry Audersen, wealthy mild-mannered fiancé to adventurous dreamer Jenny Ladimoor (Elsa Zara). He is secretly the "ghost athlete," a hero in chainmail hood and evening dress. The plot of the film concerns the Grand Museum's sale of a sacred Jewish Urim and Thummim high priest's breastplate, a priceless mystical amulet that interests many shady figures. A first visit to the museum highlights a pedestal featuring a classical marble statue of a man reclining on one arm, but the statue is clearly a whitewashed performer. It is presented as a superb reproduction of *The Dying Gaul* (also *The Dying Galatian* or *The Dying Gladiator*), a statue that is in itself a Roman reproduction of a lost Hellenistic work dating back to *c.*230 BC. The camera frames the work from behind in an attempt not to give away the illusion completely, and it also garners a lot of attention from visitors. One of those is the disillusioned Jenny, who wishes Harry could be more masculine and heroic like *The Dying Gaul*. When scheming antiquarians Tesy and Mesy break into the museum that night to steal the amulet, the ghost athlete catches them in the act by pretending to be the statue of *The Dying Gaul*. The animation is foreshadowed by a close-up of the statue's peering eyes, before we see the whitewashed hero don the chainmail hood and throw Tesy and Mesy out of the window. When the fleeing antiquarians look back, their fear animates another statue on the façade of the museum, as a chainmail hood appears over its head. The ghost athlete bulges his biceps on many more occasions in the film to protect and retrieve the amulet, especially when it becomes the property of his fiancée Jenny. (V.A.)

The Penalty (Wallace Worsley, 1920)

In this chilling horror film we follow San Francisco sculptor Barbara Ferris (Claire Adams), who sets out to make one last work entitled "Satan – After the Fall." Ferris looks for male applicants resembling Satan and winds up with a legless criminal mastermind known as Blizzard (Lon Chaney). Little does she know, however, that her model's artistic aspirations are part of a vengeance plot against her father, Dr. Ferris, who was responsible for the unnecessary amputation of Blizzard's legs as a child. The criminal tries to use the female sculptor as leverage in order to coax Dr. Ferris into amputating the legs of Ms. Ferris's fiancé and grafting them onto his stumps. His plan is thwarted, however, when they operate on his brain instead, turning him into a sane and harmless person, but also enabling his enemies to kill him. Barbara Ferris nevertheless manages to capture the essence of evil that once dominated Blizzard in her life-sized clay bust. The expression on the sculpted face is one of evil intent with a hint of sadness; the artist also added two small horns as an explicit satanic reference. Ms. Ferris described her own work as "an evil mask of a great soul." *The Penalty* is one of the first films equating the art of sculpture with that of surgery, a trope that would become more apparent in the horror films from the 1960s and 1970s. (V.A.)

Modeling (Dave Fleischer, 1921)

This Koko the Clown cartoon in Max and Dave Fleischer's *Out of the Inkwell* series is a perfect example of how animation and live action were successfully blended together as early as 1921. Apart from Koko coming to life on the page out of the artist's inkwell, there is also a sculptor at work on a portrait bust in the same studio. His model – an older man with large ears and a big nose – is none too happy with the result because the bust looks too much like him. When Koko appears he first mocks the man's appearance from on the page, but then jumps off the page and into the real world, making his way to the bust. The animated character crawls into the bust's mouth and makes the bust appear to come alive through stop-motion. The model is so startled that he keels over and leaves the studio in anger, chucking a big piece of clay at the sculptor and causing Koko the Clown to flee back into his inkwell. The Fleischers' use of stop-motion is echoed by filmmakers such as Ray Harryhausen and Tim Burton, who would also go on to animate statues. (V.A.)

The Goat (Buster Keaton and Malcolm St. Clair, 1921)

On the run from being mistaken as the notorious murderer Dead Shot Dan, Buster Keaton walks into the unveiling of a new statue in the park in this slapstick chase film. While the sculptor – beret, goatee and all – presents his statue of famous racehorse "Man o' War," Buster jumps onto the statue and pretends he is part of it to evade capture. The sculptor is devastated and Buster's weight slowly makes the freshly sculpted horse buckle to its knees before he and the horse fall off the pedestal and Buster has to flee the scene again. Slapstick performers pretending to be statues pop up more than once, but Keaton's gag is a truly transformative one. (V.A.)

Bronenosets Potemkin (S. M. Eisenstein, 1925)

After the working classes are slaughtered by the Tsarist forces in the famous Odessa steps sequence, the titular *Battleship Potemkin* retaliates by firing its guns at the Opera House, which is the enemy stronghold. It is then that Eisenstein's intellectual montage magic intervenes, animating statues by the simple juxtaposition of images. We see the battleship fire a round and are consequently confronted with three quick shots of cherub statues in different positions, photographed in a way that makes them appear to throw a punch. Eisenstein's clever montage is followed by a few shots of destruction by the ship's guns, before similarly animating a statue of a sleeping lion in three shots. The lion statue is first shown sleeping, then aroused, with its mouth open, and finally raised up and fearsome. In this sequence, the cherub represents the "little man" striking back to finally awaken and frighten the lion that is Tsarist Russia. Eisenstein made more use of statuary montage in his films, most notably in *Oktyabr* (*October*, with Grigori Aleksandrov, 1928). (V.A.)

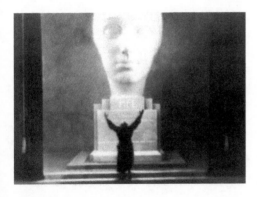

Metropolis (Fritz Lang, 1927)

Statuary imagery abounds in Fritz Lang's epic science fiction dystopia *Metropolis*, which features a cathedral with impressive gothic sculptures, including a statuesque specter of death. The film's most famous sculpture is a *Maschinenmensch* (Brigitte Helm) devised by evil inventor Rotwang (Rudolf Klein-Rogge) to replace his lost love Hel, who left him for the wealthy city's founder Joh Fredersen (Alfred Abel) and died while giving birth to her son. This set-up drives the plot forward, and to commemorate Hel, Rotwang had a giant marble statue of her head constructed as a funerary monument at his house. When Joh Fredersen discovers the monument, Rotwang says that for him Hel is still very much alive, showing him his mechanical creation. With a nod to *Cabiria* (1914), *Metropolis* also prominently features a comparison between the factory and the temple of Moloch. The statuary head of the Moloch idol gives way to the factory in this film, suggesting the sacrifice the workers are making to the idol of modernity. (V.A.)

Oktyabr (S. M. Eisenstein and Grigori Aleksandrov, 1928)

Focusing on the October Revolution of 1917, *Oktyabr*, or *October: Ten Days that Shook the World*, opens with a large crowd that sets out to bring down the gigantic statue of Emperor Alexander III with ropes. Eisenstein and Aleksandrov make the point that the new leaders in the wake of the February 1917 revolution are not all that different from the emperors of the past. Provisional government leader Alexander Kerensky (Nikolay Popov) is not only mockingly compared to a mechanical peacock in the film, but also to emperor Napoleon, by cutting back and forth between shots of Kerensky and a statuette of Napoleon with his arms crossed. When the forces of General Kornilov try to stage a military coup on Petrograd, Kerensky calls upon all to defend the city for God and country. This call to arms is followed by a famous montage of statues of different deities to accompany the word "God," and accompanying the word "country" are shots of different military medals and a stop-motion sequence that shows the statue of Emperor Alexander III put back together again reversely, as if to imply that the old power has been reinstated. General Kornilov suffers the same fate, however, as a shot of him on his horse is juxtaposed with a statuette of Napoleon on horseback. The film also features two marble Rodin statues, *Le Baiser* (*The Kiss*) and *L'Éternelle Idol* (*The Eternal Idol*) (both *c.*1889), which the camera treats as sensuously as if they were flesh. (V.A.)

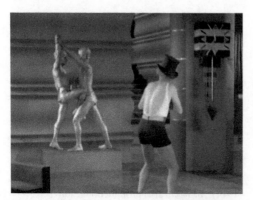

Animal Crackers (Victor Heerman, 1930)
In this Marx brothers' comedy caper about the theft and forgery of a painting – Beaugard's *After the Hunt* – a bronze statue of two fighting gladiators on a pedestal briefly comes to life. When Harpo takes a crack at the duo with his gun, the bronzed men suddenly break their pose and fire back at him, before resuming their fighting statuary stance. The oddity of this gag is entirely in keeping with the surreal nature of Harpo's persona. (V.A.)

Ein Lichtspiel: schwarz weiss grau (László

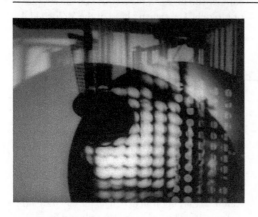

Moholy-Nagy, 1930)
At the center of Bauhaus professor, painter, and photographer Moholy-Nagy's avant-garde film is the kinetic sculpture that he created with

the help of Hungarian architect István Seboek, *Lichtrequisit einer elektrischen Bühne (Light Prop for an Electric Stage/Light-Space Modulator)*. The sculpture's dynamism is emphasized in this truly "sculptural film" which shows the work spinning around from several angles and distances, focusing on how it interacts with light and shadow and employing mirror effects, negative images, superimposition, and double exposure to strengthen these effects. The juxtaposition of the images not only shows the sculpted work's true potential, it also shows the impact that cinema can have on sculpture and its graphic representation, animating the static beyond what is possible in real life. *A Light Play: Black White Gray* is one of the first avant-garde films to engage a sculpture in this cinematic way. (V.A.)

L'*Âge d'or* (Luis Buñuel, 1930)

In the fourth episode of this Surrealist classic, *The Golden Age*, two lovers secretly meet in a sculpture garden. While they are making love, the man's attention is drawn to the naked foot of a Roman statue. When the man leaves, the woman sucks the toe of the statue, unambiguously evoking fellatio. In addition to this provocative scene of fetishism and agalmatophilia, the film also includes a brief scene in which a man passes a statue of Bossuet. Both the statue and the man have a loaf of bread on their heads. Buñuel's first surrealist film, *Un Chien Andalou* (*An Andalusian Dog*, 1930), also features sequences that evoke sculpture. In one scene, a man is shot and falls against a sitting nude in a garden. In another scene, two petrified characters are half-buried in sand, an image that was used by Salvador Dalí (who co-wrote the script with Buñuel) in his painting *Remorse, or Sphinx Embedded in the Sand* (1931). (L.C.)

City Lights (Charles Chaplin, 1931)

The opening sequence of *City Lights* visualizes the unveiling of a monument, *Peace and Prosperity*. When the drapes are lifted, the bourgeois bystanders are startled because a vagrant (Chaplin) is asleep in the arms of a female statue. When he awakens, his attempts to extract himself from the situation result in a series of mortifying poses, which unintentionally cause more dismay. For example, while climbing down, his pants are torn by the sword of one of the figures. Likewise, when Chaplin stands up from sitting on the hand of one of the statues, the suggestion is made that the statue's hand is making provocative movements. As Kenneth Gross described it, in his vain attempts to rigidify himself Chaplin evokes the idea that the statues are moving. (L.C.)

Le Sang d'un poète (Jean Cocteau, 1932)
In this first part of his Orphic trilogy, *The Blood of a Poet*, Cocteau tells the story of a young artist (Enrique Rivero), who is bewildered when the mouth in his self-portrait comes to life. When he tries to wipe it out, the mouth is transferred to his hand. The artist then tries to wipe it off on the mouth of a female statue. The awakened statue (Lee Miller) orders the artist to leave the studio. When he arrives at the Hôtel des Folies-dramatiques, the artist sees animations of hermaphrodites through a keyhole. Back in his studio, the artist violently smashes the statue and is turned into stone. Later in the film, a statue of the artist is decapitated during a snowball fight by young schoolboys. Full of references to the Pygmalion and Medusa myths, Cocteau's film visualizes the interaction between motion and stillness, creation and destruction, and living and dead through the animation of statues. As in *La Belle et la bête* (*Beauty and the Beast*, 1946), *Orphée* (*Orpheus*, 1950), and *Le Testament d'Orphée* (*Testament of Orpheus*, 1960), Cocteau combines the petrification of living people with statues coming to life. (L.C.)

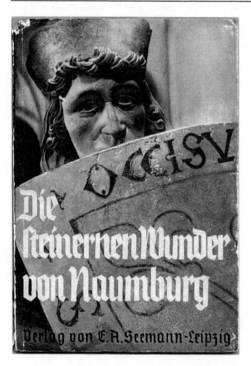

Die steinernen Wunder von Naumburg (Curt Oertel and Rudolf Bamberger, 1932)
This landmark art documentary explores the famous sculptures that are a part of the Gothic Naumburg Cathedral and that were made by an anonymous local Master in the middle of the thirteenth century. Particularly the twelve donor portraits, or *Stifterfiguren*, in the west choir of the Cathedral are praised for their extraordinary realism and craftsmanship. The documentary is notable for its approach to the Cathedral's impressive architectural space, as well as the sculptural details of the artworks. The film restricts verbal information to a minimum, conveying meaning on the whole visually. Oertel went on to make a few more art documentaries, including *Michelangelo: Das Leben eines Titanen* (*Michelangelo: Life of a Titan*, 1938). (V.A.)

Love Me Tonight (Rouben Mamoulian, 1932)

When an aristocratic family discovers that their jovial visitor (Maurice Chevalier) is not a baron but just a tailor, the Rodgers and Hart song *The Son of a Gun Is Nothing but a Tailor* is sung by just about everyone in the film. On the verses "the news would make your ancestor upon the wall grow paler; if painted ears could hear it all, that frame would crash from off the wall," an ancestral bas-relief portrait does just that, and upon its rough landing the bas-relief's mouth opens to join in the chorus with a deep voice. (L.C.)

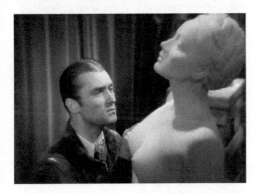

The Song of Songs (Rouben Mamoulian, 1933)

Set in turn-of-the-century Berlin, this pre-Code film depicts the story of young sculptor Richard (Brian Aherne), who falls in love with Lily (Marlene Dietrich), a naive country orphan who has moved to the big city. The film's artistic context is clearly used as a license to show off Dietrich's body: on paper, sculpturally, and in the flesh. When Richard asks Lily to model for him, she can't refuse the handsome artist. As Lily undresses behind the curtains, Richard unveils all of the nude female statues in his studio. The naked torsos are a prelude to Lily's bare body, which we see through the artist's pencil sketches and clay model. They fall in love during the artistic process, but since Richard doesn't really want commit to marriage, he sets her up with a rich baron. The baron wanted to buy the statue, but ends up going for the real thing. The statue thus remains in the artist's studio and the baron gets an original sketch. In the end, however, Lily destroys the statue, and reunites with her original lover, Richard.

The "real" statue was made by Salvatore Cartaino Scarpitta, an Italian sculptor who lived and worked in Los Angeles and who also made the statues for Karl Freund's *I Give My Love* (1934). The artist's studio is packed with both academic and modern pieces (obvious anomalies in a turn-of-the-century studio) made by legitimate contemporary artists – including a marble nude statue by Scarpitta entitled *Transition*. These don't merely decorate the workplace of the artist, however, they also function as a surrogate for Marlene Dietrich's naked body. (L.C.)

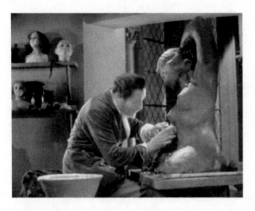

Mystery of the Wax Museum (Michael Curtiz, 1933)

In 1920s London, Ivan Igor (Lionel Atwill) is on the verge of getting his sculptural work recognized by the Royal Academy. Igor is a former sculptor in the more conventional sense, but he felt he could "reproduce the warmth and flesh and blood of life far more better [*sic*] in wax than in cold stone," treating his wax sculptures as living beings. Not pleased with the money the wax museum is making, however, his investor tells him that his "artistic nonsense" is not luring any people in the way that the competition's horrific characters such as Jack the Ripper and Burke and Hare do. The investor proposes they set fire to the museum in order to collect the insurance money. A fight ensues and the wax artist is left for dead in a burning museum. About a decade later, a crippled Igor opens a new wax museum in New York, but his new collection showcases quite a few wax mannequins that bear an uncanny resemblance to disappeared and murdered men and women. The horribly disfigured sculptor, it turns out, kidnapped people who resemble his old masterpieces, so that he could make them immortal once more by spraying them with hot wax and putting them in his museum. This was the first film to feature the Pygmalion reversal trope of living beings turned into statues, as well as being the trendsetter for many other horror conventions, particularly with regard to the wax museum film. (V.A.)

The Scarlet Empress (Josef von Sternberg, 1934)

An inherent part of Hans Dreier's art direction, Peter Ballbusch's sculptures play an important role in von Sternberg's biopic of Catherine the Great (Marlene Dietrich). Throughout the film, the characters are surrounded by expressionist figures, which evoke the mood of the characters (e.g. distraught or mourning), depict their personality (e.g. vicious or suffering), or emphasize the plot (e.g. the statue of a mother and child above Catherine's bed). Strikingly, these expressionist sculptures set the ubiquitous mood of suffering, which sometimes contrasts with the glamorous and royal atmosphere in which the story takes place. (L.C.)

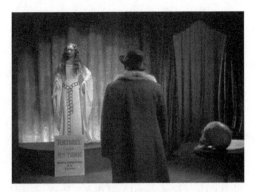

Mad Love (Karl Freund, 1935)

The story of Maurice Renard's *Les Mains d'Orlac* is adapted and infused with elements of the wax museum film in *Mad Love*. Set in Paris, the story opens on mad surgeon Dr. Gogol (Peter Lorre) who is deeply in love with actress Yvonne (Frances Drake), but she is married to famous pianist Stephen Orlac (Colin Clive). Yvonne rejects Gogol's love and so the latter takes what he can: a wax effigy of the actress. When Yvonne's husband loses his hands in a terrible train crash, Gogol transplants a dead murderer's hands onto Orlac's and tries to set him up. Now struggling to play the piano, he is left with nothing but a marble likeness of his former hands, and a knack for throwing knives. When Yvonne goes to Gogol's home, the maid lets her in, thinking she is the wax statue come to life. Once upstairs, Yvonne stumbles into her wax effigy and breaks it. She takes its place when Gogol comes home, but his cockatoo startles her and nicks her on the cheek, leaving a drop of blood. A drunken Gogol sees his wax statue come to life and says: "Galatea, I am Pygmalion. You were wax, but you came to life in my arms." When she resists his advances, he tries to strangle her with her hair, while quoting Robert Browning's "Porphyria's Lover." Luckily, Orlac bursts in at the right moment, killing Gogol with a throwing knife. (V.A.)

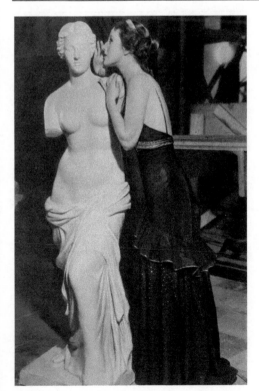

Night Life of the Gods (Lowell Sherman, 1935)

This adaptation of the eponymous novel by Thorne Smith – of *Topper* and *I Married a Witch* fame – is a screwball caper in which eccentric inventor Hunter Hawk (Alan Mowbray) devises a ray that can turn living organisms into marble statues and vice versa. The effect is quite subtly achieved through freeze frames and dissolves and the inventions are quickly brought down to the size of a ring. The first people to feel Hawk's wrath are his pesky relatives, but the real fun begins when Hawk and his newly found magical friend Meg (Florine McKinney) pay a visit to the Metropolitan Museum of Art in New York and decide that some of the sculpted gods could use a night out on the town. It is thus that Hawk brings to life statues of Apollo, Bacchus, Neptune, Mercury, Diana, Hebe, Perseus, and Venus in the Met. Incidentally, the Venus statue is the famed *Venus de Milo* (Alexandros of Antioch, *c.*130–100 BC), so she is brought back without any arms. When the gods and goddesses are properly dressed they are taken out in New York City for eating, swimming, and lots of

drinking – Venus is even outfitted with new arms – but it isn't long before they turn every place upside down. After a long night of partying

and wreaking havoc, Hawk brings them back to the Met and returns them to statuary form. (V.A.)

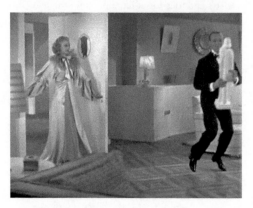

Top Hat (Mark Sandrich, 1935)

Annoying his upstairs neighbor Dale Tremont (Ginger Rogers), Jerry Travers (Fred Astaire) tap

dances and nearly bumps into a statuette of a woman in a stiff pose, which echoes the stiff and uptight Dale. Travers, however, prevents the statue from falling on the floor and continues his dance with the statuette. Statues are an important motif in musicals, their motionlessness emphasizing the mobility of dancers. Famous dance sequences in films such as *42nd Street* (Lloyd Bacon, 1933), *Ziegfeld Follies* (Vincente Minnelli, 1945), *An American in Paris* (Vincente Minnelli, 1951), *Funny Face* (Stanley Donen, 1957), and *Gigi* (Vincente Minnelli, 1958) are set in the vicinity of statues and fountains. In *Living in a Big Way* (Gregory La Cava, 1947), Leo Gogarty (Gene Kelly) dances with a dog in a garden next to a big statue of a woman in a dancing pose, and the choreography also involves a statue of a Roman goddess carrying a water basin. (L.C.)

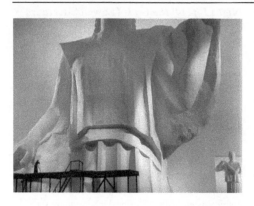

Things To Come (William Cameron Menzies, 1936)

When the city of Everytown goes completely subterranean in 2036 after being ravaged by war for decades in this dystopian science fiction film, a sculptor by the name of Theotocopulos (Cedric Hardwicke) starts a Luddite rebellion against the progress that sees Everytownians starting to explore space. He is working on a giant marble statue of a woman in ancient Greco-Roman dress that is portrayed in an angular modernist style. H. G. Wells absolutely despised Fritz Lang's *Metropolis* and so instructed famous art director William Cameron Menzies to take a different direction with the film. (V.A.)

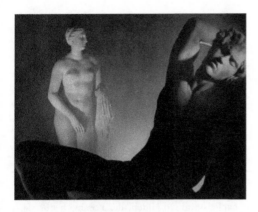

Olympia (Leni Riefenstahl, 1938)

The opening sequence of *Olympia* brings antique statues of Roman and Greek mythological figures, gods and goddesses to life, connecting them to the athletes participating at the 1936 Berlin Olympic games. A downward camera movement passing through a cloudy sky suggests a descent from Mount Olympos. This shot is followed by a series of tracking shots that wander the empty ruins of the Acropolis. A shot of the Parthenon and the introduction of several statues of Olympian deities emphasize the link with the origins of the Olympic games. One of the recurring statues is the *Barberini Faun* (a Hellenistic Sleeping Satyr), used as an image of sleeping antiquity being brought to life. Circling camera movements are intercut with close-ups and a cinematic play of vivid camera movements, chiaroscuro lighting, dust swirls, and dissolves animates the marble faces and sculpted bodies, dramatized further by Windt and Gronostay's score. A full-length Roman copy of the *Aphrodite of Knidos* and the bust of a *Colonna Venus*, for example, are visualized by split screens and dissolves. The sequence transitions from images of marmoreal gods to living athletes, as, after a dynamic circling shot, the camera tracks back from a copy of Myron's *Discobolus* and the frame dissolves into a slow-motion shot of a real discus thrower. After lyrical shots of athletics, the sequence ends with athletes carrying the torch from Greece's Acropolis across Europe to Berlin. This sequence exemplifies Riefenstahl's interest in physical beauty and strength, which was a recurrent theme in all her films. (L.C.)

Michelangelo: Das Leben eines Titanen (Curt Oertel, 1938)

This feature-length film, *Michelangelo: Life of a Titan*, tells the story of Michelangelo's life, which is evoked without depending on re-enactments, but by the visualization of his art, in particular his sculptures; camera movements, montage, sound, and light effects are vital to this depiction. *The Battle of the Centaurs* (1492), for example, is enlivened with the full image of the bas-relief, followed by insert shots and close-ups; the camera glides over the relief and shows all the details of the depicted scene. The next sequence depicts Michelangelo's move to Rome, where recent excavations of marvelous antiquities are said to have inspired his *Bacchus and Young Satyr* (1497–8); a vivid montage of circling camera movements illustrates the intoxication that this god symbolizes. The creation of the first *Pietà* (1498–9) is enigmatically evoked by a shot from behind. The drama of the theme is captured by a moving camera, which slowly explores its subject. The voiceover and Alois Melichar's score reinforce the cinematic treatment of hands and faces, which are captured through chiaroscuro lighting. The creation and history of *David* (1501–4) is evoked through a series of images, suggesting its movements from Michelangelo's studio, through

Florence, to the Piazza della Signoria, where low-angle shots of the replica were photographed, intercut with close-ups of the face and hands of the original displayed in the Galleria dell' Accademia. Later, an attack on Florence and its *David* is evoked: a missile falls and shatters the arm of the statue, followed by dramatic close-ups of David's face and shattered marble pieces. Toward the end, the film focuses on the masterpieces that Michelangelo made in solitude late in life, including *Pietà Rondanini*

(1555–64). In 1950, the film was re-edited by Richard Lyford under the supervision of Robert J. Flaherty and Robert Snyder and was distributed as *The Titan: The Story of Michelangelo*. Carol Reed's biopic *The Agony and the Ecstasy* (1965) also explores Michelangelo's sculptures in its opening sequences, when the camera shows his (Charlton Heston) talent as a sculptor by gliding over some of his finished products and going into the Carrara marble quarries. (L.C.)

The Great Dictator (Charles Chaplin, 1940)

Chaplin's satire of Hitler's dictatorship features a parody of the *Venus de Milo* and Rodin's *Le Penseur* (*The Thinker*) (*c*.1880). The *Venus of Today* and the *Thinker of Tomorrow* are the fictional country Tomainia's modern masterpieces, placed on dictator Hynkel's (Charles Chaplin) monumental avenue of culture. Both famous masterpieces have their right arms point upwards, making the Nazi salute. *The Great Dictator* also features two frustrated artists, a painter and a sculptor who desperately try to portray the dictator, but he only poses for a few seconds. (L.C.)

Charlie Chan at the Wax Museum (Lynn Shores, 1940)

This installment of the Charlie Chan detective movie series combines a popular investigatory

narrative with the unsettling horror of the wax museum. An escaped murderer hides out in Dr. Cream's Museum of Crime, a New York wax museum that showcases wax statues of famous murderers in tableaux settings. The museum also functions as a mob hideout led by wax museum artist and former plastic surgeon Dr. Cream (C. Henry Gordon), who readily supplies thugs with new mugs. An intricate murder mystery unfolds in which people pose as wax statues; people make use of the chess automaton's room for one; wax faces double as secret peepholes; and a wax tableau vivant functions as a disguised entrance to a secret room. Charlie Chan (Sidney Toler) manages to solve the case by baiting the killer with a wax replica of himself, until one of the gangsters discovers that "It's only a dummy, you dummy!" (V.A.)

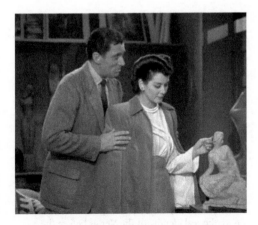

Design for Scandal (Norman Taurog, 1941)
In an attempt to save his job, news reporter Jeff Sherman (Walter Pidgeon) offers to help his wealthy employer out of a scorching alimony settlement. He travels to Cape Cod, where he tries to trick the judge on the case (Rosalind Russell) – an amateur sculptor – into a romance so that he can blackmail her. In order to win her over, he pretends to be a sculptor as well. Sherman, in a ruse that enables him to take over a studio, sends a local sculptor away to the city under the pretense that he will be commissioned to create an ambitious cycle of American history for a building belonging to the wealthy employer. The sculptor's beach house studio is used as a love nest to bait the judge and it is stuffed with modern nudes and two abstract works, including a statuette entitled *Midnight on a Glass Bottom Boat*. In addition to numerous wisecracks about the overly-complex meanings of modern statues, there is also a joke about an abstract artwork that had been bothering the reporter because it was turned upside down. (L.C.)

The Maltese Falcon (John Huston, 1941)
Often considered one of the first examples of film noir, this film revolves around the search for a statuette of a falcon. Shown in the background of the opening credits, the statue is described as a golden falcon encrusted from beak to claw with the rarest jewels. Sent by the Knight Templars of Malta to Charles V of Spain in 1539, it was seized by pirates and had been missing ever since. Dashiell Hammett, who wrote the original novel, was said to have been inspired by the *Kniphausen Hawk*, a ceremonial pouring vessel made in 1697 for a Swedish count. However, the prop used in the film, designed by American painter Fred Sexton, rather resembles an Egyptian Horus statue, a symbol of the sky and the god of war and hunting. The myth regarding the Maltese falcon was an invention, but ironically the mascot of the real Knights Hospitallers, nicknamed Knights of Malta, was a falcon as well. In Huston's film, private detective Sam Spade (Humphrey Bogart) gets involved in the hunt for this priceless statuette. Made unrecognizable by a coat of black enamel, the statue is intercepted by Kaspar Gutman (Sydney Greenstreet), Joel Cairo (Peter Lorre), and Bridget O'Shaughnessy (Mary Astor) but turns out to be a fake. Apart from the opening credits, the titular prop remains invisible until the end of the film. When the four protagonists finally receive the falcon and begin to remove its enamel coat, it is revealed as a fake. Ironically, this presumably inexpensive film prop, with its dark moral about "the stuff that dreams are made of," is now a priceless object, several replicas of which are circulating. A comedy sequel, *The Black Bird* (David Giler), was made in 1975; in it, villains attempt to steal the falcon from the son of Spade (George Segal). The noir drama *The Lineup* (Don Siegel, 1958) also features a statuette that is valued because of its secret content, but this oriental work contains narcotics instead of gold. (L.C.)

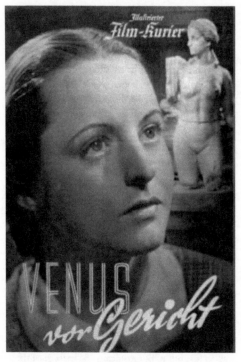

Venus vor Gericht (Hans H. Zerlett, 1941)

Venus on Trial, set in the 1920s, revolves around an excavated statue named *Venus vom Acker* (*Venus of the Fields*), found in a Bavarian field. Experts incorrectly identify the statue as by Praxiteles (fourth century BC). The *Venus vom Acker* becomes front-page news and is widely reproduced on postcards and through plaster replicas. However, sculptor Peter Brake (Hannes Stelzer), a member of the Nazi Party, claims that he has created the statue in the style of the ancient masters as a form of criticism against modern art, which he despises. Nevertheless, he is unable to prove that he is the true creator, and a (Jewish) dealer of contemporary art who has obtained it sells the Venus as a genuine relic to the museum. In his quest against "degenerate art" and the corrupt Berlin art scene, Brake tries to prove his legitimacy without revealing the identity of his model, who lives as the respectable housewife of a small town mayor. As the sculptor is unable to prove the real identity of the Venus before the court, his model finally comes forward as a witness. In the end, sculptor and model are amorously reunited. The sculptor character seems loosely based on Arno Breker, who was endorsed by the Nazi authorities and whose work is known as the neo-classical antithesis of so-called degenerate, modernist art. In the fictitious artist's studio, we see artifacts that resemble Breker's monumental work. According to Felleman, to furnish the decor in this anti-Semitic condemnation of modernism, Zerlett used real sculptures that had been confiscated and banned by the Nazi government, including Ernst Kirchner's wooden sculpture *Das Paar (The Couple*, 1923–4), Otto Freundlich's black-glazed terracotta *Kopf* (*Head*, 1925), and Marg Moll's bronze *Tänzerin* (*Dancer*, c.1930). (L.C.)

Cat People (Jacques Tourneur, 1942)

The apartment of Serbian immigrant Irena (Simone Simon) is decorated with artworks representing cats, including a little statue of King John of Serbia on horseback, who is piercing cats with his sword. The violent nature of the statuette not only emphasizes the cruelty of the horror story, it also hints at the uncannily atavistic powers attributed to Irena, who fears that she is bewitched by a cat curse. (L.C.)

Saboteur (Alfred Hitchcock, 1942)

At the end of this spy thriller, a saboteur of a US Navy battleship flees to the *Statue of Liberty*. Shadowed by a young woman who tries to distract him in the interior of the statue's crown, he escapes to the platform on the torch of the statue, on top of which the dramatic closing scene takes place in which the villain falls from the statue. As with *Mount Rushmore* in *North by Northwest* (1959), Hitchcock explores not only the patriotic and moral meanings of this monument to American democracy but also its dramatic capabilities. Filmed from extreme angles, the statue's dramatic assets are highlighted.

This iconic scene was one of the first of a long list of Lady Liberty's appearances in film. She emerges in films such as *Splash* (Ron Howard, 1984) and *Titanic* (James Cameron, 1997), and she is the site of epic battles in *Around the World in 80 Days* (Frank Coraci, 2004) and *X-Men* (Brian Singer, 2000). She is used as a weapon as in *Superman IV* (Sidney J. Furie, 1987), and attacked and destroyed by villains in *Superman II* (Richard Lester and Richard Donner, 1980) and *Batman Forever* (Joel Schumacher, 1995). In several apocalyptic films, such as *Independence Day* (Roland Emmerich, 1998), *A.I.* (Steven Spielberg, 2001), and *Resident Evil: Extinction* (Russell Mulcahy, 2007), the famous landmark operates as a symbol of the extinction of humanity. Her destruction is often a sign of an upcoming disaster, as in *Deep Impact* (Mimi Leder, 1998), *The Day After Tomorrow* (Roland Emmerich, 2004), *Escape from New York* (John Carpenter, 1981), and *Cloverfield* (Matt Reeves, 2008). In *Planet of the Apes* (Franklin J. Schaffner, 1968), her half-buried body is found on a beach to reveal that the "alien" planet was Earth all along. *Ghostbusters II* (Ivan Reitman, 1989), by contrast, reverses the plot and uses a mobilized *Statue of Liberty* as a symbol of the rescue of New York City. (L.C.)

Les Visiteurs du soir (Marcel Carné, 1942)

Marcel Carné's medieval tale with Surrealist sensibilities tells of two traveling minstrels arriving at a baron's castle on the night of his daughter Anne's (Marie Déa) engagement party. Minstrels Dominique (Arletty) and Gilles (Alain Cuny) have secretly been sent by the devil (Jules Berry), however, to keep the wedding from happening by seducing both parties. When Gilles and Anne fall in love, the devil decides that he wants her for himself, but in the end there is no keeping the two from each other. In a final attempt to thwart their love, the devil turns Anne and Gilles into statues at the fountain where they first declared their love to one another, but even he cannot stop the beating of their hearts. (V.A.)

I Walked with a Zombie (Jacques Tourneur, 1943)

A statue of Saint Sebastian, which was once the figurehead of a slave ship and which is reminiscent of one of the characters, who is hypnotized by voodoo and looks like a zombie, is placed centrally in the garden of the villa in the West Indies where a young nurse has been hired as a caretaker for the paralyzed wife of a sugar planter. Impaled with arrows, the statue symbolizes slavery and is an important token of the voodoo ceremonies that the slaves perform. The statue also instigates the nurse's fear about her paralyzed precursor – she falls in love with the husband of her paralyzed patient – and functions as a Gothic symbol of this hauntingly present absentee. Similarly, several shots of a sculpture of a three-headed monster set the mysterious and ominous mood in Mark Robson's horror mystery *Isle of the Dead* (1945), which was also part of producer Val Lewton's horror cycle. (L.C.)

Experiment Perilous (Jacques Tourneur, 1944)

Tourneur's Gothic melodrama, which takes place in turn-of-the-century New York, features a frustrated, unhappily-in-love sculptor, Claghorn (Albert Dekker). During a party in his studio, he shows off his masterpiece: *Woman*, a giant bust of a woman with serpents for hair. As in Bernini's *Medusa* (1630) and Canova's *Perseus with the Head of the Medusa* (1804–6), the eyes of *Woman* have no irises. Through representing only the head of Medusa, the sculptor is identified with Perseus, who had cut off Medusa's head and gave all men the opportunity to look into her eyes without being turned to stone. This side character exemplifies the other male characters, who try to mold the female protagonist to their ideal image, and the Medusa imagery explicit in his sculpture echoes the film's atmosphere of anxiety about repressed sexuality. The film also features an uncanny painted portrait of the female protagonist, which equally visualizes the theme of a woman's confinement. (L.C.)

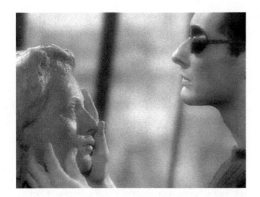

L'Ange de la nuit (André Berthomieu, 1944)

In *Night Angel*, a young sculptor (Jean-Louis Barrault) returns blinded from the war, devastated and anguished by self-doubt. A friend encourages him to take up sculpting again. He regains his confidence as an artist and falls in love with his model. Two clay busts play an important role in the film: one of his former girlfriend, who has since married a wealthy older man, and one of his friend. After touching his former girlfriend's bust, he is distraught, but when he touches his new girlfriend's face, he is inspired to sculpt her. A two-shot of the sculptor touching his model's face dissolves into a shot of him working on her sculpted portrait, which becomes the pièce de résistance at an exhibition, where it is adored by many rich clients. (L.C.)

Phantom Lady (Robert Siodmak, 1944)

This noir thriller features sculptor Jack Marlow (Franchot Tone), whose apartment-cum-studio is decorated with sculptures of heads and a pair of marble hands. Marlow is depicted as mad, murderous, and suffering from artist's block. This stereotypical portrayal of the mad artist is associated with familiar tropes. First, Marlow's madness is signaled by modernism; throughout the first part of *Phantom Lady*, Marlow's work is traditional, but when the artist's murderous identity is revealed, it is associated with a modern, expressionist self-portrait, and connected to Vincent van Gogh's self-portrait with bandaged ear. Also, compulsively touching his sculptures, the artist's expressive hand gestures evoke his psychotic madness. This leitmotif is echoed by a marble sculpture of a pair of hands, which is visualized when Marlow is exposed as a murderer. (L.C.)

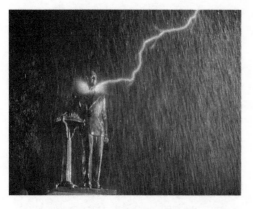

Together Again (Charles Vidor, 1944)

A full-length bronze statue of Jonathan Crandall, the deceased mayor of a small Vermont village, gets decapitated when struck by lightning. The father of the mayor sees the statue's decapitation as a sign from his deceased son, who wanted his wife (Irene Dunne) to leave the village so that she could fall in love and be happy again. His wife – now mayor herself – travels to New York to commission a new statue of her husband and is charmed by sculptor George Corday (Charles Boyer), who claims not to look at women's eyes but at their bone structure. The sculptor follows her to her village, charms her family, and confesses his love to her while they are hiding from a rainstorm, next to a Cupid statue. When she is re-elected as mayor and the sculptor finishes the statue, he returns to New York, where he keeps working on a clay portrait of her. When another lightning bolt beheads the second sculpture of Jonathan Crandall, his wife sees it as a sign to leave her job as mayor and live with the sculptor. She soon discovers, however, that the sculptor had sabotaged the statue himself, but she reconciles with him, nonetheless. (L.C.)

Roma città aperta (Roberto Rossellini, 1945)

In *Rome, Open City*, a film otherwise solemn with the burden of war and Nazi occupation, priest and underground resistance patriot Don Pietro Pellegrini (Aldo Fabrizi) provides a little statuary comic relief. When Don Pietro steps into an antiques store that is a front for the Resistance, he inquires with the clerk after a statue of St. Anthony the Abbot, but the store clerk can only offer him one of St. Roch. The clerk is insistent upon the merits of the saint and tries to make the sale, unaware that this is not really why the priest is in the store. The statuette of St. Roch is set up next to a slightly larger marble nude, and the framing of the shot makes it seem as if the nude statuette is looking provocatively at St. Roch while he glances at her naked front sideways. Don Pietro notices and tries carefully to turn the nude statuette away while averting his eyes, but thereby leaves St. Roch to glance at her behind. Clearly embarrassed, he awkwardly turns St. Roch the other way so there is no more eye contact between the two figures. This sculptural jest may seem extraneous to the plot but does much to confirm the already affable nature of the brave priest. (V.A.)

The Picture of Dorian Gray (Albert Lewin, 1945)

The titular portrait in Lewin's adaptation of Oscar Wilde's novel depicts Dorian Gray (Hurd Hatfield) standing next to a table on which sits a black Egyptian statuette of a cat. One of Lewin's oriental amendments to Wilde's plot, this statuette is first visualized while the other characters look at Dorian's portrait. When Dorian's fiancée sees the statuette, she thinks she sees its eyes move and it frightens her. The allusion to the statuette's mysterious powers foreshadows the supernatural properties of the portrait. Numerous other statues – classical, neo-classical and orientalist – are seen in the film's art-filled interiors. (L.C.)

Ziegfeld Follies (Vincente Minnelli, 1945)

In the sequence "The Babbitt and the Bromide," Gene Kelly and Fred Astaire dance their first and only choreography together in front of a bronze equestrian statue. The sequence starts with a shot of the statue and tracks downward to the dancers sitting on a bench, where the two stars banter as themselves. Then they get up and dance, playing a babbitt (a self-satisfied materialist) and a bromide (a tiresome person), who meet at three different stages in their lives. In the first part, the dance is energetic and the horse in the equestrian statue is rearing up on hind legs. When they meet ten years later, the dancing is more relaxed, as are the rider and the horse in the statue, who look a bit weary. When the men finally meet twenty years later in heaven, the statue has resumed its original posture but has turned into marble and both horse and rider carry golden harps. (L.C.)

Visual Variations on Noguchi (Marie Menken, 1945)

Studying the work of American sculptor Isamu Noguchi, this is Marie Menken's debut film, though many avant-garde films on artists' works would follow. In *Visual Variations*, Menken allows the camera to slide freely between Noguchi's works in wood, plaster and stone, intercutting them to create a fragmented and abstracted but kinetic view of Noguchi's sculptures. Menken's visual approach, which dissolves the sculptural volumes, transforming them into flashes of light, would prove influential, providing a rhythmic animation for static works. (V.A.)

Crack-Up (Irving Reis, 1946)

On-the-run art expert George Steele (Pat O'Brien), a former curator at the "Manhattan Museum," whose mission against art forgery and modernism has led him into the dark corners of the art world, is crushed by a *Farnese Hercules* in his own museum. *Crack-Up* is exemplary of how art is often incriminated or desecrated in noir thrillers. In *The Dark Corner* (Henry Hathaway, 1946), for example, one of Donatello's so-called finest works is part of a detective's scheme to frame a crooked art collector; in *Murder, My Sweet* (Edward Dmytryk, 1944), an angel statue is profaned by a detective who lights a match by striking the statue's buttocks. (L.C.)

La Belle et la bête (Jean Cocteau, 1946)

In *Beauty and the Beast*, the living statue of the Roman goddess Diana stands in the pavilion next to the enchanted castle and gardens of the Beast (Jean Marais), which are populated by other magical living and still statues. In a famous scene in which the young Belle (Josette Day) enters the bewitched castle, the walls have living sculptural arms that hold candelabras and follow her as she passes by. The sculpted bas-reliefs, busts, and caryatids that adorn the castle are all impersonated by actors. Their presence, with only their eyes moving, conjures the uncanny sensation that the castle is haunted and that everything in it is staring back. Because Cocteau considered cinematographer Henri Alekan's lighting too bright, he darkened the faces of the living statues with paint, which had the enthralling effect of merging their heads into the moldings and illuminating their eyes. The caryatids in the fireplace have smoke coming out of their mouths. The decor includes other statues, created by art director Christian Bérard, including two of Louis XIV, which Belle uses to hide from the beast; a dog and a deer group in the castle's garden; and another of a horse next to the lake in the woods where the beast is transformed into the beautiful Prince Ardent. This transformation occurs when the living statue of Diana strikes Belle's handsome young suitor Avenant (also played by Marais) with her bow and arrow, killing him. (L.C.)

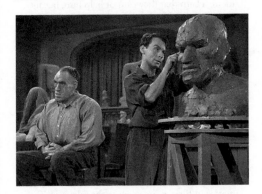

House of Horrors (Jean Yarbrough, 1946)

Impoverished European avant-garde sculptor Marcel DeLange (Martin Kosleck) contemplates suicide in the docks of New York at the start of this classic Universal horror picture, when told by *Manhattan Magazine* art critic F. Holmes Harmon that his nonsensical surrealist sculptures are clearly evidence of his lunacy. Reminiscent of the work of Jean Arp and Henry Moore, the sculptor's biomorphic work is characterized by converging humanoid forms with a scaly stone finish, or as the art critic puts it: "a meaningless jumble of anatomical accidents." DeLange destroys one of his prize pieces with a mallet but is saved from suicide when he rescues a brute of a man drowning, seeing in the man's misshapen face the inspiration that will make him a respected artist. Or so he thinks, for the drowning man is an escaped spine-snapping killer known as the Creeper (Rondo Hatton). The two forge an unlikely friendship in DeLange's candlelit studio, where the artist works on a bust of the Creeper and manipulates him into murdering his greatest critics, F. Holmes Harmon and Hal Ormiston. Eventually, the Creeper learns that his friend has been using him. He kills the artist and destroys the bust but is stopped by police bullets. Look for the headpiece of one of the Rock Men from the popular *Flash Gordon Conquers the Universe* (1940) serial in DeLange's studio. (V.A.)

***Ritual in Transfigured Time* (Maya Deren, 1946)**

In an extended sequence of this trance film, performers dance in a sculpture garden, exemplifying the juxtaposition of movement and stillness that is essential in Deren's work. This takes form in many ways: dancers are shot in freeze frames; sculptures contrast with moving dancers on pedestals; dancers are filmed in slow motion; and so on. A shot/reverse shot between a woman and a freeze frame of a dancer suggests that she is looking at him as if he were a statue. When he starts moving, she is horrified and runs away. The dancer on the pedestal mimes the pose of the famous bronze athletes uncovered at the Villa of the Papyri in Herculaneum, and when he jumps off the pedestal, he is filmed in slow and intermittent motion. This scene brings to mind the many Hollywood musicals in which performers dance next to statues, and is reminiscent of the opening sequence of Riefenstahl's *Olympia* (1938), in which athletes are filmed in slow motion and visually connected to statues. (L.C.)

***The Missing Lady* (Phil Karlson, 1946)**

An art collector is murdered and his statuette worth $250,000 and known as the *Jade Lady* is stolen. The crime fighter known as "The Shadow" (Kane Richmond) sets outs to retrieve it but soon finds himself in a whirlpool of mistaken identities and murdered accomplices. The police inspectors, not knowing that the lady in question is in fact a statuette, claim that they cannot help him, because they have no report of a lady who has gone missing. It turns out that a painter had incited a thug to murder the art collector and steal the statuette, and then stole it from the thug. The *Jade Lady* is eventually found in an urn which supposedly carries the ashes of the painter's grandfather, and which stands under his grandfather's painted portrait. This farcical crime thriller reminds us of *Murder, My Sweet* (Edward Dmytryk, 1944), in which a detective is asked to find a missing woman, a search that turns out to be a quest for a missing jade jewel. *The Missing Lady*'s jade statuette is part of a series of desired statuettes in films noirs, such as the falcon in *The Maltese Falcon* (John Huston, 1941), a statue of Kwan Yin in *Three Strangers* (Jean Negulesco, 1946), and an oriental statue in *The Lineup* (Don Siegel, 1958). (L.C.)

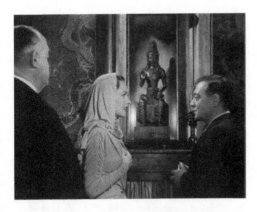

Three Strangers (Jean Negulesco, 1946)

Three characters wish upon a shared sweepstakes ticket in front of the idol of Kwan Yin, the Chinese goddess of fortune and destiny, evoking 1940s interest in Asian cultures. In line with the ubiquitous haunting painted portraits in film noir and gothic melodramas of the era, the medieval, exotic, or pseudo-primitive sculptures in *Three Strangers*, *The Maltese Falcon* (John Huston, 1941), *Cat People* (Jacques Tourneur, 1942), *I Walked with a Zombie* (Jacques Tourneur, 1943), *Isle of the Dead* (Mark Robson, 1945), *The Big Sleep* (Howard Hawks, 1946), or *North by Northwest* (Alfred Hitchcock, 1958) denote an uncanniness inherently connected to mystery, danger, threat, and the supernatural. The sculpture also brings to mind the Tahitian idol, made by Icelandic sculptor Nina Saemundsson, that plays a role in Albert Lewin's *The Moon and Sixpence* (1942). John Huston, who wrote the film's screenplay, was allegedly inspired by a wooden figure he bought in an antique shop while working in London. (L.C.)

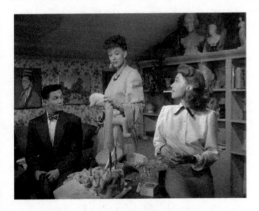

Body and Soul (Robert Rossen, 1947)

In a scene that reverses the pattern of male creator and female model, alluring sculptor Irma (Virginia Gregg) tries to get the attention of boxer Charley Davis (John Garfield) when he visits the apartment of her roommate, and his future fiancée, art student Peg Born (Lilli Palmer). Irma stares intently at Charley when he walks into the apartment, lying back on the sofa and smoking a cigarette. As if her intentions were not clear enough, she reveals her latest work to him: a highly phallic abstracted sculpture of a dockworker that she strokes while looking at him. When Irma leaves the room, it remains awkwardly in the shot between Charley and Peg. The film uses the modern statuette to identify the female artist as sexually threatening. This characterization connects to the portrayal of other emasculating female artists such as both Kiki Bridges (Linda Fiorentino) and June (Verna Bloom) in *After Hours* (1985), Delia Deetz (Catherine O'Hara) in *Beetlejuice* (Tim Burton, 1989), and Maude Lebowski (Julianne Moore) in *The Big Lebowski* (Joel and Ethan Coen, 1998). (L.C.)

La diosa arrodillada (Roberto Gavaldón, 1947)

In *The Kneeling Goddess*, a wealthy industrialist buys his ailing wife a statue to adorn the basins in the garden of their lavish mansion, which is already excessively ornamented with columns, caryatids, and small Medici lions. The life-size statue is a nude entitled *The Kneeling Goddess*, for which his mistress, a nightclub performer, has posed. The statue is introduced in a studio, nearly finished, juxtaposed with its model who hides her naked body behind the room divider. The statue is hauntingly present throughout the film, as it is placed in the central garden, adjacent to both the industrialist's office and his wife's bedroom, and it is further animated by swelling music, strokes of lightning, and stormy gusts of rain. The statue also has a counterpart in a painted portrait of the industrialist's wife, who, so we learn, ends up dying under her painted image, with her husband committing suicide. The new landlady removes the haunting portrait, and in the end she remains alone with the sculpture. Ultimately, the statue connotes the mistress's narcissism and self-absorption, which connects it to the motif of the painted portrait in noir thrillers. (L.C.)

The Unfaithful (Vincent Sherman, 1947)

After having killed an intruder in self-defense, Chris Hunter (Ann Sheridan) is blackmailed by art dealer Martin Barrow (Steven Geray). Although Chris claims not to know who the intruder was, he turns out to be the sculptor for whom she had modeled when her husband was away during the war. The sculptor made her portrait, which has now become proof of her infidelity and guilt. This sculpture exemplifies how artworks are often tokens of crime and adultery, and how artists and art dealers are portrayed as criminal characters capable of blackmail and murder. The woman's face and her bust are cinematically connected through a dissolve. There is also a two-shot that marks an uncanny resemblance between the bust of Chris and the sculptor's widow. (L.C.)

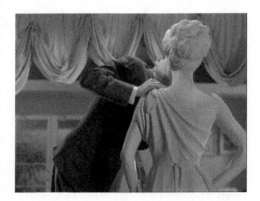

One Touch of Venus (William Seiter, 1948)

A statue of the so-called Anatolian Venus magically comes to life after being kissed by a window dresser (Robert Walker) in the art gallery of a department store. After the Venus (Ava Gardner) descends her pedestal, the window dresser is accused of having stolen the artwork. She helps him by letting his boss fall in love with her, but of course the window dresser falls in love with her himself. As the romantic intrigues get out of hand, Venus is called back to Mount Olympos and returned to her statuesque state. The statue was made by neo-classicist sculptor Joseph Nicolosi, for whom Ava Gardner originally posed nude, much to the displeasure of the studio. Nicolosi made the second version, which appears in the film, with Ava wearing one of Orry-Kelly's gowns. (L.C.)

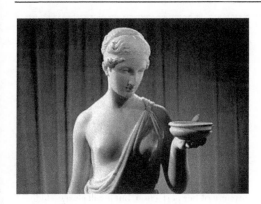

Thorvaldsen (Carl Theodor Dreyer, 1949)

Shot a little over a hundred years after Bertel Thorvaldsen's death, this film brings to life the works of Denmark's most famous sculptor. Dreyer employs stark black and white cinematography, superimpositions, camera cranes, dolly movements, and rotating platforms to animate the statues. The works are first shown solely against a white curtained background so that nothing distracts from their craftsmanship, but toward the end of the film Dreyer also focuses on Thorvaldsen's sketches and a few commissioned works in the Church of Our Lady in Copenhagen, where his famous rendition of the Christ figure stands. (V.A.)

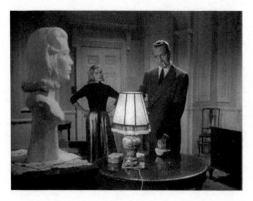

Stolen Face (Terence Fisher, 1952)

The contrast between the evil personality of criminal Lily Conover (Mary Mackenzie) and her new face – courtesy of plastic surgeon Dr. Philip Ritter (Paul Henreid) – is emphasized by her sculpted bust, which is prominently displayed in her living room. Conover marries Dr. Ritter after he reconstructs her disfigured face to look like that of famous pianist Alice Brent (Lizabeth Scott), who once rejected him. After her makeover, however, Conover does not change into a better person but remains a hateful character. She eventually destroys her bust and dies falling out of a train, thereby reuniting Ritter with Brent. In line with many painted portraits in films noirs of the era, this sculpture denotes the personality split of the self-absorbed femme fatale and her virtuous double. (L.C.)

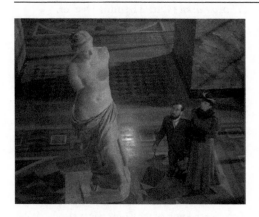

Moulin Rouge (John Huston, 1952)

In this biopic of Henri Toulouse-Lautrec, the mise-en-scène of which skillfully reproduces his illustrations and paintings, the artist (José Ferrer) takes a woman friend to see the *Venus de Milo* at the Louvre. The well-known statue is first visualized from a high camera angle. Admiringly, Toulouse-Lautrec describes the masterpiece's history, as the camera tracks down the figure and toward him: "All we know about her is that a Greek peasant found her in a cave and sold her to the French government for 6000 francs. She is so beautiful; we forget how old she is. She is older than Paris itself. She was before Christ, before Caesar. Until the end of time, men will try to penetrate the mystery of her perfection, but it will always elude them." Dissolving to the visitors' point of view, a mesmerizing rotating camera approaches the statue, as if animating it. Although this point of view is no longer that of the artist and his friend, it intends to convey their astounded perception and confirm the audience's esteem for this grand masterpiece. (L.C.)

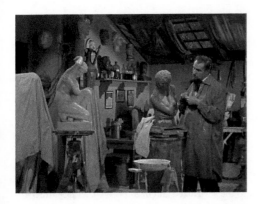

House of Wax (André de Toth, 1953)

In this remake of Michael Curtiz's *Mystery of the Wax Museum* (1933), Vincent Price takes on the role of wax artist Henry Jarrod. The plot doesn't vary all that much from the original but this film has the added attraction of being recorded in three dimensions, apart from also being in color. As a sculptor, Henry Jarrod does place more emphasis on craftsmanship than his 1933 counterpart Ivan Igor by explaining the painstaking work that goes into making his wax figures. The film has a noted appearance by Charles Bronson as the mute sculptor's apprentice and criminal heavy Igor. The mute fashions every wax sculpture he makes in his own likeness, which makes for a few interesting surprises in the museum. (V.A.)

Les Statues meurent aussi (Chris Marker, Alain Resnais, and Ghislain Cloquet, 1953)

As the title professes, *Statues Also Die* presents sculptures first and foremost as dead objects that have lost their original significance when they are reduced to museum objects. The opening sequence displays a montage of decomposing medieval and classical statues. We see fractured bas-reliefs, busts in ruins, demolished faces. Swaying trees subtly reveal that these statues are motionless; the

Western cultural heritage is presented as dead, both in museums and in ruins. According to Marker and Resnais, the African heritage was colonized and put in museums as well, where it was demystified, exposed to our Western gaze, and turned into a commodity. This documentary aims to restore and celebrate these African art artifacts. Snappy montages, zooms, forward and lateral tracking shots, and music reanimate the African statues. Wooden faces framed in low-key close-ups and in split screens seem almost alive, as if they are staring back at us. Nevertheless, these objects are presented as enigmatic ones that cannot be comprehended. As the voiceover declares: "They are represented as if we want them to speak, but these statues are mute. They have eyes, but they do not see us." As we see images of African artists and rites taking place, the statues are brought closer to their original function and closer to life. Resnais and Marker's filmmaking intended to celebrate African art, but the directors also decontextualize and demystify the objects and submit them to our Western gaze, critically mirroring the impact of colonialism. (L.C.)

The Barefoot Contessa (Joseph Mankiewicz, 1954)

The film opens with a shot of the funerary statue of Maria Vargas Torlato-Favrini (Ava Gardner), tracking down toward the bare foot of the statue peeking out from under its long gown. The protagonist is represented posthumously by her sculpted counterpart in the opening of the film, which begins at her funeral. A flashback tells the story of Maria Vargas, a Spanish nightclub dancer who turned into a movie star and then married a rich Italian count. The statue was sculpted during her marriage with the count – she had modeled barefoot to acknowledge her poor and sordid past – and when it was finished she was murdered by her husband because she was carrying the child of another man. The statue is connected intrinsically to the sexualized and dead body of Ava Gardner's character. Moreover, the bare foot emphasizes her carnal desires, which remain unfulfilled during her marriage, and at the same time frames her as an object of desire. The statue was made by a Bulgarian-born sculptor, Assen Peikov, who sculpted portraits for the Italian elite. (L.C.)

Gyromorphosis (Hy Hirsch, 1954)

In *Gyromorphosis*, experimental filmmaker Hy Hirsch interacts with sculptural work belonging to Dutch artist Constant Nieuwenhuys' New Babylon project, an almost twenty-year endeavor to redesign the modern metropolis. This resulted in drawings, designs, scale models, and sculptures. Hirsch takes on the sculptural work for New Babylon and brings it to life in such a way that the film appears to showcase an experimental laser light show. Underscored by light jazz, Hirsch has the models spin in front of the camera while employing multiple exposure and colored light effects, making complete abstraction of the work and its context but at the same time evoking the impressions one might get from walking around in Nieuwenhuys's futurist metropolis. (V.A.)

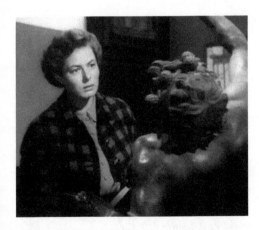

Viaggio in Italia (Roberto Rossellini, 1954)
Katherine Joyce's (Ingrid Bergman) visit to the
Museum of Naples with its Greek and Roman
sculptures is the centerpiece around which *Journey to*

Italy is structured. Animating the stone and bronze
statues with circular camera movements, Rossellini
celebrates the way in which these Hellenistic
sculptures transferred movement into stillness,
and he evokes the sculptors' attempts to create
the appearance of an action caught in suspended
animation. Rossellini's camera often visualizes
both the statue and Bergman's facial expressions
in one sliding movement, combining objective
and subjective viewpoints. As with the catacombs,
Pompeii, and the streets of Naples – other tourist
attractions she visits – the sculpture gallery filled
with sensual and hedonistic nudes functions as
a mental landscape of Katherine's unhappy and
sterile marriage. Like the characters depicted in
the statues, such as the *Drunken Faun*, the *Discus
Thrower*, and the *Farnese Bull*, Katherine seems to be
mesmerized and frozen, on the verge of moving
forward. (L.C.)

Rear Window (Alfred Hitchcock, 1954)
Hitchcock's classic about photographer L. B.
"Jeff" Jeffries (James Stewart) who spies on his
neighbors features an abstract sculpture entitled
Hunger. It was sculpted by the so-called "Miss
Hearing Aid" (Jesslyn Fax), a middle-aged female

sculptor who lives across the courtyard from
Jeff. When a worker carrying a heavy stone block
naively asks the sculptor "What's that supposed
to be ma'am?," she proudly replies: "Hunger!"
While it might seem like a mockery of the starving
artist cliché, this abstract statue, which has a void
at its center, might also be read as a reference
to the so-called "hunger" of the characters: the
protagonist's hunger for adventure, and his
girlfriend's hunger for love and recognition.
In addition, the title of the statue emphasizes
sculpture as visceral, contrasting it with Jeffries,
who, confined to a wheelchair, can only see the
world from a distance. Moreover, the sculpture
also reinforces the Greenwich Village setting
as an artistic one, inhabited by visual artists,
photographers, composers, and dancers. (L.C.)

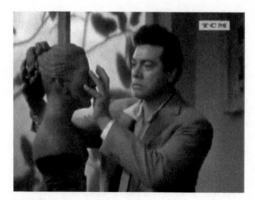

Serenade (Anthony Mann, 1956)

Tenor Damon Vincenti's (Mario Lanza) jealousy is aroused when he walks into his patroness's (Joan Fontaine) apartment and finds her posing for a sculptor working on her portrait. Vincenti falls madly in love with his patroness and she helps him to sing in the best operas of San Francisco and New York. When she fails to come to his premiere of *Otello*, the tenor leaves his act, goes to her apartment, and rips the face off her clay bust. The film is beautifully visualized with shot/reverse shots and two-shots of Vincenti and the bust; director Anthony Mann also using swelling music to underscore the mood swing when the beautiful clay face is destroyed. (L.C.)

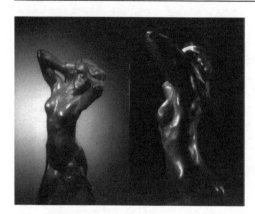

L'Enfer de Rodin (Henri Alekan, 1957)

Directed and shot by renowned French cinematographer Henri Alekan, this short documentary, *Rodin's Hell*, deconstructs Auguste Rodin's *La Porte de l'Enfer* (*The Gates of Hell*, 1880–1917) by isolating its figures (of which there are roughly 180) in an effort to, in its own opening words, "bring together the dreams of Dante and Rodin." The sculptures come alive through the clever use of moving platforms, a highly mobile camera, chiaroscuro lighting, and suggestive music and editing. The film shifts in tone through its sequence of imagery, evoking first the passions of life before moving to the realm of death. Save for the opening titles, the film is a strictly visual and musical experiment, as no words interfere with Alekan's poetic analysis of Rodin's work. (V.A.)

Angel (Joseph Cornell, 1957)

In this three-minute silent film, shot by Rudy Burckhardt according to Cornell's instructions, we see a statue of an angel, which overlooks a small circular pool, surrounded by flowers and tree-lined footpaths at Flushing Cemetery. The individual shots, all but one static, pick out details, abstracting them from their context as the film does not contain a wide establishing shot. Showing us the statue from a number of perspectives, the film has nothing that seems to move within the frame. When the water in the basin starts to ripple, movement slowly sets in. Flowers and leaves that surround the water start to waver, and the slowly rustling trees in the background mark the statue's unmoving solitude. The montage suggests that the shots are connected by eye-line matches, implying the idea of the statue looking at the pool and leaves. (L.C.)

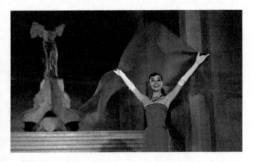

Funny Face (Stanley Donen, 1957)

Before the action moves to Paris, fashion photographer Dick Avery (Fred Astaire) encourages one of his models (Dovima), who is posing next to a life-size Giacometti pastiche, to look at it as if "she understands it, as if it understands her." The idea is to use the sculpture by "Itsubuchi" to sell clothes to women who are not interested in clothes, namely intellectuals. When she touches the modern statue, Avery replies that this is not the way we look when we think of "Itsubuchi." This musical also features the sequence "Bonjour Paris," which explores all the famous tourist sites of Paris. It includes many well-known fountains, such as the *Fontaine de l'Observatoire* and *Le Bassin d'Apollon* at Versailles, and many statues, including Georges Récipon's quadriga *L'Harmonie triomphant de la Discorde* (1900) at the Grand Palais, *Statue La Renommée* (1699) in the Tuileries Garden, and Frémiet's equestrian statue of *Jeanne d'Arc* (1874). Protagonist Jo Stockton (Audrey Hepburn) even climbs on one of Emmanuel Frémiet's bronze horses from the *Fontaine de l'Observatoire* (1873). The fashion shoot sequence places the model before iconic tourist attractions, including the *Arc de Triomphe du Carrousel* and the Louvre, where Jo surprises Avery by walking down the stairs in front of the *Winged Victory of Samothrace* (200–190 BC) in an amazing red gown. The artful drapery for which the statue is famous beautifully resonates in her dress and swirling red scarf as she descends the stairs past the winged goddess and Avery captures a picture. (L.C.)

Ten Thousand Bedrooms (Richard Thorpe, 1957)

This musical comedy features it all: a ridiculous, starving modern sculptor (Paul Henreid as Anton), who shares his studio with his beloved, a young female sculptor (Eva Bartok as Maria Martelli),

and a rich mogul who likes nude statues. Although the mogul is much more in favor of the female sculptor's representational work, he commissions some abstract sculptures so that the poor sculptor can marry his beloved. He does so because he wants to marry the female sculptor's younger sister, but he eventually ends up marrying the sculptor's fiancée. The sculptor is easily bribed with a well-paid job in one of the mogul's hotels. Even though an academic bust is also briefly ridiculed when the mogul puts some clay on its nose, the abstract artifacts displayed in the artist's studio illustrate Hollywood's hostility toward modern art and artists. (L.C.)

Mon Oncle (Jacques Tati, 1958)

An aluminum fish-shaped fountain is the centerpiece of the eccentric garden of the Villa Arpel, an ultra-modern house in a new suburb. The inhabitants of the house continuously try to impress guests with clever gadgets and eye-catching displays such as the fountain. Madame Arpel (Adrienne Servanti) activates it only for important visitors, which is a running gag throughout the film. When the family's uncle (Jacques Tati) arrives and sees that the fountain is activated, he knows that they have received important company, and he quietly slinks off. When he accidently fractures a service pipe, however, a leak creates a new fountain and upsets the guests. After a guest repairs the leak, the fish first spouts mud, and eventually impresses the guest with azure-colored water. (L.C.)

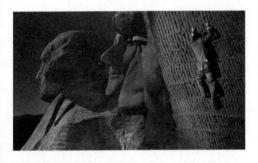

North by Northwest (Alfred Hitchcock, 1959)

A pre-Columbian figurine is sold at an auction in Chicago to spy and master criminal Phillip Vandamm (James Mason) for $700. In the end, it turns out that the statuette contains a piece of microfilm, making the exotic sculpture an enigmatic object and a Hitchcockian McGuffin. Strikingly, the climactic scene involving the pre-Columbian statuette in *North by Northwest* is situated in the "sculptural landscape" of Mount Rushmore. Under the gaze of the founding fathers, ad man turned secret agent Roger Thornhill (Cary Grant) and double agent Eve Kendall (Eva Marie Saint) tangle with Vandamm and his henchmen. Hitchcock clearly explores the patriotic, moral, and dramatic capacities of this monument, turning it into a landscape of terror in the closing scene. As Thornhill and Kendall are chased by villains, they try to hide by scaling down the face of the monument. In the end, one of the villains falls off and another is killed by policemen. This icon of American democracy thus becomes the place where the enemies of democracy are defeated. (L.C.)

Shadows (John Cassavetes, 1959)

Even though they wanted to see the mummies at the Metropolitan Museum, three young friends end up at The Abby Aldrich Rockefeller Sculpture Garden at MoMA. As they gallivant between bronze statues by Duchamp-Villon, Gaston Lachaise, Pierre-Auguste Renoir, Henry Moore, and Jacques Lipchitz, one of them ridicules the museum as "a place for a bunch of sexless women who don't have any love in their lives, big deal professors and creeps who try to show off how much they know." Passing by Aristide Maillol's *La Rivière* (*The River*, 1938), they stop to discuss Auguste Rodin's *Monument à Balzac* (*Monument to Balzac*, 1897–8), which becomes the subject of an absurd dialogue concluding that the sculpture represents "a statue." The frantic discussion about the sense and meaninglessness of art continues in front of Max Ernst's *Le Roi jouant avec la reine* (*The King Playing with the Queen*, 1944), Charles Despiau's *Assia* (1938), and Henri Matisse's bas-relief *Nu de Dos I–IV* (*The Back I–IV*, 1909–30). One of the friends is distracted and fascinated by Polygnotos Vagis's *Revelation* (1951), touching his own face and comparing it with that of the sculpture. The three men then run toward Lachaise's *Standing Woman* (1932) and one of them mocks it by patting on its buttocks while saying "What are we supposed to do, get serious with a can like that?" The museum scene contributes to Cassavetes's construction of two opposite realms, the world of art and culture versus the universe of the everyday, which marks the film in multiple perspectives. (L.C.)

A Bucket of Blood (Roger Corman, 1959)

This black comedy is a satire of beatnik culture and the art world that winks knowingly at the *Mystery of the Wax Museum*. We see busboy Walter Paisley (Dick Miller) in a hip bohemian café-cum-art gallery, envying the artistic beatnik crowd. Tired of being mocked, and poised to win over a beautiful girl, Paisley buys a block of clay and forces himself to become creative. As he struggles with the clay, shouting at it to turn into a human body part of the nasal variety, he becomes immensely frustrated with his own lack of talent. Paisley's agitation grows with the increasing noise of his landlady's cat, which he accidentally stabs to death. In an inspired moment, however, Paisley covers the cat – including the knife that killed it – with a fine layer of clay, turning it into an almost readymade sculpture. He unpretentiously names his first work of art *Dead Cat* and it earns him an exhibition. Sure enough, the sculptor starts wearing a beret and a scarf, and also sporting a long cigarette holder. Walter's inadvertent artwork continues, as he kills a policeman – turning him into *Murdered Man* – and a nude model, who becomes *Nude in the Chair*, before topping off his oeuvre with a morbid final pièce de résistance. (V.A.)

La dolce vita (Federico Fellini, 1960)

The famous opening scene of *The Good Life* shows helicopters approaching Rome in the distance over ancient ruins, the first one carrying a statue of Christ with open arms. Children run after it, workers give it a wave, and young ladies in bikinis get up from their penthouse tanning positions when the statue passes. The second helicopter carries journalist Marcello Rubini (Marcello Mastroianni) and his camera crew, who hover over the girls to explain that the statue is going to the Pope. The scene ends when the helicopter approaches St. Peter's basilica and its bells toll. Whether the statue has its arms open in benediction or for redemption of the film's characters is up for debate, and the opening scene has certainly been food for much analytical thought. What we know for sure is that Fellini had a real life precedent for the scene, as a helicopter carried a statue of Christ to the Vatican from the Piazza del Duomo in Milan on 1 May 1956. (V.A.)

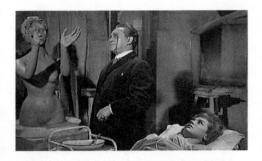

Il mulino delle donne di pietra (Giorgio Ferroni, 1960)

Mill of the Stone Women was the first Italian horror film to be shot in color. According to the credits, the film's screenplay was based on an eponymous short story by Flemish author Pieter Van Weigen from his *Flemish Tales*, but this must have been a publicity ploy to add some prestige to the picture, as no such author or book exists. Interestingly, the film was produced by the Galatea film company, hinting at its content. The film opens with Hans von Arnim (Pierre Brice) arriving in a Dutch countryside town to look for Professor Gregorius Wahl (Herbert Böhme), a sculptor. The professor lives in a windmill known as the "mill of the stone women" and his studio is populated with strange sculptures, the most remarkable of which is a bald nude woman hanging from actual gallows with her tongue out. The mill does not only house a studio, however – it is really a mechanical wax museum that is powered by the wind to animate the statues. Von Arnim is there to work on the publication of a history of the mill, but he quickly discovers that there is more to the statues than meets the eye and also runs into the Professor's mysterious daughter Elfie (Scilla Gabel). The mechanical theater presents its public with a rotating stage carousel of famous murdered and murderous women. Elfie turns out to have an illness that needs her blood to be transfused completely in order for her to stay alive, so with the help of the macabre Dr. Bohlem (Wolfgang Preiss) the Professor periodically kidnaps local women for their blood. A special serum petrifies the women when they are bled dry, allowing the Professor to turn them into statues for his mechanical theater as he supplies them with a mask, gives them a coat of paint, and props them up in the correct position as if they were dolls. He even makes a clay model as a reference point first. At the climax of the film, Professor Wahl kills Dr. Bohlem for wanting to marry Elfie, thereby accidentally destroying the medicine he needs to save his daughter. He sets the mill on fire and perishes with his daughter, while we watch the statues burn. (V.A.)

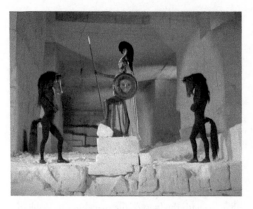

Le Testament d'Orphée ou ne me demandez pas pourquoi! (Jean Cocteau, 1960)

In this final episode of Cocteau's Orphic trilogy, *Testament of Orpheus*, the poet (Cocteau himself) travels through time and past different mythological locations where he encounters a series of statuesque idols and goddesses. Like the statue in *Le Sang d'un poète* (*The Blood of a Poet*, 1932), the enchanted statues and bas-reliefs in *La Belle et la bête* (*Beauty and the Beast*, 1946), and the statuary appearance of the princess in *Orphée* (*Orpheus*, 1950), many of these idols and goddesses are living statues impersonated by actors and actresses. These statues – all beautifully designed by Janine Janet, who provided both costumes and sculptures – seem to be something between the living and the dead. One of them is an idol, consisting of a mask attached to a long *peplos*, with four mouths and six eyes that eats autographs and subsequently produces novels, poems, and songs. Another sculpture is a living statue representing Minerva, accompanied by two half-human and half-horse creatures. When Minerva kills the poet, he is turned into a statue with the eyes of a Roman sculpture. Unlike the poet in *Le Sang d'un poète*, the poet in *Le Testament d'Orphée* is turned into a moving statue. He continues his voyage in a statuesque state and is briefly accompanied by a sphinx, waving its feathered wings. Cocteau also used a garden replica of a Roman statue of Diana to adorn the entrance of the garage of Orpheus. (L.C.)

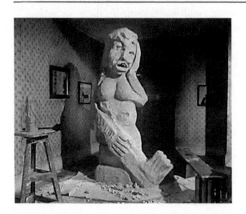

The Rebel (Robert Day, 1961)

Also known as *Call Me Genius* for its US release, *The Rebel* sees Anthony Hancock (British comedian Tony Hancock) abandon his longstanding office job and move to Paris to pursue his dream of becoming an artist. Much like *A Bucket of Blood* (Roger Corman, 1959), the film pokes fun at the 1950s–60s art scene, in particular beatniks and those working in the realm of the abstract. As everyone knows, all one has to do is don a smock and beret to become an artist, and that is exactly what Hancock has been doing in the privacy of his own London bedroom before moving to Paris. In his bedroom we find a monumental statue of a female form entitled *Aphrodite at the Waterhole*. The statue is halfway between figurative and abstract, a mixture of expressionist and cubist characteristics. The torso of Aphrodite returns to an actual waterhole when Hancock boards a ship to Paris and the inept sailors drop it in the Channel. The first café he enters in Paris is populated with poor young artists who spout their opinions on the role and style of modern art, measure themselves up against Picasso and Cézanne, and are mocked by the bar owner for being poor and useless. A misunderstood artist himself, Hancock fits right in, and his made-up opinions and pseudo-philosophical statements soon make him the belle of the ball. In Paris, Hancock mostly paints, dabbling in different styles, and becoming famous when he takes credit for the paintings of a fed up colleague. When he reveals his own second version

of Aphrodite he is mocked and has to flee the scene to get away from the angry model and her husband. The artist returns to recreate his *Aphrodite at the Waterhole* for the third time in the end, taking a crude hammer and chisel to six propped-together stone blocks, and using his craggy landlady as a model. The real works of art in the film were made by Alistair Grant and some of these were recreated along with *Aphrodite at the Waterhole* by the London Institute of Pataphysics in 2002. (V.A.)

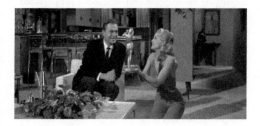

The Marriage-Go-Round (Walter Lang, 1961)

The film features a golden statuette that is a naked self-portrait by young, tall, and blonde Swede Katrin Sveg (Julie Newmar). Sveg gives it to her host, American college professor Paul Delville (James Mason), whom she wants to father her child. Evoking tactility, sensuality, and flesh, the statuette forms the counterpart to a photo representing the platonic relationship between the professor and his wife. As an act of jealousy, the professor's wife desecrates the statue by striking its buttocks with a match. Other Hollywood comedies in which an erotic statuette plays a part include *Top Hat* (Mark Sandrich, 1935), *A Foreign Affair* (Billy Wilder, 1948), *Pillow Talk* (Michael Gordon, 1959), and *The Lady in Question* (Charles Vidor, 1940). (L.C.)

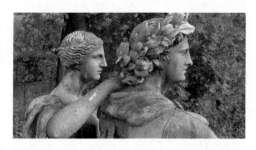

L'Année dernière à Marienbad (Alain Resnais, 1961)

In *Last Year at Marienbad*, a man, trying to convince a woman they had had a love affair the previous year, talks about their first meeting in the vicinity of a statue in the garden of a chateau. The man states that they discussed the identity of the man and the woman in the statue, who would be Greek gods or heroes from mythology or perhaps allegorical figures. Its identity unclear, the statue connotes the uncertainty and untrustworthiness of memories. The voiceover of the man telling the story is accompanied by a camera that animates the statue; tracking from low-angle shots to bird's-eye views, the camera frames the statue from different angles. Made especially for the film, the statue evokes movement reminiscent of Baroque sculpture, while the water of the pool and the fountains in the background animate it and Resnais's camera emphasizes the appearance of frozen moment. Moreover, the statue is invoked and reflected in various ways: in the decor of a theater performance; in the voiceover; in the dialogue; animated by a mobile camera; unmoving in the background; and in a drawing on a wall. The prop is also visualized in different locations, and it echoes the film's characters, who are depicted and described as dead and statuesque and almost cut off from the outside world. The baroque statue even seems to be more alive than the almost petrified figures wandering among the empty pedestals in the gardens. (L.C.)

The Innocents (Jack Clayton, 1961)

In *The Innocents*, adapted from Henry James's 1898 gothic ghost story *The Turn of the Screw*, the emotionally fragile governess Miss Giddens (Deborah Kerr) believes that the country manor she works at is haunted by her predecessor and her lover, valet Peter Quint (Peter Wyngarde), and that the children she takes care of – Miles (Martin Stephens) and Flora (Pamela Franklin) – are an integral part of this haunting. A group of six statues encircling a sculpture of a lovemaking couple plays an important part in the governess's horrifying assumption that little Miles is possessed by Peter Quint, and at several moments in the film the governess mistakenly thinks one of the statues has become Quint. As in numerous Gothic horror films, such as *The Haunting* (Robert Wise, 1963), *The Haunting* (Jan De Bont, 1999), and *The Haunted Mansion* (Rob Minkoff, 2003), the anxiety is instigated by the sculpted or painted counterpart of the predecessor. (L.C.)

Jules et Jim (François Truffaut, 1962)

While watching a slide projection of sculptures that includes an Incan and Roman statue, Jules (Oskar Werner) and Jim (Henri Serre) are mesmerized by the photograph of a bust of a young woman with a peaceful smile and rough, simple features. As a documentary-like voiceover describes the statue's features, a series of extreme close-up inserts show us the eyes and lips. As the voiceover continues, Jules and Jim visit the actual bust in a sculpture garden. Truffaut now uses a highly mobile camera that rapidly glides from statue to statue, evoking the infatuation of the young men with the smile of the bust. Jules and Jim later meet Catherine (Jeanne Moreau), a young woman who resembles the statue and with whom they both fall in love. Switching from objective to subjective viewpoints, from photography to film, and from a static to a dynamic visualization, Truffaut emphasizes the role of the camera in the sculpture's animation. (L.C.)

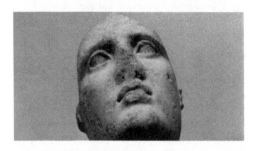

La Jetée (Chris Marker, 1962)

Almost a decade after *Les Statues meurent aussi* (*Statues Also Die*; Chris Marker, Alain Resnais and Ghislain Cloquet, 1953), Chris Marker again included images of decomposing statues and fractured faces in *The Jetty*, when the protagonist (Davos Hanich) of this experimental time travel photo roman is transported to the museum of his memory. Strikingly, the first things appearing in his memory are images of statues. Moments before this sequence, he encounters fragments of classical sculptures in underground halls that function as a reminder of the fact that mankind has been eradicated in the future; the statuary is a token of a lost civilization. If the sculptures' function is to preserve memory of mankind, however, it seems to be failing. The death masks in *La Jetée* are fractured and demolished, as the montage of the Hellenistic statues ends with a shattered face that dissolves into that of the protagonist. (L.C.)

Jason and the Argonauts (Don Chaffey, 1963)

Graced with the awe-inspiring special effects of Ray Harryhausen, *Jason and the Argonauts* tells the tale of the quest for the Golden Fleece in a mythological world populated with gods, demi-gods, monstrous creatures, and divine creations. The film opens with a giant painted sculpture of the Olympian queen of the gods, Hera (Honor Blackman), seated on a throne in one of her temples. When King Pelias brutally murders one of Hera's praying devotees in her sacred temple in the name of Zeus, the goddess materializes and tells the warrior that his shameful deed will cause him to die by the hand of Jason. Twenty years later, Jason (Todd Armstrong) undertakes the perilous journey to procure the Golden Fleece. A sturdy boat known as the Argo takes Jason and his ragtag band of adventurers,

the Argonauts, on their mission. A painted wooden figurehead of Hera guides Jason through the hazardous waters, opening her eyes and whispering sound advice when it is most needed. The figurehead leads them to the Isle of Bronze, where the Greek god of sculpture Hephaistos once resided. The isle is populated by gigantic bronze sculptures, among them Talos, known in Greek mythology as the giant bronze automaton guardian of Crete, here depicted as a Spartan warrior in a fighting stance. Hercules (Nigel Green) and a friend approach the statue and find that its pedestal is filled entirely with riches, but when Hercules attempts to take a brooch back, the door closes and the statue of Talos comes to life. The stop motion magic of Ray Harryhausen convincingly animates the bronze giant as he wrecks the Argo and goes after its crew. The figurehead of Hera comes to life again and advises Jason to defeat the murderous statue by going for its ankle, which corresponds with some mythological accounts that describe the automaton as having one single vein running from his head to his ankle that is sealed with a stud. It is thus that Jason opens a hatch on the ankle that releases a liquid, seemingly suffocating Talos before his façade starts to crack and he keels over and falls apart. (V.A.)

Méditerranée (Jean-Daniel Pollet, 1963)

Like Chris Marker and Alain Resnais, Jean-Daniel Pollet visualizes sculpted relics and ruins in *Mediterranean*, once described as a "Marienbad *marin*." In this ciné-poème, both unmoving images and slowly tracking shots of sarcophagi, fractured Egyptian busts, and Corinthian columns in ruins are intercut

with images of the surging Mediterranean Sea and an unconscious girl passing through the corridors of a hospital. The hypnotic rhythm of the montage and the mesmerizing music do not animate these statues; rather, the still presence of the ancient deities and the history they represent is put forward, a voiceover stating that nothing speaks anymore: "It's a sort of tacit speech, halted, asleep just before speaking." The busts are presented as fossilized people, but it is somehow as if they are living, and as such they resonate with the images of the unconscious woman's face. At the same time, Pollet intercuts these scenes with images of a dying bull, making more explicit the connection with the theme of death. Although the public and film critics heavily rejected *Méditerranée* after its premiere at the experimental film festival in Knokke Zoute, the critics of *Cahiers du Cinéma* have always defended the film. A few years after its first screening it was rediscovered by the Tel Quel group, as well as by leftist critics. (L.C.)

Le Mépris (Jean-Luc Godard, 1963)

In *Contempt*, copies of famous classical statues are featured in the film within the film, an adaptation of Homer's *Odyssey* by Fritz Lang, who plays himself. Both the statues and the actors who represent Greek gods and goddesses are boldly painted, as if they all stepped out of the Orphic world of Jean Cocteau – originally cast in the role of the director. In many instances, the rushes of the film-in-the-film show mobile images of immobile sculptures – of Minerva,

Homer and other gods and mortals – against a blue sky, echoing the image of the sky in *Le Mépris*'s impressive opening shot of a camera dolly. These images are combined with reaction shots of the faces of producer Jeremy Prokosch (Jack Palance), director Fritz Lang, and writer Paul Javal (Michel Piccoli), who are watching the footage in a Cinecittà screening room. Godard also animates some of the statues, such as the famous fifth-century BC Poseidon, by shooting the sculptures with a rotating camera and zooms. As Liandrat-Guigues has pointed out, the statues are not originals but obvious reproductions, which denote a world without gods in which the film's characters are wandering. In addition, classical nudes such as a Medici Venus are intercut with images of swimming naked starlets and echoed by Brigitte Bardot, a modern "love goddess" whose body is also doubled by a bronze modern statue in the scene set in a Rome apartment. (L.C.)

The Damned (Joseph Losey, 1963)

Freya Neilson (Viveca Lindfors) is a sculptor who has a summer studio on the cliffs by the sea, known as the "Birdhouse," where she creates and displays figurative sculptures of animals and human

figures, such as *Graveyard Bird*. The sculptures were made by Elizabeth Frink, an English sculptor and printmaker. One of the film's characters describes the statues as "sort of unfinished," to which the artist replies: "Isn't everything unfinished?" The statues are scarred, expressive figures, and they symbolize an existential angst that resonates with the nuclear anxiety haunting the entire film. In a violent confrontation between art and psyche, King (Oliver Reed), a pathological gang leader, attacks Freya's work, strangling one figural sculpture and destroying another, and the artist herself is eventually killed by her lover, after she discovers that he secretly conducted radioactivity experiments on children. (L.C.)

The Haunting (Robert Wise, 1963)
This gothic horror drama features an ancestral family sculptural group portrait of the master of the haunted Hill House, Hugh Crain (Howard Lang), his two wives, his daughter, an unknown woman, and a dog. When scientist Dr. John Markway (Richard Johnson) takes up residence in the mansion to study the house's paranormal activity and its effects on two test subjects, one of the young women invitees is fascinated by the group of statues and starts believing that she is the unknown woman in the sculpture. A nocturnal scene shows us the interaction between the young woman and the statues, with shot/reverse shot editing animating the statue. (L.C.)

Gertrud (Carl Theodor Dreyer, 1964)
On two occasions that divorced heroine Gertrud (Nina Pens Rode) meets with her lover, composer Erland Jansson (Baard Owe), in a park, Dreyer visualizes the rendezvous in the vicinity of a copy of the *Medici Venus*. In the first scene, Gertrud and her lover recall their first kiss and discuss their impossible future, while Dreyer's slowly moving camera visualizes the Venus and its marble whiteness in the background, as if commenting, next to the connotation of love, on the opposition between the purity of the statue and the tainted social status of Gertrud. In a second scene, Gertrud is sitting next to the Venus, making the opposition even greater, for she breaks up with her lover, who reveals that he is expecting a child with another woman. Dreyer's camera follows Gertrud as she walks away from the statue, leaving behind both lover and Venus. (L.C.)

Une Femme mariée (Jean-Luc Godard, 1964)
In *A Married Woman*, Godard intercuts a car drive with a montage sequence that includes three Aristide Maillol statues: *Méditeranée (Mediterranean,* 1923–7), *La Rivière (The River,* 1943), and *Île-de-France* (1925). Underscored by a poetic voiceover of female protagonist Charlotte (Macha Méril), this montage evokes the eerie atmosphere that is tangible between Charlotte and her lover. Like the museum visit in *Viaggio in Italia* (Roberto Rossellini, 1954), this sequence can be read as a mental landscape and a commentary on the lives of the protagonists. Unlike Rossellini, who brings the Hellenistic statues to life, however, Godard shows us static images of the sculptures, respecting the stillness of Maillol's art. The insert shots of the full-length Maillol nudes also echo the naked body parts of Charlotte in the opening sequence, with Godard emphasizing the melancholy and sensuous nature of the female lead character. (L.C.)

Strait-Jacket (William Castle, 1964)

Returning home from an insane asylum after doing twenty years for the double axe murder of her husband and his mistress, Lucy Harbin (Joan Crawford) tries to reconnect with her daughter,

Carol (Diane Baker). Carol witnessed her mother's gruesome murders as a child but is now a sculptor on the verge of getting married. Though apparently unfazed by her past and happy to see her mother, Carol has created a bronze bust of her mother that she uses to make a mask of her mother's face. While her mother makes passes at her wealthy fiancé, axe murders start to happen. Everyone thinks this is Lucy relapsing, until it is revealed that Carol has gone to great lengths to frame her mother by acting as a copycat, and so the daughter ends up in the asylum at the end of the film. Like other instances, such as the incriminating portraits in *Stolen Face* (Terence Fisher, 1952) and *The Unfaithful* (Vincent Sherman, 1947), the bust denotes the split between the model's innocence and insanity. (L.C.)

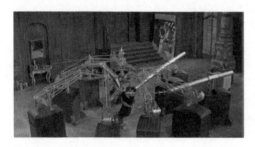

What a Way To Go! (J. Lee Thompson, 1964)

When Larry Flint (Paul Newman) – an undiscovered American artist who drives a Paris cab and lives *la vie bohème* – meets his future wife (Shirley MacLaine), things turn around for him. Flint is poor, ambitious, and conceited, claiming that the Louvre is a garbage pail for the arts and

that he is one of only five people who can be called an artist. He designs "sonic palettes," kinetic machines that translate his noises into abstract paintings, and describes them as "a fusion of the mechanized world and the human soul." These machines are reminiscent of the kinetic art of neo-avant-garde artists such as Jean Tinguely, and transform the paintings and their process into sculptural objects. Despite believing that money corrupts, Flint embraces his financial success, for which he is indebted to his wife, who came up with the idea of playing a Mendelssohn recording through the sonic palette. He keeps on translating classical masterpieces into abstract paintings and his success skyrockets. Flint becomes obsessed with his work and his machines seem to take on a mind of their own, start to disobey him, and eventually kill him. (L.C.)

The Fall of the Roman Empire (Anthony Mann, 1964)

One of the most expensive films of its time, this peplum epic in 70mm Technicolor focuses on the Roman succession crisis in the aftermath of the death of Emperor Marcus Aurelius (Alec Guinness), when his volatile son Commodus (Christopher Plummer) takes charge. One of Commodus's first actions as newly minted Emperor is to enter the Capitol and lay down his crown before a giant statue of Jupiter seated on a pedestal and clad partially in a gold robe. The shot first dwarfs Commodus against the imposing figure of the king of the gods, but a reverse angle reveals the Emperor in close-up, mischievously enjoying the moment as if it were an act of defiance against the gods – as indeed it is against his dead father, who had wanted to appoint someone else. The Emperor's throne room also features a giant statue of Athena with shield and spear behind the throne, placing the two on the same level. Commodus associates himself with statuary on one more occasion at the end of the film, when the delirious Emperor reveals himself to the public by coming out of the doors of a giant copper hand on which a sarcophagus of sorts has been sculpted. The hand is reminiscent of the (usually much smaller) votive images of hands, the fingers of which form the gesture of benediction still familiar in Christian practice, which played an important role in the late-Roman cult of Bacchus. When the Emperor is defeated in a fight by Marcus Aurelius's preferred successor, Livius (Stephen Boyd), the hand is framed in long shot against the fire of the stake while the voiceover tells us that "this was the beginning of the fall of the Roman empire . . ." (V.A.)

Mickey One (Arthur Penn, 1965)

On the run from the mob, a stand-up comedian taking on the alias of Mickey One (Warren Beatty) repeatedly encounters a mute artist (Kamatari Fujiwara) who is building a gigantic self-destructive sculptural machine entitled *Yes*. This creation is an over-engineered Rube Goldberg-like machine, designed to perform the one simple task of destroying itself. Somewhat reminiscent of Jean Tinguely's kinetic contraptions, the gigantic machine consists of spinning wheels that spit fireworks. The performance of the machine is orchestrated by the artist, who is overwhelmed with joy until the fire department arrives and essentially destroys the sculpture and its purpose by putting out the fire. (L.C.)

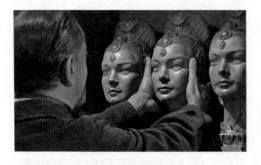

Gambit (Ronald Neame, 1966)

Gentleman thief Harry Deane (Michael Caine) and his associate Emile recruit exotic dancer Nicole (Shirley MacLaine) because she resembles the deceased wife of millionaire Shahbandar (Herbert Lom) in this curious art heist film. Interestingly, the latter's deceased wife also resembled a priceless marble bust of the Chinese empress Leizu. Using a hollow bronze Buddha statue sold to Shahbandar for $5000, as well as Nicole's charm, Deane manages to break into the heavily secured art room – lasers notwithstanding – and steal the Leizu bust. Or does he? After a few noteworthy plot twists, we find out that Emile happens to be a high-quality forger who can work miracles with 2000-year-old Mongolian clay and that nothing was what it seemed. (V.A.)

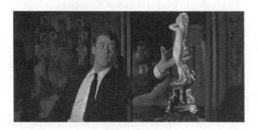

How To Steal a Million (William Wyler, 1966)

This romantic comedy features a fake Cellini Venus statue, supposedly worth one million dollars, that is owned by Bonnet (Hugh Griffith), a painter who sells fake masterpieces to millionaires. He confesses to his daughter Nicole (Audrey Hepburn) that the Venus sculpture was made by her grandfather and that her grandmother posed for it. In order to protect her father, the forger's daughter asks an inspector whom she takes for a burglar to steal the fake sculpture. Nicole's ivory two-piece suit immediately links her with the Venus statue and the resemblance is further reinforced in a photo of the actual model who posed for the statue in turn-of-the-century attire. When inspector Simon Dermott (Peter O'Toole) sees the resemblance between the statue and the forger's daughter with his binoculars, he realizes that the statue is a fake. (L.C.)

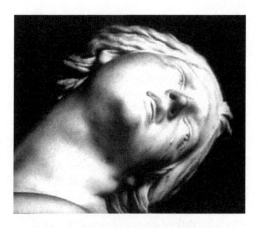

Si j'avais quatre dromadaires (Chris Marker, 1966)

Director Chris Marker explores the relations between the still and the moving image in this travelogue, *If I Had Four Dromedaries*, that is entirely composed of still photographs, many of which are of statues. The first is an enigmatic face of a young woman. Over a close-up of it, the voiceover comments, "a sculptor eternalizes a certain face with a certain gaze. And with a photo you eternalize your own gaze onto the gaze of the statue – and I look at the photo that is looking

back." The visualization of this unmoving stone face against a dark background recalls the statues of *Les Statues meurent aussi* (*Statues Also Die*; Chris Marker, Alain Resnais, and Ghislain Cloquet, 1953). Here, however, Marker films only photos of the statues, not the statues themselves, although his cinematography is reminiscent of the earlier art documentary, for instance when tourists are shown photographing modern statues in sculpture gardens: we see them gazing at sculptures such as Gaston Lachaise's *Standing Woman* (1932) and one of Alexander Calder's monumental sculptures, while the voiceover philosophizes about the different types of gaze. Later, after a rapid montage of modern and African statues, Marker shows an abstract statue that was supposedly made by a peasant who had called it *Hunger* – perhaps an allusion to Hitchcock's *Rear Window* (1954). Toward the end of the second part, Marker shows images of funerary statues, tombs, sarcophagi, and corpses, echoing the connection between art and death seen in numerous other modernist films. These images eventually dissolve into a museums sequence, which first shows marble statues of erotic bodies, then Alfonso Balzico's *Cleopatra* (1870) and Aristide Maillol's *La Rivière* (*The River*, 1938), and ends with a montage of fractured bodies and faces. (L.C.)

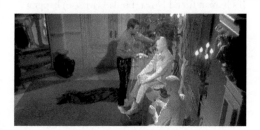

Games (Curtis Harrington, 1967)

Paul and Jennifer Montgomery (James Caan and Katharina Ross) enjoy baroque diversions in their fancy house's game room, but the delicate balance of these games is upset when they take in scheming saleswoman Lisa Schindler (Simone Signoret). The overcomplicated plot of the film involves ritual

sacrifice, elaborate set-ups, double homicide, and Paul's extensive art collection. The latter features a realistic life-sized plaster statue of a man entitled *Man on a Chair*, which was made by Terry Tower and sits morbidly in their hallway holding a cup of coffee. The sculpture looks very much like a whitewashed or encapsulated person, and this suspicion is somewhat confirmed when a delivery boy is accidentally shot in the face during a game gone wrong, and Paul decides to put him in plaster as a companion piece to the existing statue. The statues are sold as art with the rest of the collection at the end of the film, when Paul's plan to drive his wife crazy has worked and he can celebrate with saleswoman Lisa. In a final twist, alas, she poisons him and takes off with the money. (V.A.)

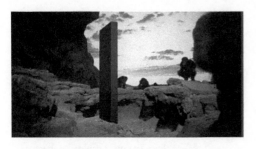

2001: A Space Odyssey (Stanley Kubrick, 1968)

A black monolith that shows a striking resemblance to the 1960s Minimalist sculptures by Donald Judd, Tony Smith, Robert Morris, and Carl Andre is the point of mystery throughout Kubrick's iconic science fiction film. It is the key feature in three important scenes, all underscored by György Ligeti's compelling score. In the opening sequence, the monolith is discovered by a group of hominids. The hominids seem to be inspired by the monolith, as they learn how to use tools for destruction. In a second scene, the monolith is discovered as the first evidence of intelligent life on another planet. Astronauts touch the monolith in the same way it was touched by the hominids in the earlier scene. In the third scene, one of the astronauts travels through space with the monolith, and he ends up in a Baroque bedroom, where the black monolith appears next to his deathbed. Over the years, Kubrick's monolith, which was actually a pyramid in the original novel by Arthur C. Clarke, has been the subject of countless interpretations. Michel Chion has defined the monolith as a "Tablet of the Law without commandments" and Gerard Loughlin has interpreted the monolith as a cinema screen, because, when turned on its side, it has the exact CinemaScope dimensions. (L.C.)

Planet of the Apes (Franklin J. Schaffner, 1968)

Nearly two millennia after leaving Earth, a crew of astronauts finds themselves on a faraway planet dominated by various species of highly intelligent apes. Finally having escaped the apes at the end of the film, astronaut Taylor (Charlton Heston) and his human friend Nova (Linda Harrison) happen upon the half-buried remains of the *Statue of Liberty* along the seashore, revealing that they are not on a distant planet at all, but on Earth in the future. Matte painting and a papier-mâché model of the *Statue of Liberty* were used to achieve the effect. (V.A.)

Spiral Jetty (Robert Smithson, 1970)

Smithson's 1970 *Spiral Jetty* is a 460-meter-long earthwork, or environmental sculpture, in the shape of a coil that starts at the northeastern shore of the Great Salt Lake in Utah. Built out of organic materials such as basalt rocks, salt crystals, and mud, the monumental landscape sculpture is ever changing in size, color, and visibility. Smithson and his wife Nancy Holt recorded the construction process in a short poetic film of the same name. Evoking the remote site of the *Spiral Jetty* as we approach and leave the construction via an endless dirt road, the film also shows us the work of art in progress as dump trucks filled with rocks create its general shape. Different shots of the jetty from a helicopter indicate its scale and these are juxtaposed with shots of prehistoric relics in a history museum, and sheets of paper floating down a cliff, illustrating the themes central in Smithson's oeuvre. The images are set to the uninflected voiceover of Smithson himself, who reads to us from literary and geological sources (e.g. Samuel Beckett's 1953 *The Unnamable*). Smithson collaborated with his wife Nancy Holt until his death in 1973, and she carried on his legacy. This resulted in several similar documentary projects chronicling environmental works of art, such as Holt's 1978 *Sun Tunnels*, or impressive geological sites, such as the collaborative *Mono Lake* (1968–2004). (V.A.)

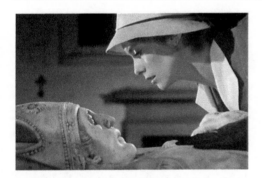

Tristana (Luis Buñuel, 1970)

Young orphan Tristana (Catherine Deneuve) first discovers her sexual desires during an encounter with a marble statue of an embalmed bishop. Buñuel introduces the statue with a montage of insert close-ups, and these point-of-view shots are countered by a shot of Tristana lying over the statue as if she is trying to kiss it. Awakened by the statue, Tristana gives in to the sexual overtures made by her guardian, an impoverished aristocrat with libertarian ideas. Toward the end of the film, her own body is turned into a *Venus de Milo* incarnate, when a shot of the illness-stricken Tristana showing her crippled naked body to a much younger man is countered by the young man's horrified gaze. This scene is immediately followed by a montage sequence of virtuous Madonna statues that contrast with Tristana's riotous nature. Buñuel uses the interaction of Catholic statues with libertarian characters to visualize his contempt for both the Catholic Church and the bourgeoisie. (L.C.)

The Statue (Rod Amateau, 1971)

The plot revolves around an 18-foot statue of celebrated linguist Professor Alex Bolt (David Niven), who has just won the Nobel Peace Prize. The statue was made by his wife Rhonda Bolt (Virna Lisi), a renowned Italian artist, as a commission for the US Embassy in London. The piece is clearly a replica of Michelangelo's *David*, but with a perfect resemblance to the professor except for the size of the private parts. This anomaly is his wife's punishment for him only

being home eighteen days in three years. At first glance, the professor is shocked, partly because it depicts him nude, but most importantly because it does not "fully" look like him. The professor takes pictures of the statue's penis in order to conduct his perverse search for the model who posed for his genitals, a man he provisionally names "Charlie." The professor eventually steals the statue's genitals and travels to Florence, where he encounters the real model. The movie's prudent visualization inhibits the spectators from seeing the statue's genitals, except for an extreme close-up of the statue's "empty" spot after the professor has stolen its penis. We can thus only rely on the expressions of the characters, who are continuously astonished by the nude statue. In a scene in which the sculptress is kissing the US ambassador, we also see the camera gliding over the statue's sensuous body; a movement that ends with a close-up of the statue's gaze, as if the linguist is watching his wife while she is betraying him. (L.C.)

A Clockwork Orange (Stanley Kubrick, 1971)

Not only is *A Clockwork Orange* populated by milk-dispensing mannequins after artist Allen Jones, it

also features two sculpted works of art by Dutch artist Herman Makkink: the phallic *Rocking Machine* and *Christ Unlimited*. While *Christ Unlimited* – four small ceramic Jesus figures holding onto each other in a seeming can-can chorus line – adorns Alex's (Malcolm McDowell) bedroom, *The Rocking Machine* – a large white penis on rocking scrotum base – adorns the home of a wealthy cat lady before she is murdered with the sculpture by Alex. Kubrick may have gotten the idea from Tinto Brass, who used *The Rocking Machine* in his 1970 film *Dropout*. The Medicom Toy Company has since manufactured versions of both *The Rocking Machine* and *Christ Unlimited* that were for sale to the general public. (V.A.)

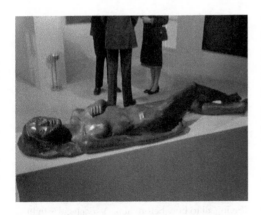

Crucible of Terror (Ted Hooker, 1971)

The opening sequence of this chiller sets the tone by showing mad artist Victor Clare (Mike Raven) at work, pouring liquid bronze over a living woman trapped in a mold. The credits display the impressive end result from all angles: a sculpture of a reclining woman in a pose reminiscent of a La Specola Venus, her left hand carelessly on her breast and her right leg slightly bent. The work is subsequently seen in a gallery and sold to an American dealer. When an overzealous admirer breaks in at night to feel up and steal the statue, however, he is murdered, and thus the statue has claimed two victims. The reclusive artist Victor Clare is mostly a painter in the film, showcasing works made in an Expressionist and sometimes almost Cubist style, and he is portrayed as a womanizer who is out to have sex with his models. At the end, however, *Crucible of Terror* inverts the idea of the mad artist murdering his models, presenting the viewer with a murderous model instead. (V.A.)

Savage Messiah (Ken Russell, 1972)

Savage Messiah is an artist biopic dealing with the life of Vorticist sculptor Henri Gaudier-Brzeska (1891–1915), portrayed by Scott Antony. The film follows a slew of Ken Russell's biopics from the 1960s, only three of which deal with visual artists. The film on Gaudier-Brzeska takes place in Paris and London between 1909 and 1915, focusing on a very brief period in the already short life of the artist. Russell depicts the artist as a crass and loutish young man who denounces the museum as a dead institution, mocking Michelangelo and the French Impressionists, and presenting the artistic process as simple hard work. The latter is exemplified by the fact that Gaudier-Brzeska starts and finishes what will become his masterpiece *Torso* in just one night in the film, with nothing but a bit of elbow grease and a chisel. The director shows us his introduction into the London avant-garde and the Vorticist movement, but apart from some pencil sketches and a brief montage of his sculptures toward the end of the film, Gaudier-Brzeska's works are hardly seen. The real focus of the film is the apparently platonic relationship between the artist and his muse Sophie Brzeska (Dorothy Tutin) and the relationship with his suffragette model mistress, Gosh Boyle (Helen Mirren). (V.A.)

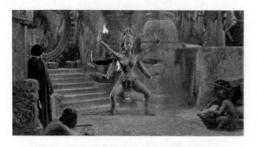

The Golden Voyage of Sinbad (Gordon Hessler, 1973)

Hessler's *The Golden Voyage of Sinbad* was a long-awaited follow-up to Nathan Juran's *The 7th Voyage of Sinbad* (1958), both of which are fueled by the spectacular effects of Ray Harryhausen. Sinbad the Sailor's fantastical realm provided filmmakers with a timeless, mythological context in which anything goes, from dinosaurs to genies and Cyclopes. On a quest to find the meaning of part of a golden tablet, Sinbad (John Phillip Law) and his crew set out to sea, but they are soon thwarted by the evil Prince Koura (Tom Baker). The Prince uses his magic to bring to life the ship's carved wooden figurehead, a robed woman with empty eyes and upright hair who wreaks havoc on the ship and kills one of the sailors. The attempt to kill Sinbad and steal his tablet is unsuccessful, however, and so the Prince repeats his trick when they reach a mysterious island. Captured by the natives, Prince Koura is brought to the temple of Kali, in which a statue of the deity resides. He turns the tables on the local shaman by bringing the statue to life, leaving all to bow before him. A spectacular fight ensues between Sinbad and the statue of Kali, in which the latter is able to wield no fewer than six deadly swords at the same time. The evil statue is eventually defeated by pushing it off a ridge, whereby it fractures to pieces on the bottom, revealing a missing part of the golden tablet. (V.A.)

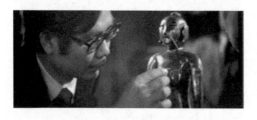

Golden Needles (Robert Clouse, 1974)

The prized object of this film is a small golden statuette named *The Golden Needles of Ecstasy* that, according to legend, was made especially for an emperor of the Song Dynasty. The statuette holds seven needles and indicates forbidden acupuncture points, which, when used in correct sequence, can bring about extraordinary sexual vigor and youth, but when used incorrectly will lead to a painful death. The film takes place in Hong Kong, where bell-bottomed detective Dan (Joe Don Baker) is tasked with retrieving the statue from criminal mastermind and amateur body painter Lin Toa (Roy Chiao). What ensues is a rather comical but violent back-and-forth between a number of interested parties who all seem to be skilled in martial arts. The statuette manages to survive the bursts of a flamethrower and being baked into a clay vase, and at the end of the film it is the subject of a big chase scene, not unlike those from the heyday of slapstick. Priceless ancient artifacts are stolen quite frequently on the silver screen, but it is not often that they also possess magical healing qualities, let alone of a sexual nature. In this case, the golden statuette itself is not of great value, but rather its needles and their seven secret locations. (V.A.)

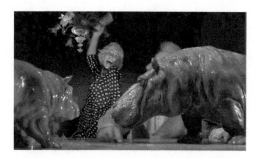

Il profumo della signora in nero (Francesco Barilli, 1974)

The Perfume of the Lady in Black is a classic *giallo* in that it favors style over a murderous story, right down to its unfathomable cannibalistic climax. We follow protagonist Silvia Hacherman (Mimsy Farmer), an industrial scientist plagued by both an Electra and Alice in Wonderland complex that manifest themselves through vivid daydreams, latent memories, and murder. One of Silvia's mnemonic triggers is a small terracotta statue of a cherub that has her name carved into it. The cherub stands in the garden of her mother's old apartment and seems to summon a violent character from her past. It is the older gentleman Signor Rossetti (Mario Scaccia), however, whose character is most linked to statuary through his obsession with hippopotamuses. He takes polaroids of the animals at the zoo and collects and paints small sculptures of them at home. The hippopotamus was a particularly salient symbol for the ancient Egyptians, signifying motherhood, birth, and the protection of children, as well as death. Ancient sculptures of the animals abound, a famous example being *William the Faience Hippopotamus*, the unofficial mascot of the Metropolitan Museum of Art, from Egypt's Middle Kingdom (*c.*1961–1878 BC). One night, Silvia brutally attacks Rossetti from behind with a meat cleaver when he is quietly painting one of his larger hippopotamuses blue. The statue and a smaller gray hippopotamus on the table are very prominently framed in the foreground of the attack, with the blue hippo seemingly doting over the bloodied head of Rossetti. (V.A.)

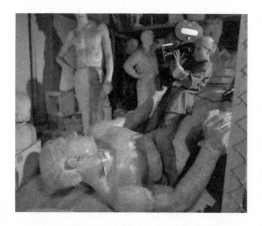

Człowiek z marmuru (Andrzej Wajda, 1976)

The titular *Man of Marble* refers to the propagandistic marble statues made in the image of Mateusz Birkut (Jerzy Radziwiłowicz), a bricklayer and Soviet Stakhanovite symbol in the socialist city Nowa Huta. Young filmmaker Agnieszka (Krystyna Janda) makes her thesis film on Birkut after he has been out of the public eye for more than two decades, and she hopes to reveal that the government initiated his downfall. On a visit to the Zachęta National Gallery of Art in Warsaw, she had found the remnants of Socialist Realist sculptures and discovered the marble statue of Birkut lying on the floor, which she secretly filmed. In the film archives, she discovered documentaries on how Birkut had become an inspiration for artists and how his portrait had supposedly caused a "revolution" in Polish art. In one of the documentaries, Birkut posed for a larger-than-life statue, which had been the centerpiece of an exhibition at the Zachęta Gallery. In the documentary, footage of Socialist Realist paintings and statues is juxtaposed with the so-called degenerate art made by artists from the capitalist West. A shot of Birkut's innocent and startled face is followed by a series of stills of works by modern artists, including Salvador Dalí's *The City of Drawers* (1936) and Henry Moore's *Reclining Figure* (1945–6). (L.C.)

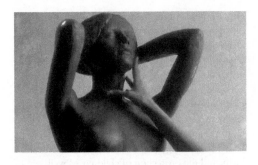

Laura, les ombres de l'été (David Hamilton, 1979)

British photographer David Hamilton is known best for his soft-focus pictures of partially clad young girls, which made him a household name in the 1960s and 1970s, but he also directed five feature films in the same style. As could be expected from Hamilton, *Laura, Shadow of a Summer*'s sculptor protagonist Paul Thomas Wyler (James Mitchell) seems to be obsessed by young girls, staring at them throughout the film with all the intensity of a serial killer. The film enforces

the idea of the artist as a womanizer and presents the viewer with many (gratuitous) shots of the nude female form, most blatantly in silly ballet dressing room scenes and shimmering seascapes. Paul finds his muse in fifteen-year-old Laura (Dawn Dunlap), the daughter of an old love. He photographs her in black and white, first in a scene that switches between the slow motion dancing of Laura and the freeze frames taken by Paul's camera. Then, working from his photographs and visual memories, he sculpts a life-sized statue of the young girl. The artistic process is shown by cutting between Paul's hands sensually sculpting, alternating color photographs of Laura in different poses, and soft-focus memories of Laura, while the shots pick up speed and the electronic soundtrack builds to a climax. In the meantime Laura has become sexually curious herself, and when an accident causes Paul to lose a lot of his work and become blind, she approaches him. The film ends with the artist and model coming together, and the statue of Laura remains as proof of the encounter in the young girl's home. (V.A.)

Césarée (Marguerite Duras, 1979)

In this short film, Duras evokes the story of the Jewish Queen Berenice of Cilicia's separation from her Roman lover, future emperor Titus, and her devastating return to Caesarea – her city, ravaged by the Romans. In voiceover, Duras recites her text while footage by Pierre Lhomme juxtaposes moving images of the Seine and Aristide Maillol's statues at the Jardin des Tuileries and still images of the Obelisk and Louis-Denis Caillouette's statues representing the cities Bordeaux and Nantes at the Place de la

Concorde. Moving camera shots show Maillol's *La Montagne* (*The Mountain*, 1937), *La Rivière* (*The River*, 1938), *L'Action enchaînée* (*Chained Action*, 1905–8), and *L'Air* (*Air*, 1938), intercut with full-length and close-up shots of the two statues, *Nantes* and *Bordeaux* (1836) by Caillouette. Whereas travelling shots of the Seine evoke the devastating separation that the Mediterranean Sea represents, the unmoving long shots of the statues of the sitting women surrounded by scaffolds and with slightly damaged faces connect Berenice to her ravaged city, with Maillol's *La Montagne* and *La Rivière* symbolizing the melancholy and hysteria of Berenice's tragic love story. The film ends with a travelling shot searching its way toward *La Seine* (1846), one of Louis Petitot's four allegorical statues at a corner of the Pont du Carrousel. The film visualizes the statue of a queen on her throne in its entirety, as if to show that both Berenice and Caesarea have overcome, and the shot is underscored by the voiceover leaving us with the final philosophical note that "there is nothing more to see than merely everything." (L.C.)

Clash of the Titans (Desmond Davis, 1981)

Chronicling the myth of Perseus, this peplum spectacle features Laurence Olivier as Zeus and special effects by none other than Ray Harryhausen. The gods oversee the narrative of the film from a Vaseline-coated Olympos, where they manipulate the lives of kings and common folk by placing small clay figurines of them in a model amphitheater. King Acrisius of Argos (Donald Houston) is the first to feel the wrath of the gods, when he is killed by Zeus, who crushes his clay effigy and then releases the Kraken and floods the city of Argos, bringing down a giant votive statue of himself in the process. Vengeful goddess Thetis (Maggie Smith) also wreaks some statuary havoc, inhabiting a giant statue of herself – achieved by superimposing her face onto it. She does so to converse with the monster Calibos and to threaten Perseus (Harry Hamlin) and Andromeda on their wedding day, even making her own statuary head fall off in a fit of anger. The star of the film is Harryhausen's animated Medusa, whose sculptural corpses populate her surroundings. She is defeated by Perseus, who uses her head to defeat the Kraken, turning it to stone and then rubble. (V.A.)

Raiders of the Lost Ark (Steven Spielberg, 1981)

The Golden Idol, or *Chachapoyan Fertility Idol,* that Indiana Jones (Harrison Ford) sets out to steal away from the native Peruvian Hovitos in *Raiders of the Lost Ark* famously triggers a plethora of booby-traps and summons the wrath of the locals in what has become one of the most iconic film scenes in recent memory. After Indy successfully escapes from the deadly temple, the *Idol* is immediately taken away from him by a rival archaeologist. Like a true McGuffin, the statue sets the plot in motion and gives spectators an idea of what they can expect from this and future Indiana Jones films, filled as they are with ancient treasures and archaeological adventure, but the *Idol* is forgotten after the opening scene as the film turns its attention to the real quest: that for the biblical Ark of the Covenant. (V.A.)

The Draughtsman's Contract (Peter Greenaway, 1982)

This murder mystery set in the late seventeenth century follows young artist Mr. Neville (Anthony Higgins), who is commissioned to make twelve drawings of an estate that features an enigmatic living statue. Greenaway made the drawings of the estate and the gardens himself, and each of them holds a clue that ultimately points toward the murder of the absent landowner Mr. Herbert (Dave Hill), whose wife (Janet Suzman) commissioned the works. The small changes to the landscape that the draughtsman suggests refer to the murder mystery to which the living statue seems an accomplice or a silent witness. Many scenes are staged as tableaux vivants which are the live counterparts of the drawings and which are disrupted by the living statue wandering through the garden and unexpectedly jumping on pedestals. The living statue's first appearance is at the end of the first day, when the artist and the masters of the house are dining. This scene starts with a long take – the camera tracks from left to right, sliding from one side of the table to the other – before an abrupt cut to a long shot shows us that the living statue is climbing on the roof trying to find a statuary position. The second time the living statue appears, it is disguised as a part of the wall. The third appearance occurs during the second dinner scene; this time, the statue stands on a column and pees while holding a torch. The fourth time, we see the living statue posing as a classical Greek statue and pretending to be a fountain. Strikingly, the living statue is at first only perceived by a child. When the dead body of the landowner is found in front of an equestrian statue, the draughtsman wonders if the rider is a real statue or a man, and his last drawing is one of the equestrian statue without the rider. In the end, the nobleman who killed the landlord also kills the draughtsman in front of the equestrian statue, burning all his drawings. The living statue posing as the equestrian statue's rider witnesses the second murder. (L.C.)

Man of Flowers (Paul Cox, 1983)

Before he went on to make the van Gogh biopic *Vincent* (1987), Paul Cox made the remarkable *Man of Flowers*, a film that displays art in almost every frame. The plot focuses on Charles Bremer (Norman Kaye), a wealthy eccentric passionate about music, flowers, and art. For his pleasure, Bremer periodically hires model Lisa (Alyson Best) to perform a slow striptease to classical music in front of an altar of flowers. The act is framed by an abstract geometrical painting in black, white, and gray and Bremer is joined in his voyeurism by a slightly abstracted sculpted head that displays African influences. His mansion is filled with paintings and sculptures in different styles and his garden prominently features a large crude piece of a reclining nude in white stone. Furthermore, sculptures abound in Bremer's sensual memories of walking through a park with his parents, with the little boy actively touching the statues and the camera examining their bodies in much detail; Bremer revisits the park and its statues often to reminisce. When Lisa's boyfriend David (Chris Haywood) gets wind of her relationship with Bremer, he decides to blackmail the wealthy

eccentric into buying his works of art. A once-famous action painter, David is a rough womanizer who doesn't treat Lisa well and whose abstract art offends Bremer's sensibilities, so the man of flowers decides to deal with the threat by turning David into a piece that he does like. Through a connection with a strange man at the antiques "coppershop" (Patrick Cook), Bremer had already

explored the idea of encasing someone in bronze, and together they put the idea into practice. The bronze creation is entitled *The Origin of Art*, a male nude leaning forward with bent head and holding up a bunch of flowers. Bremer gifts the piece to the community so that it ends up in a public park where visitors can both appreciate and touch it. (V.A.)

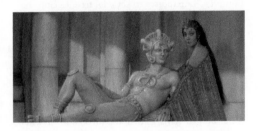

Conan the Destroyer (Richard Fleischer, 1984)

A classic sword-and-sorcery film in which the statuesque Conan (Arnold Schwarzenegger) is

sent out on a quest by the evil Queen Taramis (Sarah Douglas) to retrieve a magic artifact in the form of a bejeweled horn that will bring life to the statue of Dagoth, "the dreaming god." The resurrection ritual is disturbed, however, when Conan wants to stop the sacrifice of the virgin Princess Jehnna (Olivia d'Abo), on whom he is particularly sweet. The statue therefore transforms into a hideous amphibian-like creature that Conan defeats heroically. In an odd gentlemanly twist, however, he turns down the Princess's request that he join her as King, so that he can continue his wanderings. (V.A.)

Ghostbusters (Ivan Reitman, 1984)

The first of what is now a trio of ghost-busting films, *Ghostbusters* brings the tradition of the haunted house to an art deco skyscraper overlooking Central Park. The evil forces in the building manifest themselves first through the icebox of Dana Barrett (Sigourney Weaver) and then on the roof deck, where a stone altar is constructed next to two large sculptural hellhounds. After an onslaught of paranormal activity in the city, the statues on top of the building burst open to reveal actual hounds. Dana is possessed by the spirit of ancient demi-god Zuul, the Gatekeeper,

and her neighbor, accountant Louis (Rick Moranis), falls prey to one of the hounds and is possessed by Vinz Clortho, the Keymaster; together they prepare for the coming of Gozer the Destructor. The architect of the skyscraper, Dr. Ivo Shandor, constructed the building with "cold-riveted girders with cores of pure selenium," in order that it might serve as a superconductive antenna to pull in "spiritual turbulence," turning it into a portal for evil. Shandor started a secret society of Gozer worshipers in 1920 that conducted bizarre rituals on the roof intended to bring about the end of the world. Gozer ends up materializing in the form of a giant Stay Puft Marshmallow Man, but the ghost busters manage to bring New York back to normalcy (in so far as this is possible) by thoroughly roasting him. In *Ghostbusters II* (Ivan Reitman, 1989), the ghostbusters use telekinetic slime to bring to life the *Statue of Liberty*, waltzing it through Manhattan to break into the building of the fictitious Manhattan Museum of Art. (V.A.)

After Hours (Martin Scorsese, 1985)

When word processor Paul Hackett (Griffin Dunne) visits the SoHo apartment of his date Marcy Franklin (Rosanna Arquette), he is more impressed by her roommate, sculptor Kiki Bridges (Linda Fiorentino), who makes cream cheese and bagel paperweights out of plaster of Paris. Kiki's current project is a life-sized plaster sculpture of a tormented figure that reminds Paul of Edvard Munch's well-known painting *The Scream* (*c.*1893–1910), which he refers to as "The Shriek." The thematic horror of Kiki's sculpture reinforces Paul's disturbing intimations about Marcy's body in this first of a series of surreal encounters and cases of mistaken identity in this exceedingly black comedy. Later, Paul accidently meets two burglars (Cheech and Chong) carrying away Kiki's sculpture, but when he confronts them they flee and drop the statue. Then he is mistaken for a burglar by an angry mob, and lonely sculptor June (Verna Bloom) hides him by covering him in plaster of Paris wrappings, turning him into a sculpture reminiscent of Kiki's; after the mob is gone, however, June refuses to set Paul free. Luckily, he is eventually "rescued" by the two burglars he met before, who take him to be Kiki's sculpture, and he falls out of their van after they steal him. One of the burglars speculates that he is a statue by "that famous guy, Segal," alluding to George Segal, known for realist plaster sculptures made from living models using the same method as June's. The other burglar remarks that art is worth more when it is ugly, so this thing must be worth a fortune. Both lifelike plaster of Paris statues clearly mirror the nightmarish vertigo in which the protagonist finds himself. The pieces were actually made by Nora Chavooshian, an American sculptor who also worked as a set and production designer. (L.C.)

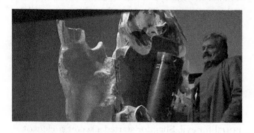

Legal Eagles (Ivan Reitman, 1986)

This comedy caper revolves around a missing painting stolen from millionaire Mr. Forrester (John McMartin) by performance artist Chelsea Deardon (Darryl Hannah). She claims the painting is hers, as it was originally made for her by her artist father when she was eight. Deardon hires attorney Laura Kelly (Debra Winger), who, with the assistance of District Attorney hopeful Tom Logan (Robert Redford), uncovers an insurance fraud conspiracy that saw Chelsea's father murdered and his paintings stolen, instead of presumably lost in a fire. Murder and mayhem ensue and the missing painting is eventually found inside a hollow sculpture by fictional artist "Bertollini" – a model for a larger statue that supposedly stood in Sutton Square. (L.C.)

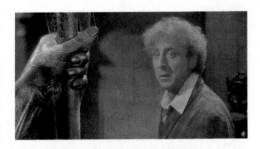

Haunted Honeymoon (Gene Wilder, 1986)

With a wink and a nudge, we are reminded of Jean Cocteau's *La Belle et la bête* (*Beauty and the Beast*, 1946) when we encounter a hallway filled with living sculptural arms holding candelabras in this haunted house farce. Living artworks are a staple of the haunted house genre and this film is part of a genre revival that took place in the 1970s and 1980s. We can see that protagonist Larry Abbot (Gene Wilder) is clearly unsettled by the sight of these sculptural arms and a close shot from the perspective of one of the arms confirms to the viewer that these are indeed alive, even if Larry doesn't notice right away. The sculpted limbs are just the beginning of Wilder's homage to Cocteau. Mere seconds after Larry passes by the arms, he walks through a mirror and into a dream world, just like the protagonist in *Le Sang d'un poète* (*The Blood of a Poet*, 1932). (V.A.)

The Belly of an Architect (Peter Greenaway, 1987)

Architect Stourley Kracklite (Brian Dennehy) is invited to Rome to oversee the construction of an exhibition devoted to eighteenth-century visionary French architect Étienne-Louis Boullée, but over the course of his stay his life starts to unravel. A noted character in the film is a man, played by Stefano Gragnani, who wanders about the Forum Romanum to chisel noses off ancient statues. The slow but deliberate action of the nose collector and his fixation on one specific body part echoes Stourley's own concern over his deteriorating body, his stomach in particular, a concern that the architect transfers to his work by starting a photocopy collection of sculptural abdomina. Further defacement of statues can be found at the Foro Italico, where ancient sculptures have been spray-painted with swastikas. Stourley's young Italian colleague Caspasian Speckler (Lambert Wilson) has not only been diverting exhibition money to restore the Foro Italico, but has also started an affair with Stourley's wife. Historically, noses, like phalluses, were the most likely appendages to get damaged or go missing from ancient sculptures, with white marble being especially easy to remove, and so it became common practice to replace these with newer ones to show the statues in their "full" form. Some museums have decided against this restoration practice, removing the "restored" noses and starting a Nasothek, or nose collection, to display them. The Danish Ny Carlsberg Glyptotek in Copenhagen harbors a Nasothek, as does Lund University in Sweden. (V.A.)

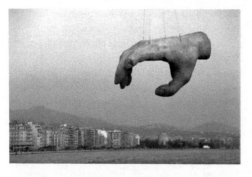

Topio stin omichli (Theodoros Angelopoulos, 1988)

Angelopoulos's *Landscape in the Mist* echoes the opening scene from *La dolce vita* (Federico Fellini, 1960), as its two wandering child protagonists witness a giant stone hand emerging mysteriously from the sea. The hand seems to be broken off a very large Ancient Greek statue and is missing part of its pointing index finger. A helicopter lifts it out of the water and quietly lifts it into the sky and over the city, from where it seems to comment on the dire situation of the two children looking for their father by themselves; something massive and broken has been unearthed and now menacingly hovers over them. Angelopoulos repeats this beautiful and impactful statuary scene in *To vlemma tou Odyssea* (*Ulysses' Gaze*, 1995). This time the water does not bring forth painful memories of ancient times, but rather memories of a recent past, as a scene showcases a boat transporting a monumental fractured statue of Lenin down the Danube. Statues of Lenin populate a large number of countries that were once under Communist influence, and so they often rear their heads in film as well, *Good Bye, Lenin* (Wolfgang Becker, 2003) being one of the most famous. (V.A.)

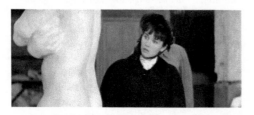

Camille Claudel (Bruno Nuytten, 1988)

Bruno Nuytten's much-awarded debut feature film is an artist biopic that focuses on sculptor Camille Claudel's (Isabelle Adjani) complicated relationship with Auguste Rodin (Gérard Depardieu). Claudel is a popular subject not only because she was a female artist, or because of her involvement with Rodin, but also because she suffered from mental illness, causing her to destroy some of her own work. Recently, for instance, Bruno Dumont's *Camille Claudel 1915* (2013), with Juliette Binoche in the title role, focused on the period of Claudel's life that she spent in confinement as a recluse, not sculpting anymore. Nuytten's film begins at the start of her career, however, as she and her friend Jessie Lipscomb become apprentices to Rodin after leaving the Academy. The cinematography and narrative focus on the haptic nature of sculpting, from Camille digging clay out of the frozen ground, to the hands-on approach of Rodin, manipulating his models' nude bodies into very uncomfortable positions. Rodin is immediately made out to be both a genius and a womanizer, and much is made of the fact that we rarely see him sculpting, but rather directing the artists and apprentices in his giant workshop. Camille proves her worth to Rodin early on by sculpting a foot out of Paros marble, the most difficult kind, and cranking out the work overnight. The relationship between the two is clearly one of peers, with respect and mutual admiration, and it quickly turns into a very passionate romance. Sculpturally, we see Camille working on the epic *La Porte de l'enfer* (*The Gates of Hell*, 1880–1917), with Camille also providing Rodin with the inspiration for *Le Penseur* (*The Thinker*, c.1880) through one of her own works. Rodin and Claudel are very emphatic about working from live models, as evidenced for instance from their work on *Les Bourgeois de Calais* (*The Burghers of Calais*, 1884–9) in the film. Nuytten does a lot to emphasize the craftsmanship that is involved with sculpture, portraying it as a raw and emotional art form that requires hard manual labor, and cinematographically he often lets chiaroscuro lighting do the talking. (V.A.)

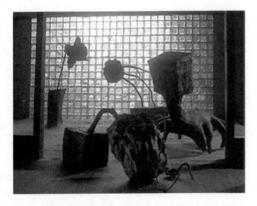

Beetlejuice (Tim Burton, 1989)

When jaded sculptor and all-round eccentric Delia Deetz (Catherine O'Hara) moves to the country with her wealthy husband Charles (Jeffrey Jones) and her morbid stepdaughter Lydia (Winona Ryder), a series of highly unusual events sparks the artistic recognition from the New York art scene she has long craved. The house turns out to be haunted by its former owners, the Maitlands (Alec Baldwin and Geena Davis), and a nasty demon named Betelgeuse (Michael Keaton). Delia's sculptures are presented as ugly and dangerous in the film. One of her larger works – shaped like a bent caricature of a Christmas tree – is hoisted up with a crane and proceeds to scare the living daylights out of Charles when it accidentally crashes through the kitchen window, missing him by an inch. Delia tells the movers to lower the work down, but she gets trapped between the work and the house wall, screaming "This is my art and it is dangerous!" Her work later turns into an actual prison, when during a séance to summon the ghosts of the house two of Mrs. Deetz's artworks are brought to life, imprisoning her and her husband. After Betelgeuse is expelled from the house, the traumatic experience ultimately succeeds in giving new meaning to the abstract works of Mrs. Deetz, as well as steering her new work toward a more figurative path. The renewed interest in her work earns her the front page of the influential art magazine *Art in America*. The artworks were made by Ed Nunnery but closely resemble works Tim Burton has made himself in the past. (V.A.)

The Addams Family (Barry Sonnenfeld, 1991)

The Addams family grounds are simply not complete without a personal cemetery, housing the family's most beloved degenerates and honoring them with a large number of expressive, and at times expressionist, funerary statues. A stroll around the graveyard reveals the colorful deaths of past Addamses, which are usually incorporated into their statues. It is thus that we find, among many others, aunt Labortia, executed by a firing squad; cousin Fledge, torn limb from limb by four wild horses; uncle Imar, buried alive; uncle Fester's (Christopher Lloyd) pet vulture Muerto; and mother and father Addams, killed by an angry mob. The statues are also used in a metaphorical way through montage, and the graveyard is put to good use during a "wake the dead" game, revealing an Ansel Addams as one of the relatives. Look out for an enchanted painting of Fester in the hallway and a double portrait of Fester and Pugsley (Jimmy Workman) by the artist Lurch (Carel Struycken), as well. (V.A.)

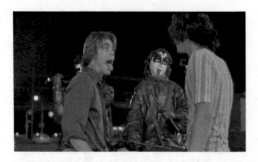

Dazed and Confused (Richard Linklater, 1993)

For the bicentennial celebration of America's independence in 1976, two high school seniors in Austin, Texas decide to steal two life-sized bronze Fife and Drum Corps statues from their original station in front of a bank. These sculptural symbols of true American values are then painted by Michelle Burroughs (Milla Jovovich) to look like members of the American hard rock band KISS, with the "Starchild" Paul Stanley on fife and the "Demon" Gene Simmons on the drum respectively. The trio unveils the statues in the parking lot of local teen hangout the Emporium, with sparklers attached to the end of Paul Stanley's fife for effect. The statues' presence in the film is somewhat mysterious, as they look to have played a much larger part in the film originally. Gene Simmons reportedly bought the statues for his private collection, selling them for $6,000 at the Butterfield's KISS auction in 2000. (V.A.)

Cronos (Guillermo del Toro, 1993)

In this del Toro chiller, a sixteenth-century wooden cherub statue hides the mysterious Cronos device in its base. Created by an alchemist, the biomechanical Cronos holds the key to eternal life. A dying millionaire and his henchman nephew have amassed a whole collection of wooden cherub statues – or "archangels" – in their search for the device, but the original ends up in the antique store of Jesus Gris (Federico Luppi). He discovers that the statue is hollow and inadvertently uses the Cronos device, with dire consequences. (V.A.)

M.D.C. – Maschera di cera (Sergio Stivaletti, 1997)

Director Sergio Stivaletti did his utmost best to combine a number of existing wax museum film tropes in *M.D.C. – Maschera di cera* (or *Wax Mask*), but also infused it with a little *giallo* and science. In 1912 Rome, mirroring the plot of Maurice Tourneur's 1914 *Figures de Cire* – a film that is later referenced literally – a gentleman makes a wager with his friend to spend the night in a wax museum. The young man stumbles upon wax artist Boris Volkoff's (Robert Hossein) laboratory, where a sculpted wax head of the Medusa makes him succumb to fright. It turns out that Dr. Volkoff has taken a page out of the book of plastination pioneer Gunther von Hagens, achieving sculptural perfection in his museum not through wax modeling, but rather by holding people hostage in their own bodies. The bodies are injected with a fluid that slows their heart rate down to almost zero, keeping them in suspended animation for the rest of their lives. The good doctor thereby exacts his revenge in a visceral manner, trading in flesh instead of wax. Dr. Volkoff follows the blueprint even further, but with a clever inversion. He reveals a mechanical hand and maimed face from having fallen into his own vat of wax during a lover's quarrel – a fate usually reserved for the end of the film – and a twist shows that the wax artist is really a robot when he gets trapped in the burning wax museum. This strange turn of events was probably inspired by the recent success of the *Terminator* films and it is one that comments on the perennial nature of the mad artist. (V.A.)

Sabrina Goes to Rome (Tibor Takács, 1998)

In this follow-up film to the successful TV series *Sabrina, the Teenage Witch*, we see Sabrina (Melissa Joan Hart) go to Rome to discover the secret of a closed 400-year-old locket that belonged to her old aunt. In a Roman museum, Sabrina makes a classical Roman statue come to life by inhabiting it to amuse her fellow witch Gwen (Tara Strong), stating that it "must have been a lot warmer then, because nobody kept their clothes on." When Gwen tries to pull the same trick, she accidentally brings to life a statue of David, who walks up to her and asks if she hasn't seen a giant by any chance. She tries to appease David by offering him jellybeans, but he hurls them away in his sling, damaging a statue of Julius Caesar. Gwen accidentally brings two more busts to life – Julius Caesar and Mark Antony – but Sabrina remedies the situation. (V.A.)

The Haunting (Jan De Bont, 1999)

This remake of Robert Wise's eponymous 1963 film proves that a haunted house is best served with some haunted art. Through montage, the characters that visit Hill House seem to be continuously looked at by paintings, sculptures, and woodcarvings, and a large eerie portrait of the house's former owner dominates the main stairway. When everyone wants to leave because something doesn't feel right, the house and its resident artworks act up. In the greenery of the house, a large sculpted man seated in a fountain comes alive to submerge and nearly drown Dr. David Marrow (Liam Neeson). Luke (Owen Wilson) is less lucky when he defaces a painting and is subsequently beheaded by a large sculpted head of a lion that acts as a chimney sweep; and Nell (Lili Taylor) is attacked by a sculpture of an eagle that comes alive. The house also features a frieze based on Rodin's *La Porte de l'enfer* (*The Gates of Hell*, 1880–1917) that comes alive to swallow up the ghost of the house's former owner, who has emerged from his portrait. Most of the effects for the artworks coming alive were achieved through early computer animation and by portrait artist Gunnar Ahmer, who also worked on the haunted paintings in Disney's *The Haunted Mansion* (Rob Minkoff, 2003). (V.A.)

The Thomas Crown Affair (John McTiernan, 1999)

In an elaborate and successful attempt to steal Claude Monet's *Saint-Georges majeur au crépuscule* (*San Giorgio Maggiore at Dusk*, 1908–12) from the Metropolitan Museum of Art, billionaire art thief Thomas Crown (Pierce Brosnan) creates a diversion whereby a "First Century Greco Asian Horse" statue is delivered to the museum. Expecting a sarcophagus, security leaves the statue alone, but out of the Trojan horse come four men who force their way into the museum disguised as guards and create a massive distraction. While the men are being arrested, Thomas Crown smoothly steals his beloved Monet in a scene also evoking the art of René Magritte. This art heist film is packed with authentic artworks and deals intimately with art theft and forgery. (V.A.)

Zoolander (Ben Stiller, 2001)

In this cult classic spoof of the fashion industry, supermodel Derek Zoolander (Ben Stiller) shares a flat with his dimwitted model friends. Their shared New York loft exemplifies their self-obsession and vanity in its decoration with Andy Warhol and Roy Lichtenstein inspired paintings of the models showcasing their characteristic looks. When the gang go out in their convertible for orange mocha frappuccinos, a stop at the gas station becomes fatal for Derek's friends when they start spraying each other with the hoses and someone decides to light a cigarette. To commemorate their loss, a bronze fountain statue is erected by Derek in which the three models are portrayed having fun with their hoses in their final moments. The fountain statue is located in front of the *Derek Zoolander Center for Kids Who Can't Read Good and Who Want to Learn How to Do Other Stuff Good Too*. (V.A.)

The Haunted Mansion (Rob Minkoff, 2003)

The film is based on the eponymous Disneyland attraction that first opened its doors in 1969, hot on the heels of a postwar resurgence of the haunted house genre and corresponding architectural attractions. Like every good haunt, the attraction banks on animating the inanimate and providing the visitors with ghostly encounters. The former is achieved by an impressive haunted portrait gallery and a barbershop quartet of singing busts, both of which make their way into the film. The titular mansion is brought to the attention of workaholic real estate agent Jim Evers (Eddie Murphy), who decides to divert a family vacation with his wife Sara (Marsha Thomason) and their two kids to visit the house. Greeted by a stern butler and the owner, the family soon realize that they've been lured to the house because Sara is the double of the master's deceased lover Elizabeth, a fact that becomes clear when the children discover a portrait of Elizabeth in the attic. In an effort to discover what happened to Elizabeth and to lift the curse that is trapping the house's ghostly inhabitants, the family encounters a variety of haunted artworks. The most interesting succession of these can be seen when Jim discovers that a marble bust triggers a secret door behind a bookshelf when its head is tilted. The passageway leads to the haunted portrait gallery, where two grumpy-looking busts also turn their heads to follow him. The family is finally confronted with the singing barbershop quartet of busts on column pedestals in the mansion's graveyard. Many of the haunted artworks in the film were made by portrait artist Gunnar Ahmer, who also worked on Jan De Bont's seminal update of *The Haunting* (1999). (V.A.)

Lo sguardo di Michelangelo (Michelangelo Antonioni, 2004)

Also known as *Michelangelo Eye to Eye*, Antonioni's short documentary on the work of his namesake must be seen in the tradition of art documentaries of the 1940s and 1950s, such as *Thorvaldsen* (Carl Theodor Dreyer, 1949) and *L'Enfer de Rodin* (*Rodin's Hell*; Henri Alekan, 1957). The film focuses on Michelangelo's statue of *Moses* (*c.*1513–15), which is located in the church of San Pietro in Vincoli in Rome and was commissioned by Pope Julius II for

his tomb in 1505. The marble giant is depicted seated with a flowing beard, strong arms holding the stone tables and draperies that fall over his lap. His head is topped with two little horns that have become part of Moses's visualization through a seeming translation error in the Latin Vulgate bible. The film opens on the backlit 92-year-old Antonioni entering the church and slowly walking up to the masterpiece. Bathed in the chiaroscuro of the church, the director first exchanges a meaningful glance with a statue in the foreground, before the camera approaches *Moses*. It deconstructs the statue by gliding over its smooth marble surface and switching up the angles in close-up, cutting back to wide shots only to frame Antonioni's experience of the statue. The director contemplates the statue vigorously and moves in closer to run his hands over its white marble. Constantly switching between shots of Antonioni looking at and touching the sculpture, the film ends with him walking toward the church's brightly lit door, as if to signify that the director can die after having witnessed the majestic *Moses* first-hand. (V.A.)

Enduring Love (Roger Michell, 2004)

Enduring Love features sculptures by renowned British sculptor Glenys Barton, a number of which were made expressly for the film. Barton is known for her work with ceramics and has been focusing on the human head since the 1980s. It is these characteristic heads with their firm elongated necks, reminiscent of Jean Cocteau's sculpted heads, that show up in the film as portraits of characters Joe (Daniel Craig) and Robin (Bill Nighy). Where most artists' work for film goes unnoticed or unpromoted, Barton and her Flowers Gallery embraced the idea, releasing a corresponding

catalogue entitled "New Sculptures and works used in the film Enduring Love." The film focuses on the psychic aftermath of a freak hot air balloon crash in the countryside that upends the life of university lecturer Joe, his loved ones, and all those involved in the accident. Joe ends up being stalked by one of the other witnesses to the balloon crash. Joe's girlfriend Claire's (Samantha Morton) sculpted heads occupy the visual landscape of the film, much like Joe's head itself does by virtue of a closely following hand-held camera. The heads serve as a metaphor for Joe's interior meltdown, a metaphor strengthened by the fact that Joe often walks in on Claire mid-process: scraping off clay gently, or preparing to cast a giant head in bronze. Joe ponders the metaphor quite openly himself when discovering sketches of his face in Claire's studio and revealing a large sculpted work of his head. The head is flat, missing its rounded back, and stares at him menacingly. In this moment of revelation Claire walks in and breaks up with Joe, as if replicating him sculpturally has truly ended their strained relationship. Soon after, the sculptor is stabbed by Joe's stalker, but she survives the attack. (V.A.)

Hellboy (Guillermo del Toro, 2004)

Director Guillermo del Toro has a thing for hollow wooden statues, from the little cherub in *Cronos* (1993) to a life-sized sixteenth-century statue of Saint Dionysius the Areopagite in *Hellboy*, "smuggled into the country by an overzealous curator." The statue serves as a prison for the hellhound Sammael in the film. While on display at a New York Library, however, the statue is sliced in half by an occult Nazi scientist, and the demon is unleashed. The film and its sequel also feature a prominent statue of Saint Michael slaying Satan, most likely inspired by the sculpture decorating the façade of the mid-eighteenth-century St. Michael in Berg am Laim church in Munich, as well as a humanoid statue that represents comic book character Roger the Homunculus; both are present in the house that harbors the Bureau for Paranormal Research and Defense. In the sequel, *Hellboy II: The Golden Army* (2008), the Bureau is once again confronted with demons from another world, this time at an auction house, where treasures of pre-Christian Europe are being sold to the highest bidder. Among these treasures is a Greek-looking marble triple deity bust reminiscent of the Celtic Corleck head, and a giant stone *Venus of Willendorf* that is described as being "a fertility goddess, dating approximately 15,000 to 10,000 B.C.," though in reality the statue is tiny and more than 10,000 years older. The auction is violently interrupted when an Elf Prince comes to claim a piece of a Royal Crown and unleashes thousands of third-century Black Forest man-eating tooth fairies on the crowd. Hellboy (Ron Perlman) and his team arrive too late and use the giant Venus to destroy some of the tooth fairies. Continuing in the vein of Celtic mythology, the paranormal investigators find an entrance to the mythical city of Bethmoora in the guise of a rock formation that turns out to be a sleeping giant, referring to man-made formations such as the *Cerne Abbas Giant* and the *Long Man of Wilmington*. The stone giant comes alive to let the team in. (V.A.)

Red Sands (Alex Turner, 2009)

Red Sands brings the mysticism of the *Arabian Nights* into the twenty-first century when a group of US soldiers stumble upon an ancient statue in Afghanistan. Separated from their convoy by a roadside explosive, the young troopers are suddenly faced with a rock face into which a centuries-old statue of an ominous-looking woman holding out one arm has been carved. The group's translator tells them that idols are forbidden in Islam, explaining the statue's remote location, adding that statues are often thought to imprison man-hating creatures named Djinn, or genies. A frustrated soldier decides to shoot the statue in the face, which destroys it entirely, and it isn't long before a curse catches up with them. When they are assigned to an isolated house in the desert to monitor a road, the squad members become haunted by their own past and a mysterious Afghan woman blown in by a sandstorm creates heightened tensions. One by one, the soldiers meet their demise, until there is only one left to tell the tale – or is there? The film plays on the archeological trope of the curse that befalls those who desecrate temples or graves, which usually applies to mummies and pyramids, but can also be seen in adventure films such as the Indiana Jones saga. This trope entered

contemporary popular culture through Howard Carter's 1922 discovery of Tutankhamun, which prompted a series of mysterious deaths among his team members as well as an entire series of mummy films, in which Egyptian statues have magical powers. Furthermore, the film mirrors the recent wave of Middle Eastern iconoclasm that saw many Byzantine and Assyrian treasures destroyed forever. In film, the destruction of a statue can signify death by a curse, but statues more often become possessed or alive themselves to extract revenge. (V.A.)

Dinner for Schmucks (Jay Roach, 2010)

Comedian Steve Carell plays well-meaning idiot and taxidermy hobbyist Barry Speck and Jemaine Clement takes on the role of arrogant multimedia artist Kieran Vollard in this reimagining of the French film *Le Dîner de cons* (*The Dinner Game*, Francis Veber, 1998). While the plot centers around a financial analyst looking for eccentrics to bring to his boss's "dinners for schmucks," it is the two aforementioned artists who steal the show. Speck impresses with his handcrafted mouse dioramas after historical events and paintings, producing several series of which the crowning achievement can be considered his *Mousterpieces*: seven diorama copies of famous paintings in which the human figures have been replaced by taxidermied mice, among them Leonardo da Vinci's *Mona Lisa* (1503–17); Grant Wood's *American Gothic* (1930); and James Abbott McNeill Whistler's *Arrangement in Grey and Black No. 1* (best known as *Whistler's Mother*, 1871). Barry Speck works very much in the realm of outsider art in the film, hence his inclusion at the dinner parties, but encounters a kindred soul in legitimate and respected artist Kieran Vollard. Vollard is a painter, photographer, sculptor, and video artist, famous for his sensual nature and fierce animal magnetism, and his work consists almost entirely of larger than life self-portraits focused on his persona. In his show at a Los Angeles gallery, we can see that Vollard's work, characterized by Dionysian hybridity, has been modeled somewhat on Matthew Barney's. Speck and Vollard form an artistic duo, combining forces to create the inaugural piece of the Martin Mueller Museum of Modern Art in Switzerland, a giant bronze sculpture of eccentric millionaire Martin Mueller's (David Walliams) severed index finger, entitled *My Wife's Favorite Finger*. The piece is based on the bizarre fencing accident that caused millionaire Martin Mueller to lose the finger. The digit is decorated with a ring that carries Mueller's family crest "Ad victorem spolias," (supposed) Latin for "To the victor go the spoils." The bronze finger seems to be a direct reference to sculptor César Baldaccini's famous *Le Pouce* (*The Thumb*, 1965), a giant bronze thumb of which several versions exist. (V.A.)

Percy Jackson and the Olympians: The Lightning Thief (Chris Columbus, 2010)

As in all decent cinematic adaptations of Greek myth, this teen update of the peplum genre, set in modern times, incorporates statuary on different levels. On a museum trip with his school, Percy Jackson (Logan Lerman) discovers that he can read the Ancient Greek subscripts on statues, most notably on a frieze depicting the Greek demi-god Perseus. It isn't long before Percy's real identity catches up to him and he is sent on a quest to retrieve Zeus's stolen lightning bolt and save the world with a team of teen demi-gods.

The statues of Zeus and Poseidon in the museum are modeled after the actors portraying them in the film (Sean Bean and Kevin McKidd), but the biggest statuary revelation can be found in Auntie Em's Garden Emporium. The sculptural shop in New Jersey boasts an owner who is responsible for all its intensely figurative statues. Uma Thurman plays a Medusa clad in leather and brandishing sunglasses, and, as behooves a teen update, Percy is able to defeat her not through the reflection of his shield, but that of his smartphone. The teen team has to recover a number of artifacts, one of which is lodged in the crown of the giant Athena statue housed in the Nashville Parthenon. It is there that they make a statue of their own, using the Medusa's head to fight off a protective hydra. The 2013 sequel, *Percy Jackson: Sea of Monsters* (Thor Freudenthal), upholds the statuary tradition by including the trope of the mythical bull automaton, or *khalkotauros*, which, in its full mechanical glory, stages an attack on the teen's training camp. (V.A.)

La grande bellezza (Paolo Sorrentino, 2013)

In the opening sequence of *The Great Beauty*, a mobile camera first offers a glimpse of one of the bronze statues of Rome's Monument to Garibaldi, and then we see a shot of a man mourning next to a bronze crown, followed by an establishing shot of the equestrian statue. As the camera tracks further away, we see the bust of Italian politician Mattia Montecchi, and subsequently several busts of other Italian patriots, juxtaposed with living actors. In what follows, a Japanese tourist, as if stricken by incomprehensible beauty, dies while making pictures of the *Fontana dell'Acqua Paola*. The main character, Jep Gambardella (Toni Servillo), an aging socialite who wrote a best-selling novel in his twenties and has lived an easy life writing columns and attending

high-end parties ever since, wanders across Rome's well-known tourist sites, galleries, and chapels throughout the film. While reflecting on unfulfilled life and love, Jep meanders through the streets and ruins, and he encounters the Eternal City as a timeless landscape of strange and superb beauty, full of eccentric contemporary artists. After a party, he, his girlfriend, and a friend who has the keys to Rome's important galleries and secret palazzos, visit the Capitoline Museums by night. At the Palazzo Nuovo, they are confronted with one of Rome's talking statues, *Marforio* (first century AD) – the statue of the river god Oceanus that adorns the poster for the film – as well as the *Capitoline Venus* and the *Statue of Flavia Giulia Elena*. Captured by a wandering camera and shot in chiaroscuro lighting, the statues are highlighted as still objects, subjected to the mobile gaze of the visitors. We see a glimpse of *The Dying Gaul*, before moving to Borromini's gallery with forced perspective at the Palazzo Spada, and the nocturnal journey finally ends at the Villa Medici. At the Villa they take pictures while posing next to the group of Niobe statues and pause at the balcony, a scene that evokes *L'Année dernière à Marienbad* (*Last Year at Marienbad*; Alain Resnais, 1961). (L.C.)

The Hobbit: The Desolation of Smaug (Peter Jackson, 2013)

In this second part of Peter Jackson's Hobbit trilogy, Bilbo Baggins (Martin Freeman) is part of a merry band of dwarves led by Thorin Oakenshield (Richard Armitage). Together they set out for their former home of Erebor to defeat the dragon Smaug (Benedict Cumberbatch) and reclaim what he has stolen from them. The secret entrance to the dwarves' mountain lair can be reached via a giant statue of a dwarf king, a gesture of overcompensation that serves as a stairway and is carved into the rock's face as if it were a fantastic *Mount Rushmore*. Inside the mountain, the dragon presides over all the golden riches of the once-great kingdom, and the team concocts a statuary plan to defeat him. Tricking Smaug into lighting their smelting furnaces, the dwarves divert molten gold into a cast for a giant dwarf king statue reminiscent of the one outside on the mountain face. The statuary process is weaponized when the team releases the statue prematurely from its cast just at the moment when the beast is perched in front of it. Eye to eye with a giant shimmering gold statue, the dragon becomes mesmerized, until a glimmer in the statue's eye reveals its unstable nature and molten gold pours out. In what would be a fitting death for a dragon, Smaug is covered in a pool of gold, but alas the effect is only temporary. The angry dragon manages to fly away and shake off the gold, looking to extract his revenge on the nearby Lake-town. This scene was specially added to the film to serve as a cliffhanger and was not in the original book. (V.A.)

Bibliography

Aben, Rob and Saskia de Wit, *The Enclosed Garden: History and Development of the Hortus Conclusus and Its Reintroduction into the Present-day Urban Landscape* (Rotterdam: 010 Publishers, 1999).

Achenbach, Michael and Paolo Caneppele, "Born Under the Sign of Saturn: The Erotic Origins of Cinema in the Austro-Hungarian Empire," in Davide Turconi (ed.), *Griffithiana: Journal of Film History* 65 (Gemona: Cineteca del Friuli, 1999), 126–39.

Ades, Dawn and Michael Taylor, *Dalí* (Philadelphia: Philadelphia Museum of Art, 2004).

Alekan, Henri, *Des Lumières et des ombres* (Paris: Editions du collectionneur, 1996).

Alekan, Henri, *Le Vécu et l'imaginaire: Chronique d'un homme d'images* (Paris: Source la sirène, 1999).

Andrew, Dudley, "*L'Âge d'or* and the Eroticism of the Spirit," in Ted Perry (ed.), *Masterpieces of Modernist Cinema* (Bloomington: Indiana University Press, 2006), 11–137.

Anker, Steve, Kathy Geritz, and Steve Seid (eds.), *Radical Light: Alternative Film and Video in the San Francisco Bay Area, 1945–2000* (Berkeley: University of California Press, 2010).

Anon., "Cabiria, A Masterpiece," *Motography* XII, 2 (11 July 1914), 37.

Anon., "Les Films tels qu'ils sont," *Le Courrier Cinématographique* 12 (30 September 1911), 6. Republished in Alain Carou and Béatrice de Pastre (eds.), "Le Film d'Art & Les Films d'Art en Europe, 1908–1911," *1895* 56 (December 2008), 317.

Anon., "The Film of the Week," *Moving Picture World* 8 (29 April 1911), 934.

Anon., "World's Greatest Film is Screened," *Motography* XII, 2 (11 July 1914), 37–9.

Aragon, Louis, "On Décor" (1918), in Paul Hammond (ed.), *The Shadow and Its Shadow: Surrealist Writing on the Cinema* (Edinburgh: Polygon, 1991), 55–9.

L'Arc 31 (1967) (theme issue on *L'Année dernière à Marienbad*).

Arnheim, Rudolf, "Sculpture: The Nature of a Medium," in *To the Rescue of Art: Twenty-Six Essays* (Berkeley: University of California Press, 1992), 82–91.

Aziza, Claude (ed.), "Le Péplum: l'Antiquité au Cinéma," *CinémAction* 89 (1998).

Baer, Elizabeth R., *The Golem Redux: From Prague to Post-Holocaust Fiction* (Detroit: Wayne State University Press, 2012).

Baker, Simon, *Surrealism, History and Revolution* (Oxford: Peter Lang, 2007).

Ballestriero, Roberta, "Anatomical Models and Wax Venuses: Art Masterpieces or Scientific Craft Works?," *Journal of Anatomy* 216 (2010), 223–34.

Barker, Jennifer M., *The Tactile Eye: Touch and the Cinematic Experience* (Berkeley: University of California Press, 2009).

Baudelaire, Charles, "Pourquoi la sculpture est ennuyeuse" [Salon de 1846], in *Ecrits esthétiques* (Paris: Union Générale d'éditions, 1986), 177–80.

Bazin, Germain, *Le Temps des museés* (Paris: Desoer, 1967).

Becherer, Richard, "Chancing it in the Architecture of Surrealist Mise-en-Scène," *Modulus* 18 (1987): 62–87.

Benjamin, Walter, "The Work of Art in the Age of Its Technological Reproducibility," Second Version, in *The Work of Art in the Age of Its Technological Reproducibility, and Other Writings on Media*, ed. Michael W. Jennings, Brigid Doherty, and Thomas Y. Levin (Cambridge, MA and London: Harvard University Press, 2008), 19–55.

Berès, Anisabelle, Henri Laurens, and Michel Arveiller, *Henri Laurens, 1885–1954* (Paris: Galerie Berès, 2004).

Bergala, Alain (ed.), *Rossellini: Le Cinéma révélé* (Paris: Flammarion, 1984).

Bergman, Ingrid and Alan Burgess, *Ingrid Bergman: My Story* (New York: Delacorte Press, 1980).

Bergstein, Mary, "We May Imagine It: Living with Photographic Reproduction at the End of Our Century," in Helene E. Roberts (ed.), *Art History Through the Camera's Lens* (Philadelphia: Gordon & Breach, 1995), 3–36.

Bernard, André and Claude Gauteur (eds.), *Jean Cocteau: The Art of Cinema* (London: Marion Byars, 1992).

Bernardi, Sandro, "Rossellini's Landscapes: Nature, Myth, History," in David Forgacs, Sarah Lutton, and Geoffrey Nowell-Smith (eds.), *Roberto Rossellini: Magician of the Real* (London: BFI, 2000), 50–63.

Berry, Francesca, "Bedrooms: Corporeality and Subjectivity," in Georgina Downey (ed.), *Domestic Interiors: Representing Homes from the Victorians to the Moderns* (London and New York: Bloomsbury Academic, 2013), 129–46.

Berthomé, Jean-Pierre, "Entretien avec Jacques Saulnier," *Positif* 329–30 (July–August 1988), 42.

Blanshard, Alastair J. L., "Nakedness without Naughtiness: A Brief History of the Classical Nude," in Michael Turner (ed.), *Exposed: Photography and the Classical Nude* (Sydney: Nicholson Museum, The University of Sydney, 2011), 14–29.

Blanshard, Alastair J. L. and Kim Shahabudin, *Classics on Screen: Ancient Greece and Rome on Film* (London: Bristol Classical Press, 2011).

Blom, Ivo, "Quo Vadis? From Painting to Cinema and Everything in Between," in Leonardo Quaresima and Laura Vichi (eds.), *La decima musa. Il cinema e le altre arti/The Tenth Muse. Cinema and other arts* (Udine: Forum, 2001), 281–96.

Bloom, Harold, *George Bernard Shaw's Pygmalion* (New York, New Haven, and Philadelphia: Chelsea House, 1988).

Bloom, Michelle E., *Waxworks: A Cultural Obsession* (Minneapolis: University of Minnesota Press, 2003).

Bois, Yve-Alain, *Painting as Model* (Cambridge, MA: MIT Press, 1990).

Bondanella, Peter, *The Films of Roberto Rossellini* (Cambridge: Cambridge University Press, 1993).

Bonitzer, Pascal, *Décadrages: Peinture et cinéma* (Paris: Cahiers du cinéma, 1985).

Borde, Raymond, "Knokke-le-Zoute: Le Cinéma expérimental en 1964," *Positif* 60 (April/May 1964), 53–62.

Bordwell, David, *On the History of Film Style* (Cambridge, MA and London: Harvard University Press. 1997).

Bordwell, David and Kristin Thompson, *Film Art: An Introduction* (New York: McGraw Hill, 1993).

Bordwell, David, Kristin Thompson, and Janet Staiger, *The Classical Hollywood Cinema: Film Style and Mode of Production to 1960* (London: Routledge, 1985).

Brandl-Risi, Bettina, *BilderSzenen: Tableaux vivants zwischen bildender Kunst, Theater und Literatur im 19. Jahrhundert* (Freiburg: Rombach Verlag, 2007).

Brewster, Ben and Lea Jacobs, *Theatre to Cinema: Stage Pictorialism and the Early Feature Film* (Oxford and New York: Oxford University Press, 1997).

Broughton, James, *Coming Unbuttoned: A Memoir* (San Francisco: City Lights, 1993).

Brude-Firnau, Gisela, "Lebende Bilder in den Wahlverwandtschaften: Goethes Journal intime vom Oktober 1806," *Euphorion: Zeitschrift für Literaturgeschichte* 74, 4 (1980), 402–16.

Brunette, Peter, *Roberto Rossellini* (New York: Oxford University Press, 1987).

Burnham, Jack, *Beyond Modern Sculpture: The Effects of Science and Technology on the Sculpture of This Century* (New York: George Braziller, 1978).

Bush, W. Stephen, "Cabiria," *Moving Picture World* 20 (April–June 1914), 1090–1.

Bussels, Stijn, "Making the Most of Theatre and Painting: The Power of Tableaux Vivants in Joyous Entries from the Southern Netherlands (1458–1635)," in Caroline van Eck and Stijn Bussels (eds.), *Art History: Theatricality in Early Modern Art and Architecture* (Oxford: Wiley-Blackwell, 2011), 156–63.

Carden-Coyne, Ana, "Intimate Encounters with the Classical Body: Social Provocations in Photography," in Michael Turner (ed.), *Exposed: Photography and the Classical Nude* (Sydney: Nicholson Museum, The University of Sydney, 2011), 22–30.

Chamarette, Jenny, "Spectral Bodies, Temporalised Spaces: Agnès Varda's Motile Gestures of Mourning and Memorial," *Image & Narrative* 12, 2 (2011): 31–49.

Champigneulle, Bernard, *Rodin* (London: Thames & Hudson, 1967).

Chappell, Sally A., "Films on Sculpture," *Art Journal* 33, 2 (Winter 1973–4), 127–8.

Christie, Ian, "A Disturbing Presence? Scenes from the History of Film in the Museum," in Angela Dalle Vacche (ed.), *Film, Art, New Media: Museum Without Walls?* (New York: Palgrave Macmillan, 2012), 241–55.

Clark, Vèvè A., Maya Deren, Millicent Hodson, Catrina Neiman, and Hollis Melton, *The Legend of Maya Deren: A Documentary Biography and Collected Works* (New York: Anthology Film Archives/Film Culture, 1984) (Vol. I, Part 2).

Cocteau, Jean, *Two Screenplays*. Translated by Carol Martin-Sperry (Baltimore: Penguin, 1968).

Cocteau, Jean, *The Difficulty of Being*. Translated by Elizabeth Sprigge (New York: Da Capo Press, 1995).

Colpitt, Frances, *Minimal Art: Critical Perspectives* (Ann Arbor: UMI Research Press, 1990).

Connolly, Maeve, *The Place of Artists' Cinema: Space, Site and Screen* (Bristol: Intellect, 2009).

Cornelius, Michael G. (ed.), *Of Muscles and Men* (Jefferson: McFarland, 2011).

Corrigan, Timothy, *The Essay Film: From Montaigne, After Marker* (New York: Oxford University Press, 2011).

Cowie, Peter, *Antonioni, Bergman, Resnais* (London: Tantivy Press, 1963).

Cürlis, Hans, "Das Problem der Wiedergabe von Kunstwerken durch den Film," in Georg Rhode *et al.* (eds.), *Edwin Redslob zum 70. Geburtstag: Eine Festgabe* (Berlin: Wasmuth, 1955), 172–85.

Curtis, Penelope, *Sculpture 1900–1945* (Oxford: Oxford University Press, 1999).

Dalí, Salvador, *Dalí* (New York: The Bignou Gallery, 1945).

Deleuze, Gilles, *Cinema 2: The Time-Image* (Minneapolis: University of Minnesota Press, 1995).

Diderot, Denis, *Diderot on Art, Volume I: The Salon of 1765 and Notes on Painting* (New Haven: Yale University Press, 1995).

Dimendberg, Edward, "Toward an Elemental Cinema: Film Aesthetics and Practice in *G*," in Detlef Martins and Michael W. Jennings (eds.), *G: An Avant-Garde Journal of Art, Architecture, Design, and Film 1923–1926* (London: Tate Publishing, 2010), 53–70.

Dodds, George, "Freedom from the Garden: Gabriel Guévrékian and a New Territory of

Experience," in John Dixon Hunt and Michel Conan (eds.), *Tradition and Innovation in French Garden Art: Chapters of a New History* (University of Pennsylvania Press, 2002), 185–203.

Douchet, Jean, "Henri Alekan: Entretien avec Jean Douchet," in Pierre-Alexandre Schwab, Henri Alekan: *L'Enfant des lumières* (Paris: Hermann éditeurs, 2012), 76–81.

Drum, Dale D., "Carl Dreyer's Shorts Were as Conscientiously Done as His Feature-Lengths," *Films in Review* (January 1969), 34–41.

Dixon, Bryony, "The Good Thieves: On the Origins of Situation Comedy in the British Music Hall," in Tom Paulus and Rob King (eds.), *Slapstick Comedy* (New York and London: Routledge. 2010), 21–36.

Durgnat, Raymond, *"Marienbad: Reviewed by Raymond Durgnat," Films and Filming* (March 1962), 30–1.

Ehrlich, Susan (ed.), *Pacific Dreams: Currents of Surrealism and Fantasy in California Art, 1934–1957* (Los Angeles: UCLA at the Armand Hammer Museum of Art and Cultural Center, 1995).

Eisenstein, Sergei M., "Montage and Architecture" (1938), *Assemblage* 10 (December 1989), 116–31.

Eisenstein, Sergei M., *Beyond the Stars: The Memoirs of Sergei Eisenstein* (London: BFI, 1995).

Elsen, Albert E., *The Gates of Hell by Auguste Rodin* (Stanford: Stanford University Press, 1985).

Elwes, Catherine, *Installation and the Moving Image* (London: Wallflower, 2015).

Erdman, Andrew L., *Blue Vaudeville: Sex, Morals and the Mass Marketing of Amusement, 1895–1915* (Jefferson and London: McFarland, 2004).

Farwell, Beatrice, "Films on Art in Education," *Art Journal* 23, 1 (Autumn, 1963), 39–40.

Faure, Elie, "De la cinéplastique" (1922), in *Fonction du cinéma: de la cinéplastique à son destin social* (Genève: Editions Gonthier, 1964), 16–36.

Felleman, Susan, *Art in the Cinematic Ima*gination (Austin: University of Texas Press, 2006).

Felleman, Susan, "Decay of the Aura: Modern Art in Classical Cinema," *Jump Cut: A Review of Contemporary Media* 53 (2011). <https://www.ejumpcut.org/archive/jc53.2011/FellemanDecayAura>

Felleman, Susan, *Botticelli in Hollywood: The Films of Albert Lewin* (New York: Twayne, 1997).

Felleman, Susan, "The Picture of Dorian Gray," *International Dictionary of Films and Filmmakers – Volume 1: Films* (Detroit: St. James Press, 4th edn., 2000), 946–8.

Felleman, Susan, *Real Objects in Unreal Situations: Modern Art in Fiction Films* (Bristol: Intellect, 2014).

Fischer, Lucy, "Spellbound: Surrealism and California Experimental Cinema," in Susan Ehrlich (ed.), *Pacific Dreams: Currents of Surrealism and Fantasy in California Art, 1934–1957* (Los Angeles: UCLA at the Armand Hammer Museum of Art and Cultural Center, 1995), 47–55.

Focillon, Henri, "The Cinema and the Teaching of the Arts," *The International Photographer* (February 1935), 3.

Ford, Hamish, *Post-War Modernist Cinema and Philosophy: Confronting Negativity and Time* (New York: Palgrave Macmillan, 2012).

Foster, George G. and Stuart M. Blumin (ed.), *New York by Gas-Light and Other Urban Sketches* (Berkeley: University of California Press, 1990).

Foster, Hal, *Compulsive Beauty* (Cambridge, MA: MIT Press, 1993).

Frauensohn, Danièle and Michel Deneuve, *Bernard Baschet: Chercheur et sculpteur de sons* (Paris: L'Harmattan, 2007).

Freud, Sigmund, *Delusion and Dream and Other Essays*, ed. Philip Rieff (Boston: Beacon, 1956).

Freud, Sigmund, "The Uncanny" (1919), in Philip Rieff (ed.), *Studies in Parapsychology* (New York: Macmillan/Collier, 1963), 19–60.

Fried, Michael, "Art and Objecthood," *Artforum* 5, 10 (June 1967), 12–23.

Garb, Tamar. "Modeling the Body: Photography, Physical Culture, and the Classical Ideal in

Fin-de-Siècle France," in Geraldine Thomson (ed.), *Sculpture and Photography: Envisioning the Third Dimension* (Cambridge: Cambridge University Press, 1998), 86–99.

Garber, Marjorie and Nancy J. Vickers (eds.), *The Medusa Reader* (New York and London: Routledge, 2003).

Gaudreault, André, "Editing: Early Practices and Techniques," in Richard Abel (ed.), *Encyclopedia of Early Cinema* (Oxford and New York: Routledge, 2005).

Geis, Terri, "'Death by Amnesia': Maya Deren, Egypt, and 'Racial' Memory," *Dada/Surrealism* 19, 6 (2013). http://ir.uiowa.edu/cgi/viewcontent.cgi?article=1275&context=dadasur

Gercke, Daniel, "Ruin, Style and Fetish: The Corpus of Jean Cocteau," *Nottingham French Studies* 32, 1 (March 1993): 10–18.

Getsy, David J., "Tactility or Opticality, Henry Moore or David Smith: Herbert Read and Clement Greenberg on The Art of Sculpture, 1956," *Sculpture Journal* 17, 2 (2008), 75–88.

Giedion-Welcker, Carola, *Moderne Plastik: Elemente der Wirklichkeit; Masse und Auflockerung* (Zürich: Girsberger 1937).

Goethe, Johann Wolfgang von, *Italian Journey* (London: Penguin, 1962).

Goethe, Johann Wolfgang von, *Die Wahlverwandtschaften* (Cologne: Anaconda Verlag, 2007).

Gorfinkel, Elena, "At the End of Cinema, This Thing Called Film," *Lola* 1 (2011). http://www.lolajournal.com/1/end_of_cinema.html

Gras, Henk, *Een stad waar men zich koninklijk kan vervelen: De modernisering van de theatrale vermakelijkheden buiten de schouwburg in Rotterdam, circa 1770–1860* (Hilversum: Verloren, 2009).

Gross, Kenneth, *The Dream of the Moving Statue* (Pennsylvania: Pennsylvania State University Press, 2006).

Grote, George, *A History of Greece: from the Earliest Period to the Close of the Generation Contemporary with Alexander the Great, vol.5* (London: John Murray, 1870).

Guerlac, Suzanne, "The Tableau and the Authority in Diderot's Aesthetic," *Studies on Voltaire and the Eighteenth Century* 219 (1983), 183–94.

Gwynn, David M., *Athanasius of Alexandria: Bishop, Theologian, Ascetic, Father* (Oxford and New York: Oxford University Press, 2012).

Hamilton, George Heard, *Painting and Sculpture in Europe, 1880–1940* (New Haven: Yale University Press, 1993).

Hammacher, A. M., *The Evolution of Modern Sculpture: Tradition and Innovation* (London: Thames and Hudson, 1969).

Hammond, Paul, *L'Âge d'Or* (London: BFI, 1997).

Hardie, Philip, *Ovid's Poetics of Illusion* (Cambridge and New York: Cambridge University Press, 2002).

Haskell, Francis and Nicholas Penny, *Taste and the Antique: The Lure of Classical Sculpture, 1500–1900* (New Haven: Yale University Press, 1981).

Heinemann, David, "*Michael* and *Gertrud*: Art and the Artist in the Films of Carl Theodor Dreyer," in Steven Allen and Laura Hubner (eds.), *Framing Film: Cinema and the Visual Arts* (Bristol: Intellect, 2012), 149–64.

Herder, Johann Gottfried, *Plastik: Einige Wahrnehmungen über Form und Gestalt aus Pygmalions bildendem Traume* (Riga and Leipzig: Hartknoch & Breitkopf, 1778).

Hermans, Lex, "Consorting with Stone: The Figure of the Speaking and Moving Statue in Early Modern Italian Writing," in Sarah Blick and Laura D. Gelfand (eds.), *Push Me, Pull You: Physical and Spatial Interaction in Late Medieval and Renaissance Art – Volume Two* (Leiden and Boston: Brill, 2011), 117–22.

Hersey, George L., *Falling in Love with Statues: Artificial Humans from Pygmalion to the Present* (Chicago: University of Chicago Press, 2009).

Hildebrand, Adolf, *Das Problem der Form in der Bildenden Kunst* (Strassburg: Heitz & Mündel, 1893).

Hodin, J. P., "Two English Films," *Films on Art* (Brussels/Paris: Les Arts Plastiques/Unesco, 1951), 17–27.

Holmström, Kirsten Gram, *Monodrama, Attitudes, Tableaux Vivants: Studies on Some Trends of Theatrical Fashion 1770–1815* (Stockholm: Almqvist & Wiksell, 1967).

Hoover Voorsanger, Catherine and John K. Howat, *Art and the Empire City: New York, 1825–1861* (New York: Metropolitan Museum of Art, 2013).

Houlgate, Stephen (ed.), *Hegel and the Arts* (Evanston, IL: Northwestern University Press, 2007).

Huxley, David, "Music Hall Art: La Milo, Nudity, and the *pose plastique* 1905–1915," *Early Popular Visual Culture* 11, 3 (2013), 218–36.

Huysmans, Joris-Karl, *L'Art moderne, Certains* (Paris: Union générale d'editions, 1975), 93–4.

Iles, Chrissie, *Into the Light: The Projected Image in American Art, 1964–1977* (New York: Whitney Museum of American Art, 2001).

Irvin, F., "The Little Theatres of Paris," *The Theatre: Illustrated Monthly Magazine of Dramatic and Musical Art* V (1905), 202–4.

Jacobs, Steven, *Framing Pictures: Film and the Visual Arts* (Edinburgh: Edinburgh University Press, 2007).

Jacobs, Steven, "Statues Also Die in Marienbad: Sculpture in *Last Year in Marienbad*," in Christoph Grunenberg and Eva Fischer-Hausdorf (eds.), *Last Year in Marienbad: A Film as Art* (Cologne: Wienand Verlag, 2015), 92–105.

Jacobs, Steven and Lisa Colpaert, *The Dark Galleries: A Museum Guide to Painted Portraits in Film Noir, Gothic Melodramas, and Ghost Stories of the 1940s and 1950s* (Ghent: AraMER, 2013).

James, David E., *The Most Typical Avant-Garde: History and Geography of Minor Cinemas in Los Angeles* (Berkeley: University of California Press, 2005).

James, Paula, *Ovid's Myth of Pygmalion on Screen: In Pursuit of the Perfect Woman* (London and New York: Continuum International, 2011).

Janson, H. W., *Nineteenth-Century Sculpture* (London: Thames & Hudson, 1985).

Johnson, Barbara, *The Feminist Difference: Literature, Psychoanalysis, Race, and Gender* (Cambridge, MA: Harvard University Press, 1998).

Johnson, Geraldine (ed.), *Sculpture and Photography: Envisioning the Third Dimension* (Cambridge: Cambridge University Press, 1998).

Jooss, Birgit, *Lebende Bilder: Körperliche Nachahmung von Kunstwerken in der Goethezeit* (Berlin: Reimer, 1999).

Klawans, Stuart, "Narcissus Sees Through Himself: On Jean Cocteau and the Invention of the Film Poet," *Parnassus: Poetry in Review* 32, 1/2 (January 2011): 321–33.

Knight, Arthur, "A Short History of Art Films," in William Mck. Chapman (ed.), *Films on Art 1952* (New York: The American Federation of Arts, 1953), 6–20.

Knowles, Kim, *A Cinematic Artist: The Films of Man Ray* (Oxford: Peter Lang, 2012).

Knowles, Kim, "From Mallarmé to Mallet-Stevens: Reading Architectural Space in Man Ray's *Les Mystères du château de dé*," *French Studies* 65, 4 (2011): 459–70.

Kovacs, Andras Balint, *Screening Modernism: European Art Cinema, 1950–1980* (Chicago: The University of Chicago Press, 2007).

Krauss, Rosalind, *Passages in Modern Sculpture* (New York: Viking Press, 1977).

Krauss, Rosalind, "Sculpture in the Expanded Field," *October* 8 (Spring, 1979), 30–44.

Krauss, Rosalind, *The Originality of the Avant-Garde and Other Modernist Myths* (Cambridge, MA: MIT Press, 1986).

Krauss, Rosalind E., "Close-Up: Frame by Frame," *Artforum International* (September 2012): 416–19.

Labarthe, André S. and Jacques Rivette, "Entretien avec Resnais et Robbe-Grillet," *Cahiers du cinéma* 123 (September 1961), 1–18.

Langen, August, "Attitüde und Tableau in der Goethezeit," *Jahrbuch der deutschen Schillergesellschaft* 12 (1968), 194–258.

Le Guay, Philippe, "Entretien avec Henri Alekan," *Cinématographe* 68 (June 1981), 23–9.

Lessing, Lauren Keach, *Presiding Divinities: Ideal Sculpture in Nineteenth-Century American Domestic Interiors* (Ph.D. thesis, Indiana University, 2006).

Leutrat, Jean-Louis, *L'Année dernière à Marienbad* (London: BFI, 2000).

Liandrat-Guigues, Suzanne, *Cinéma et sculpture: Un Aspect de la modernité des années soixante* (Paris: L'Harmattan, 2002).

Liandrat-Guigues, Suzanne, "Le Jardin des sculptures: *Shadows* de John Cassavetes," in Dominique Sipière and Alain J.-J. Cohen (eds.), *Les Autres arts dans l'art du cinéma* (Rennes: Presses universitaires de Rennes, 2007), 197–206.

Liandrat-Guiges, Suzanne and Jean-Louis Leutrat, *Alain Resnais: Liaisons secrètes, accords vagabonds* (Paris: Cahiers du cinéma, 2006).

Lichtenstein, Jacqueline, *The Blind Spot: An Essay on the Relations between Painting and Sculpture in the Modern Age* (Los Angeles: Getty Publications, 2008).

Lindsay, Shana G., "Mortui Docent Vivos: Jeremy Bentham and Marcel Broodthaers in Figures of Wax," *Oxford Art Journal* 36, 1 (March 2013), 93–107.

Lindsay, Vachel, *The Art of the Moving Picture* (1915) (New York: The Modern Library, 2000).

Lippard, Lucy, "As Painting Is to Sculpture: A Changing Ratio," in Maurice Tuchman (ed.), *American Sculpture of the Sixties* (Los Angeles: Los Angeles County Museum of Art, 1967), 31–2.

Lopate, Phillip, "In Search of the Centaur: The Essay-Film," in Charles Warren (ed.), *Beyond Document: Essays on Nonfiction Film* (Wesleyan University Press, 1998), 243–70.

Loughlin, Gerard, *Alien Sex: The Body and Desire in Cinema and Theology* (Malden, MA: Blackwell, 2004).

McCall, Anthony, "Anthony Mccall: Five Minutes of Pure Sculpture at Hamburger Bahnhof. flv." YouTube video, 4:12. Posted by "haad vn," May 4, 2012.

McCall, Anthony, "Line Describing a Cone and Related Films," in Jackie Hatfield (ed.), *Experimental Film and Video: An Anthology* (New Barnet: John Libbey, 2006), 61–73.

McCullough, Jack W., *Living Pictures on the New York Stage* (Ann Arbor: UMI Research Press, 1983).

Madeleine-Perdrillat, Alain, Florian Rodari, and Marie du Bouchet, *Entretiens avec Claude Garache* (Paris: Hazan, 2010).

Maierhofer, Waltraud, "Goethe on Emma Hamilton's 'Attitudes': Can Classicist Art Be Fun?," in Thomas P. Saine (ed.), *Goethe Yearbook: Publications of the Goethe Society of North America* (Columbia: Camden House, 1999), 222–52.

Malraux, André, *Le Musée imaginaire de la sculpture mondiale* (Paris: Gallimard, 1952–4).

Malraux, André, *Psychologie de l'art* (Genève: Skira, 1947).

Man Ray, *Self Portrait* (Boston: Little, Brown, 1988).

Marcoci, Roxana, *The Original Copy: Photography and Sculpture, 1839 to Today* (New York: The Museum of Modern Art, 2010).

Marks, Laura U., *In the Skin of Film: Intercultural Cinema, Embodiment, and the Senses* (Durham, NC: Duke University Press, 2000).

Marshall, Gail, *Actresses on the Victorian Stage: Feminine Performance and the Galatea Myth* (Cambridge, New York, and Melbourne: Cambridge University Press, 1998).

Martini, Arturo, *La Scultura Lingua Morta e altri scritti* (Milan: Abscondita, 2001).

Mason, Rainer M. and Hélène Pinet, *Pygmalion photographe: La sculpture devant la caméra 1844–1936* (Geneva: Editions du Tricorne, 1985).

Métraux, Guy P. R., *Sculptors and Physicians in Fifth-Century Greece: A Preliminary Study* (Montreal and Kingston: McGill-Queen's University Press, 1995).

Michaud, Philippe-Alain, *Brancusi Filming 1923–1939* (Paris: Centre Pompidou, 2011).

Monaco, James, *Alain Resnais* (New York: Oxford University Press, 1979).

Miller, Joan Vita (ed.), *The Sculpture of Auguste Rodin: Reductions and Enlargements* (New York: B. G. Cantor Sculpture Center, 1983).

Miller, Ron, *Special Effects: An Introduction to Movie Magic* (Minneapolis: Twenty-First Century Books, 2006).

Milne, Tom, *The Cinema of Carl Dreyer* (London: Zwemmer, 1971).

Moholy-Nagy, László, "Space-Time and the Photographer" (1943), in Steve Yates (ed.), *Poetics of Space: A Critical Photographic Anthology* (Albuquerque: University of New Mexico Press, 1995), 145–56.

Moholy-Nagy, László, *Vision in Motion* (Chicago: Paul Theobald, 1947).

Mowll Mathews, Nancy, "Art and Film: Interactions," in Nancy Mowll Mathews and Charles Musser (eds.), *Moving Pictures: American Art and Early Film 1880–1910* (Manchester and Vermont: Hudson Hills Press, 2005), 145–58.

Mulvey, Laura, *Death 24x a Second: Stillness and the Moving Image* (London: Reaktion Books, 2006).

Murphy, Douglas, *The Architecture of Failure* (New York: Zero Books, 2012).

Musser, Charles. "A Cornucopia of Images: Comparison and Judgment across Theater, Film, and the Visual Arts during the Late Nineteenth Century," in Nancy Mowll Mathews and Charles Musser (eds.), *Moving Pictures: American Art and Early Film 1880–1910* (Manchester and Vermont: Hudson Hills Press, 2005), 5–37.

Nead, Lynda, *The Female Nude: Art, Obscenity and Sexuality* (London and New York: Routledge, 1992).

Nead, Lynda, *The Haunted Gallery: Painting, Photography, Film c.1900* (New Haven and London: Yale University Press, 2008).

Neer, Richard, *The Emergence of the Classical Style in Greek Sculpture* (London and Chicago: The University of Chicago Press, 2013).

Okuyama, Yoshiko, *Japanese Mythology in Film: A Semiotic Approach to Reading Japanese Film and Anime* (Lanham: Lexington Books, 2015).

Ollier, Claude, *Souvenirs écran* (Paris: Cahiers du cinéma/Gallimard, 1981).

Ovid, *Ovid's Metamorphoses, in fifteen books. Translated by Mr. Dryden. Mr. Addison. . . . and other eminent hands. Publish'd by Sir Samuel Garth, M.D. Adorn'd with sculptures. . . . The third edition* (Ann Arbor: Gale ECCO, 2007).

Panofsky, Erwin, "Style and Medium in the Motion Pictures," in Gerald Mast, Marshall Cohen, and Leo Braudy (eds.), *Film Theory and Criticism: Introductory Readings* (New York: Oxford University Press, 1992 [1936]), 233–48.

Panzanelli, Roberta, "Introduction: The Body in Wax, the Body of Wax" in Roberta Panzanelli (ed.), *Ephemeral Bodies: Wax Sculpture and the Human Figure* (Los Angeles: Getty Research Institute, 2008), 1–12.

Peucker, Brigitte, "The Material Image in Goethe's *Wahlverwantschaften*," *The Germanic Review* 74, 3 (1999), 195–213.

Peucker, Brigitte, *The Material Image: Art and the Real in Film* (Stanford: Stanford University Press, 2007).

Phillips, Sarah R., *Modeling Life: Art Models Speak about Nudity, Sexuality, and the Creative Process* (Albany: State University of New York Press, 2006).

Pigott, Michael, *Joseph Cornell versus Cinema* (London: Bloomsbury, 2013).

Pilbeam, Pamela, *Madame Tussaud and the History of Waxworks* (London and New York: Hambledon Continuum, 2003).

Pine, Julia, *Breaking Dalinian Bread: On Consuming the Anthropomorphic, Performative, Ferocious, and Eucharistic Loaves of Salvador Dalí* (University of Rochester, 2010). <http://www.rochester.edu/in_visible_culture/Issue_14/pine/>

Pinet, Hélène (ed.), *Rodin et la photographie* (Paris: Gallimard/Musée Rodin, 2007).

Podro, Michael, *The Critical Historians of Art* (New Haven: Yale University Press, 1982).

Potts, Alex, "Dolls and Things: The Reification and Disintegration of Sculpture in Rodin and Rilke," in John B. Onians (ed.), *Sight and Insight: Essays on Art and Culture in Honour of E. H. Gombrich at 85* (London: Phaidon, 1994), 354–78.

Potts, Alex, *The Sculptural Imagination: Figurative, Modernist, Minimalist* (New Haven: Yale University Press, 2000).

Potts, Alex "Introduction: The Idea of Modern Sculpture," in Jon Wood, David Hulks, and Alex Potts (eds.), *Modern Sculpture Reader* (Leeds: The Henry Moore Foundation, 2007), xiii–xxx.

Prettejohn, Elizabeth, *The Modernity of Ancient Sculpture: Greek Sculpture and Modern Art from Winckelmann to Picasso* (London: I. B. Tauris, 2012).

Racz, Imogen, *Henri Laurens and the Parisian Avant-Garde*. Ph.D. thesis (University of Newcastle, 2000). https://theses.ncl.ac.uk/dspace/bitstream/10443/425/1/Racz00.pdf

Rascaroli, Laura, *The Personal Camera: Subjective Cinema and the Essay Film* (London: Wallflower Press, 2009).

Read, Herbert, *A Concise History of Modern Sculpture* (New York: Frederick Praeger, 1964).

Rees, A. L., Duncan White, Steven Ball, and David Curtis (eds.), *Expanded Cinema: Art, Performance, Film* (London: Tate, 2011).

Reff, Theodore, *Paul Cézanne: Two Sketchbooks* (Philadelphia: Philadelphia Museum of Art, 1989).

Renger, Almut-Barbara, *Oedipus and the Sphinx: The Threshold Myth from Sophocles through Freud to Cocteau* (Chicago and London: University of Chicago Press, 2013).

Richardson, Michael, *Surrealism and Cinema* (Oxford: Berg, 2006).

Rilke, Rainer Maria, *Rodin and Other Prose Pieces* (London: Quartet Books, 1986).

Robert, Valentine, "La Pose au cinéma: film et tableau en corps-à-corps," in Christine Buignet and Arnaud Rykner (eds.), *Entre Code et corps: Tableau vivant et photographie mise en scène* (Pau: Presses Universitaires de Pau et des Pays de L'Adour, 2012), 73–89.

Robert, Valentine, "L'Histoire de l'art prise de vue," in Valentine Robert, Laurent Le Forestier, and François Albera (eds.), *Le Film sur l'art: Entre histoire de l'art et documentaire de création* (Rennes: Presses universitaires de Rennes, 2015), 37–54.

Rozas, Diane and Anita Bourne Gottehrer, *American Venus: The Extraordinary Life of Audrey Munson, Model, and Muse* (Los Angeles: Balcony Press, 1999).

Sandberg, Mark, *Living Pictures, Missing Persons: Mannequins, Museums, and Modernity* (Princeton and Oxford: Princeton University Press, 2003).

Sartre, Jean-Paul, "The Search for the Absolute" (1948), in Charles Harrison and Paul Wood (eds.), *Art in Theory, 1900–2000: An Anthology of Changing Ideas* (Oxford: Wiley-Blackwell, 2002), 599–604.

Schwab, Pierre-Alexandre, *Henri Alekan: L'Enfant des lumières* (Paris: Hermann éditeurs, 2012).

Selz, Peter, *Directions in Kinetic Sculpture* (Berkeley: University of California, Art Museum, 1966).

Sheehan, Rebecca, "The Time of Sculpture: Film, Photography and Auguste Rodin". http://tlweb.latrobe.edu.au/humanities/screeningthepast/29/film-photography-rodin.html

Sheehy, Terry, "Celebration: Four Films by James Broughton," *Film Quarterly* 29, 4 (Summer 1976): 2–14.

Short, Robert, *The Age of Gold: Surrealist Cinema?* (London: Creation Books, 2003).

Sitney, P. Adams, *Visionary Film: The American Avant-Garde, 1943–2000* (New York: Oxford University Press, 2002).

Simmel, Georg, "Über die dritte Dimension in der Kunst" (1906), in *Aufsätze und Abhandlungen 1901–1908* (Frankfurt am Main: Suhrkamp Verlag, 1993), II, 9–14.

Simmel, Georg, "Rodin mit einer Vorbemerkung über Meunier" (1911), in *Philosophische Kultur: Gesammelte Essays* (Berlin: Kiepenheuer, 1983), 139–53.

Sobchack, Vivian, *The Address of the Eye: A Phenomenology of Film Experience* (Princeton: Princeton University Press, 1992).

Solomon, Matthew, *Disappearing Tricks: Silent Film, Houdini, and the New Magic of the Twentieth Century* (Urbana and Chicago: University of Illinois Press, 2010).

Steele, Valerie, "Fashion, Fetish, Fantasy," in Efrat Tseëlon (ed.), *Masquerade and Identities: Essays on Gender, Sexuality, and Marginality* (London: Routledge, 2001), 73–82.

Stoichita, Victor, *The Pygmalion Effect: From Ovid to Hitchcock* (Chicago: University of Chicago Press, 2008).

Sweet, Freddy, *Last Year at Marienbad: The Statues* (MacMillan Films, 1975).

Szondi, Peter, "Tableau und *Coup du Théâtre*: Zur Sozialpsychologie des bürgerlichen Trauerspiels bei Diderot," *Schriften* (Frankfurt am Main: Suhrkamp, 1978), II, 205–32.

Tarkovsky, Andrey, *Sculpting in Time: Tarkovsky, The Great Russian Filmmaker Discusses His Art* (Austin: University of Texas Press, 1989).

Tarn Steiner, Deborah, *Images in Mind: Statues in Archaic and Classical Greek Literature and Thought* (Princeton and Oxford: Princeton University Press, 2001).

Tesson, Charles, "Dreyer et la sculpture ou le corps interdit: *Thorvaldsen* (1949) de Carl Theodor Dreyer," in Michel Frizot and Dominque Païni (eds.), *Sculpter Photographier: Actes du colloque organisé au Louvre* (Paris: Marval, 1993), 121–31.

Thiele, Jens, *Das Kunstwerk im Film: Zur Problematik filmischer Präsentationsformen von Malerei und Grafik* (Bern/Frankfurt: Herbert Lang/Peter Lang, 1976).

Thomas, François, *L'Atelier Resnais* (Paris: Flammarion, 1989).

Thompson, Dave, *Black and White and Blue: Adult Cinema from the Victorian Age to the VCR* (Toronto: ECW Press, 2007).

Thomson, Claire, "A Cinema of Dust: On the Ontology of the Image from Dreyer's *Thorvaldsen* to Ordrupgaard's *Dreyer*," presented at the symposium *Film and the Museum*, University of Stockholm, 2007. <http://discovery.ucl.ac.uk/4963/>

Thomson, Claire, "The Artist's Touch: Dreyer, Thorvaldsen, Venus". http://english.carlthd reyer.dk/AboutDreyer/Visual-style/The-Artists-Touch-Dreyer-Thorvaldsen-Venus.aspx.

Toepfer, Karl, *Empire of Ecstasy: Nudity and Movement in German Body Culture, 1910–1935* (Berkeley: University of California Press, 1997).

Tolles, Thayer (ed.), *Perspectives on American Sculpture Before 1925* (New York: Metropolitan Museum of Art, 2004).

Trier, Eduard, *Form and Space: The Sculpture of the Twentieth Century* (New York: Frederick A. Praeger, 1961).

Tucker, William, *The Language of Sculpture* (London: Thames & Hudson, 1974).

Turim, Maureen, "The Ethics of Form: Structure and Gender in Maya Deren's Challenge to Cinema," in Bill Nichols (ed.), *Maya Deren and the American Avant-Garde* (Berkeley: University of California Press, 2001), 77–102.

Tyler, Parker, *The Three Faces of the Film: The Art, the Dream, the Cult* (New York: Thomas Yoseloff, 1960).

Uroskie, Andrew V., *Between the Black Box and the White Cube: Expanded Cinema and Postwar Art* (University of Chicago Press, 2014).

Usai, Paolo Cherchi, *The Death of Cinema: History, Cultural Memory and the Digital Dark Age* (London: BFI, 2001).

Van der Coelen, Peter and Francesco Stocchi, *Brancusi, Rosso, Man Ray: Framing Sculpture* (Rotterdam: Museum Boijmans van Beuningen, 2013).

Van Doesburg, Theo, "Licht- en tijdsbeelding (Film)," *De Stijl* VI, 5 (1923), 62.

Van Doesburg, Theo, "Abstracte Filmbeelding," *De Stijl* IV, 5 (1921), 72.

Vidler, Anthony, *Warped Space: Art, Architecture, and Anxiety in Modern Culture* (Cambridge, MA: MIT Press, 2000).

Wall-Romana, Christophe, *Cinepoetry: Imaginary Cinemas in French Poetry* (New York: Fordham University Press, 2013).

Walley, Jonathan, "Not an Image of the Death of Film: Contemporary Expanded Cinema and Experimental Film," in A. L. Rees, Duncan White, Steven Ball, and David Curtis (eds.), *Expanded Cinema: Art, Performance, Film*" (London: Tate, 2011), 241–51.

Weiss, Allen, "Between the Sign of the Scorpion and the Sign of the Cross: *L'Age d'or*," in Rudolf E. Kuenzli (ed.), *Dada and Surrealist Film* (New York: Willis, Locker, & Owens, 1987), 159–75.

Weyergans, François, "KNKK XPRMNTL," *Cahiers du cinéma* 152 (1964), 49.

White, Murray J., "The Statue Syndrome: Perversion? Fantasy? Anecdote?," *The Journal of Sex Research* 14, 4 (November 1978): 246–9.

White, Susan, "Kubrick's Obscene Shadows," in Robert Phillip Kolker (ed.), *Stanley Kubrick's 2001: A Space Odyssey New Essays* (New York: Oxford University Press, 2006), 127–46.

Wiegand, Daniel, *Gebannte Bewegung: Tableaux vivants und früher Film in der Kultur der Moderne* (Marburg: Schüren Verlag, 2016).

Wiegand, Daniel, "'Performed Live and Talking. No Kinematograph': Amateur Performances of Tableaux Vivants and Local Film Exhibition in Germany around 1900," in Scott Curtis, Frank Gray, and Tami Williams (eds.), *Performing New Media, 1890–1915* (New Barnet: John Libbey, 2014), 373–87.

Wiles, David, "Theatre in Roman and Christian Europe," in John Russell Brown (ed.), *The Oxford Illustrated History of the Theatre* (Oxford: Oxford University Press, 2001), 49–92.

Williams, James S., *Jean Cocteau* (London: Reaktion Books, 2008).

Williams, Linda, *Figures of Desire: A Theory and Analysis of Surrealist Film* (Berkeley: University of California Press, 1981).

Wilson, Emma, *Alain Resnais* (Manchester: Manchester University Press, 2009).

Wölfflin, Heinrich, "Wie man Skulpturen aufnehmen soll," *Zeitschrift für Bildende Kunst* VII (1896), 224–8; VIII (1897), 294–7; and XXVI (1915), 237–44.

Wood, Jon, *Close Encounters: The Sculptor's Studio in the Age of the Camera* (Leeds: Henry Moore Institute, 2002).

Wood, Robin, "Ingrid Bergman on Rossellini," *Film Comment* 10, 4 (July–August 1974), 14.

Wyss, Beat, *Hegel's Art History and the Critique of Modernity* (Cambridge: Cambridge University Press, 1999).

Youngblood, Gene, *Expanded Cinema* (New York: E. P. Dutton, 1970).

Yourcenar, Marguerite, "That Mighty Sculptor, Time" (1954), in *That Mighty Sculptor, Time* (New York: Farrar, Straus, & Giroux: 1982), 57–62.

Zerner, Henri, "Malraux and the Power of Photography," in Geraldine Johnson (ed.), *Sculpture*

and Photography: Envisioning the Third Dimension (Cambridge: Cambridge University Press, 1998), 116–30.

Zewadski, William K., "Reflections of a Collector: The Classical Alibi, or How Nudity in Photography Found Cover in the Classics," in Michael Turner (ed.), *Exposed: Photography and the Classical Nude* (Sydney: Nicholson Museum, 2011), 132–9.

Ziegler, Reiner, *Kunst und Architektur im Kulturfilm 1919–1945* (Konstanz: UVK Verlagge-sellschaft, 2003).

Ziolkowski, Theodore, *Disenchanted Images: A Literary Iconology* (Princeton: Princeton University Press, 1977).

About the Authors

Vito Adriaensens is a visiting scholar and Adjunct Assistant Professor at Columbia University's Film Department, with a fellowship from the Flemish Research Council and the European Union's Horizon 2020 Project at the University of Antwerp. His research focuses on the aesthetic, cultural and (art-)historical interaction between film, theater, and visual arts. He is the author of the upcoming monograph *Velvet Curtains and Gilded Frames: The Art of Early European Cinema* and is currently also the treasurer of Domitor, the International Society for the Study of Early Cinema.

Lisa Colpaert is a fashion designer, film scholar, and film programmer. She is the author of *The Dark Galleries: A Museum Guide to Painted Portraits in Film Noir, Gothic Melodramas, and Ghost Stories of the 1940s and 1950s* (2013, with Steven Jacobs). She currently works as a curator for *Cinea* at the Belgian Royal Film Archive. She is a Ph.D. candidate at the London College of Fashion, where she is undertaking a practice-based, textual and archival investigation of Edith Head's film costume designs in 1940s film noir, with a fellowship from the British Art and Humanities Research Council (TECHNE).

Susan Felleman is Professor of Art History and Film and Media Studies at the University of South Carolina. She is the author of *Botticelli in Hollywood: The Films of Albert Lewin* (1997), *Art in the Cinematic Imagination* (2006), and *Real Objects in Unreal Situations: Modern Art in Fiction Films* (2014). She has published in *Camera Obscura*, *Film History*, *Film Quarterly*, *Iris*, *Jump Cut*, and *Millennium Film Journal*, among other journals, as well as in a variety of edited volumes and exhibition catalogues.

Steven Jacobs is an art historian specialized in the relations between film and the visual arts. His other research interests focus on the visualization of architecture, cities, and landscapes in film and photography. His publications include *The Wrong House: The Architecture of Alfred Hitchcock* (2007), *Framing*

Pictures: Film and the Visual Arts (2011), *Art & Cinema: Belgian Art Documentaries* (DVD and booklet, 2013), and *The Dark Galleries: A Museum Guide to Painted Portraits in Film Noir, Gothic Melodramas, and Ghost Stories of the 1940s and 1950s* (2013, with Lisa Colpaert). He teaches at the University of Antwerp and Ghent University, Belgium.

Index

272 *Screening Statues*